HOWARD HAWKS

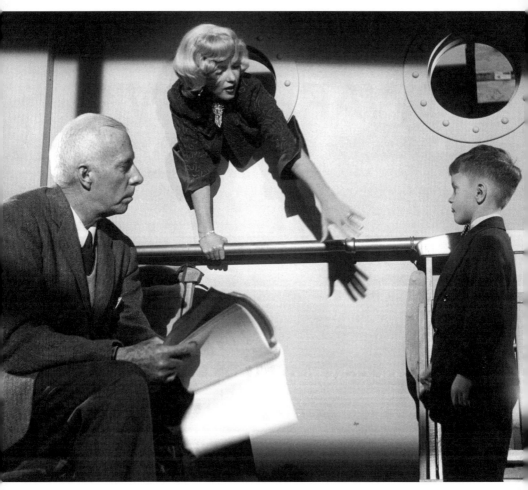

Howard Hawks with Marilyn Monroe and George Winslow on the set of *Gentlemen Prefer Blondes* (1953) (courtesy of L. Tom Perry Special Collections, Harold B. Lee Library, Brigham Young University)

HOWARD
HAWKS
New Perspectives

edited by **Ian BROOKES**

A BFI book published by Palgrave

'We Hawksians ...'

First published in 2016 by
PALGRAVE

on behalf of the

BRITISH FILM INSTITUTE
21 Stephen Street, London W1T 1LN
www.bfi.org.uk

There's more to discover about film and television through the BFI. Our world-renowned archive,
cinemas, festivals, films, publications and learning resources are here to inspire you.

PALGRAVE in the UK is an imprint of Macmillan Publishers Limited, registered in England,
company number 785998, of 4 Crinan Street, London N1 9XW. Palgrave Macmillan in the US is a
division of St Martin's Press LLC, 175 Fifth Avenue, New York, NY 10010. Palgrave is a global
imprint of the above companies and is represented throughout the world. Palgrave® and
Macmillan® are registered trademarks in the United States, the United Kingdom, Europe
and other countries.

Designed by couch

Set by Cambrian Typesetters, Camberley, Surrey
Printed and bound by CPI Group (UK) Ltd, Croydon, CR0 4YY

This book is printed on paper suitable for recycling and made from fully managed and sustained
forest sources. Logging, pulping and manufacturing processes are expected to conform to the
environmental regulations of the country of origin.

British Library Cataloguing-in-Publication Data
A catalogue record for this book is available from the British Library
A catalog record for this book is available from the Library of Congress

ISBN 978–1–84457–541–1 (pb)
ISBN 978–1–84457–542–8 (hb)

Contents

Acknowledgments

In the course of working on this book I encountered what is truly a global community of Hawks aficionados and I'm grateful to them for sharing with me their expertise and enthusiasm. Molly Haskell, an outstanding early critic of Hawks, once obliquely referred to that community in a sentence beginning 'We Hawksians ...' and it is to them (us) that this book is dedicated.

Like everyone with an interest in Hawks, I'm indebted to James D'Arc, Curator of the Motion Picture Archive at the Harold B. Lee Library at Brigham Young University, Provo, Utah. Jim, as an enterprising young archivist and film buff, originally acquired the papers from Hawks himself in a timely rescue of an already depleted collection shortly before Hawks's death. I'd also like to thank Jim for writing the Preface to this book. Thanks also to staff at the Library's L. Tom Perry Special Collections for making my research trip there so productive and enjoyable. At the same time, special thanks to Angie Panos who kindly saw to it that I was prised out of the Library basement from time to time and shown something of Utah.

Thanks to staff at the Hallward Library at the University of Nottingham, notably Philip Bellamy, Kenneth Robinson, Anne-Marie Llewellyn – and not forgetting my long-standing debt to Alison Stevens. Thanks also to library and archive staff at the following institutions: the Academy of Motion Picture Arts and Sciences, the American Film Institute, the British Film Institute, the BFI Reuben Library, the British Library, New York Public Library, including the Schomburg Centre for Research in Black Culture. I'm particularly grateful to Nigel Arthur, Curator of Stills at the BFI National Archive at Berkhamsted, for facilitating my visit to this wonderful collection. I would also like to thank Kevin Brownlow for kindly providing me with a copy of the unpublished interview he conducted with Hawks in 1967.

Mindful of that defining collaborative quality that characterises 'the Hawksian group', I happily thank the many generous and talented friends and colleagues who have helped in the development of this book by providing wise advice and sharp-eyed criticism. In the Department of Culture, Film and Media at the University of Nottingham I would especially like to thank Andy Goffey, James Mansell, Tracey Potts and Mark Gallagher. Throughout the period in which this book was taking shape I had the good luck to share an office with Alex Simcock who not only arrived with 'My Rifle, My Pony, and Me' *already* on her iPod, but also helped in myriad ways. In the university's

Department of American and Canadian Studies, I would like to thank Celeste-Marie Bernier, Hannah Durkin, Nick Heffernan, Richard King, Pete Messent, Dave Murray and Graham Taylor.

Dana Polan has been a good friend to this project from the outset and a number of his suggestions have helped to make this a better book. Mark Jancovich was characteristically enthusiastic and helpful in several conversations during the planning of this collection. Particular thanks (again) to Dana Polan and Alex Simcock as well as to Graham Taylor for their readings of earlier drafts of my own chapter. I owe another hefty debt of gratitude to Nick Heffernan for his critical commentary on draft versions of my introductory essay. I should also like to thank Brian Faucette, Fredrik Gustafsson and Marie Liénard-Yeterian for our discussions about Hawks.

Heartfelt thanks go to other inspirational friends: Bret Battey, Jacky Boucherat, Gill Branston, Julia Cooper, Deniz Ertan, Jean Darnbrough, Charlotte Fallenius, Geoffrey Fielding, Eva Giraud, Isabel Jones Fielding, Helen Oakley, Lynne Pettinger, David Purveur, Brent Reid and Lisa Rull. Additional thanks go to Julia Cooper for her invaluable contributions to the preparation of the manuscript and for her equally invaluable translations of several French publications on Hawks.

One of the pleasures of working on this book has been the opportunity to work with some terrific people at Palgrave Macmillan. First, thanks to Rebecca Barden who responded to the initial proposal with a sunburst of enthusiasm. Since then Jenna Steventon has been at the helm where she has been, quite simply, the ideal editor. Working with Sophia Contento has been a joy and I very much appreciate her superb work on the book's design. Special thanks also go to Chantal Latchford for bringing her exceptional acuity to the text and doing it with alacrity too.

My deepest gratitude is to Caroline Robinson, not only for her graceful understanding of my obsessive preoccupation with Hawks during the writing of this book, but also for her frequent participation in it. She has by now seen *Red River* nearly as many times as I have.

Last, but certainly not least, I owe a special debt of gratitude to Judy Christian and Julian McGlashan whose work ensured that this book eventually got to see the light of day.

Preface
'Who the Hell Is Howard Hawks?'

James V. D'Arc

The title for this preface is that used by Robin Wood – in a 1969 issue of *Focus!* – whose landmark study on the director published the year before did much to initiate future examinations of Hawks's body of work. Now, however, the question invokes the past tense, much like the reply that Scrooge received from the ghost of Jacob Marley in *A Christmas Carol*: 'Don't ask me who I am. Ask me who I was.' This thoughtful volume that you hold in your hands does much to reflect continued interest in a man who was ranked in numerous polls, from *Movie* to *Sight and Sound*, as one of the greatest film directors of all time.

My contribution to this question of who Howard Hawks *was* comes from pondering on my visit to his home in Palm Springs, California, when, as an archivist, I had come to collect for Brigham Young University the accumulation of papers, scripts, photographs and memorabilia that would eventually constitute the Howard Hawks Papers. That visit in April 1977 was not to a sprawling estate protected by gates and surrounded by a meticulously manicured lawn and garden – the home that one might expect of a man who had lived in beautiful houses in the fashionable Brentwood district of Los Angeles; rather, it was a modest white brick rambler with perhaps two or three bedrooms and a backyard patio surrounded by patches of grass struggling to survive in the desert climate. The door opened to reveal a trim, fit man dressed simply in a white t-shirt, blue jeans and the noticeably neat moustache that he sported during his final years.

The legendary director greeted my associate and myself as he welcomed us into his home with a low, almost guttural growl of 'Hello. Come on in'. No movie posters, plaques or memorabilia lined the walls or sat on shelves. There was nothing to give away the accomplished past of the director of *The Dawn Patrol*, *Scarface*, *Twentieth Century*, *Only Angels Have Wings*, *His Girl Friday*, *Sergeant York*, *Air Force*, *The Big Sleep*, *Red River*, *Gentlemen Prefer Blondes* and *Hatari!*. There was no boasting of films that he had produced and directed, no tales offered up of how he'd been wronged by any number of studio bosses, and there were no getting-even accounts. In fact, he seemed to not really care about the string of now highly regarded classics that he had made. 'When a film was finished, I didn't think about it anymore,' he said, 'I was on to the next project.' His demeanour with me confirmed what Richard Schickel wrote after his extended visit to Hawks: 'He will not sue for attention or favor. On

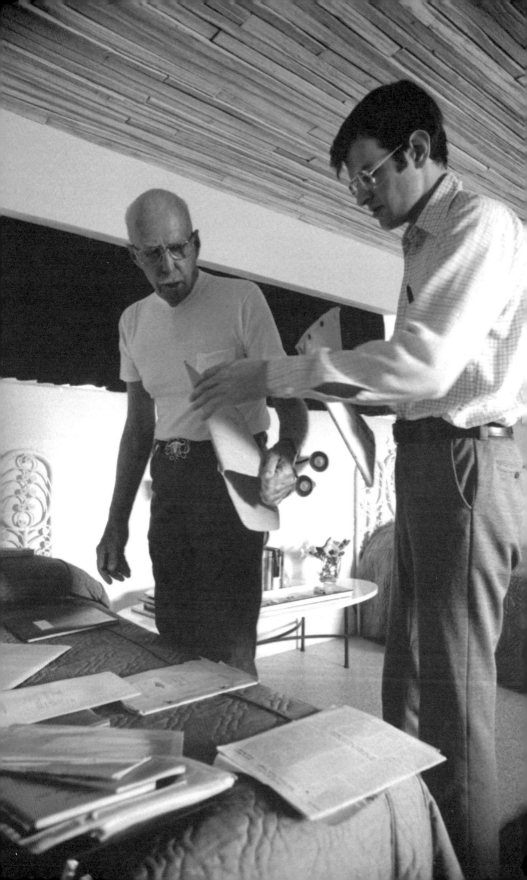

screen and in person he wants you to come to him to discover the merits in his work and in himself which he knows are there.'

Hawks was polite and self-effacing as he guided us into bedrooms with their bed-spreads littered with a few correspondence files, scripts and photographs. Unfortunately, what remained of the record of his career was significantly fragmented as there were multiple versions of scripts for *To Have and Have Not*, *Red River* and *The Big Sleep*, but none from some of his other films. Garage fires and careless secretaries over the years accounted for the numerous gaps in the historical record, he said. Our visit was brief as we gathered up the items he had laid out. However, when I asked whether there were any other items to collect, perhaps more photographs, he led us outside to the backyard patio and pointed to a tall filing cabinet. Opening it, he invited us to 'Take anything you like.' It was full of photographs, including many of his famous discovery, Lauren Bacall, whom his then-wife Nancy 'Slim' Gross had noticed on the cover of a wartime issue of *Harper's Bazaar*. This sighting had led to Bacall visiting California and signing an exclusive contract with Hawks and his business partner, the flamboyant talent agent and producer Charles K. Feldman.

Before leaving, I sat down with Hawks to arrange for a return trip in order to conduct an oral history. He graciously consented to this after I had prepared questions suggested by materials in his collection. He was open to such a meeting: 'Ask me anything you like,' he said. Unfortunately, his death only eight months later in December rendered this impossible. As we drove away, my colleague and I talked about what had happened. Robin Wood's *Howard Hawks* had been out just under ten years. Schickel's fine instalment on Hawks for his television series, *The Men Who Made the Movies*, had come out in 1973, and the companion book was published two years later. Nevertheless, aside from film scholars, the question was not just who *was* Howard Hawks, but who among the general public *cared*? That was one of the prime reasons that I sought out Hawks in his desert abode, the culmination of weeks of telephone calls to invite him to place his papers at Brigham Young University. An archival record that would be available to the public, I reasoned, should stimulate continued interest and research in this jack-of-all-genres director. Thankfully, I think that it has, and so has the increased availability of his work through film retrospectives and home-video formats. The significance of who Howard Hawks *was* relates directly to who he *is* to us and why he matters. Appropriately then, this volume effectively addresses those questions about the director whose films, in the words of Andrew Sarris, 'were good, clean, direct, functional cinema, perhaps the most distinctively American cinema of all'. That this book bears the simple, straightforward title of *Howard Hawks* is something that I think the no-frills Hawks whom I met in the last year of his life would have liked.

Howard Hawks at his Palm Springs home with James V. D'Arc, April 1977 (Photo: Nelson Wadworth. Courtesy of L. Tom Perry Special Collections, Harold B. Lee Library, Brigham Young University)

He was a keen properties man and very clever with his hands. … He was fascinated with the mechanics of design. He wanted to know all about how things happened, how the people lived and what were their hierarchies and ceremonies. But he was also the world's biggest bluffer, capable of making you instantly believe in the unlikeliest of stories which he recounted with a totally straight face.

Alexandre Trauner, Production Designer on *Land of the Pharaohs* (1955) from *Décors de Cinéma: Entretiens avec Jean-Pierre Berthomé* (Paris: Jade-Flammarion, 1988), translated byJulia Cooper

Introduction
'Who the Hell Is Howard Hawks?'

Ian Brookes

Hawks has always, perhaps purposely, been an undefined figure.

Peter Bogdanovich[1]

In the 1950s, a young film fan called Eugene Archer was planning a book about six of the most important American film directors: John Ford, John Huston, Elia Kazan, George Stevens, William Wyler and Fred Zinnemann. On a Fulbright to Paris, Archer became an habitué of the Cinémathèque Française and an avid reader of *Cahiers du cinéma*, discovering there that French critics were unimpressed by the pantheon of directors in his proposed study and were instead championing Alfred Hitchcock and Howard Hawks. Hitchcock was well enough known, certainly, but Hawks hardly at all. Archer wrote to his friend, the New York film critic Andrew Sarris, asking: 'Who the Hell Is Howard Hawks?' 'Archer and I thought we knew all about Hitchcock,' Sarris later recalled. 'But Hawks? Who was he? And why were the French taking him so seriously?' Sarris recounted how François Truffaut and Jean-Luc Godard 'were just crazy about Hawks. And especially at that time, *Rio Bravo* [1959] had just come out, and that was, to them, huge. And here, people just thought it was another western.'[2]

Sarris's anecdote serves to bring together some of the main issues and key players in the knotty problem of locating Howard Hawks. In 1950s' Paris, Archer found himself in the thick of a cineaste culture that was forging a new agenda for film theory and criticism, and taking Hollywood seriously when American criticism, such as it then was, did not. Archer's question continues to reverberate: it recurred as the title of a 1967 article by Robin Wood, and another in 2002 by Peter Wollen, each of whom would become influential figures in shaping Hawks's reputation.[3]

Although Hawks made some of Hollywood's most critically acclaimed and enduringly popular films, he remains something of a marginalised figure. And although he is acknowledged in some quarters as an important auteur in American cinema, he hasn't received the same kind of attention as others such as Alfred Hitchcock, John Ford, Frank Capra, Cecil B. DeMille, George Cukor, Billy Wilder or Orson Welles. While all these figures have attracted a substantial number of critical and biographical studies, the first biography of Hawks, by Todd McCarthy, didn't appear until 1997, some twenty years after Hawks's death. Despite having his 'name above the title' for most of a career spanning half a century, he often goes unrecognised as the director of his own

films. As late as 1968, Andrew Sarris could describe Hawks as 'the least known and least appreciated Hollywood director of any stature'.[4] Today, several of his films are either unavailable or obtainable only as foreign imports. Tellingly – and unlike all those directors mentioned above – there has never been any collected edition of his work on video or DVD.

In the course of working on this book I've lost count of the times I've been asked who Hawks was and what he did. When I explained that he was an important American film-maker the enquirers were often none the wiser until I mentioned a film title or two, which more often than not they did recall and often admired. 'Oh,' they would typically say, 'did he make that?' (Occasionally, encouraged by a flicker of recognition when I mentioned his name, I found that the enquirer was thinking not of Howard Hawks but Howard Hughes.) My own experience echoes Robin Wood's nearly fifty years ago when he reported 'a commonly observed phenomenon that people who think they have never heard of Hawks retain vivid memories of films directed by him'.[5]

One explanation for this is that Hawks's films don't seem to have a distinctive style and so could be deemed to lack the requisite directorial signature of the auteur. As Manny Farber, an astute early critic of Hawks put it, his films 'are as different as they're similar'.[6] Some of Hawks's contemporaries were more obviously recognisable through their identification with a particular genre: Ford with the Western, Hitchcock with the suspense thriller, DeMille with the historical epic and Cukor with the 'woman's film'. Hawks is characterised by the very opposite, what we might call generic promiscuity. No other film-maker worked across genres as he did, yet specific Hawks pictures have come to be seen as exemplary instances of their type: *Scarface* (1932) of the gangster film; *The Big Sleep* (1946) of film noir; *Gentlemen Prefer Blondes* (1953) of musical comedy; *I Was a Male War Bride* (1949) of romantic comedy; *Twentieth Century* (1934), *Bringing Up Baby* (1938) and *His Girl Friday* (1940) of screwball comedy; *Red River* (1948), *The Big Sky* (1952) and *Rio Bravo* of the Western; *Ceiling Zero* (1936) and *Only Angels Have Wings* (1939) of the aviation film; and *Air Force* (1943) of the combat film. Nor did Hawks have any longterm association with a particular studio, unlike, say, DeMille at Paramount, Vincente Minnelli at MGM or Michael Curtiz at Warner Bros. Indeed, Hawks worked for all of the major studios at one time or another, but only on shortterm contracts. From 1943, his films were made by a succession of his own production companies.

Another explanation for this under-recognition is that Hawks's films don't appear to present the same kind of narrative complexity as others do. He is often described as a 'storyteller' whose narratives have been viewed as straightforward and simply told stories. Hawks himself added to this impression in later interviews. 'If I can make about five good scenes and not annoy the audience,' he said, 'it's an awfully good picture.'[7] This seems like a disingenuously modest aspiration for a film-maker, although it does indicate the reliance on 'scene-making' in his work.

Howard Hawks on location in Germany for the making of *I Was a Male War Bride* (1949) (BFI)

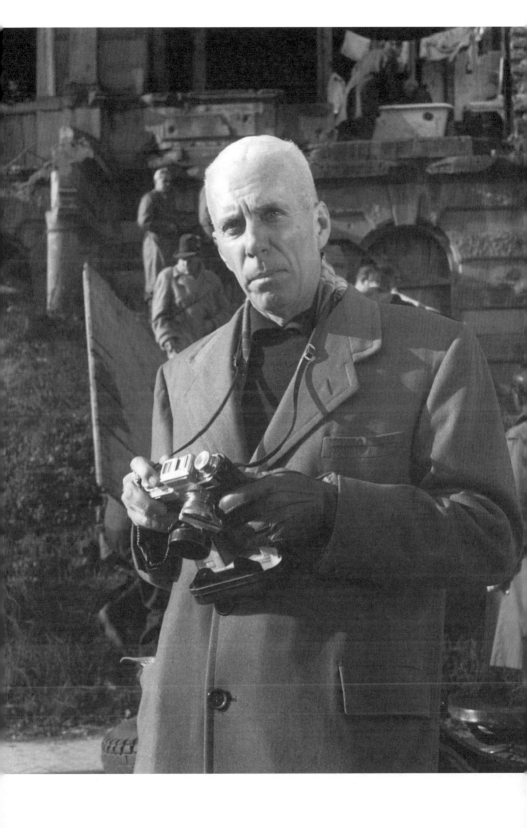

Although his films were commercially successful, Hawks himself was often over-looked by critics, at least until later in his career. He received little official acclaim from the industry during his lifetime and was nominated only once for an Academy Award, as Best Director for *Sergeant York* (1941), which he didn't win (losing out to John Ford with *How Green Was My Valley*). He did receive an Honorary Academy Award in 1975, the kind of belated recognition for lifetime achievement which the Academy occasion-ally bestows on a recipient shortly before his death. Although he was among the best-connected figures in the industry – his personal telephone directory constituted a veritable *Who's Who* of Hollywood from Jean Arthur to Darryl F. Zanuck – he was also a remote and enigmatic figure, nicely described by his script girl and 'major-domo' Meta Carpenter Wilde as a 'moated' man.[8] This is also suggested by the photograph chosen for the cover of Gerald Mast's study of Hawks which shows a scarcely dis-cernible figure wreathed in cigarette smoke.[9] He cared little about what posterity thought of him. His papers were carelessly kept and many accidentally destroyed. What remained he readily gave away.[10] Even his name gets misspelled (as 'Hawkes').

Other anomalies have obscured Hawks's reputation. He is often seen as an 'action' director and much of his work seems to corroborate that view. He is associated with genres with a masculine bias, like the Western; settings in the worlds of the gangster, the prison and the private eye; and 'manly' pursuits like boxing, motor racing, deep-sea fishing, logging and safari hunting. Hawks himself seemed to personify an outdoorsman ethic. Like his friend Ernest Hemingway, he liked hunting, shooting and fishing. Screen-writer Leigh Brackett confirmed this view in her account of working with Hawks: 'He is an intensely masculine person, with an intensely masculine outlook on life,' she said. 'He has done most of the things he makes pictures about – driven racing cars, piloted planes, ridden motorcycles. ... He values bravery, strength, expertise, loyalty, all the "masculine" virtues.'[11] And yet Hawks wasn't quite the action director he seemed. The action sequences in his films were usually relegated to second-unit directors and they often look like the interpolated scenes they were, conspicuously mismatched within the 'Hawksian' narrative world.[12] Hawks favoured interior spaces as his working habitat and, as his biographer Todd McCarthy has pointed out, 'was most comfortable in a drawing room, an office, a home, or a hotel'.[13]

It is also the case that critical perceptions of Hawks's films often fall back on taken-for-granted notions such as the 'Hawksian woman' or the 'Hawksian group', categories that appear to be unproblematically settled under the rubric of 'Hawksian'. Thus, even when he comes to critical attention, Hawks seems to be a known entity, causing few problems of interpretation. This view is further compounded by the apparent dearth of any obvious relationship between narrative theme and visual style, the kind of relation-ship more readily identifiable in the work of such directors as Hitchcock, Ford or Douglas Sirk. One of the main problems in identifying Hawks's style is his use of a camera that seems scarcely discernible, making it look like no style at all. It's a style often described in terms of what it isn't: unobtrusive, inconspicuous, undemonstrative. This is not to suggest that Hawks lacked a discernible style, but rather it was one that derived from a working method rather than a visual or narrative conception, a process

which is, in itself, absent from the screen. The crucial elements which constitute Hawks's style are only partly to be found in the straightforward or functional shooting style he preferred. Rather, the process of collective improvisation, especially with a trusted cast and crew, and the development of ensemble performance are the hallmarks of a Hawks production. Any attempt to define 'Hawksian' would need to recognise the intrinsic importance of that collaborative, improvisational process. Indeed, Hawks's film-making technique is best understood as analogous to jazz improvisation, as we shall see.

Hawks on Hawks

Hawks's posthumous reputation owes much to the series of interviews he gave during the last decade of his life, especially before audiences of academics and film school acolytes. Although he habitually professed incomprehension at much of the critical interest in his work, he clearly took to the interview form in which he found it congenial to recount, or invent, stories of his Hollywood experiences. But although these stories provide fascinating insights into Hollywood film-making in the studio era, they often conceal as much as they disclose, largely through displays of self-aggrandisement and one-upmanship. We should also remember Alexandre Trauner's description of him as 'the world's biggest bluffer' and so we should take the stories he tells about himself with something more than a pinch of salt. Hawks certainly became adept at telling stories in which he was centre stage, dispensing advice to actors and crew or taking on studio bosses. In this practised anecdotal mode, Hawks would typically describe confrontational episodes with studio heads such as Sam Goldwyn, Louis B. Mayer and Jack Warner in which he himself would invariably emerge triumphant. However, according to his second wife, Slim Keith, Hawks was a kind of Walter Mitty fantasist and an unreliable witness to his own life story. 'Everything that he did had a storybook quality to it,' said Keith. 'Every story or experience he related had him as the central character, committing great feats of derring-do or acts of heroic bravery.'[14] In a similar vein, Joseph McBride and Michael Wilmington described Hawks at the 1971 Chicago Film Festival

> beguiling the audience with a flow of anecdotes. Some were familiar, but he embellished them with new twists and flourishes, just as his heroes repeat the same tasks in an endless but volatile routine until they achieve an almost effortless mastery.[15]

Hawks's *modus operandi* began to prove frustrating to interviewers, as Joseph McBride and Gerald Peary found in 1974. They described 'the way he somehow managed, despite our stated intentions, to slip in most of his favorite, and by now maddening, anecdotes'.[16] In another interview the same year for the radical film journal *Jump Cut*, there was a more concerted effort by the leftist interviewers to hold Hawks to political account and to forestall the predictable anecdotal responses – 'to circumvent the usual What-Was-It-Like-To-Work-With-Humphrey Bogart approach' – as they described it. But even these hard-nosed inquisitors found themselves 'perversely

enchanted … hanging batedly on every scabrous John Wayne anecdote'.[17] Hawks could be amiably expansive when he felt like it, but he was invariably recalcitrant when asked about political subjects as, for example, in this terse response to Peter Bogdanovich:

> BOGDANOVICH: It's been said [by Robin Wood] that the picture [*To Have and Have Not*, 1944] is implicitly antifascist …
> HAWKS: I don't even know what 'antifascist' is, so I couldn't tell you.[18]

But even when Hawks gave short shrift to a question, this in itself could be revealing, as in this exchange – a masterclass in acerbic concision – in an unpublished interview with Win Sharples:

> SHARPLES: I loved *Monkey Business* [1952].
> HAWKS: French do, I didn't.[19]

Hawks affected a defensive strategy against 'theory', one resistant to academic prob-ing, and to that end he liked to describe himself as just a storyteller. 'All I'm doing is telling a story,' he often said. 'I don't analyze or do a lot of thinking about it.'[20] All the same, in the best of these interviews – notably two unpublished ones, by Kevin Brown-low and Win Sharples, together with those by Joseph McBride published as *Hawks on Hawks* – we can see a much more reflective and analytical Hawks, who comes across as an astute commentator on his own work as well as on the practice and – indeed – *theory* of film-making. There is a paradox at work here that François Truffaut shrewdly identified:

> something I feel that's very interesting with Hawks is that in all those interviews, he always criticizes, he raps the intellectuals, and in my opinion he is one of the most intel-lectual filmmakers in America. He often speaks in terms of film concepts. He has many general theories. He doesn't belong to the school of instinctive filmmakers. He thinks of everything he does, everything is thought out. So somebody ought to tell him one day that despite himself, he is an intellectual and that he has to accept that![21]

French Critics, American Artist

> I remember [Hawks] always laughed when someone would send him a copy of *Cahiers du Cinéma*. 'I just aim the camera at the actors,' he liked to say, 'and they make up all these things about me.'
>
> George Kirgo[22]

French critics took an early interest in Hawks: a prescient French reviewer of *A Girl in Every Port* (1928) was already speaking of Hawks's 'simplifying style'.[23] The French

have always taken cinema more seriously than the Americans and Auriol's exuberant appreciation of *A Girl in Every Port* in *La Revue du cinéma* reflected the longstanding esteem which French critics had for American film-makers. In that same year, the *Revue* also included accounts of Charles Chaplin, Buster Keaton, Mack Sennett, Harry Langdon, Frank Borzage, King Vidor, Josef von Sternberg and Erich von Stroheim alongside others on European 'art' cinema and the avant-garde. The *Revue*, a precursor to *Cahiers du cinéma*, was already paving the way for the critical and theoretical framework of the *politique des auteurs* through which Hawks would find himself elevated to the upper echelons of a new French canon.

A cluster of laudatory articles on Hawks appeared in *Cahiers* during the 1950s inaugurated by Jacques Rivette's 'The Genius of Howard Hawks' in 1953. 'The evidence on the screen is proof of Hawks's genius,' Rivette proclaimed, 'you only have to watch *Monkey Business* to know that it is a brilliant film'.[24] Rivette's essay was the first to apply an auteurist methodology to Hawks's work. The *Cahiers* writers reconfigured Hawks as a major auteur and effectively triggered new auteurist appraisals of his work in Britain and America. Rivette's essay was an important influence on Robin Wood's groundbreaking study of Hawks and on Wood's colleagues such as V. F. Perkins at *Movie*, which published a special Hawks issue in 1962. The French critical evaluation of Hawks also influenced Peter Wollen's structuralist study of film, *Signs and Meaning in the Cinema*, its chapter on auteur theory featuring a 'test case' devoted to the director.[25] Wood's and Wollen's books were founding texts in the development of film studies in the 1960s and 1970s, granting Hawks a central position in the emergent academic discipline. Film scholars, at least, no longer had to ask 'Who the hell is Howard Hawks?'

The idea of Hawks the auteur was launched by French criticism and it would be difficult to imagine his subsequent reputation without it. Rivette's declaration of Hawks's 'genius' was characteristic of the rhetorical flamboyance that accompanied the polemical writings of the *Cahiers* firebrands, as in Eric Rohmer's review of *The Big Sky* the same year. 'I think that one cannot truly love any film deeply,' said Rohmer, 'if one does not love deeply the films of Howard Hawks.'[26] Another of the characteristically hyperbolic instances of *Cahiers* writing would acquire aphoristic force: Jean-Luc Godard's claim that Hawks was nothing less than 'the greatest American artist'.[27] Godard's juxtaposition of 'artist' and 'American' here worked as an expression of *Cahiers' politique* manifesto, conferring on the Hollywood director the status of artist, but it also provided a useful epithet to recast the otherwise unclassifiable Hawks as 'American Artist'.[28] Hawks's auteur status was boosted again when the *politique*, including its penchant for categories and rankings, was taken up by Sarris in his highly influential book *The American Cinema* which effectively imported the means of legitimating the study of Hollywood directors and placed Hawks in its highest category of 'Pantheon' directors. Like the *Cahiers* writers, Sarris admired Hawks's styleless 'American' style as 'good, clean, direct, functional cinema, perhaps the most distinctively American cinema of all'.[29] Hawks was gaining recognition, although largely within the parameters of scholarly study.

Hawks, Modernity and Modernism

The modern man – that's Hawks, completely.

Henri Langlois[30]

Hawks appealed to French critics because he seemed to them both modern and mod-
ernist at a juncture which was witnessing major cultural shifts both in France and Amer-
ica. As Langlois wryly reminded his *Cahiers* readers at the time of the Hawks
retrospective at the Museum of Modern Art in 1962, New York was only belatedly
catching up with Paris in its recognition of *A Girl in Every Port*, over thirty years after
Auriol's review in *Revue du cinéma*. The Paris of 1928 was 'rejecting expressionism',
Langlois said. 'It was the Paris of the Montparnassians and Picasso, of the surrealists
and the Seventh Art, of Diaghilev, of the "Soirées de Paris", of the "Six", of Gertrude
Stein, of Brancusi's masterpieces.'[31] Paris had become the centre of European mod-
ernism, Langlois is saying, and Hawks can bear comparison with Walter Gropius and
Le Corbusier, then at the vanguard of modernist architecture and design. Langlois cites
the claim by the modernist writer Blaise Cendrars that *A Girl in Every Port* 'definitely
marked the first appearance of contemporary cinema'. Langlois considered Hawks's
cinema to be 'ahead of its time' and 'even in the vanguard of artistic movements'.[32]

There was no more important figure than Langlois in establishing a profile for
Hawks, not only in print but also through regular screenings of his films. The Cinémath-
èque Française had been founded by Langlois in 1935 and run by him ever since,
becoming by the 1950s, when Eugene Archer arrived in Paris, the very centre of
French cineaste culture as both cinema and film archive. It was because of Langlois'
regard for Hawks that Paris had become 'the only place' where most of his films could
be seen. It was also the place frequented by the Hawksian critics and film-makers
associated with *Cahiers* – Truffaut, Godard, Chabrol, Rivette, Rohmer – who became
collectively known as 'les enfants de la Cinémathèque'. Langlois played an incalculable
role on Hawks's behalf in the foundation of an informal academy at the Cinémathèque
in which the *Cahiers* critics were effectively schooled in Hawks studies as they were
creating a new paradigm for the study of film.[33]

'The Hawksian Woman'

The idea of Hawksian modernity noted by Langlois can be linked to his narrative treat-
ment of women and what some feminist critics of the 1970s identified as the 'Hawksian
woman'.[34] Hawks's formative studio experience coincided with the emergence of the
'new woman' of the 1920s when there was a significant increase in the number of
women working outside the home, together with a conspicuous shift in social and
sexual mores. This was evident in women's appearance where the full frocks, tight
corsets and elaborate hats of the Edwardian era, determinants of a sedate and deco-
rous demeanour, were replaced by shorter dresses with a freer-flowing look, exempli-
fied by the figure of the 'flapper'. The typical upswept hairstyle of the 'Gibson Girl' gave
way to the short 'bob' cut, exemplified by film stars Colleen Moore, Clara Bow and

Hawks with Henri Langlois, Director of the Cinémathèque Française and longstanding champion of Hawks's work, Paris, 1967 (BFI)

'She was way ahead of her time': Louise Brooks as high-diving Marie in *A Girl in Every Port* (1928) (BFI)

Louise Brooks. These new fashions provided a more natural and streamlined look for women and were better suited to activity. The flapper became emblematic of new kinds of female expressiveness.

We can see in Louise Brooks in *A Girl in Every Port* a new kind of female charac- terisation taking shape, an incipient version of the Hawksian woman. Although hers was a relatively minor role, Brooks had a mesmerising effect on French critics. Langlois, for example, admired her as 'the modern artist par excellence'.[35] Brooks's Marie is a carnival performer, 'Mam'selle Godiva', with a high-diving act. Hawks's tracking camera makes much of her climb up a vertiginously high ladder, her lithe physique emphasised in a tight-fitting swimsuit, followed by a spectacular dive into the little tank. But what is even more striking is the way she executes the task. She is exceptionally good at what she does, performing the daredevil feat with fearless expertise. If she looks modern, she also enacts a modern kind of femininity, and it was this quality which attracted Hawks. 'Just think of how modern she looks,' he told Kevin Brownlow. 'Oh, God, she was a good looking girl.'[36] Hawks spoke admiringly about Brooks and his reflections provide real insight into his casting preferences:

I wanted a different type of girl. I didn't want what they'd been playing. I wanted a new type. I hired Louise Brooks because, see, she's the type of person – she's very sure

of herself, she's very analytical, she's very feminine, and [...] she's damn good and sure she's going to do what she wants to do. I could use her today. She was way ahead of her time, with that hairdress. And she's a rebel. I like her, you know. I like rebels.[37]

Whatever the Hawksian woman is, Brooks appeared as its prototype: a new kind of femininity that French critics identified as an expression of Hawks's modernity. Dynamic, intelligent and sexually assertive, she could even be physically likened to Streamline Moderne design.

The Hawksian Group

In tension with the modern, assertive Hawksian woman is the 'Hawksian group', also a familiar narrative trope, comprising an exclusive all-male enclave with a common professional purpose, a shared bond of comradeship, unified by its own rituals and codes of conduct. This homosocial group may admit a woman into its ranks if she can prove that she is 'good'. These groups typically tackle problems through collective effort, working with limited resources and against the odds, making use of what's at hand. The Hawksian group is a motley crew which, whatever the shortcomings of its individual members, derives its strength from a collective bond and common purpose. In *Rio Bravo*, for example, Pat Wheeler (Ward Bond) asks Sheriff Chance (John Wayne) who he's got helping him take on the Burdette gang and is unimpressed with the sheriff's reply. 'That's all you got?' asks Wheeler. 'That's *what* I got,' replies Chance. This could be something of a credo for the Hawksian group. The group itself is often formed in makeshift circumstances and with unofficial status, such as in the deputies' swearing-in ceremony in *El Dorado* (1967):

BULL HARRIS (ARTHUR HUNNICUTT): Here's a couple of badges. Raise your right
 hand. I forgot the words but, you'd better say 'I do.'
COLE THORNTON (JOHN WAYNE) and MISSISSIPPI (JAMES CAAN) [in unison]:
 I do.
BULL: Now you're deputies.

The Hawksian group has a penchant for nicknames which work to consolidate the unofficial culture of the group, dispensing with official or family names in favour of the reinvention of an individual as a member of the group. Sometimes this involves a levelling, as in *El Dorado*, when Alan Bourdillon Traherne (James Caan) is mocked for his fancy name and becomes simply 'Mississipi', while Anna-Maria D'Alessandro (Elsa Martinelli) in *Hatari!* (1962) gets similarly streamlined and Americanised as 'Dallas'.[38]

This recurrent group-work trope can also be seen as a metaphor for Hawks's own collaborative working practices. Indeed, Jean Douchet has identified *Hatari!* as an analogy to film-making, 'with the communal life of its crew, its plan for the next day's work improvised every evening, its idle periods and bursts of effort'.[39] Certainly, no other director deployed 'workshop' collaborations to the extent that Hawks did, especially in an era when the studios' departmental organisation and schedule-driven mode of production militated against the looser and lengthier practices entailed. Perhaps above all else,

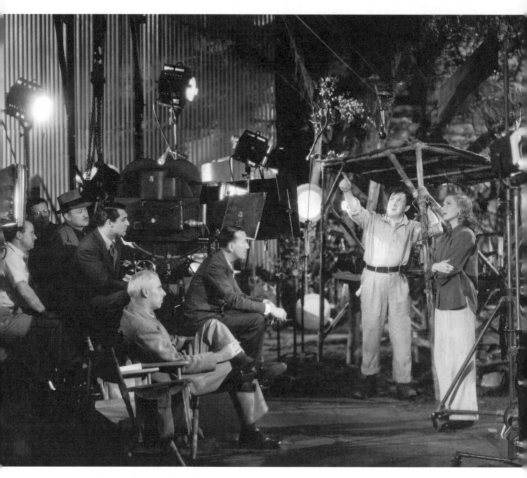

Group work: Hawks (seated in foreground) with cast and crew on the set of *Only Angels Have Wings* (1939) (BFI)

Hawks's most distinctive quality was his gift for collaboration. He was adept at gathering around him a cast and crew of exceptional talent and expertise with whom he could enjoy a congenial and empathetic working relationship, something akin to the camaraderie of his on-screen groups.

This was a process that began with his writers. Hawks worked with two Nobel Prize-winning authors, Ernest Hemingway and William Faulkner, and with such pre-eminent screenwriters as Ben Hecht, Charles MacArthur and Jules Furthman. The writing process typically involved Hawks working in the same room with the other writers in a form of collective improvisation (although rarely taking a writing credit himself). Hawks liked to work together with his own team in his own space in his own preferred way. William Faulkner described the arrangements for one of their frequent collaborations, on *Battle Cry* (unproduced). 'Hawks … has a little house on the lot for

his office,' said Faulkner. 'It has a kitchen, two baths, reception rooms, etc. I have moved my office into it, where we can work together, the whole unit of us undisturbed: director, writer, cutter, property men, etc.'[40] Hawks also worked with the best of Hollywood's cinematographers, including James Wong Howe, Gregg Toland and, most frequently, Russell Harlan. Lee Garmes, cinematographer on *Scarface*, described Hawks's approach in an early example of his preferred working methods on the set:

> every morning we would get into a huddle, sit around a table, and Howard would say in his slow and meticulous voice, 'You know, it would be kind of fun if we did this today this way. And if any of you have got any ideas or suggestions' – and he meant anybody; the prop men, grip, or anybody, and he would say, '– I'd like to have them because we're all making this picture together.'[41]

Hawks's eye for casting was central to the process of group formation. He became known as an astute talent-spotter and star-maker, notably of females, an attribute prominently noted in his obituaries.[42] Although, most famously, he 'discovered' Lauren Bacall, casting her in *To Have and Have Not* and *The Big Sleep*, he also played a major role in instigating or developing the careers of many others. Louise Brooks became a European sensation through her starring roles in G. W. Pabst's *Die Büchse der Pandora/Pandora's Box* (1929) and *Das Tagesbuch einer Verlorenen/Diary of a Lost Girl* (1929), but only on the basis of her performance in *A Girl in Every Port*. Others followed: Ann Dvorak in *Scarface* and *The Crowd Roars* (1932); Carole Lombard in *Twentieth Century*; Frances Farmer in *Come and Get It* (1936); Rita Hayworth in *Only Angels Have Wings*; Jane Russell in *The Outlaw* (1943) and *Gentlemen Prefer Blondes*; Joanne Dru in *Red River*; Marilyn Monroe in *Monkey Business* and *Gentlemen Prefer Blondes*; Angie Dickinson in *Rio Bravo*; and Jennifer O'Neill in *Rio Lobo* (1970). Hawks worked with major male stars, too – James Cagney, Gary Cooper and Humphrey Bogart – and was particularly associated with Cary Grant and John Wayne, making five films with each.

Several of these stars have affirmed Hawks's democratic set and its group ethic, invariably in affirming terms. 'Everyone contributed anything and everything they could think of to that script [*Bringing Up Baby*],' said Katharine Hepburn.[43] Lauren Bacall described working on *To Have and Have Not*:

> Each morning when we got to the set, [Hawks], Bogie, and I and whoever else might be in the scene, and the script girl would sit in a circle in canvas chairs with our names on them and read the scene. Almost unfailingly Howard would bring in additional dialogue for the scenes of sex and innuendo between Bogie and me. After we'd gone over the words several times and changed whatever Bogie or Howard thought should be changed, Howard would ask an electrician for a work light – one light on the set – and we'd go through the scene on the set to see how it felt. Howard said, 'Move around – see where it feels most comfortable.' Only after all that had been worked out did he call [cinematographer] Sid Hickox and talk about camera set-ups.[44]

And Kirk Douglas's account of *The Big Sky* relates how Hawks would 'sit down with a yellow legal pad and a pencil and say, "Well, now, let's see, Kirk. Suppose you said ..." And we'd work out a whole scene that we would shoot that afternoon.'[45] These collaborative working methods with his preferred cast and crew were a constituent component in Hawks's film-making. There was, however, another, largely unacknowledged collaborator, who would have a major role in helping to shape his later work.

Hawks and Charles K. Feldman

In 1940, Hawks entered into partnership with the Hollywood agent and producer Charles K. Feldman in what Todd McCarthy describes as 'the most important professional association of his life'.[46] Feldman was a highly placed and well-connected Hollywood operator: smart, savvy and adept at negotiating exceptionally advantageous deals on behalf of his clients, to circumvent the kind of controlling, longterm contracts that studios typically required.[47] Feldman and Hawks suited each other. Hawks was already proficient in securing for himself an extraordinary degree of independence and control over his film-making, resisting to a remarkable extent the standard scrutiny and intervention from studio executives to work in his own way, at his own tempo and with his own preferred personnel. But with Feldman and the production companies they formed together, Hawks was able to increase the control he had over his films even further. Moreover, as Tom Kemper describes him, Feldman was 'a probing reader of contracts and a writer of nuanced and inventive provisions',[48] useful and attractive qualities to Hawks. By 1940, with his own production company and talent agency – the Famous Artists Corporation – Feldman had consolidated a power base from which to create a new paradigm for the industry, having 'staked out a specialty market – supplying productions or packages to complement studio output'.[49]

Their partnership began when Feldman was approached by producer Jesse L. Lasky, who was seeking a director for his planned biopic of the World War I hero, Sergeant Alvin York at Warner Bros. Feldman nominated Hawks and negotiated a substantial salary of $85,000 for the director and the proviso that Warners would credit *Sergeant York* as 'A Howard Hawks Production' on advertising and in the title sequence, even though Lasky remained the film's producer. The huge commercial success of the film not only raised Hawks's professional profile but also further strengthened Feldman's negotiating position. In 1942, Feldman went on to negotiate concurrent contracts with both Warner Bros. and Universal, an example of the kind of non-exclusive or 'overlapping' contractual arrangement that facilitated Hawks's favoured *modus operandi*. Feldman also persuaded both studios to feature the credit 'A Howard Hawks Production' in advertising and title sequences with a prominence granted few other directors.[50] In 1943, Hawks and Feldman formed the first of a series of production companies, H-F Productions, a company designed to acquire literary properties that Hawks wanted to turn into films with the intention of selling them on to the studios.[51] In 1945, Hawks and Feldman incorporated Monterey Productions to make *Red River*. Several others followed.

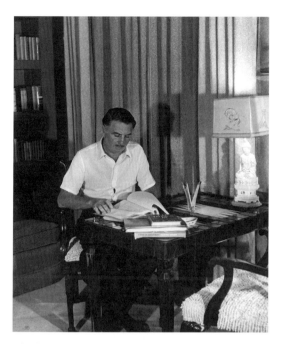

Charles K. Feldman. Agent producer and longstanding associate of Hawks: 'the most important professional association of his life' (courtesy of the Academy of Motion Picture Arts and Sciences)

Feldman's contributory role in the development of Hawks's stature in the industry was extraordinarily influential, complex and multifaceted. This can be seen in a letter Feldman wrote to Jack Warner in November 1945, following production of *The Big Sleep*. The letter is revealing in several ways, not least as it demonstrates the remarkable extent to which Feldman intervened in the production process. Feldman had previously signed Hawks's recent discovery Lauren Bacall to both his talent agency and H-F Productions. She had appeared first in the hugely successful *To Have and Have Not*, in which she had made a phenomenal impact. After *The Big Sleep*, Feldman cast her with Charles Boyer, another of his clients, in Warners' wartime spy thriller *Confidential Agent* (1945), which opened to poor reviews, particularly of Bacall's performance. Having seen test screenings of *The Big Sleep*, Feldman's letter sought to have the film reworked in the light of the adverse criticism of *Confidential Agent*. The letter shows Feldman to be on friendly terms with the studio boss and positioned as an insider in the upper echelons of studio decision-making. He is an insistent and persuasive lobbyist, pressing his case 'to make three or four days additional scenes with some retakes', that he thought would benefit the film and improve its box-office potential. He justifies this appeal by recounting how he has already made suggestions to Hawks about certain scenes which the director has accepted, all designed to boost Bacall's role in the film. And he shows himself to be a sensitive and perceptive critic with a finely judged understanding of the nuances of film production and critical opinion together with a shrewd appraisal of the estimated costs and benefits of the proposed changes. So confident is Feldman of his nose for what makes a successful and profitable film that he mildly rebukes Warner for his failure to act on previous advice to 're-do' a scene in which Bacall's character appears in a ludicrous hat with full-face veil, warning him of the likely consequence if he doesn't. 'Give the girl at least three or four additional scenes with Bogart,' he urges. And make them 'of the insolent and provocative nature that she had in TO HAVE AND HAVE NOT. You see, Jack,' Feldman counsels, 'in TO HAVE AND HAVE NOT Bacall was

more insolent than Bogart and this very insolence endeared her in both the public's and the critic's mind when the picture appeared. It was something startling and new.'[52] This could be Hawks himself talking, defining the appeal of what critics would later celebrate as the Hawksian woman. Indeed, in a letter to Warner the following month, Hawks reiterated many of the points made by Feldman.[53]

Warner went on to authorise the proposed scenes and the version that was ultimately released, with Bacall *sans* veil, was attributable in no small part to Feldman's intervention. The letter is a small masterpiece of persuasive rhetoric, demonstrating acumen, insight and chutzpah. With their business interests intertwined, the two men were also kindred spirits and remained friends until Feldman's death in 1968.

The Hawksian Effect

> I happen to like jazz very much. I know a lot of … good jazz players. … So it's fun to get out there and make that kind of stuff. You have to make it right on the set; you can't write it beforehand. You just have to go out and do it.
>
> Howard Hawks[54]

Hawksian groups are *improvisational* groups and Hawks's working practices and narrative concerns are akin to jazz improvisation. Cary Grant, an inveterate improvisor himself and a frequent Hawks collaborator, likened the process to how 'Dave Brubeck's musical group improvises on the central theme, never losing sight of the original mood, key or rhythm, no matter how far out they go.'[55] Nevertheless, we can trace an even closer musical parallel here, one between Hawks and Duke Ellington. With careers covering the same period, from the 1920s to the 1970s, both saw themselves as popular entertainers and both were attuned to what audiences liked – Ellington with songs, Hawks with stories. Both were savvy businessmen with entrepreneurial flair, alert to the commercial potential of their respective ventures. Both developed their own particular working practices on their own terms within the commercial constraints of their respective industries. In each case, the group became the creative source of their respective productions. For Ellington, the rehearsal room was the creative workshop for his own compositional method, where he would draw on the unique qualities of his players, each selected for the distinctive instrumental voice he brought to the collective mix.[56] This also accurately describes Hawks's workshop method of 'composition'. Here, for both composer and director, the question of 'authorship' becomes a more complex one, with collective composition and improvisation obscuring the traditional attribution of composer or auteur status to an individual. As Ellington's collaborator Billy Strayhorn later put it:

> Each member of his band is to him a distinctive tone color and set of emotions, which he mixes with others equally distinctive to produce a third thing, which I like to call the Ellington Effect. Sometimes this mixing happens on paper and frequently right on the bandstand. … Ellington's concern is with the individual musician, and what happens when they put their musical characters together.[57]

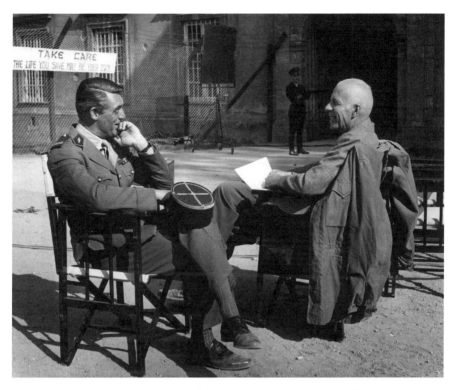

'You have to make it right on the set': Cary Grant, a frequent collaborator in Hawks's 'improvisatory circus', with the director on location for *I Was a Male War Bride* (1949) (BFI)

We can make a comparison here between Ellington's group compositional method and Hawks's practice of allowing the story to evolve in response to the on-set improvisational input of his players, working collectively to develop the script through rehearsal performance. On *Bringing Up Baby*, for instance, Gerald Mast describes the set as an 'improvisatory circus', although this doesn't mean an untrammelled free-for-all. The improvisation 'could only have been accomplished by an attuned group of professionals exercising their craft,' says Mast. 'Improvisation means taking chances and taking time; ideas may erupt spontaneously but they then require refinement, polishing, development, selection, and, perhaps, even rejection.'[58]

There are several narrative instances of that 'Ellingtonian' emphasis on the functioning unity of the group and the role of the individual within it. In *Air Force*, for example, Captain Quincannon (John Ridgely) tells Sergeant Winocki (John Garfield): 'We all belong to this aeroplane. Every man has got to rely on every other man to do the right thing at the right time.' Quincannon's imperative also serves as a definition of a jazz band performance and the narrative itself works as an analogy to jazz improvisation. When, for example, their aircraft is damaged, seemingly beyond repair, it's rebuilt by the crewmen with spare parts taken from other damaged aircraft. As jazz musicians

improvise and 'rebuild' a song, the crewmen fashion a new aircraft from the remnants of old ones.

Hawks's films abound with jazz-like features, especially in what can be seen as his use of the riff. As many Ellington compositions were based on a riff or musical phrase which had emerged during band practice sessions, Hawks also used verbal riff-like motifs. In *The Criminal Code* (1931), for example, convict Robert Graham (Phillips Holmes) is playing checkers with a cellmate when he receives a telegram notifying him of his mother's death. 'Your move, kid,' says his cellmate at intervals, a marker of the prisoners' stoical code. 'Was you ever bit by a dead bee?' Eddie (Walter Brennan) repeatedly asks in *To Have and Have Not*, a test to see if a newcomer is 'all right'. Other examples recur from film to film. Repeated phrases, such as 'I'm hard to get … all you have to do is ask me,' recur with slight variations spoken by Bonnie (Jean Arthur) in *Only Angels Have Wings*, Marie (Lauren Bacall) in *To Have and Have Not* and Feathers (Angie Dickinson) in *Rio Bravo*. There is also Hawks's trademark use of overlapping dialogue, as in the antagonistic verbal duetting of the screwball comedies, which could be considered as analogous to polyphonic jazz. And Hawks even develops a visual correlative to the jazz riff in the repeated use of objects and gestures such as the hook-backscratching routine in *Tiger Shark* (1932) and George Raft's coin-flipping habit in *Scarface*.[59] Another kind of riff-like 'repeat' can be seen in the recurrent use of character actor Walter Brennan who, in a series of similar roles, became something of a Hawksian trope in his own right. A supporting player for Hawks on six films, Brennan always looked preternaturally old and always played various types of old-timer: Stumpy in *Rio Bravo*, Groot in *Red River* and Eddie the 'rummy' in *To Have and Have Not*. The first incarnation of the character was Old Atrocity in *Barbary Coast* (1935) followed by Swan Bostrom in *Come and Get It*, here with a cod-Swedish accent. There is even a 'non-Brennan' version of Brennan in Arthur Hunnicutt's Bull in *El Dorado*. Hawks's proclivity for reworking material could even look like he was remaking a remake of a previous film. Scriptwriter Leigh Brackett complained that *El Dorado* 'could have been called *The Son of Rio Bravo Rides Again*'.[60]

How did Hawks acquire his penchant for improvisation? For all his self-centred claims, it's interesting to note how frequently he acknowledged the influence of his formative years in the industry. He conveys a real sense of the experience of apprenticeship and often talks about training, studying and learning. As Ellington eschewed conservatory training in favour of a more practical apprenticeship, learning on the job in various settings and with a loose agglomeration of mentors of his own choosing,[61] Hawks did the same, learning film-making from the bottom up, serving a wide-ranging apprenticeship through various studio departments. He started out in a summer vacation job as a prop boy at Famous Players-Lasky where he worked on the Douglas Fairbanks film *In Again – Out Again* (1917), and with Cecil B. DeMille on *The Little American* (1917) starring Mary Pickford. Standing in for an indisposed Marshall Neilan, Hawks directed a few scenes on *The Little Princess* (1917), also with Pickford, and then again on Neilan's *Amarilly of Clothes-Line Alley* (1918). He embarked on the first of his producing ventures at this time, forming Associated Producers, and arranging

finance for Neilan and others to direct their own projects. Most importantly, he began writing too, contributing both story and screenplay for *Quicksands* (1923) before returning to Paramount as a production editor in the scenario department. He worked on an assortment of films in various roles, with an editing credit on *Empty Hands* (1924), directed by Victor Fleming, and on two Zane Grey Westerns directed by William K. Howard: *The Code of the West* (1925) and *The Light of Western Stars* (1925). He wrote the intertitles for DeMille's *The Road to Yesterday* (1925) and was starting to accumulate writing credits himself: on *Tiger Love* (1924), *The Dressmaker from Paris* (1925), *Fig Leaves* (1926), *Honesty – the Best Policy* (1926), *The Road to Glory* (1926), *A Girl in Every Port* and, in the first of many uncredited writing contributions, for Josef von Sternberg's *Underworld* (1927).[62] Hawks's apprenticeship schooled him in virtually every facet of the film-making process.

Hawks's mentors included Marshall Neilan and Leo McCarey, both of whom allowed extensive improvisation on their sets. Neilan is little known today after a career that went into early decline but he remained an acknowledged influence on Hawks's career. 'You'll see an awful lot of Neilan [in *El Dorado*],' Hawks told Kevin Brownlow:

> [He] had a great sense of humour. He had a very opposite sense … he could get fun out of odd, quick little things, he could get fun out of stress and duress. And he taught me how to do it. And it's a history of a great many things that I've done.[63]

Cary Grant developed his improvisational technique with McCarey, a close friend of Hawks's, on *The Awful Truth* (1937) and McCarey's account of on-set improvisation sounds like Hawks talking. McCarey improvised with Grant in 'almost every scene', including with dialogue: 'a lot of times we'd go into a scene with nothing', he said.[64] McCarey, with a background in two-reeler comedies for Hal Roach and as director of the Marx Brothers' *Duck Soup* (1933), had been schooled, like Hawks, in a culture of film-making that more readily accommodated improvisation. Screwball comedies like McCarey's *The Awful Truth* and Hawks's *Bringing Up Baby* harked back to the slapstick tradition of vaudeville – in which Grant had trained with an acrobatic troupe – and comedy shorts. Pauline Kael, in her profile of Grant, noted a crucial shift in the culture of film-making at this time: 'No longer so script-bound, movies regained some of the creative energy and exuberance – and the joy in horseplay, too – that had been lost in the early years of the talkies.'[65] Hawks's collective improvisation worked like a jam session, that informal gathering of jazz musicians playing for themselves in spaces closed off to the public, unseen and unsupervised. Hawks was famously intolerant of studio executives visiting his set, which he saw as an unacceptable intrusion.[66] The set was his jam-session space, removed from studio scrutiny and control, and it was here that he was able to hone his distinctive working method.

The Hawksian Unit

Irrespective of their given genre, most of Hawks's pictures are really war films and the 'Hawksian group', which recurs so frequently in them, a quasi-military unit. There was

a military dimension to Hawks's background. He trained as a flying instructor with the Army Air Corps in Texas during World War I.[67] Although he didn't see active service, it was often assumed and widely reported that he had served as a pilot in France, an instance of his mythologised past.[68] An experienced pilot himself with a lifetime interest in aviation, Hawks liked to hobnob with the Army's top brass. He knew Major General 'Hap' Arnold, head of the Army Air Corps, an association that greatly facilitated the production of *Air Force*. He befriended many World War I pilots. He monitored postwar surplus aircraft sales, evident both in his collection of Surplus Government Property catalogues and the boyishly enthusiastic correspondence with his friend the stunt pilot and aircraft dealer Paul Mantz – who offered Hawks 'a nice Flying Fortress as a souvenir for the ranch'.[69]

Several of his unrealised productions were war stories such as the aborted *Battle Cry*, a largescale, multifaceted wartime propaganda project,[70] and another about RAF bombing raids on the Ruhr. Hawks possessed detailed accounts of the raids on the Moehne and Eder dams from the British *Air Ministry Weekly Intelligence Summary* as well as aerial photographs, surely classified documents, suggesting that Hawks must have been well placed in intelligence circles. The Assistant Air Attaché at the British Embassy in Washington, Squadron Leader Roald Dahl, wrote to Hawks in December 1943 assuring him that he would have 'full Air Ministry co-operation' for 'the Dams film'.[71]

Aviation features in six of Hawks's films, two of which, *The Dawn Patrol* (1930) and *Today We Live* (1933), were linked to the 'Lost Generation' airmen of World War I. It also impacted on his life. While he was making *The Dawn Patrol*, his brother Kenneth was killed in a mid-air collision while directing his own film, *Such Men Are Dangerous* (1930). Hawks's other aviation films were *The Air Circus* (1928), *Ceiling Zero* and *Only Angels Have Wings* together with the World War II combat film *Air Force*. *To Have and Have Not* is a resistance film set in occupied Martinique and *I Was a Male War Bride* has a wartime setting with many of its exteriors shot in a bomb-shattered Germany. Hawks also made the World War I drama *The Road to Glory* (1936),[72] its narrative themes and structure closely resembling those of *Ceiling Zero*. The film interpolates battle footage from the French war film *Les Croix de bois/Wooden Crosses* (1932), directed by Raymond Bernard. War was also a pervasive presence across all the different genres he worked in. Even his 'adventure' films could look like war films. In *The Crowd Roars*, for example, the close-up shots of a racing driver make him appear like a pilot in the cockpit of his aircraft while the flaming crashes, fatal collisions and track ambulances look like the aftermath of aerial combat.

Hawks also made the hugely popular *Sergeant York*. This was something of an anachronism in its biopic focus on an individual war hero and its affirmative revisionist history of World War I, the cultural memory of which had been freighted with pessimism and cynicism. By contrast, the dominant narrative device for depicting World

The aviator: Hawks on location for *The Dawn Patrol* (1930) (BFI)

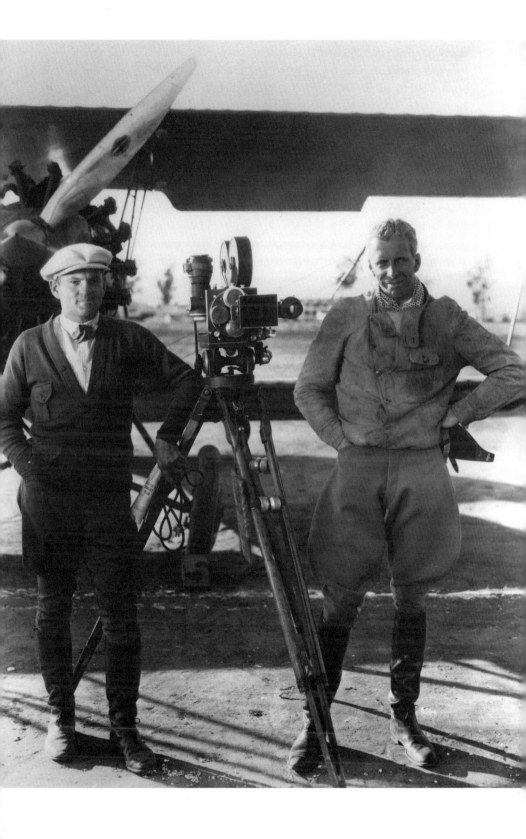

War II became what Jeanine Basinger calls 'the concept of the unified group'. Here Hawks's predilection for largely masculine character ensembles came into its own, exemplified by *Air Force*. The film's central characters constitute a provisional, operational unity, temporarily counteracting Basinger's observation that 'We are a mongrel nation, ragtail, unprepared, disorganized, quarrelsome among ourselves, and with separate special interests.'[73] This trope occurs across Hawks's multi-genre filmography. The Hawksian group is constructed as a kind of army unit, its core values and purpose loosely derived from a military ethos that owes something to the citizen-soldier of the American military tradition and especially to the GI buddy culture of World War II exemplified by the figure of GI Joe. A key characteristic of the Hawksian group is its relative informality and, indeed, the American Army in World War II was often seen as overly informal and unmilitary in its appearance, especially in contrast to the highly regimented *Wehrmacht*. That image, however, signified the scepticism of a 'democratic' or 'people's' army convened out of immediate necessity toward the kind of militarism and regimentation associated with more martial and authoritarian cultures. As infantryman Leon C. Standifer put it:

> Our image was as carefully cultivated and as misleading as that of the Nazi-designed army. We were sons of the pioneers, railsplitters, mountainmen, cowboys, rednecks, and lumberjacks. Our image was, and still is, pragmatism. We were … competence and ingenuity in the face of hardship.[74]

The Hawksian group embodies this idea of socially diverse and inherently individualistic Americans forged by adversity into a temporary unity. With it, Hawks effectively provided the template for the new genre of the World War II combat film.

If *Air Force* perfected the form, *Only Angels Have Wings* is a key precursor, providing a blueprint for Hawks's actual war film. Ostensibly a melodrama about mail pilots in South America, *Only Angels Have Wings* works as a proto-combat narrative, an archetype for what would become the 'democracy-at-war' combat film and introducing several of that genre's staple elements: the close-knit, democratically constituted 'combat' unit; the beleaguered outpost; the hazardous flying missions and repeated exposure to danger (there is even a 'bombing' sequence). The narrative deals with issues of leadership and cooperation, injury and disfigurement, death and bereavement.

Hawks also produced *Corvette K-225* (1943), a wartime flag-waver in praise of the small escort ships accompanying North Atlantic convoys. Although the film was directed by Richard Rosson, who shot all the Atlantic footage, Hawks supervised its sound-stage sequences.[75] The film has several characteristic Hawksian touches demonstrating the extent of his involvement such as the idiosyncratic crew and the stoical acceptance of death in action. 'Somebody had to go,' says Commander McClain (Randolph Scott) to Joyce Cartwright (Ella Raines), explaining her brother's death. 'He was available.' Also, like the mongrel Tripoli smuggled aboard the aircraft in *Air Force*, a stray dog is brought on board by the crewman Cricket (Fuzzy Knight), later seen in

its own custom-made mini-hammock and life-jacket, a whimsical example of improvisational ingenuity.

Hawks never made another war film and resisted invitations to do so. Even when he was approached by the agent Frank Orsatti to make a film about General Billy Mitchell with Gary Cooper and General Hap Arnold as technical advisor – an opportunity to cash in on the success of *Sergeant York* – Hawks was adamant in his refusal: 'NOT INTERESTED NOW IN ANYTHING REMOTELY CONNECTED WITH THE WAR', he telegrammed Orsatti.[76]

Nevertheless, the Hawksian unit emerges in virtually all his postwar films, its military traces apparent everywhere. In *Hatari!*, for example, the group works at the Momella game reserve where their dangerous safari excursions resemble 'missions', depicted in terms of reconnaissance operations and tactical pursuits. The multinational personnel live together at the reserve in quarters which look part-hostel, part-barracks and part-commune. The trappings of this 'combat' unit – khaki clothing, army vehicles, hunting rifles, short-wave radio – are here mapped onto a kind of proto-sixties countercultural collective. Bedrooms are situated off the main living area and there is no demarcation between men and women. Indeed, Sean Mercer (John Wayne) returns to find Dallas casually installed in his bed. Here there is no real leader as such and no chain of command. The camp is a typical example of the kind of self-contained world in which the Hawksian group establishes itself according to its own informal, democratic and collective rules and values. In the absence of any conventional home – always a theme in Hawks – the multifunctional communal spaces that characterise so many of the films can be seen as Hawksian 'heterotopia', the kinds of counter-sites in which alternatives to the more conventional norms of social life can thrive. Here, the Hawksian group occupies a space outside structures of power and authority, subject neither to hierarchical nor bureaucratic systems of organisation. Such spaces are transitory and makeshift, the kind of spaces soldiers use in the intervals between drills and action.

The Hawksian group or unit can also be seen as the basis for what Quentin Tarantino calls the 'hangout' movie. In a comparison between *Rio Bravo* and *Jackie Brown* (1997), Tarantino talks about the kind of relationship the viewer can develop with screen characters through repeated viewings over time, particularly when characters are defined by their sharing and inhabiting of communal screen spaces. Hawks's characters lend themselves to such 'hangout' relationships *par excellence*, whether at the game reserve in *Hatari!*, the jailhouse in *Rio Bravo*, the flying outpost in *Only Angels Have Wings* or the research station in *The Thing from Another World* (1951). These are spaces in which we can hang out with the characters at our leisure, spending time with them in their informal, democratic and affable Hawksian enclaves.[77]

New Perspectives

This new collection of essays is designed to raise questions about some of the traditional approaches to Hawks and revisit the criticism that has accreted around his work. The collection is divided into seven broad categories. Part 1 deals with the visual

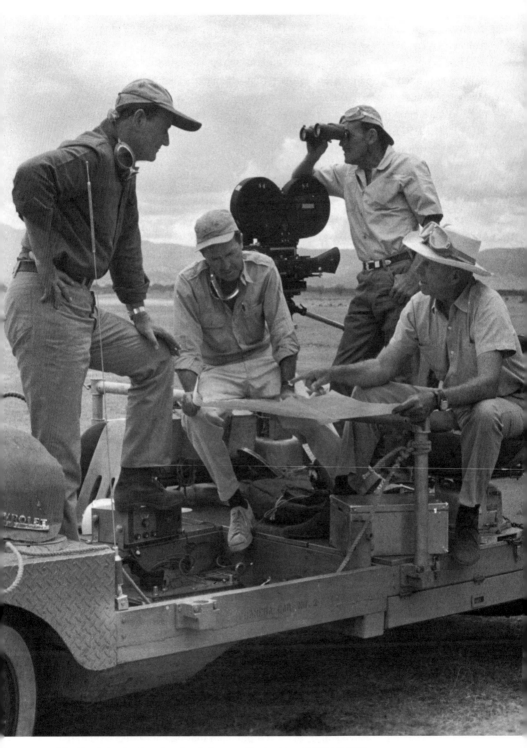

The Hawksian 'unit' on location in Tanganyika for *Hatari!* (1962) (BFI)

dimensions of Hawks's work. In 'Ain't There Anyone Here for Love?' Adrian Danks highlights Hawks's distinctive use of space and place, demonstrating how he repeatedly creates hermetic worlds of domestic interiors, often staged with conspicuously artificial sets and 'defined by a circumscribed and highly constructed sense of space'. Harper Cossar examines Hawks's visual style through the use of widescreen in a comparative analysis of *Red River*, shot in the industry's standard aspect ratio format, and *Land of the Pharaohs* (1955) – Hawks's 'only really wide film' – in CinemaScope. Cossar examines the generic, aesthetic and narrative implications of the new ratio format and assesses its impact on the 'Hawks style'.

Several essays here focus on critically neglected examples of Hawks's work which have been dismissed as inferior or insufficiently 'Hawksian'. Robin Wood's relegation of some titles to an appendix of 'Failures and Marginal Works' includes *Sergeant York*, *Gentlemen Prefer Blondes*, *Land of the Pharaohs* and, unexpectedly, *The Big Sleep*, each of which is subjected to new evaluation here. Auteurist critics like Wood did much to establish a hierarchy of Hawks films, rankings which remain influential today. Part 2 looks at the politics of genre. *Sergeant York*, as Jesse Schlotterbeck points out in his account of Hawks's 'Unhawksian' biopic, is often deemed peripheral to Hawks's oeuvre and lacking in the requisite Hawksian attributes, its narrative focus being on a single figure and a devoutly religious one at that. Nevertheless, *Sergeant York* was a spectacular critical and box-office success on release and Schlotterbeck resituates the film in that historical moment, examining its production, promotion and reception in the early days of World War II, and reassessing its place in Hawks's oeuvre.

Surprisingly little work has been done on the historical reception of Hawks's films. *The Big Sleep*, for example, is now regarded as a classic film noir but, on first release, it was widely attacked by critics and described by the *New York Times* as 'a poisonous picture'. As Mark Jancovich and Robert Manning remind us, *The Big Sleep* was made before the inception of noir and their study of the film's reception is situated within the 'pre-noir' cultural politics of postwar America. They examine the film's place within discourses of stylistics and realism.

Part 3 focuses on 'The Hawksian Western'. Hawks is often recognised as a Western director although his Westerns have not featured prominently in critical literature on the genre. He made five Westerns, two of which are seen as exemplars of the genre, *Red River* and *Rio Bravo*, while his last two, *El Dorado* and *Rio Lobo*, have suffered by comparison, often being seen as pale imitations of the *Rio Bravo* 'original'. Tom Ryall reconsiders the place of all five Westerns in terms of the history of the West and examines how they relate to the different postwar phases of the genre as well as to the work of other Western directors of the period, John Ford, Sam Peckinpah and Sergio Leone.

The significance of gesture and gestural motifs has been noted as intrinsic to Hawks's work and Steve Neale examines the 'informal gestural vocabulary' that Hawks deploys in *Rio Bravo*. Hawks, as noted, liked to slow down the production process on set in order to 'make a good scene' and Neale's analysis can be seen as a kind of correlative to Hawks's working method as he effectively slows down moments in the narrative to deconstruct the gestural composition of key scenes.

Part 4 looks at Hawks and gender, a longstanding focus of interest in Hawks studies, particularly since the pioneering work of feminist film scholars like Molly Haskell in the 1970s. Here, in 'A Travesty on Sex', Ellen Wright investigates *Gentlemen Prefer Blondes*, another of Robin Wood's 'failures' and another awkward fit for auteurist critics, a film more often seen today as a Marilyn Monroe vehicle. Wright locates the production within its historical context and examines the performance of femininity in an analysis drawing on postwar pin-up culture within the film and its promotion.

There has been a critical tendency to see Hawks's comedies as separate from his other work. Wood categorised some of them in a chapter called 'The Lure of Irresponsibility', dwelling on their characters' repudiations of the 'responsible' behaviour expected of Hawks's typical male groups. Traditional perspectives on the comedies have also relied on genre periodisation, typically grouping together *Twentieth Century*, *Bringing Up Baby* and *His Girl Friday* as instances of 1930s' 'screwball'. Jeffrey Hinkelman takes a different approach, examining four 'gender' comedies spanning four decades of Hawks's career: *The Cradle Snatchers* (1927), *Bringing Up Baby*, *I Was a Male War Bride* and *Man's Favorite Sport?* (1964). Reading against the critical grain, Hinkelman examines how Hawks and his writers reworked the original source material for these films, reducing the apparent distance between the 'adventure dramas' and 'crazy comedies', and making a case for reading these comedies as a social and economic critique of contemporary American society.

Part 5 deals with Hawks and music, another area overlooked in Hawks studies. New scholarship on film music over the past two decades has begun to address this 'neglected art'. Hawks's films were scored by several eminent Hollywood composers including Max Steiner, Franz Waxman, Henry Mancini and Jerry Goldsmith, although one of his most important collaborations, as Kathryn Kalinak shows in her account of Hawks's Western soundtracks, was with Dimitri Tiomkin who contributed such significant musical expression to Hawks's vision of the West. Kalinak examines that collaboration through her analysis of the music in *Red River* and *Rio Bravo*.

Hawks liked popular music and jazz, both of which featured in his films to significant narrative effect. Even before the advent of sound he was deploying popular song on screen. *Fazil* (1928) featured 'Neapolitan Nights (Oh, Nights of Splendour)' – utilising a synchronised Movietone music/sound sequence – the sheet music itself appearing superimposed on the screen as it's sung. In 'More Than Just Dance Music', I look at Hawks's use of jazz in two of his 1940s films, *Air Force* and the musical comedy *A Song Is Born* (1948). Drawing on their critical reception, especially in the African American press, I investigate how racial issues are played out through the films' use of jazz.

Part 6, 'Hawks, Ancient and Modern', looks at two differing historical perspectives on the director. Joe McElhaney focuses on one of Hawks's most critically disparaged films, *Red Line 7000* (1965). McElhaney highlights the historical moment of this 'eccentric' film which saw the decline of studio-era film-making coincide with the prevalence of a mid-sixties pop culture and the *nouvelle vague*. The film appeared to be at odds with contemporary definitions of modern cinema and, in genre terms, woefully inade-

quate in comparison with more technically sophisticated motor-racing films of the period. McElhaney's new perspective enables us to see the film in its wider cultural moment.

Michael J. Anderson examines the historical ethos of professionalism, often seen as a characteristically Hawksian trope. Hawks belonged to a Protestant cultural tradition through his family's midwestern background and Anderson draws on eighteenth-century New England portraiture to place both the stylistic and social values of Hawks's work in relation to the cultural codes of an 'ancestral value system'.

The final part, 'Dark Circles', considers Hawks's treatment of war and aviation. One of the impediments to Hawks scholarship has been the fact that certain of his films were not available. *Scarface* all but disappeared from view after its first run and remained unavailable for decades except in prints of dubious quality and provenance. Another instance is Hawks's first sound film, *The Dawn Patrol*. As Tony Williams points out, the film is often seen (inaccurately) as constrained by the technological limitations of the early sound film that restricted camera movement. In '*The Dawn Patrol*: The Once and Future Hawks', Williams identifies in this key film early instances of Hawks's distinctive use of visual style, performance and dialogue, features which would recur in later films and be deemed definitively Hawksian. Also on the aviation film, Doug Dibbern identifies in Hawks what he calls an 'irresolvable circularity' in which characters are locked into endless cycles of conflict which remain unresolved by narrative closure. Tony Williams in his chapter points out that at the end of *The Dawn Patrol* the narrative wheel has turned full circle: Dibbern sees *Only Angels Have Wings* in comparable terms, a sense of nihilism implicit in its narrative closure. A darker, more pessimistic Hawks emerges from these accounts of the films, both of which are linked to a mood of cynicism and disillusionment about the war.

Who the hell is Howard Hawks, then? What more have we learned about him since Eugene Archer first asked the question in Paris nearly sixty years ago? Although Hawks remains under-recognised, his work, as Todd McCarthy reminds us, has always attracted an extraordinary amount of interest from different constituencies. 'What remains impressive,' says McCarthy, 'is how Hawks's body of work provokes and sustains such a considerable volume and diversity of study and analysis, generally at a very high level of appreciation and intelligence, and how this work easily accommodates this multitude of interpretations.'[78] Hawks has been exceptionally well served by his critics and the present collection, we hope, continues that tradition of analytical diversity and quality. Where we depart from some of their standpoints has more to do with the fact that we are no longer in thrall to the auteurist agenda which informed much of their work and which remains a residual presence in Hawks studies today. The kinds of questions we engage with here have less to do with a search for thematic and stylistic unity across his work and more with his place within the collaborative film-making practices of studio-era Hollywood. It is one of the arguments of this book that Hawks was *the* collaborator *par excellence* and that what was most distinctively 'Hawksian' about him derived precisely from a *modus operandi* evolved through close working relationships with a cast and crew he liked and trusted, assisted by the sort of control

he was able to exercise over his productions as director-producer. Our work in this collection draws on a wide range of approaches to Hawk's work. The collection includes reappraisals of his little-known early films, including the silents, as well as several of the critically disdained 'failures and marginal works'. Different chapters here draw on technological history, production and reception histories, historical studies of the studio system and other archival research, including the collection of Hawks's papers at Brigham Young University. There are also reassessments of some of the traditional Hawksian categories of genre and gender and revaluations of such traditional Hawksian tropes as professionalism, group work and music-making. Hawks himself may escape notice, but his film-making is at the very centre of American cinema.

Notes

1. Peter Bogdanovich, *The Cinema of Howard Hawks* (New York: Museum of Modern Art, 1962), p. 4.
2. Andrew Sarris, *'You Ain't Heard Nothin' Yet': The American Talking Film, History and Memory, 1927–1949* (New York: Oxford University Press, 1998), p. 264; quoted in David Schwarz, 'Bringing Up Hawks: Andrew Sarris and Molly Haskell on the Discovery of an Auteur', *Moving Image Source* (25 September 2008): http://www.moving imagesource.us/articles/bringing-up-hawks-20080925 (accessed 11 February 2015).
3. Robin Wood, 'Who the Hell Is Howard Hawks?', *Focus!* no. 1 (February 1967), pp. 3–6; *Focus!* no. 2 (March 1967), pp. 8–18. Peter Wollen, 'Who the Hell Is Howard Hawks?', *Framework* vol. 43 no. 1 (Spring 2002), pp. 9–17.
4. Andrew Sarris, *The American Cinema: Directors and Directions: 1929–1968* (New York: Dutton, 1968), p. 53.
5. Wood, 'Who the Hell Is Howard Hawks?', p. 3.
6. Manny Farber, 'Howard Hawks', *Artforum* (April 1969), repr. in Robert Polito (ed.), *Farber on Film: The Complete Film Writings of Manny Farber* (New York: Library of America, 2009), p. 656.
7. Joseph McBride and Michael Wilmington, '"Do I Get to Play the Drunk This Time?" An Encounter with Howard Hawks', *Sight and Sound* vol. 40 no. 2 (Spring 1971), repr. in Scott Breivold (ed.), *Howard Hawks: Interviews* (Jackson: University of Mississippi Press, 2006), p. 63.
8. 'Personal Telephone Directory', MSS 1404, Howard Hawks Collection, 1925–1970; Arts and Communications; L. Tom Perry Special Collections, Harold B. Lee Library, Brigham Young University, Box 1, Folder 17; Meta Carpenter Wilde and Orin Borsten, *A Loving Gentleman: The Love Story of William Faulkner and Meta Carpenter* (New York: Simon and Schuster, 1976), p. 49.
9. Gerald Mast, *Howard Hawks, Storyteller* (New York: Oxford University Press, 1982).
10. See James V. D'Arc, 'Howard Hawks and the Great Paper Chase', in John Boorman and Walter Donohue (eds), *Projections 6: Film-makers on Film-making* (London: Faber & Faber, 1996), pp. 315–24.

11. Leigh Brackett, 'Working with Hawks', *Take One* vol. 3 no. 6 (October 1972), repr. in Karen Kay and Gerald Peary (eds), *Women and the Cinema: A Critical Anthology* (New York: E. P. Dutton, 1977), p. 196.

12. See, for instance, assistant director Richard Rosson's 'documentary' ocean fishing sequences in *Tiger Shark* (1932), the torpedo boat attacks in *Today We Live* (1933) and the logging scenes in *Come and Get It* (1936).

13. Todd McCarthy, *Howard Hawks: The Grey Fox of Hollywood* (New York: Grove Press, 1997), p. 10.

14. Slim Keith with Annette Tapert, *Slim: Memories of a Rich and Imperfect Life* (New York: Simon and Schuster, 1990), p. 78.

15. McBride and Wilmington, 'Do I Get to Play the Drunk This Time?', p. 59.

16. Joseph McBride and Gerald Peary, 'Hawks Talks: New Anecdotes from the Old Master', *Film Comment* vol. 10 no. 3 (May/June 1974), repr. in Breivold, *Howard Hawks*, p. 72.

17. Constance Penley, Saunie Salyer and Michael Shedlin, 'Hawks on Film, Politics, and Child-rearing', *Jump Cut* (January/February 1975), repr. in Breivold, *Howard Hawks*, pp. 100–27.

18. Quoted in Peter Bogdanovich, 'Howard Hawks: The Rules of the Game', in *Who the Devil Made It? Conversations with Legendary Film Directors* (New York: Ballantine, 1997), p. 332.

19. 'Interview with Howard Hawks' by Win Sharples, Jr, 27 July 1977. MSS 1404, LTPSC, Box 1, Folder 13, 23.

20. Quoted in Joseph McBride, *Hawks on Hawks* (Berkeley: University of California Press, 1982), p. 8.

21. Quoted in John Andrew Gallagher, 'Truffaut Interview', in *Film Directors on Directing* (Westport, CT: Greenwood Press, 1989), pp. 267–8.

22. Quoted in McCarthy, *The Grey Fox* , p. 611.

23. Jean-George Auriol, '*A Girl in Every Port*', *La Revue du cinéma* (December 1928), trans. John Moore, repr. in Jim Hillier and Peter Wollen (eds), *Howard Hawks: American Artist* (London: BFI, 1996), p. 13.

24. Jacques Rivette, 'The Genius of Howard Hawks', trans. Russell Campbell and Marvin Pister, *Cahiers du cinéma* no. 23 (May 1953), repr. in Jim Hillier (ed.), *Cahiers du Cinéma: The 1950s* (Cambridge, MA: Harvard University Press, 1992), p. 126.

25. Robin Wood, *Howard Hawks* (London: Secker & Warburg/BFI, 1968); Peter Wollen, *Signs and Meaning in the Cinema* (London: Secker & Warburg, 1969), pp. 80–94; *Movie* no. 5 (December 1962), 'Howard Hawks' issue.

26. Eric Rohmer (as Maurice Schérer), 'Masters of Adventure', trans. Julia Cooper, *Cahiers du cinéma* no. 29 (December 1953), p. 45.

27. Jean-Luc Godard (as Hans Lucas), 'Defence and Illustration of Classical Construction', trans. Tom Milne, *Cahiers du cinéma* no. 15 (September 1952), repr. in Jean Narboni and Tom Milne (eds), *Godard on Godard: Critical Writings by Jean-Luc Godard* (London: Secker & Warburg, 1972), p. 20.

28. Godard's phrase was adopted as the title of Hillier and Wollen's edited collection on Hawks, the 1997 BFI Hawks retrospective at the National Film Theatre and Kevin Macdonald's accompanying documentary.

29. Sarris, *The American Cinema*, p. 55.

30. Henri Langlois, 'The Modernity of Howard Hawks', *Cahiers du cinéma* no. 139, trans. Russell Campbell (January 1963) ['Howard Hawks' issue], repr. in Joseph McBride (ed.), *Focus on Howard Hawks* (Englewood Cliffs, NJ: Prentice-Hall, 1972), p. 65.

31. Ibid.

32. Ibid., pp. 65, 66.

33. Richard Roud, *A Passion for Films: Henri Langlois and the Cinémathèque Française* (1983, Baltimore, MD: Johns Hopkins University Press, 1999), pp. 26, 64–5.

34. See Naomi Wise, 'The Hawksian Woman', *Take One* (January/February 1971), repr. in Hillier and Wollen, *American Artist*, pp. 111–19; Leigh Brackett, 'A Comment on "The Hawksian Woman"', *Take One* vol. 3 no. 8 (July/August 1971), repr. in Hillier and Wollen, *American Artist*, pp. 120–2; Molly Haskell, 'Howard Hawks: Masculine Feminine', *Film Comment* vol. 10 no. 2 (March 1974), pp. 34–9; Molly Haskell, 'Howard Hawks', in Richard Roud (ed.), *Cinema: A Critical Dictionary: The Major Film-Makers, Vol. 1, From Aldrich to King* (London: Secker & Warburg, 1980), pp. 477–8.

35. Cinémathèque programme (1955), quoted in Roud, *A Passion for Films*, p. 9.

36. Kevin Brownlow, 'Interview with Howard Hawks' (30 June 1967), p. 6.

37. Ibid., p. 8.

38. On Hawks's use of nicknames, see David Boxwell, 'Howard Hawks', *Senses of Cinema* no. 20 (May 2002): http://sensesofcinema.com/2002/great-directors/hawks/ (accessed 6 March 2015).

39. Jean Douchet, '*Hatari!*', *Cahiers du cinéma* no. 139 (January 1963) trans. John Moore, repr. in Hillier and Wollen, *American Artist*, p. 82.

40. Faulkner, letter to Mrs William Faulkner (1 August 1943) in Joseph Blotner (ed.), *Selected Letters of William Faulkner* (New York: Random House, 1977), pp. 176–7.

41. David Prince, Peter Lehman and Tom Clark, 'Lee Garmes, A.S.C: An Interview', *Wide Angle* vol. 1 no. 3 (1976), p. 64.

42. See, for instance, Robin Brantley, 'What Makes a Star? – Howard Hawks Knew Best of All', *New York Times* (22 January 1978), D11, p. 19; Jennifer Dunning, 'Howard Hawks, Director of Films and Developer of Stars, Dies at 81', *New York Times* (28 December 1977), p. 34.

43. Katharine Hepburn, *Me: Stories of My Life* (New York: Knopf, 1991), p. 239.

44. Lauren Bacall, *By Myself* (London: Jonathan Cape, 1979), p. 96.

45. Kirk Douglas, *The Ragman's Son: An Autobiography* (New York: Simon and Schuster, 1988), p. 190.

46. McCarthy, *Grey Fox*, p. 319.

47. See Peter Biskind, 'The Man Who Minted Style', *Vanity Fair* (April 2003), pp. 100–11.

48. Tom Kemper, *Hidden Talent: The Emergence of Hollywood Agents* (Berkeley: University of California Press, 2010), p. 74.

49. Ibid., p. 199.

50. Ibid., pp. 210–11.

51. McCarthy, *Grey Fox*, p. 401.

52. Feldman, letter to Jack L. Warner, 16 November 1945. MSS 8067, Charles K. Feldman Papers; Arts and Communications; L. Tom Perry Special Collections, Harold B. Lee Library, Brigham Young University, Box 2, 'Howard Hawks, 1949–59'.

53. Hawks, letter to Jack L. Warner, 18 December 1945. MSS 1404, LTPSC, Box 3, Folder 7.

54. Quoted in McBride, *Hawks on Hawks*, pp. 128–30.

55. Cary Grant, 'Archie Leach', *Ladies' Home Journal* (Part 2: March 1963), p. 42.

56. This was a radical departure from the norm when most jazz bands were playing from 'stock' or standard arrangements. On early Ellington, see Mark Tucker, *Ellington: The Early Years* (Oxford: Bayou Press, 1991).

57. Billy Strayhorn, 'The Ellington Effect', *Down Beat* (5 November 1952), p. 2.

58. Gerald Mast, '"Everything's Gonna Be All Right": The Making of *Bringing Up Baby*', in Mast (ed.), *Bringing Up Baby: Howard Hawks, Director* (1988, New Brunswick, NJ: Rutgers University Press, 1994), pp. 8, 9.

59. On Hawks's use of motifs and gestures, see Mitchell Cohen, 'Hawks in the 30s', *Take One* vol. 4 no. 12 (1975), p. 13.

60. Quoted in Steve Swires, 'Leigh Brackett: Journeyman Plumber', in Patrick McGilligan (ed.), *Backstory 2: Interviews with Screenwriters of the 1940s and 1950s* (Berkeley: University of California Press, 1991), p. 21.

61. See Harvey G. Cohen, *Duke Ellington's America* (Chicago, IL: University of Chicago Press, 2010), pp. 17–19.

62. On Hawks's early career, see McCarthy, *Grey Fox*, pp. 50–63; Brownlow, 'Interview with Howard Hawks'.

63. Ibid., p. 9.

64. Peter Bogdanovich, 'Leo McCarey: The Ineluctability of Incidents', in *Who the Devil Made It?*, p. 412.

65. Pauline Kael, 'The Man from Dream City', *New Yorker* (14 July 1975), p. 56.

66. See McCarthy, *Grey Fox*, pp. 169, 377.

67. Ibid., pp. 46–7.

68. See, for example, Kyle Crichton, 'The Flying Hawks', *Collier's* (16 January 1943), p. 37.

69. Surplus Government Property (Aircraft) catalogues, War Assets Administration (1946); Letter from Mantz to Hawks, 5 December 1945. MSS 1404, LTPSC, Box 1, File 2.

70. See McCarthy, *Grey Fox*, pp. 352–7; MSS 1404, LTPSC, Box 2, Files 12–18.

71. Dahl [the British writer], letter to Hawks, 6 December 1943. MSS 1404 LTPSC, Box 5, Folder 1. A British film version of the raid was eventually made as *The Dam Busters* (1955).

72. This title is unrelated to Hawks's melodrama *The Road to Glory* (1926).

73. Jeanine Basinger, *The World War II Combat Film: Anatomy of a Genre* (New York: Columbia University Press, 1986), pp. 36, 42–3, 51.

74. Quoted in Reid Mitchell, 'The GI in Europe and the American Military Tradition', in Paul Addison and Angus Calder (eds), *Time to Kill: The Soldier's Experience of War in the West, 1939–1945* (London: Pimlico Press, 1997), p. 314.

75. McCarthy, *Grey Fox*, p. 350.

76. Telegram from Hawks to Frank Orsatti, 11 October 1945. MSS 1404, LTPSC, Box 1,
File 10. A film was eventually produced with Cooper, *The Court-Martial of Billy Mitchell*
(1955), directed by Otto Preminger.

77. Ryan Gilbey, 'Days of Gloury', *Sight and Sound* vol. 19 no. 9 (September 2009), p. 18.

78. McCarthy, *Grey Fox*, p. 14.

PART 1
HAWKS, SPACE, PLACE AND STYLE

1 'Ain't There Anyone Here for Love?'

Space, Place and Community in the Cinema of Howard Hawks

Adrian Danks

In the opening moments of Howard Hawks's manic and at times outwardly grotesque 'fountain of youth' comedy *Monkey Business* (1952), Cary Grant's 'character' attempts to leave through the tightly framed front door of his house. On two occasions a directorial voice – Hawks's – is heard on the soundtrack, halting Grant's movement across the threshold: 'Not yet, Cary.' On one level this credit sequence acts as a self-conscious commentary on the relation between actor and character, displaying an overt reflexivity that is not all that surprising, though still bracing, during a title sequence and within the comedy genre. It also illustrates a cosy familiarity between actor, director and audience built across such previous films as *Bringing Up Baby* (1938), *Only Angels Have Wings* (1939), *His Girl Friday* (1940) and *I Was a Male War Bride* (1949), which emphasise the kinds of clubby, exclusive but 'utopian' meritocracies that accumulate across much of Hawks's best work.

But on another level this sequence also provides a commentary on the place of the domestic within Hawks's cinema. Although Hawks's work is consistently marked by the construction and reorganisation of somewhat reified – even openly exclusionary – but communal interior spaces populated by speed-talking, quick-witted, fast-moving, outwardly independent and interactive, though pointedly professional individuals, it also demonstrates an 'antipathy … to marriage, home, and family'.[1] This is a quality that runs throughout Hawks's cinema from the beginning of the sound era to the final brace of Westerns, *El Dorado* (1967) and *Rio Lobo* (1970). For example, although it is outwardly a 'comedy of remarriage',[2] *His Girl Friday* manufactures the exclusion of Hildy's (Rosalind Russell) would-be suitor (Ralph Bellamy) – and thus a certain kind of domesticity – through the combination of segregated framing and specific characters' control of the interior offices and carrels of the newspaper office, their command of the camera, and their domination of the contested and limited 'space' of the soundtrack dictated by the incessant flow of the wisecracking, overlapping dialogue.

Hawks's cinema also includes a surprisingly small collection of children, married couples, families or straightforwardly domestic scenes (*Monkey Business* is somewhat atypical in this regard). When it does appear in Hawks's work, this domesticity is often transmuted to homosocial relationships between men of varied ages and backgrounds such as the characters played by Walter Brennan (Stumpy) and John Wayne (Chance) in *Rio Bravo* (1959), a generously cross-generational film that also incorporates the

virtually adolescent Ricky Nelson and the drink-addled Dean Martin into its 'family'. This view of domesticity – even of a kind of marriage – is reinforced by the incessant chatter and bickering of Brennan's Stumpy and crowned by the moment when Chance kisses him on the head. Even when heterosexual couples do form in Hawks's cinema – and this ranges from the potent sexual bond between Humphrey Bogart and Lauren Bacall in *To Have and Have Not* (1944) and *The Big Sleep* (1946) to the less convincing couplings of Wayne with a range of attractive women across films like *Hatari!* (1962) and *El Dorado* – they still tend to be positioned within a larger, predominantly male group: *His Girl Friday*, *Only Angels Have Wings*, *El Dorado*, *The Thing from Another World* (1951), and others.

The opening moments of *Monkey Business* are exceptional for the ways in which they restrict Grant's character to the domestic space and require him to retreat to an initial scene-setting exchange with his wife before finally venturing outside. Although this somewhat staid, boxed-in, nondescript interior space is largely figured as an intellectual realm where Grant's scientist can comfortably play the 'absent-minded professor', it would be incorrect to argue that the film presents a distinct or even necessary contrast between its 'inactive' interiors and the looming world of action and danger to be found outside. While *Monkey Business*, like a number of other later Hawks films such as *El Dorado*, is partly a film about ageing, this opening sequence also clearly demonstrates the couple's intimacy, sexuality *and* familiarity. Although these initial domestic scenes do sometimes perfunctorily replay familiar tropes from earlier Hawks comedies, such as the gag of the zipper caught in a dress from *Bringing Up Baby*, they are also marked by a frankness and directness uncommon in Hawks's largely diversionary cinema.

Hawks is a director widely noted for his devotion to what we might call classical style, his command of various Hollywood genres, his creation of hypermasculine communities, his fast-paced presentation of action and dialogue, and his fixation on the 'moment' or a character's gesture. Manny Farber has argued that this final component provides the peculiar essence of Hawks's cinema:

> Not many moviemakers have gone so deeply into personality-revealing motion, the geography of gesture, the building and milking of a signature trait for all its worth. Hawks's abandon with his pet area, human gesture, is usually staggering, for better or worse.[3]

In keeping with Farber's observation, I would argue that Hawks's cinema is defined by the ways that characters talk, the 'volume' of this talk, the notion of dialogue as in itself a form of action and the way that figures interact with, help construct and gesture towards the spaces and places around them (the kind of 'geography' Farber mentions). Despite common claims of Hawks's pre-eminence as an action director, proselytiser of a straight-ahead shooting style and master creator of male milieux, his work is also marked by a fascination with singular female figures (often situated within masculine enclaves) and with interior spaces. The narratives of numerous Hawks films like *Rio*

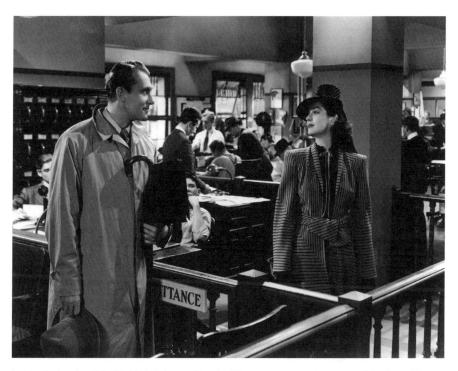

In *His Girl Friday* (1940), Hildy Johnson (Rosalind Russell) occupies the space of the 'gated' community at the newspaper offices while her fiancé Bruce Baldwin (Ralph Bellamy) remains outside (BFI)

Bravo, *Ball of Fire* (1942), *A Song Is Born* (1948) and even such patently action-driven works as *Air Force* (1943) and *To Have and Have Not*, revolve around the creation of, or retreat into, interior or enclosed spaces and the kinds of ramshackle, jerry-built though 'gated' communities that are forged within these cramped, opportune places. So although Hawks's cinema is characterised by an absence of straightforwardly domestic spaces and actions, the need for equivalent intimate environments is nevertheless transferred to the interiors of other commercial or utilitarian places such as nightclubs, offices, hotels, bookshops and airports. In this regard, Hawks's is a profoundly interior, communal and even domestic cinema.

This chapter examines the ways in which many of Hawks's films – though always the result of collaborations with different writers, actors and technicians – create a largely hermetic world that embraces the heightened artificiality of classical Hollywood cinema. Although Hawks is often celebrated as a masculine action director who utilises exterior locations, his work is more accurately defined by a circumscribed and highly constructed sense of space. For example, the ambulatory characters in *The Big Sleep* seem to move through various landscapes but remain blissfully entrapped within an interiority marked by the extensive use of such elements as sets and rear-projection: 'It is an interior film, without sunlight, fresh air or real nature,' argues David Thomson.[4]

This emblematic Hawksian film even plays games with the absence of reality. Towards the end, Bogart's Marlowe is finally shown to be leaving the familiar surrounds of his studio-built Los Angeles city playground. He journeys to Realito, 'a name to tease detectives and scholars'.[5] Although among the most violent scenes in the film, the conflation of studio-bound mist, workshop-built rustic exteriors and chiaroscuro lighting (as well as the largely unmotivated and magical appearance of Bacall's Vivian) belie the promise embedded in that location's name. Through the exploration of such moments in Hawks's work, this chapter will present a re-examination of particular aspects of the director's style in relation to the construction and representation of space and place.

Such a fixation upon interior space and the ways in which it is occupied and colonised is unsurprising in the small number of Hawks films that are based on plays such as *Twentieth Century* (1934) and *His Girl Friday* – and even the larger string of combative sexual comedies to which these two films belong – both of which move through a series of interior, compartmentalised environments while giving little sense of, or feel for, an exterior world. For example, the penultimate section of *Twentieth Century* relies upon the coincidence of the two main warring characters, Oscar Jaffe (John Barrymore) and Lily Garland (Carole Lombard), occupying interconnected suites on the same train as it speeds through the night. Almost as much as in the work of John Ford, but in a markedly different register, Hawks's cinema is characterised by the movement of characters across thresholds and, much less like Ford, between compartmentalised spaces.

A film such as the largely location-shot *I Was a Male War Bride*, spends most of its running time creating the necessary conditions for its central couple, an American officer (Ann Sheridan) serving in Germany and *her* 'war bride' (Cary Grant), to be alone together in a room in order to consummate their marriage. The close confines of this final space and Grant's character's tossing of the key to the cabin's locked door out of the porthole, as the two characters finally settle into their own cabin as the none-too-subtle image of the Statue of Liberty (a phallic symbol perhaps, but also a French gift to America, symbolising freedom) drifts by, reinforce the relief *of* such bondage and the retreat to enclosed space. The fact that the statue is of a woman, and that Grant only finds 'freedom' through confinement, reiterates the complex deconstruction of terms, identities, spatiality and nationalities played out in the film. But such a desire for 'retreat' or confinement is also characteristic of other Hawks films across a dizzying spread of genres: *The Big Sleep, Only Angels Have Wings, Land of the Pharaohs* (1955), *Hatari!, Rio Bravo, The Thing from Another World* and so on.

Joe McElhaney has suggested that this focus on what happens within interiorised spaces helps us to pinpoint the peculiar modernity of Hawks's work:

> As literal pictures of modern America, though, Hawks's films are disappointments. The films mainly keep inside of cramped, functional quarters, showing us very little of contemporary American architecture, décor, and technology. Instead, modernity in Hawks is largely articulated through the physicality and rhythm of the actors.[6]

Michael J. Anderson has argued for a connected but more prosaic reading of these same qualities: 'the director's egalitarianism and even humanism is figured through a series of homogenous spaces, where people share metaphorically by occupying the same space. The style doubles the sentiment.'[7] In both instances, the writers revealingly highlight the importance of characters/actors and the ways in which they use, define, create and transcend space. For both Anderson and McElhaney, Hawksian space is largely 'homogeneous' or 'functional', gaining little appeal, atmosphere or density except through the gestures, interactions, materiality and ritualistic behaviour of the characters.

If one were to look at Hawks's cinema for a time capsule of American life in the middle of the twentieth century, it would give us little idea of the look or feel of this extended moment in time or its specific geography. What it would show us is the way that certain highly idiosyncratic people and actors behaved and how they interacted with the objects, elements of décor and spatial dynamics of their immediate surroundings. But although I would argue that Hawks's interior spaces are often routine and lacking in characteristic detail – they are nothing like the filigreed places we might find in the work of Max Ophuls or Josef von Sternberg – they are central to the sense of community that grows up around his often exclusionary, though 'non-denominational' utopias. As McElhaney has argued, Hawks's characters, and their modernity, are often defined by the ways in which they deal with objects, as well as how they relate to their immediate surroundings.

I initially intended to prove the basic premise that Hawks's films are largely dominated by artificial, abstracted, utopic environments and spaces that act as rarefied, somewhat exclusive enclaves and compounds. This is certainly one way of thinking about such 'non-places' as the interior of the aircraft in *Air Force*, the bar in *Only Angels Have Wings*, the jail in *Rio Bravo*, Geiger's oddly fascinating house in *The Big Sleep* and the steadily constructed tomb in *Land of the Pharaohs*. It does also pretty much account for the spatial dynamics of such a seminal Hawks film as *Ceiling Zero* (1935), a work that divides most of its screen time between the cramped cockpit of Cagney's plane and interiors of the airfield buildings. Its play of limited spaces and places provides a framework for much of what was to follow in Hawks's career, and is an explicit influence on the overheated, claustrophobic melodrama of *Only Angels Have Wings*.

But the more I looked at the movies, the more I realised that the 'picture' was more complex and variegated. Although the basic principle of the retreat to such preferred spaces and hardly secretive hideouts was commonly upheld, the exceptions and variations began to pile up. It is pretty clear that a film like *Land of the Pharaohs* largely follows the logic of this retreat into interior space, the early 'documentary' movement from vast exterior to enclosed interior making such a telescoped progression inevitable. As Richard Combs suggests:

> The whole sequence is a succession of movements inward, from the desert to the inner chambers of the pharaoh's palace – a movement the film will extend thematically as Khufu [Jack Hawkins] exploits every resource of his kingdom to establish himself in the most secreted place within his pyramid.[8]

Although we are inevitably positioned with the travelling freed slaves as the elaborate sealing mechanism for the pyramid finally falls into place,

> At the end, as Vashtar [James Robertson Justice] and his newly liberated people trek away into the desert, it's a fair bet that Hawks isn't with them in spirit, but locked in the pyramid with his surrogates, master builder Khufu and storyteller Hamar [Alexis Minotis].[9]

For Combs, Hawks emerges as an aloof master architect of both space and narrative form.

But Hawks's cinema does not routinely follow the linear logic of an increasing retirement or retreat to such contained and artificial spaces and places, even though such leisurely 'hanging-out' films as *Hatari!* and *Rio Bravo* might give the impression that it does. The last twenty years or so of Hawks's career provide a more schizophrenic response to the changing realities and dynamics of American film-making in this period. For example, although *Land of the Pharaohs* is monomaniacally preoccupied with the engineering and construction of the pyramid – the film's other elements of drama are largely dissatisfying, even ridiculous – and with the ultimate placement of a set of mostly subservient characters within a fully articulated, controlled, engineered and almost vacuum-sealed interior environment, it is also marked by the monumental staging of various sequences within the actual sands of the Egyptian desert (and captured under very difficult conditions). Although the implacable Hawks routinely asked his second-unit and assistant directors to shoot the action scenes and exterior 'backgrounds' for most of his films, further qualifying his reputation as an 'action director', he was certainly present during the filming of numerous location-based scenes in the most adventurous and outgoing of his 'outdoor' pictures of the 1950s and 60s. The last period of Hawks's career is characterised by this movement between the needs of location shooting and the increasingly artificial terrain of mostly interior-bound sets. Although his last two Westerns do manage to exert some perfunctory energy into their use of locations, his other final films, *Man's Favorite Sport?* (1964) and *Red Line 7000* (1965), are marred by their garishly unnatural interior settings.

Rio Bravo is obviously the key film in the last phase of Hawks's career. Numerous critics have commented upon its largely interior dynamics, and the ways in which it manages to create a kind of utopic community from meagre resources and within the confines of the jail and other interior spaces.[10] This reading of the film is exemplified by the sequence that features back-to-back songs performed *by* Dude (Dean Martin), Stumpy, and Colorado (Ricky Nelson), indulgently watched over by John T. Chance. This is one of the many scenes in Hawks's cinema that acts to decelerate the drama, or provide a kind of 'space' within the narrative that relishes gesture, character, behaviour, the 'moment' and, perhaps most revealingly, the exploration of the relationship between character and actor. This final element is central to this scene from *Rio Bravo*, as the use of Martin and Nelson almost demands such a musical interlude (though their performance, accompanied by Stumpy's less convincing mouth-organ and vocals, also

reinforces the formation of this rarefied and reified community and provides a counter-weight to the Mexican 'cutthroat' song that recurrently dominates the soundtrack). But this practice is also evident in the musical interludes of *To Have and Have Not* and *Only Angels Have Wings*, or the famously digressive mutual seduction between Bogart and a youthful Dorothy Malone in the Acme Bookshop in *The Big Sleep*.[11]

Each of these sequences demonstrates an absolute command and control of an environment, specifically the relationship between space, place, character and object. Although some of these spaces are marked by a degree of surface clutter, such as the piles of books in the Acme Bookshop or the rustic furniture in *Rio Bravo*'s jail, they generally demonstrate a simplicity of *mise en scène* that is reinforced by Hawks's unfussy shooting style and common reliance on group compositions and two-shots. John Belton has rightly argued that this clear, almost inexpressive construction of space – seldom are we confused or even curious about where Hawks's characters are – is designed to allow characters to carry out complete actions.[12] The relatively long takes and long shots, and the alternation of medium close-ups and group compositions in the musical sequence in *Rio Bravo* allow us to observe and spend time with the characters, focusing on the ways in which they relate to one another, their gestures, their relation to objects and the essential companionship of the group singalong. To paraphrase David Thomson in relation to the deceptively dark and murderous noir trappings of *The Big Sleep*, the brightly illuminated and warmly coloured corner of the jail in *Rio Bravo* becomes a kind of utopia or 'paradise',[13] a found community of four companions that moves beyond the more solipsistic configuration of 'My Rifle, My Pony, and Me'.

Although this simply composed and leisurely sequence might be dismissed by some as a folksy indulgence, it is actually a pivotal moment that rewards this disparate group of characters for finally overcoming their differences (for example, Dude has just defeated his alcoholism) and allows them to enjoy briefly the shared, intimate space of the jail. In this scene, Dude shifts from the darker, alcoholic excesses of Dean Martin's star persona to the more comfortable realm of the outwardly effortless singer. The dynamic between these four characters is expressed and reinforced by the relaxed spatial dynamics of this scene and the ways in which each of the characters exudes an aura of comfort and ease: Chance relaxes his gait, smiles and drinks his coffee; Stumpy faces the back of his chair and positions himself between Dude and Colorado; Dude barely raises himself from his slumber as his hat shades his eyes and he croons 'My Rifle, My Pony, and Me'; Colorado sits on a table and strums a guitar, looking admiringly over to Dude before taking over the singing duties.

One might expect that the interiority and even warmth found in *Rio Bravo* would continue to characterise the films Hawks made in the last decade of his career, particularly the final two Westerns, *El Dorado* and *Rio Lobo*, both of which were shot in a number of the same locations, and feature variations on many of the same themes and incidents. But both *El Dorado* and *Rio Lobo* have a more exterior and even expansive focus. Nevertheless, in some ways, each of the final five films Hawks made in the 1960s and early 70s provide a kind of summation, even refinement, of his earlier work and its approach to character, situation, space and place.

The first of these, *Hatari!*, as critics such as Jean Douchet have pointed out,[14] is a kind of meta-Hawks film, both a characteristically indirect portrait of the film-making process and a composite of many of the dominant elements of the director's work. It is chock full of actions, situations, characters and gestures recycled from earlier films, but these are placed within a narrative framework that is singularly lacking in any real tension and drama beyond the excitement of some of the hunting sequences. *Hatari!* is largely 'situational' in form, mostly concerned with being in an environment or community rather than caught up in the narrative drama of capturing animals to be supplied to zoos in the West. As Combs claims, 'in plot terms *Hatari!* is like running on the spot'.[15] In this regard, it continues and furthers the conversational 'tone' of *Rio Bravo*. But, as Michael J. Anderson has outlined, *Hatari!* is also a composite film that relies upon a synthetic combination of location and studio shooting, actors in actual places and against rear-projection, a defined narrative structure and often-digressive improvisation. Much of the film's plot and the dialogue between characters were only manufactured once the actors and crew were back in the Hollywood studio after the completion of location shooting in Africa.

Although Hawks's subsequent film, *Man's Favorite Sport?*, is marked by an obvious disconnect between its few location-shot sequences and its otherwise luridly artificial outdoor settings (and the placement of the film's stars mostly within these studio-bound interiors and exteriors), *Hatari!* is remarkable for the ways in which it actually places and situates its pointedly multinational cast on location. The importance of placing these actors in real African locations is signified from the very first, highly composed shot of the film, featuring a number of the men (including John Wayne's character) carefully assembled around a vehicle on the vast African plain. Although the film does sometimes use rear-projection as a means of artificially placing its actors 'within' these African surroundings – an effect that looks hopelessly out-of-date in the car-racing sequences of *Red Line 7000* three years later – this approach is generally (and necessarily) only used when these figures are required to speak.[16] The camera also gets close enough to the actors for us to recognise that it is actually the film's stars who are being jostled around on the vehicles moving across the African plain and directly involved in capturing the animals.

As is evident from this brief account of the use of Africa in *Hatari!*, location is particularly important to Hawks's cinema. Hawks has been discussed as among the most American of film-makers and his work is generally concerned with American characters or settings, especially a film such as *Only Angels Have Wings*, a work that is, in many ways, the most hermetic and artificial of Hawks's sound movies. The film's portrayal of the fictional port of Barranca provides a fantastical image of an exoticised South American town teeming with local 'colour', disaffected expatriates, clearly demarcated character types, racist stereotypes, and features an absurdly proximate geography. But even within this fast-paced, rarefied, 'intricately silly'[17] confabulation, '*Only Angels*, the ur-Hawks action film, is much more a comparative and analytical discussion of action than a *depiction* of action.'[18] On the few occasions that the film breaks away from this highly composed, artificial, hermetic, though always material, world – the interior of the bar, Grant's character's shabby room, the absurd lookout hut perched on the mountain,

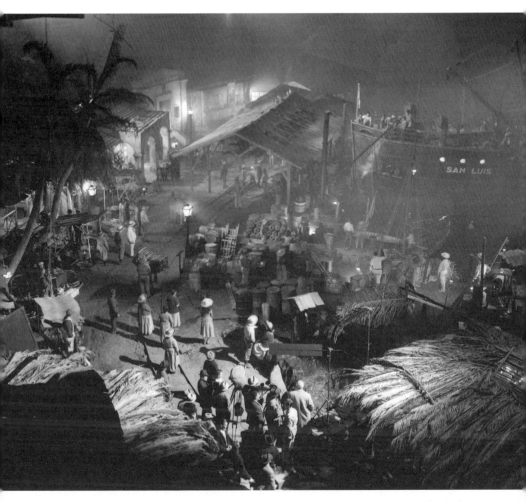

The Barranca port set on *Only Angels Have Wings* (1939): 'the most hermetic and artificial of Hawks's sound movies' (BFI)

the interior of a cockpit – such as the sequence where Richard Barthelmess's ethically compromised flier has to prove himself in a medical emergency by landing on a vertiginous rocky outcrop,

> the second-unit sequences of actual planes flying, the only recognizable exterior shots in the entire film, actually yank one out of the action, so disconnected are they from the artificial world of Barranca. The film contains a tremendous amount of truth and insight into people and behavior, but virtually no reality.[19]

It is a general truism, as Larry Gross argues, that Hawks's films are more interested in discussing and analysing action than actually showing it. Despite the description of

Hatari! I have given above, the film is still dominated by interior dialogue sequences that help evaluate the behavioural qualities and capacities of the various characters – though in contrast to many earlier films, almost all the characters prove themselves worthy members of the group. It is less the landscape that dominates one's impression of the film than the group arrangement of characters across the recurring interior spaces of the hunting lodge and its immediate surrounds. Similarly, a film like *The Big Sleep* delivers a less interesting and even less 'real' portrait of the streets and outer suburbs of Los Angeles than it does of the stage-like interiors of nightclubs, General Sternwood's (Charles Waldron) bizarrely situated greenhouse and Geiger's (Theodore Von Eltz) orientalist 'house'. As Todd McCarthy has argued:

> Hawks was a master of events played out within tight quarters among a handful of people in a limited period of time; despite his reputation as an outdoorsman, as a director he was most comfortable in a drawing room, an office, a home, or a hotel. These enclosed settings magnified the importance of every gesture and look, every remark, every decision, to the point where meaning, if you were looking for it, was densely packed into every moment.[20]

A simple illustration of this emphasis is given by the straightforwardly staged exchange of looks, glances, gestures, words and poses in the famous seduction scene between the characters played by Bogart (Steve) and Bacall (Slim) in *To Have and Have Not*. The setting for this exchange, mostly with Bogart seated and Bacall circling around him, is a relatively banal and dimly lit hotel room (though the build-up to this moment is quite elaborate and involves movement between various rooms as well as the forestalling of this sexy exchange). The 'geography' of the scene focuses upon the choreography of the carefully calibrated movement of the characters' bodies, as well as the contrastive faces and features of the two actors. As McCarthy argues, the relative confinement and enclosure of this setting, its spare *mise en scène* and the double meaning of their conversation act to magnify and intensify the exchange.

Hawks's sound films are predominantly located within contemporary settings and only occasionally move beyond the geographic borders of the United States. Even when his films move outside of this realm, such as in the lively, cluttered and almost fetid rendering of the incessantly inclement port of Barranca (or the murky Martinique of *To Have and Have Not*), the action predominantly stays close or returns to such 'any' or 'non' places as airfields, bars, jails and other utilitarian, though sometimes also highly atmospheric, interiors. This is very different to the appearance of iconic actual places in the work of Hitchcock and Ford, or the positioning of characters in relation to monumental elemental landscapes in the films of Anthony Mann. In some ways, the ultimate Hawks interior is the clubhouse or hunting lodge, one of the possible reasons why *Hatari!* emerges as such a genial, leisurely, companionable, pleasurable and even 'ideal' Hawksian confection.

But I do need to be careful not to misdescribe Hawks's cinema here. A number of the films that Hawks made after World War II are set and partly shot outside of America

in such places as postwar Europe (*I Was a Male War Bride*), Paris (*Gentleman Prefer Blondes*, 1953), Egypt (*Land of the Pharaohs*) and Kenya (*Hatari!*). But with the exception of *I Was a Male War Bride* (remarkable for its contrastive cinematography and location shooting while still contriving to get its characters into confined spaces and 'back home' to the US), these films are generally characterised by a lack of interest in 'actual' landscapes, settings and environments. Despite his geographic movement outside of America, Hawks's subsequent films still present a mostly touristic and inattentive vision of these 'foreign' locales. For example, in *Gentlemen Prefer Blondes* 'Paris becomes the object of their [the female protagonists'] and the cinema spectators' tourist gaze, a gaze that operates through the artificiality of the screen'.[21]

Even though *I Was a Male War Bride* is more attentive to, or at least openly situated within, these locations, it shows only limited interest in the local culture and inhabitants. The decision to make Cary Grant's character French – though he never really speaks the language or even attempts a French accent – displays a similarly perfunctory approach to the question of nationality and, in turn, of place. In response to a query about the questionable authenticity of Grant's Frenchness and his failure to even bother to affect a pseudo-French patois, Hawks simply replied: 'In the very first scene he comes across the border. ... They say passport and it says French. So there ...' .[22] Other aspects of Grant's performance were also marginally attenuated to affect this minimally rendered sense of ethnicity, such as his wearing rather tight, somewhat effete leather gloves. Even *Hatari!* seldom moves beyond a relatively picturesque and even perfunctory vision of the African landscape, other than to insist on the positioning of the actors within this environment.

Hawks's work sits in contrast to such landscape or environment-driven film-makers as John Ford and Anthony Mann, directors who often stage their characters and action within or against overwhelming geographies; the characters in Hawks's often small-scale cinema rarely seem to fully engage with these landscapes, but neither are these environments particularly hostile. Hawks's cinema is also distinct from the more fatalistic and nightmarishly constrictive use of place and space in the sparsely rendered work of a film-maker like Fritz Lang. As Farber has argued: 'Hawks, a born movie-manipulator who suggests a general moving flag pins around a battle map, is not very fussy about the pulp-story figures nor the fable-sized scenery into which he jams them.'[23] But although Hawks's films are often characterised by claustrophobic and reiterative places and spaces, they rarely seem to 'jam' their central characters into such contained environments. Many of the best Hawks films return to moments where the main characters seem to be just 'hanging-out', enjoying the pleasure and camaraderie of a cosy place or environment. By way of example, just think of how specific elements work in combination to establish a particular setting: the blinds being drawn, the small adjustments of costume and set design, and the Hollywood weather crowding in – the low rumble of thunder we hear as Bogart's Marlowe crosses the slowly moving street, a characteristic 'jaunt' that 'helps the illusion of real space'[24] – that heightens the intimacy of *The Big Sleep*'s Acme Bookshop sequence. But Hawks's cinema is memorable for many such casual hideouts, improvised places and clubhouse compositions.

Although Hawks's cinema inevitably features a range of shot types, with some films such as *Scarface* (1932) more dynamic and varied in their camera placement and use of mobile framing than others, it is still dominated by two-shots and slightly wider group compositions. This is emphasised in a film like *The Big Sky* (1952). As a big-budget, epic outdoors adventure film, it does feature more long shots and extreme long shots than is common with Hawks, but it also includes very few shots of individual characters. It is mainly concerned, at least pictorially, with positioning the group within an environment and in relation to one another – it even grants a degree of intimacy by 'containing' these exterior locations by visually contrasting them to the confines of the boat and the dense wood on the banks of the river. But this arguably unconscious aesthetic only becomes fully evident in the final moments of the film. In one of the few truly 'domestic' endings in a Hawks film, Boone Caudill (Dewey Martin) at first rejects and then ultimately accepts his 'unintended' marriage to an Indian princess, Teal Eye (Elizabeth Threatt). This final acceptance of marriage and racial miscegenation, and the symbols of a union Boone doesn't culturally 'understand', is suggested by the ways in which these final shots of the two figures – an exchange between two characters who can't generally see one another – are composed and framed (as, finally, shot/reverse-shots). This final sequence contrasts the tracking shot of the moving boat with the static, carefully framed long shot of the solitary Teal Eye (who then moves to exit the frame) and the closely framed shot of Boone as he sets out purposively on his journey back towards her.

But we shouldn't view Hawks's work in isolation. The movement out of the studio from the somewhat atypical *Red River* (1948) onwards, and after the highly artificial and self-consciously studio-bound run of *To Have and Have Not*, *The Big Sleep* and *A Song Is Born*, is in keeping with broader postwar trends towards decentred Hollywood film production. For example, *Land of the Pharaohs* is one of a series of epics shot by various studios in Northern Africa and Southern Europe in the 1950s and 60s. But even when Hawks left the confines of the Los Angeles studios, he still favoured such contained environments as the purpose-built sets and buildings of Old Tucson, originally constructed in 1939 and used in *Rio Bravo*, *El Dorado* and *Rio Lobo*. This setting is one of the key factors – along with the redeployment of personnel and the replay of various bits of action and character types – allowing for the spatial and philosophical unification of the final trio of Westerns that cap the last decade or so of his career.

Although Hawks deployed a style and approach that is notoriously difficult to identify, he was, according to McCarthy, 'actually the most stylized Hollywood director this side of Josef von Sternberg'.[25] This heightened stylisation is clearly related to the ways in which Hawks constructed and represented place and space. His films are marked by what we might call 'privileged' spaces, constricted environments that regulate and stage the often highly refined and ritualised actions and reactions of his films' characters. These spaces rarely include the 'domestic' interiors common to the world of classical Hollywood cinema, and are characterised by such interstitial places as nightclubs, bars, airports, hotels and jails. Hawks's cinema, despite its utopic aspirations, is commonly transitory. Even the final embrace of Bogart and Bacall in *The Big Sleep*

occurs while they await the arrival of the police, holed up in a mysterious suburban house of sedition and murder that is being staked out by a criminal gang. It is in this transitoriness, this sense of an indifferent, Darwinian cosmos that trumps other gauges of value and worth, that one can glimpse the darkness, bitterness and despair critics such as Andrew Sarris have seen as the dominant sensibility of Hawks's work.[26]

This quality is also central to the more utopic and positivist readings of Hawks's cinema. In this sense, Hawks' characters are not pinned down, but are able to make their own place within whatever 'found' environment they are situated. Everything else suggests that Dude, Chance, Stumpy and Colorado are in desperate straits in *Rio Bravo*, but those few moments when they sing their songs and kick back to share some 'space' and time in the jail interior are both a celebration of the 'moment' and an indication of the world that might await them beyond the film's final shootout. As Thomson says of *The Big Sleep*,

> It's a dark world, and nearly every composition offers the shape of claustrophobia, if you want to feel gloomy. But Bogart handles himself and the space as deftly as Joe DiMaggio running left field. The space is like his shadow, or familiar.[27]

It is this attitude toward space, the ability to carve out and use it as an image or 'shadow' of oneself or the group that is one of the defining features of Hawks's overwhelmingly positivist cinema. It is also one of main reasons we might wish to return to these films, to exist within the spaces and places they shape and occupy. A key to the pleasure of that scene in the jailhouse is that we feel as if we occupy the homey space alongside the unlikely gang of Chance, Dude, Colorado and Stumpy. For a little while, we are one of them.

Notes

1. Joseph McBride, 'Hawks', *Film Comment* vol. 14 no. 2 (March/April 1978), p. 38.
2. See Stanley Cavell, *Pursuits of Happiness: The Hollywood Comedy of Remarriage* (Cambridge, MA: Harvard University Press, 1981), pp. 161–87.
3. Manny Farber, 'Howard Hawks', *Artforum* (April 1969), repr. in Robert Polito (ed.), *Farber on Film: The Complete Film Writings of Manny Farber* (New York: Library of America, 2009), p. 656.
4. David Thomson, *The Big Sleep* (London: BFI, 1997), p. 9.
5. Ibid., p. 11.
6. Joe McElhaney, 'Howard Hawks: American Gesture', *Journal of Film and Video* vol. 58 nos 1–2 (Spring/Summer 2006), p. 33.
7. Michael J. Anderson, '*Hatari!* and the Hollywood Safari Picture', *Senses of Cinema* no. 52 (2009): http://sensesofcinema.com/2009/52/hatari-and-the-hollywood-safari-picture/ (accessed 25 September 2014)
8. Richard Combs, 'The Choirmaster and the Slavedriver: Howard Hawks and *Land of the Pharaohs*', *Film Comment* vol. 33 no. 4 (July/August 1997), p. 45.
9. Ibid., p. 49.

10. See Molly Haskell, 'Howard Hawks', in Richard Roud (ed.), *Cinema: A Critical Dictionary: The Major Film-makers, Vol. 1, From Aldrich to King* (London: Secker & Warburg, 1980), p. 485. Despite acclaiming *Rio Bravo* as masterpiece, Haskell is understandably wary of the masculine clubbiness the film promotes.

11. See David Thomson, 'At the Acme Bookshop', *Sight and Sound* vol. 50 no. 2 (Spring 1981), pp. 122–5.

12. John Belton, *The Hollywood Professionals Vol. 3: Howard Hawks, Frank Borzage, Edgar G. Ulmer* (London: Tantivy Press, 1974), p. 12.

13. Thomson, *The Big Sleep*, p. 12.

14. Jean Douchet, 'Hatari!', *Cahiers du cinéma* no. 139 (January 1963), trans. John Moore, repr. in Jim Hillier and Peter Wollen (eds), *Howard Hawks: American Artist* (London: BFI, 1996), p. 82.

15. Combs, 'The Choirmaster and the Slavedriver', p. 45.

16. See Anderson, '*Hatari!* and the Hollywood Safari Picture'.

17. Farber, 'Howard Hawks', p. 654.

18. Larry Gross, 'Hawks and the Angels', *Sight and Sound* vol. 7 no. 2 (February 1997), p. 13.

19. Todd McCarthy, *Howard Hawks: The Grey Fox of Hollywood* (New York: Grove Press, 1997), p. 277.

20. Ibid., p. 10.

21. Fiona Handyside, 'Beyond Hollywood, into Europe: The Touristic Gaze in *Gentlemen Prefer Blondes* (Hawks, 1953) and *Funny Face* (Donen, 1957)', *Studies in European Cinema* vol. 1 no. 2 (2004), p. 84.

22. Recounted by James Caan in the documentary *Howard Hawks: American Artist* (BFI: Kevin Macdonald, 1997).

23. Farber, 'Howard Hawks', p. 657.

24. Thomson, 'At the Acme Bookshop', p. 124.

25. McCarthy, *Grey Fox*, p. 10.

26. See Andrew Sarris, *'You Ain't Heard Nothin' Yet': The American Talking Film, History and Memory, 1927–1949* (New York: Oxford University Press, 1998), pp. 263–81.

27. Thomson, *The Big Sleep*, p. 9.

2 Hawks, Widescreen and Visual Style

Harper Cossar

I don't think that CinemaScope is a good medium. … it's distracting – it's hard to focus attention and it's difficult to cut. If the CinemaScope size had been any good, painters would have used it more – they've been at it a lot longer than we have.

Howard Hawks[1]

Howard Hawks directed forty-seven feature films of which only seven are in an aspect ratio other than the pre-1953 industry-standard Academy format (1.33:1).[2] *Land of the Pharaohs* (1955) is Hawks's only *really* wide film (that is, wider than the now 'standard' 1.85:1), and it was filmed in CinemaScope (2.55:1). As he suggests above, Hawks wasn't keen on the format, nor the 'concept' behind the systematic industrial conversion to widescreen processes in 1953. Hawks had spent his entire career composing and constructing images for the Academy ratio. When the shift to wider screens mandated that he work outside 'the box', Hawks didn't care for the change and he subsequently made comparatively few films after 1953.

This essay seeks to provide a comparative analysis of Hawks's pre- and post-widescreen film-making strategies. More specifically, by observing films that Hawks made with his longtime cinematographer Russell Harlan both before and after widescreen, Hawks's visual practices may emerge in ways that previous analyses of his work have left under-examined. Hawks and Harlan collaborated on both *Red River* (1948) and *Land of the Pharaohs*, and a detailed textual analysis of the visual strategies deployed in each film reveals how the film-makers had to accommodate, alter or completely rupture their previous stylistic and aesthetic choices.[3] While *Red River* and *Land of the Pharaohs* differ generically (Western and historical epic respectively), both films feature an emphasis on expansive outdoor locales, epic struggles of human collaboration against the natural elements and the corrupting nature of power. Because both films depict grand exteriors and psychological struggles of will and conscience, the two films can provide canvases of comparison to evaluate Hawks's visual choices before and after widescreen.

As a longtime studio director, Hawks was required to work in many different genres and, as auteur critics have long noted, he often transcended straightforward genre vehicles. Rather, Hawks's films, regardless of genre, often reflect the 'Hawks style' in aesthetic form, narrative structure and content. So how does Hawks serve the tropes

and strictures of the Western or epic genres within the newly widened CinemaScope frame?[4] How are these shifts represented within the 'Scope frame when dealing with close-ups, landscape shots, camera angles and/or camera movement? This essay questions if Hawks's film-making approach and 'style' were forced to adapt or change within the newly adopted widescreen frame.

Having worked in the studio system since 1917,[5] how would Hawks adapt his formal choices and aesthetic style to a format he felt to be counter-intuitive to the kind of cinema he believed in? The focus here is limited to the close inspection of close-ups, landscape shots, camera angles and movement that occur in:

1) opening sequences;
2) interior conversation set-ups;
3) outdoor vistas and;
4) complex camera movements (defined as more than a tilt or pan).

Why limit this examination of film style to these narrow parameters? First, this systematic methodology of inquiry provides a rubric so that Hawks's Academy-ratio and widescreen films can be analysed equally. Opening sequences function as a site for a film-maker to explore new options for widescreen poetics, and thus create a kind of primacy effect to prepare the spectator for viewing strategies that may be different from those of the Academy-ratio era. Interior scenes often rely on close-ups, but practitioners and scholars alike have suggested that widescreen 'progresses' beyond the need for close-ups so an interrogation of the texts is warranted. Anecdotal evidence suggests that, due to the extra width of the CinemaScope frame, canted or extreme camera angles were jarring to audiences. Finally, camera movement is reportedly minimised in early 'Scope films because scenes can be taken in 'naturally' by long shot without any 'distracting' cuts.[6] By establishing these ground rules, this analysis focuses on aesthetic and narrative aspects present in Hawks's genre films before *and* after widescreen. Additionally, this model allows for consistent inquiry across the board rather than concentrating on scenes of 'attraction', novelty or spectacle.

Studio chief Jack Warner was initially 'raving' about Hawks's CinemaScope footage in *Land of the Pharaohs*, but soon felt that Hawks 'wasn't using the format well in his interiors'. Hawks retorted that he found 'Scope 'clumsy' and questioned its use: 'We have spent a lifetime learning how to compel the public to concentrate on one single thing [in the Academy ratio]. Now we have something that works in exactly the opposite way, and I don't like it very much.'[7] Several issues about widescreen's potentialities are revealed in the Warner/Hawks exchange. First, Warner, who understood the revolutionary (and fiscal) power of 'new' film technology, believed that Hawks was not using CinemaScope *properly*. This suggests that Warner believed that CinemaScope had certain capabilities that Hawks either wasn't utilising or didn't recognise, specifically in interior set-ups. Hawks, then, is understandably flummoxed by the demands of the new format, as he had 'spent a lifetime' composing for the mostly square Academy ratio. How might these opposing and dialectical needs be assuaged

within the construction of the filmic challenges posed by the industrial shift to wider films? How is it that a veteran such as Hawks is somehow failing (in Warner's eyes) to adapt to the 'new' demands of widescreen film-making?

Criticism of Widescreen

The early 1950s and the shift to widescreen was a time in which a subtle dance occurred between new film technologies and the subsequent aesthetic strategies that 'debut' simultaneously.[8] A gap emerged between the stylistic and exhibition norms of the Academy-ratio screen and the new CinemaScope frame (and a multitude of competing widescreen formats and processes). In addition, the newly widened frame was also a radical challenge to the home television screen also governed by the Academy- ratio dimensions. CinemaScope was marketed as something *different from* the 'old' screen and/or television ('Breathtaking CinemaScope!'). The impetus was therefore very strong for the early CinemaScope-era film-makers to make use of the unique framing possibilities in ways that would oppose the Academy ratio's potentialities.[9] However, there was very little common ground with regard to specifically *how* widescreen changed studio film-making practices when it 'debuted' in the earlier 1950s. Cinema after widescreen's introduction foregrounded a new norm of exhibition, and the production and stylistic practices had to adapt and stabilise. In short, if cinematic history can be compared to painting (as Hawks's remarks suggest), then prior to 1953's adoption of widescreen film-making, cinema existed as a portrait-*only* operation with a premium placed on vertical compositions. Feature films before 1953, with very few exceptions, were composed in only one shape: the almost square Academy ratio. This 'elongation' of the screen is particularly salient in the comparison here with Hawks's genre films. Hawks and Harlan were quite adept in the Academy ratio and accustomed to its formal constraints for landscape compositions. In *Land of the Pharaohs*, however, the film-makers were frustrated by the wide frame's unwieldiness with regard to the isolation of visual elements. Widescreen, as Hawks and Harlan discovered, was quite simply a break from previous stylistic norms because the shape of the frame itself was radically reconfigured.

Widescreen's aesthetic cornerstone, according to early critics, was that it achieved a visual breadth absent in Academy-ratio-era film-making, providing potential for what Eric Rohmer described in his account of CinemaScope as 'more breadth of expression'.[10] Several scholars have wrestled with isolating widescreen cinema's unique features and more specifically *how* it differs from pre-1953 cinema. Charles Barr's 'CinemaScope: Before and After', argues that widescreen cinema challenges spectators to be 'alert', and that widescreen film-makers should adopt a 'gradation of emphasis' regarding its implementation. Barr's assumption is that widescreen cinema (and specifically CinemaScope) offers the possibility of 'greater physical involvement' for the spectator and a 'more vivid sense of space'.[11] Barr purports that wide films represent a different experience than that of Academy-ratio films by composing action laterally, yielding fewer edits. Given the wider visual field, to say nothing of the wider screens in exhibition sites, Barr suggests that widescreen film-makers may *finally* compose scenes of expanded width and scope (!) that elicit greater attention on the part of the spectator

to discern details of performance, composition, narrative significance, etc. Note that this particular *advance* that Barr cites as CinemaScope's triumph is precisely the difficulty that Hawks rails against.

David Bordwell surveys earlier scholars' critiques (including Barr's) of widescreen poetics and presents a slightly underwhelmed assessment of widescreen's impact upon film-making practices and reception.[12] Bordwell observes that widescreen film-making was a slight experimental bump in the road for the classical Hollywood Cinema studio system, but that technicians and film-makers quickly adapted to the newly widened frame with little difficulty. John Belton offers both a cultural and ideological critique of the industrial and social factors present in widescreen's adoption. While Belton's book serves as an indispensable guide to the diffusion of widescreen technologies and formats, he stops short of offering specific terminology or typology for aesthetic criticism about widescreen.[13]

Critical reactions to widescreen and its importance to the film canon are, at best, conflicted. Other scholars have examined widescreen practices with regard to lens characteristics, exhibition practices or advertising strategies, all of which contributed to CinemaScope and widescreen's ultimate success. James Limbacher, Barry Salt, James Spellerberg, Richard Hincha, Leo Enticknap and others have all provided useful studies of these areas.[14] More recently, editors John Belton, Sheldon Hall and Stephen Neale have examined the worldwide exhibition practices of widescreen films beyond Hollywood.[15]

Hollywood Authorship and Hawks's Visual Style

According to David Bordwell, Kristin Thompson and Janet Staiger, directors establish a narrative voice via systematic uses of devices and techniques that realise their narrative and visual style.[16] Janet Staiger suggests that authorship 'as origin' occurs when 'the author is conceptualized as a free agent', and 'the meaning is a direct expression of the author's agency'. This simply presumes a 'grouping on the basis of the historical body of the individual's' work.[17] Specifically with regard to the transition to widescreen, Bordwell observes that 'we can learn a great deal about cinematic technique, particularly staging and composition, by studying how talented directors managed the distended image' of CinemaScope and widescreen overall.[18] To define stable and recurring aesthetic trends within the Hollywood group style, Bordwell argues that a hallmark of the classical Hollywood cinema mode of production is the reliance upon 'fundamental aesthetic norms'. The author sees the classical Hollywood mode of production as a menu of 'bounded alternatives' and 'functional equivalents' for stylistic variations within a group style. In short, within the logic of the classical studio era, there 'is always another way to do something'.[19] While this is certainly observable in the classical studio film-making era of the Academy ratio, I propose that the introduction of widescreen formats stretch (literally) the boundaries of alternative or equivalent stylistic devices. In short, do directors continue to apply the same techniques as they had in the Academy-ratio frame, or do they experiment within the new CinemaScope proportions and forge new norms to signify their presence and fulfil generic aims?

I suggested in *Letterboxed* that there is a tendency for widescreen directors to stress the lateral nature of widescreen. However, to accommodate the new wide film-making technology, sets had to be *constructed* wider and thus lower overall. As Hawks implied in the opening comments, this is a rupture from the previous standards of composition and editing, and a stumbling block for film-makers accustomed to the Academy ratio. Additionally, Marshall Deutelbaum suggests that a common strategy for composing in (anamorphic) widescreen was to divide the screen into thirds (ie, 33% left, 33% center, 33% right) to accommodate the expanded dimensions of widescreen.[20] While this is true for many widescreen film-makers such as Otto Preminger, Douglas Sirk, Vincente Minnelli and others, Nicholas Ray would often break the wide and rectangular 'Scope frame into essentially *two Academy-ratio frames*. By shooting in this way, Ray could normalise and adjust to the new format by breaking it down into familiar and compose-able parts.[21] Bruce Block observes that such widescreen framing strategies

> not only place the actor in a new, smaller area of the frame, but also helps confine the audience's attention to one portion of the overall frame. ... [This composition] controls and limits the audience's ability to visually roam the frame [and] acts like a visual fence.[22]

In *Red River*'s cattle-herding terms, Hawks recognises widescreen's difficulty in corralling the audience's eye. To labour the metaphor further, the Academy ratio is a fenced pen for film-makers to compose within, and widescreen is pastoral; an open plain for the viewer's eye to roam.

An examination of the 'Hawks style' throughout his film-making career reveals a number of recurring themes, tropes and choices. Formally, Hawks generally does not practise what would today be called a 'stylish style'.[23] That is, Hawks usually prefers to shoot at eye level, with little camera movement unless an action 'demands' the camera move, as with perhaps a Western or gangland shootout or maybe an aerial assault. Thus, Hawks's films are often dialogue- and character-focused, rather than visually bravura or what Hawks might consider 'showy'. Hawks's comments on directing reveal how he feels that what appears on screen should be as visually Spartan as possible:

> I try to tell my story as simply as possible, with the camera at eye level. I just imagine the way the story should be told, and I do it. If it's a scene that I don't want anybody to monkey with or cut, I don't give them any way to cut it. ... That's about all I can say about it. I like to tell it with a simple scene. I don't want you to be conscious that this is dramatic, because it throws it all off.[24]

Hawks's analysis of his own style is quite representative of the classical Hollywood era's directorial *modus operandi*. Many studio-era directors considered themselves simply 'doing a job of work' with as few artistic or creative interruptions as possible. Of

course, the nature of the studio system relied upon efficiency of both practice and pro-ficiency, often shooting as many script pages daily as possible, not to mention shooting multiple pictures in a year. As such, the Hawks look is often accompanied by 'orthodox' editing and easily comprehended narrational structures as well.[25] Hawks generally makes *genre* films, but not *generic* films. A Hawks film noir is distinctive as such, and the same is true of a Hawks Western. Hawks the film-maker is uniquely identifiable for his consistent narrative devices as well as for the thematically and aesthetically familiar strategies.

Red River and *Land of the Pharaohs*

It is often difficult to compare or contrast multiple films with regard to similarities of pro-duction, editing, narrative structure or aesthetics. A critic can usually only make very broad, macro observations with regard to recurring themes or generic tropes. Such analysis is further complicated by comparing/contrasting multiple films made years apart or with separate production crews.[26] By selecting two films helmed by Hawks and visualised by Harlan across *both* formats, the analysis will be both consistent and cogent. Again, the narrow rubric of opening sequences, interior conversation sequences, landscape shots and complex camera movement allows for a consistency of analysis and uniformity of formal observation.

Both films begin with the process of writing. *Red River* (left column) opens as a story being told from a book, which leads to a vertically aligned composition to mimic the portrait orientation of a bound novel. The viewer's eye must scan the text from top to bottom and right to left as would a book reader. This textual device is repeated often throughout the film as the cattle drive progresses, and thus the vertical, Western-style reading strategy is re-activated for the viewer multiple times. In the opening shot of

Red River (1948) (left); *Land of the Pharaohs* (1955) (right)

Land of the Pharaohs (right column), the high priest Hamar (Alexis Minotis) is shown writing the history of Pharaoh, visualised with a slow-creep dolly shot that finishes in a centred, medium shot. While both films begin with the process of reading, and thus fabulism, Hawks and Harlan vivify them in different ways. In *Red River*, the film-makers provide a vertical and/or up-and-down viewing strategy, whereas *Land of the Pharaohs* is lateral. Of course, early 1950s widescreen films usually necessitated much lower and wider set construction, and thus, a lower camera overall. These opening scenes reveal that *Red River* is an Academy-ratio film and thus akin to portraiture, whereas *Land of the Pharaohs* is landscape.

Red River (left); *Land of the Pharaohs* (right)

The next shots in each film's opening sequence display these tendencies even more strikingly. *Red River's* wide shot aligns with the Western's generic expectations of open spaces, man's exploration/taming of nature and the vastness/emptiness of the wilderness. Note, however, that Hawks and Harlan quickly index from a sprawling wide shot of openness to individuals, whereas *Land of the Pharaohs* is primarily impressed with spectacle, scale and the immensity of labour.

Hawks and Harlan deliberately demonstrate the grandeur of CinemaScope with *Land of the Pharaohs'* opening shots, while in *Red River*, the West is quickly 'tamed' to foreground narrative and character.[27] If film-makers use opening sequences to 'teach' the audience what to expect – formally, generically, structurally, aesthetically – then Hawks and Harlan are indeed drawing formal boundary lines here. *Red River* will be about the West, certainly, but it will be more about *characters* struggling to tame it; *Land of the Pharaohs* is about characters being overwhelmed by nature itself, and labouring to cope within its awesome environment. Critics such as Gerald Mast have noted this tendency in Hawks's Westerns to shift the generic expectations 'away from the external incidents toward the underlying psychological and emotional interactions'. Mast notes (citing a Joseph McBride interview with the director) that in *Red River*, Hawks is 'more interested in the story of friendship between the two men than … about a range war, or something like that'.[28] The lateral and lower formal decisions by Hawks and Harlan continue throughout *Land of the Pharaohs'* opening sequence with the procession of Pharaoh Khufu's (Jack Hawkins) legions and subjects. Repeatedly, the film-makers utilise and even accentuate the horizontal proportions of the Cinema-Scope frame. Perhaps in evidence here is the oft-cited (but underanalysed) cliché about CinemaScope's usefulness being limited to 'snakes and funerals'. Director Fritz Lang claimed CinemaScope is 'a format for a funeral, or for snakes, but not for human beings: you have a close-up, and on either side, there's just superfluous space'.[29] We can examine this 'superfluous space' by observing how Hawks and Harlan use both Academy ratio and CinemaScope in interior, conversation set-ups.

Richard Combs observes that Hawks's opening sequence in *Land of the Pharaohs* is a bit of formal sleight of hand with regard to the remainder of the film's visuals. Combs notes that the director 'renowned for his static, eye-level camera', gives in to the spectacle of CinemaScope and 'employs the more sweeping movements of epic cinema'. After the initial display of CinemaScope's grandeur, Combs notes that Hawks actually uses 'the whole sequence [as] a succession of movements inward, from the desert to the inner chambers of the pharaoh's palace …'.[30] Jack Warner obviously felt that for CinemaScope to 'work' it needed to display its novelty in every scene, not just the opening shots of set design and spectacle. Warner evidently felt that Hawks and Harlan weren't exploiting the full potential of the new wide format as well indoors as they were outdoors.

An examination of interior conversation set-ups in both *Red River* and *Land of the Pharaohs* shows that the film-makers are indeed exploring and adapting two disparate techniques for the distinct formats. In *Red River*, Tom Dunson (John Wayne) is relaying to his charges that their cattle drive will take them to Missouri, and thus will be quite

Red River (left); *Land of the Pharaohs* (right)

dangerous across formidable terrain. Hawks and Harlan show Dunson as being quite mobile and, as is often the case in Hawks's Academy-ratio films, in fairly claustrophobic blocking. Hawks's close-knit, all-male groups are highlighted in such blocking schemes as the viewer internalises the danger, tension and trapped nature of the group's perilous plight. Note that while Hawks and Harlan crowd the vertical Academy-ratio frame in *Red River*'s interior conversation, a very different approach is revealed in *Land of the Pharaohs*' indoor conversation.

In *Red River*, the film-makers use Dunson's mobility to show not only the anxious nature of the cattle drive, but also the reaction shots of leery and unsure men. Of course, Dunson delivers the oft-cited Hawksian question of the all-male group's evaluation: how 'good' will the men on the cattle drive be? Will they fail or falter in the face of danger and uncertainty? Thus, the interior conversation set-up (one of the few *interior* sequences in the entire film) serves as a metaphorical *internal* glimpse of the group's inner workings. In his Westerns, as with his other male-centric groups, Hawks highlights the internal psychological tension with tight, claustrophobic blocking. The Academy-ratio-era framing lends itself to corralling actors vertically, and thus narrows 'the walls' of the frame. Of course, CinemaScope does exactly the opposite, much to Hawks's chagrin.

On the other end of the visual and metaphorical spectrum, *Land of the Pharaohs*' interior set-up is a conversation between two men, Khufu and Hamar. Note that what Hawks and Harlan are able to show in two cuts in CinemaScope material would need

four cuts (and more overall) in the Academy ratio. Even more revealing is the 'superflu-
ous space' in Land of the Pharaohs's framing that Hawks and Lang both criticised.
Whereas Dunson and his men look as though they are stacked on top of one another,
Khufu and Hamar are 'floating' in the ultrawide CinemaScope frame. Narratively, this
visual crowding of the frame 'works' in Red River to vivify the dangerous task the men
are facing. In contrast, while Combs notes that Land of the Pharaohs is about 'inward
... inner chambers', we see on display here that those interiors are actually airy singles
in a shot/reverse-shot format. For brevity's sake, I am only using comparable set-ups
for analysis of film form. Red River has very few interior sequences, and Land of the
Pharaohs has many. A number of Land of the Pharaohs' internal conversations are
carried out in mobile, low-camera master shots with many fewer edits than would have
been utilised in a similarly framed Academy-ratio set-up. The chosen sequences are
meant to be representative, though not necessarily synecdochal.

Ironically, the outdoor vista sequences for Red River are often horizontal and
widescreen-esque whereas the landscape set-ups for Land of the Pharaohs are seg-
mented, as Deutelbaum suggests. When Dunson and the cattle drivers reach the Red
River and must cross, Hawks and Harlan show this Western generic trope in a manner
that seems to presage widescreen's 'scope', typically with higher angles to emphasise
the sheer breadth of the undertaking. Hawks admired the crew's efforts throughout
Red River's production because 'when you have to shift 3,000 head of cattle every
time you shoot a new scene, that's hard work'.[31]

As Mast observes, Red River 'is an awesomely outdoor film, shot on location [in
Elgin, Arizona], unlike his later and more modest westerns, which are primarily indoor,
studio-interior films'.[32] Note that Mast's assessment of Hawks's later 'more modest'
Westerns would include Rio Bravo (1959), El Dorado (1967) and Rio Lobo (1970), all
made in the widescreen era. Again, the irony bellows that Hawks's favourite Western
is an 'awesomely outdoor' Academy-ratio film that feels widescreen in its exteriors, but
Hawks's later widescreen Westerns are interior and thus feel more like Academy-ratio
films. Hawks and Harlan show the river crossing with almost symmetrically vertical
bisection. Note that each frame could be segmented laterally into earth and sky. Hawks
and Harlan do not show the individuals – though Dunson and Garth (Montgomery Clift)
share a contemplative moment on the riverbank before the crossing – but rather marvel
from a distance at the task of moving such an enormous herd of livestock. While the
hallmark of widescreen is said to be its scope and 'lack of emphasis' that is so preva-
lent in the Academy-ratio era of montage cinema, Red River's cattle crossing allows
the eye to wonder vertically in airy awe of this monumental task.

In contrast, Land of the Pharaohs' exterior sequence shows the honoured dead
being praised by Pharaoh. By 'bookending' framings, the film-makers restrict the
viewer's eye from roving laterally and thus focus attention. Film-makers of later
widescreen eras will continue to explore widescreen framing techniques to funnel the
eye as they experiment with the new demands of the formal shift. Hawks and Harlan
have utilised parts of the set design to serve as blocking tension points or what Block
calls visual 'fences'. When the Egyptian gods such as Osiris and Anubis are said to

Red River (left); *Land of the Pharaohs* (right)

'speak' to the people and acknowledge the sacrifice of the dead, the film-makers block the set-design elements in such a manner that the CinemaScope frame is no longer an elongated, 'unfenced' rectangle, but is broken down into manageable segments. To belabour the point of irony between the two films and the film-makers' formal choices: *Red River* features the unfenced West, where cattle may be driven thousands of miles unimpeded, and the Academy ratio demands that Hawks and Harlan capture the horizontal scope of the cattle drive within a vertical shape. *Land of the Pharaohs* focuses upon the awesome construction of Pharaoh's (vertical) tomb (with herds of people rather than cattle), and the laterally expansive CinemaScope frame must be segmented into smaller shapes to rein in the eye of the viewer.

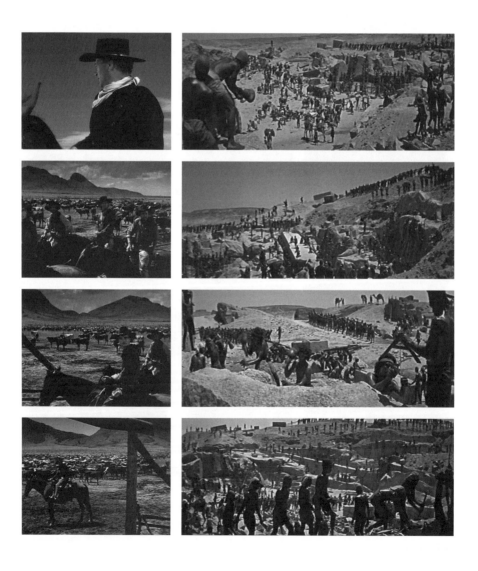

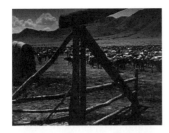

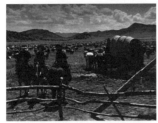

Red River (left); *Land of the Pharaohs* (right)

It is commonly assumed that camera movement becomes *verboten* with the advent of widescreen processes. There is much variation among directors and genres, though overall, there is an uptick for a short historical window with regard to shot length; the notion that an expanded screen needed more time to be consumed. While *Red River* certainly has a shorter average shot length than *Land of the Pharaohs*, neither film has what would be considered much complex or bravura camera movement. Hawks and Harlan do seemingly reprise a famous shot from *Red River* in *Land of the Pharaohs*. Before the legendary 'yahoo!' montage inaugurates the cattle drive, Dunson surveys the men, the cattle and the land. In a fixed camera with a near-360° pan, Hawks and Harlan show at man-on-horseback eye level the vastness of the task and the wilderness that Dunson's men must overcome. Note that the *Red River* shot originates from Dunson's watchful and suspicious eye as he sizes up the men, wondering who will be up to the task and who will not. [33]

A similar shot in *Land of the Pharaohs* is a continuous 1:20 shot from a mostly fixed, low camera panning left to right. Hawks and Harlan need nearly 360° of cinematic space to capture the lateral nature of the West in the more vertically oriented Academy-ratio format. In contrast, *Land of the Pharaohs*' pan necessitates that the camera move to reframe both up and down as the view taken in is epic and exhausting in a single take. The CinemaScope position originates lower overall, and thus the reframing tilts accommodate the lower nature of the shot overall. The corresponding *Red River* shot is visualised on horseback, while *Land of the Pharaohs*' dominant point of view is from the vantage of the labourers on the ground. While neither of these shots is technically a complex camera move, the similarity of the visuals across the two formats is intriguing enough to forgive the methodological break. A similar visual task in both films required the film-makers to accomplish its execution quite differently between the two formats.

What can be gleaned from analysing Hawks and Harlan's work across two films using different formats within different genres? We can observe that the film-makers are addressing separate 'problems' – generic, aesthetic, narrative, etc. – using similar but unequal tools. In *Red River*, the film-makers must show the expanse of the West, the brutality of both psychology and landscape within the vertically oriented Academy ratio. This necessitates an up-and-down reading style for the viewer, and Hawks reinforces this strategy with the written pages that initially (and periodically throughout)

propel the narrative forward. One can imagine that perhaps Hawks may have vivified the book-to-West transition as Ang Lee and cinematographer Claudio Miranda did in their adaptation of *Life of Pi* (2012). Lee and Miranda shift aspect ratios multiple times, from 1.33:1 to 1.85:1 to 2.00:1 to 2.35:1, as the shifts of narrative demand. When reading from the book, the film-makers use the verticality of the Academy ratio, but when flying fish must 'break through' the frame, a 2.35:1 aspect ratio is deployed. Of course, Hawks and Harlan are 'limited' to a static aspect ratio in *Red River*, and given Hawks's 'resistance' to flashy or overtly 'dramatic' visuals, he wouldn't use such devices regardless. Hawks and Harlan move the camera higher overall and cut more in *Red River* as the common decree about pre-widescreen montage cinema (and its attendant shot lengths) suggests. However, the film-makers do struggle with the 'superfluous' space created by CinemaScope's width when framing singles. As Hawks criticises the format's shortcomings, his prophecy is fulfilled with regard to *Land of the Pharaohs* as he and Harlan struggle to wield CinemaScope's breadth when shooting interiors. Overall, the exterior shots in *Land of the Pharaohs* are truly 'breathtaking' in their scope and grandeur, but as Combs notes, *Land of the Pharaohs* is largely an interior film, and becomes more so as it marches on, retreating further and further within Pharaoh's cavernous tomb. Clearly, Hawks and Harlan were a bit reticent shooting in CinemaScope and *Land of the Pharaohs* is in many ways not a typical Hawksian outing. Perhaps the overwhelming construction of the project in a far-flung land using many unfamiliar cast and crew is the best metaphor: Hawks has his dangerous project, an all-male group with a conflicting female. However, CinemaScope dictates (as does Warner no doubt) that the film-maker must heel to spectacle and the novelty of the format rather than the comfort and familiarity of the 'Hawks method'. Thus, while we may see hints of the easy, striding Hawks/Harlan creative vision in *Land of the Pharaohs*, it lacks the narrative punch, generic familiarity and formal mastery on display in the Academy-ratio *Red River*. Perhaps the wide-open nature of the CinemaScope format to 'focus on one thing' is analogous to the Hawksian female: complicating, unruly and ultimately a threat to the entire endeavour. However, unlike Nellifer's (Joan Collins) cruel end in *Land of the Pharaohs*, it is Hawks and Harlan who find themselves unable to escape from CinemaScope's decrees.

Notes

1. Peter Bogdanovich, 'Howard Hawks: The Rules of the Game', in *Who the Devil Made It? Conversations with Legendary Film Directors* (New York: Ballantine, 1997), p. 365.
2. On the Academy-ratio 'standard' from 1889–1952, see Harper Cossar, *Letterboxed: The Evolution of Widescreen Cinema* (Lexington: University of Kentucky Press, 2010), pp. 27–30.
3. Hawks and Harlan also collaborated on *The Thing from Another World* (1951), *The Big Sky* (1952), *Rio Bravo* (1959), *Hatari!* (1962) and *Man's Favorite Sport?* (1964).
4. Generic definitions can be elusive when dealing with Hawks's films. Some scholars have suggested that Hawks often mixes multiple genres within one film, and several have suggested that *Red River* can also be categorised as an epic as well as a Western.

5. The first film Hawks worked on was probably the Douglas Fairbanks comedy, *In Again – Out Again* (1917). See Todd McCarthy, *Howard Hawks: The Grey Fox of Hollywood* (New York: Grove Press, 1997), p. 42.

6. For a survey of widescreen criticism by scholars and practitioners, see Cossar, *Letterboxed*, pp. 1–27.

7. McCarthy, *Grey Fox*, p. 532.

8. Widescreen experiments had been occurring sporadically since the beginning of cinema. On pre-1953 widescreen film-making, see Cossar, *Letterboxed*, pp. 27–94.

9. Twentieth Century-Fox's Darryl F. Zanuck famously noted after widescreen's introduction: 'Our actors now can move without fear of moving out of focus. Relatively they've been moving in handcuffs and leg irons and so has everything else on the screen, from jet planes to alley cats. CinemaScope is an Emancipation Proclamation on the sound stages. Like all freedoms it must be exercised soberly and intelligently.' Darryl F. Zanuck, 'CinemaScope in Production', in Martin Quigley Jr (ed.), *New Screen Techniques* (New York: Quigley, 1953), p. 157.

10. Eric Rohmer (as Maurice Schérer), 'The Cardinal Virtues of CinemaScope', trans. Liz Heron, *Cahiers du cinéma* (January 1954), repr. in Jim Hillier (ed.), *Cahiers du Cinéma: The 1950s: Neo-Realism, Hollywood, New Wave* (Cambridge, MA: Harvard University Press, 1985), p. 281.

11. Charles Barr, 'CinemaScope: Before and After', *Film Quarterly* vol. 16 no. 4 (Summer 1963), p. 11.

12. David Bordwell, 'Widescreen Aesthetics and *Mise en Scène* Criticism', *Velvet Light Trap* no. 21 (Summer 1985), pp. 118–25. Bordwell's frequent return to widescreen criticism (1985, 1997, 2008) is in itself evidence of widescreen's importance and indicative of its difficult-to-nail-down properties.

13. John Belton, *Widescreen Cinema* (Cambridge, MA: Harvard University Press, 1992).

14. James L. Limbacher, *Four Aspects of the Film* (New York: Arno Press, 1978); Barry Salt, *Film Style and Technology: History and Analysis,* 2nd edn (London: Starword Press, 1992); James Spellerberg, 'CinemaScope and Ideology', *Velvet Light Trap* no. 21 (Summer 1985), pp. 26–34; Richard Hincha, 'Selling CinemaScope: 1953–1956', *Velvet Light Trap* no. 21 (Summer 1985), pp. 44–53; Leo Enticknap, *Moving Image Technology: From Zoetrope to Digital* (London: Wallflower Press, 2005).

15. John Belton, Sheldon Hall and Steve Neale (eds), *Widescreen Worldwide* (Bloomington: Indiana University Press, 2010).

16. David Bordwell, Janet Staiger and Kristin Thompson, *The Classical Hollywood Cinema: Film Style and Mode of Production to 1960* (New York: Columbia University Press, 1985).

17. Janet Staiger, 'Authorship Approaches', in David A. Gerstner and Janet Staiger (eds), *Authorship and Film* (New York: Routledge, 2002), pp. 30, 33.

18. David Bordwell, *Poetics of Cinema* (New York: Routledge, 2008), p. 283.

19. Bordwell, Staiger and Thompson, *The Classical Hollywood Cinema*, p. 5.

20. Marshall Deutelbaum, 'Basic Principles of Anamorphic Composition', *Film History* vol. 15 no. 1 (2003), pp. 72–80.

21. For more on Ray's widescreen style, see Harper Cossar, 'Ray, Widescreen and Genre: The True Story of Jesse James', in Steve Rybin and Will Scheibel (eds), *Lonely Places, Dangerous Ground: Nicholas Ray in American Cinema* (Albany: State University of New York Press, 2014), pp. 189–209.

22. Bruce Block, *The Visual Story: Seeing the Structure of Film, TV and New Media* (Boston, MA: Focal Press, 2001), p. 63.

23. David Bordwell, *The Way Hollywood Tells It: Story and Style in Modern Movies* (Berkeley: University of California Press, 2006), p. 115.

24. Joseph McBride, *Hawks on Hawks* (Berkeley: University of California Press, 1982), p. 82.

25. Hawks's version of *The Big Sleep* (1946) is a notable exception here.

26. In *Letterboxed*, I try to avoid these issues by contrasting Academy-ratio and widescreen versions of the *same* film shot *simultaneously*. For more, see Cossar, *Letterboxed*, pp. 61–94.

27. Fox's 1930 70mm widescreen process was named 'Grandeur'.

28. Gerald Mast, *Howard Hawks, Storyteller* (New York: Oxford University Press, 1982), pp. 300–1.

29. Lang actually speaks these words in Jean-Luc Godard's *Le Mépris* [*Contempt*] (1963), but the quote is cited here from Charles Higham and Joel Greenberg, *The Celluloid Muse: Hollywood Directors Speak* (London: Angus and Robertson, 1969), p. 122.

30. Richard Combs, 'The Choirmaster and the Slavedriver: Howard Hawks and *Land of the Pharaohs*', *Film Comment* vol. 33 no. 4 (July/August 1997), p. 47.

31. Quoted in Mast, *Storyteller*, p. 298.

32. Ibid.

33. The shot technically also involves a screen direction continuity error, as we begin with Dunson facing screen left, and after the circular pan, he is facing screen right.

PART 2
HAWKS AND
THE POLITICS OF GENRE

3 Hawks's 'UnHawksian' Biopic

Sergeant York

Jesse Schlotterbeck

Howard Hawks's *Sergeant York* (1941) tells one of the most fabled stories of World War I. The film is an adaptation of the life story of Sergeant Alvin C. York, a religious rural Tennessean who, as a conscientious objector, initially resisted military service but went on to become one of the greatest American heroes of the war. York, so the story goes, almost singlehandedly defeated an entire German battalion on the strength of his sharpshooting abilities, first cultivated as a turkey hunter in his Tennessee homeland. Add to this both a devoted mother and sweetheart waiting at home for York to return and we have the makings of a story with multifarious appeal: romance, action, heroism and patriotism. *York* remains an interesting film for a number of reasons: Gary Cooper's performance as York is compelling; the black-and-white cinematography, by Sol Polito, is strikingly picturesque; and the story is told with satisfying efficiency. Moreover, the timing of *York*'s production turned a popular film into a politically important one, as a widely admired and inspiring affirmation of American patriotic ideals during the World War II era.

Sergeant York was released at a fortuitous moment, the summer of 1941, when the United States had yet to enter World War II, generating some controversy as isolationist senators were concerned with the potentially propagandistic function of the film. Following Pearl Harbor, this division in American politics was decisively resolved as the nation's politicians and citizens overwhelmingly supported American participation in the war. The film was released and re-released in the same markets numerous times from 1941 to 1942 and received almost unanimously positive reviews in the popular press. The *New York Journal American*, for instance, proclaimed it 'One of the best pictures of this or any other year!' Walter Winchell, in the *New York Daily Mirror*, called it 'One of the greatest entertainments of all time!' and the *New York Daily News*, 'One of the greatest pictures ever made!'.[1] In his authoritative biography of Hawks, Todd McCarthy also noted the laudatory response: 'The critical reaction to *Sergeant York* was so unanimous that it is difficult to find a single negative or even lukewarm review from the time of its release.'[2] *York* went on to earn eleven Academy Award nominations, including Best Picture and Best Director. Gary Cooper won the Award for Best Actor and William Holmes for Best Film Editing.[3]

With this reputation as a critical and commercial hit in its day, it is surprising on reviewing the studies of Hawks to find that *Sergeant York* is frequently considered a

minor work. Why is this so? There are many reasons why *York* remains understudied. First, the film is neither a screwball comedy nor a Western, the two genres Hawks is best known for.[4] Second, *York* has one main protagonist who is the primary focus of the entire film. By contrast, many of Hawks's most highly regarded films feature what critics have called the 'Hawksian group', a characteristic trope identifiable in such films as *Only Angels Have Wings* (1939), *Ball of Fire* (1942), *Air Force* (1943), *To Have and Have Not* (1944), *The Thing from Another World* (1951) and *Hatari!* (1962). Other Hawks films often feature a professional rivalry which develops into a more personal relationship between two co-leads, such as Tom Dunson (John Wayne) and Matthew Garth (Montgomery Clift) in *Red River* (1948), or Hildy Johnson (Rosalind Russell) and Walter Burns (Cary Grant) in *His Girl Friday* (1940). Third, its focus on a male lead diminishes an important aspect of Hawks's films that made them appeal to later critics – the presence of strong female lead characters, such as Mildred Plotka/Lily Garland (Carole Lombard) in *Twentieth Century* (1934) or Susan Vance (Katharine Hepburn) in *Bringing Up Baby* (1938). Fourth, it stands out as an unusually topical and historical film. Whereas most Hawks films are patently fictional and ahistorical, *York* is both biographical and topically relevant. Fifth, Hawks's films have attracted critical attention as popular entertainment with unexpected critical depth. Robin Wood, for example, focuses on Hawks's repeated exploration – whether consciously or not – of gender politics.[5] This is hardly the case with *Sergeant York*, which fulfils the lesson-teaching tendency of the biographical film. George Custen emphasises the instructional function of biopics as 'agents of socialization … [that] were assumed to be capable of actually teaching something'.[6] Whereas the 'lessons' or topical interests of Hawks's other films are more subtle, *York* lays it on thick. The dilemma of the pacifist deciding to serve his country is a deliberate, methodically considered subject. Its subject matter and seriousness, as opposed to playfulness, makes *York* a very different kind of Hawks film. Moreover, it is also worth pointing out that the biopic is a genre often held in low critical esteem.[7]

The primary aim of this chapter is to situate York in its original contexts: to try to see the film the way it was understood by its critics, by Warner Bros. and by Hawks himself. This focus on historical context is especially appropriate, not only because of what was often then described as the film's 'timeliness', but also because it is a biopic. George Custen reminds us that '[u]nlike the fictive discourse out of which the rest of Hollywood's canon is acknowledged to be fabricated, biopics' putative connection to accuracy and truth makes them unique'.[8] *York* was released at a crucial time when Americans were aware of a rumbling national dilemma between isolationism and interventionism. *York*, appropriately, does not just tell an entertaining story, but attempts to reconcile an ideology of pacifism with the imperative of military intervention in the context of American history and religious ideals. The success of the film means that it has accomplished what Dennis Bingham calls the biographical 'genre's charge', to 'enter the biographical subject into the pantheon of cultural mythology, one way or another, and to show why he or she belongs there'.[9] Through telling York's life story, the film eventually worked in the service of bolstering support for the US war effort and, at the same time, attracting large and enthusiastic audiences.

York was far and away Hawks's biggest hit – both critically and commercially. It was the highest-grossing film of 1941, eventually earning $16.3 million on a budget of $1.4 million.[10] *York* was then the third most profitable film of all-time, surpassed only by *Gone With the Wind* (1939) and *Snow White and the Seven Dwarfs* (1937). The film also earned Hawks his only Academy Award nomination for Best Director.[11]

But if *York*, in its own time, was Hawks's most successful film both economically and critically, later critical studies of Hawks have usually been dismissive of it, often treating it as only a minor work. Here, I want to review three key studies on Hawks which have helped to lay the foundation for that dismissive tendency: Gerald Mast's *Howard Hawks, Storyteller*, Robin Wood's *Howard Hawks* and Andrew Sarris's entry on Hawks in *The American Cinema: Directors and Directions, 1929–1968*. Each critic clarifies the qualities that denote a Hawks film as more or less 'Hawksian'. All three of them count *York* as less than Hawksian.

Mast lists *Ball of Fire* and *Sergeant York* as films which appear

> as if Hawks was working in a style, a deliberate fable or fairy-tale, that was a bit foreign to him … . The same kind of conversion, the same sweet actor, and the same fablelike artificiality of someone else's pious style seem to infect *Sergeant York*.[12]

Mast further speculates that *York* was Hawks's only feature nominated for an Academy Award due to its 'pious seriousness'.[13] Sarris also tacitly excludes *York* from what he sees as the characteristic tone of much of Hawks's work. He writes: 'Hawks has stamped his distinctively bitter view of life on adventure, gangster and private-eye melodramas, Westerns, musicals, and screwball comedies.'[14] Note also how many of the generic designations which might aptly apply to *York* – the biopic, war film or topical film – fail to appear on this list of Hawksian genres. Wood also categorises *York* as a less interesting, less Hawksian film: 'When his intuitive consciousness is fully alerted, we get a *Scarface* [1932], a *Rio Bravo* [1959]; when it is alerted only spasmodically, we get a *Gentlemen Prefer Blondes* [1953] or a *Sergeant York*.'[15] More specifically, Wood is particularly drawn to those of Hawks's films with relationships outside of a conventional, familial context:

> There are no families in his films … members are bound, not by blood or the legalities and responsibilities of marriage and parenthood, but by personal loyalty and mutual respect. If they constitute some kind of family, it's because that's what they have chosen, and they are free to opt out at any moment.[16]

Wood believes *York* is an exception to this rule: 'In the very atypical *Sergeant York* the male protagonist has a supportive mother...'.[17] Wood also objects to the militarism of the film.[18]

In each case, Wood, Sarris and Mast take an auteurist approach, highlighting what they take to be the common aspects of Hawks's films. This mode of criticism has significant limitations, however, not least in the tendency for the critic's own particular

interests to become projected onto the director's work and subsequently seen as an inherent property of it. This bias is notably present in all three of the studies under review here. For Sarris, Hawks's films are at their most interesting when they are 'distinctively bitter'; for Mast, the presence of a 'pious style' and a tone of 'seriousness' qualify *York* as a less Hawksian film; while for Wood, being rooted in social liberalism, films with what might appear to be more conservative values are less appealing. Critics' readings of Hawks's work will typically be based on their own proclivities towards certain tones, groups of characters or genres, leading to their own specific perspectives about what is most interesting or special about Hawks's films. Taking these critics' evaluations of *York* at face value, the implication is that Hawks made an uncharacteristically 'inauthentic' or 'impersonal' film. Mast says it's as if 'someone else's pious style seem[s] to infect' the film; Sarris not only finds Hawks's 'bitter' films are more effective, but also believes them to be closer to Hawks's own worldview. Wood wonders if the conditions of *York*'s production may have inhibited Hawks's 'courage' to explore the themes he imagines Hawks would have preferred.[19] Part of the attraction of auteur criticism is precisely that it is up to the critic's critical ingenuity to skilfully dissect each film to locate repeated themes, styles and character types which constitute – to that critic at least – the director's signature across his work. The critic's authority becomes the centre of auteurist analysis as much as, or more than, the masterful director's.

I approach *Sergeant York* differently, bringing historical context to the forefront of my analysis. In doing so, I follow Mike Chopra-Gant's call to redress a tendency in film scholarship to 'ignore those films that were seen, and presumably enjoyed, by the greatest number of people at the time in question'.[20] In his study of postwar Hollywood film-making, Chopra-Gant considers films that were at the top of the box-office charts to allow himself a sense of mainstream film-making in this era closer to that of the average filmgoer at that time.[21] Similarly, if we want to understand film culture during World War II and get an idea of how Hawks's audiences knew his work, we would do well to pay more attention to those of his films that were most popular at that time. By this criterion, then, *York* would effectively be his most significant film. Contextual attention to *York* is also not out of step with the way Hawks viewed himself as a director: as an entertainer and storyteller, rather than as an artist or an incipient auteur with an identifiable stylistic and thematic agenda.[22]

This study largely brackets out attention to the film itself, focusing instead on the extratextual materials which situate *Sergeant York* at the time of its release. The production and early reception of the film took place in 1940 and 1941, before the United States entered the war. Most of its audiences saw the film during the World War II era, from December 1941 to 1945. *York* was initially intended as a patriotic and dramatic film with enduring appeal. America's entry into the war rendered the movie much more topical, and it was then deliberately marketed by Warner Bros. in support of the war effort.

Todd McCarthy has summarised the long pre-production history of *York*: when independent producer, Jesse Lasky watched Alvin C. York's 1919 ticker-tape parade from his New York City office window and approached York about starring in a film of

his own life story. York refused him, saying, 'Me, I don't allow Uncle Sam's uniform for sale.'[23] Lasky repeated his request in 1929 and was again denied. A decade later he tried again. 'In the winter of 1939–40, with the outbreak of war in Europe, it occurred to Lasky that he might be able to prey upon York's patriotic sentiments as a way of finally bringing him around.'[24] In 1940, York finally agreed to an adaptation. Lasky then shopped the project around the major studios before approaching Warner Bros. where, at the urging of 'the ultrapatriotic Harry Warner', his brother Jack made a deal with Lasky. Though McCarthy emphasises Warner's patriotism as a key factor in green-lighting Lasky's project, Lasky announced that the picture would 'downplay the war theme'.[25]

From pre-production to release, *York* took less than sixteen months: York signed a contract for the adaptation on 21 March 1940 and the 'film's dignitary-studded premiere in the nation's capital' took place on 1 August 1941. Filming took place from 3 February to 1 May 1941.[26] Following America's entry into the war, Warner Bros. promoted *York* as a film that openly supported the war. But before this, Senate hearings had taken place in September 1941 about the alleged propagandistic function of *York* and seven other Hollywood films: *Dive Bomber* (1941), *Underground* (1941) *Confessions of a Nazi Spy* (1939), *Flight Command* (1940), *The Great Dictator* (1941), *That Hamilton Woman* (1941) and *Escape* (1940).[27] Gerald Nye, Republican Senator from North Dakota, alleged that these popular films violated their charge as 'entertainment' and were in fact 'operating as war propaganda machines almost as if they were directed from a single central bureau'.[28] In addition, Democratic Senator D. Worth Clark argued that these films aimed to

> arouse [the audience's] emotions, and make them clamor for war. And not one word on the side of the argument against war is heard Unless [the movies] are restrained, unless the people of this country are warned about them, [the movies] will plunge the country into war.[29]

At these hearings, Jack Warner defended *York* as 'an actual portrait of the life of one of the great heroes of the last war. If that is propaganda, we plead guilty.' Warner contended that films like *York* and *Confessions of a Nazi Spy* 'are prepared on the basis of factual happenings and they were [sic] not twisted to serve any ulterior purpose'.[30] Pearl Harbor effectively rendered politicians and the public firmly behind the war effort and the Senate hearings were soon abandoned.

York went on to become a topical, propagandistic film *and* a major box-office success. However, production materials from the Warner Bros. archive reveal how careful the film's creative staff were to avoid any perception of a pro-war stance. The first scriptwriters, Julian Josephson and Harry Chandlee, wrote a twenty-eight-page letter to Lasky dated 8 May 1940 to affirm that *York* was planned as a biographical character drama rather than a film with overt political intention. Following 'a thorough consider-ation of the research to date on the York story', Josephson and Chandlee list '[t]he problems which the story presents'.[31] They write:

1. We all realize that this should not be a war picture in the usual sense of the sort, and should not be definitely interpretable as either propaganda for or against war. Therefore, according to the plan discussed, the story will be primarily the story of York, himself, and though every possible value will be given to his heroic exploit and, from the standpoint of production values this will be an outstandingly spectacular sequence, its purpose in the story will be to solve York's personal problems and the problems of his fellow mountaineers rather than to aggrandize war or even heroism.[32]

At this point in pre-production, the scriptwriters were anxious to avoid any imputation that *York* could be seen as propagandist and they stressed how much it would be drawn as a personal story rather than a political one. They also noted that for decades York had rejected requests to authorise any adaptation of his life story. Moreover, they also pointed out that portraying York's initial resistance to reward and recognition in the film could be off-putting to viewers who would have a hard time understanding his reluctance to accept fame and fortune:

7. A minor problem is represented by York's refusal to accept the many offers of money made to him after his return. Actually he said, 'Uncle Sam's uniform wasn't for sale,' but this may have the color of flag waving, which we want to avoid; and it may give the appearance that he is being influenced by a bigoted and narrow-minded religious attitude.[33]

This is one of two instances where Josephson and Chandlee note that the depiction of York's religiosity is itself one of the problems that the story has to contend with:

3. It is recognized that if York's real religious attitude is included in the picture, there is a great danger of his appearing to be merely a religious fanatic and thus lose heavily in audience understanding and sympathy. . . [they hope to emphasize] that his conversion is the result of Pastor Pile's appeal to his reason, rather than to his emotions. Care will be taken, however, not to lose the spiritual side of York's character, but on the contrary to make it far more appealing and convincing.[34]

There is a fine line, Josephson and Chandlee are saying, between the characterisation of a deeply spiritual and morally purposeful man on the one hand, and a fanatical, narrow-minded bigot on the other.

Such careful efforts by *York*'s writers to temper the film's religious, heroic and militaristic aspects may seem surprising today. Robin Wood speculates that Hawks was 'handicapped' by the biographical 'facts' of *Sergeant York* – and with York himself still alive – which likely contributed to Hawks lacking 'the courage' to produce a film that was more critical of the protagonist's Christian conversion. He suggests that the film is unable to effectively reconcile combat with pacifism, or treat their opposition as sufficiently tragic: 'Some critics see it as the tragedy of a man decorated for going against his beliefs: the idea is implicit in the material, but it never reaches adequate realis-

ation.'[35] Wood also objected to portrayals of American and German deaths on the battle-field: 'it is exclusively the *Americans* who die messily and horribly – the German deaths are clean and painless'.[36] Wood's viewpoint, informed by the progressive social ideals of the late 1960s, tended to elide the historical context of the film. We should bear in mind that he was writing criticism for a predominantly liberal/leftist academic reader-ship, whereas Josephson and Chandlee were trying to craft a popular film for a main-stream American audience at a time when it was uncertain whether the United States would enter the war. Wood is effectively asking *York* to do something that its makers would *not* have actually wanted: to refuse to acknowledge religious beliefs as a reason to join the combat; to portray German and American wartime deaths as equally unfor-tunate; and to portray York as more of a tragic figure than a hero. These archival doc-uments demonstrate the extent to which creative staff at Warner Bros. actively weighed the difficulties of representing a self-consciously religious war hero on screen. What might appear as simplistic and conservative hokum to a film critic in the late 1960s was originally conceived in its own time as a moderate, balanced, fact-based biopic, rather than as a pro-war, or anti-war, propaganda film.[37]

Questions of the story's conception were also taken up by Lasky himself. Major J. M. Tillman had written to Warner Bros. to complain that some of the military details – such as military rank, procedure and battle strategy – were not being represented with com-plete accuracy. In his reply, Lasky laid out an overview of the film and appealed to Tillman to consider the factual characteristics of *York* in more general terms. This corres-pondence effectively details Lasky's view of *York*:

> So that you will have a clearer idea of the nature and general purpose of the picture, I want to explain that it tells the life story of York, presenting him as an outstanding American rather than as an outstanding hero alone. The circumstances by which he became a hero are shown as the most important incident in his life but they are presented as a part of his development as a man rather than for their inherent value only.[38]

Lasky also discusses York's acceptance of military service: 'when he is drafted we show that he has every reason for clinging to his conscientious objection but that, when he fails to obtain exemption, he accepts the inevitable without animosity'.[39] As in Josephson and Chandlee's correspondence, Lasky is concerned about York's paci-fist convictions, which he hopes to portray as emerging from 'a spiritual standpoint rather than a dogmatically religious one'.[40] What Wood saw from his 1960s viewpoint as a decidedly conservative position, Lasky understood as an attempt to achieve an evenhanded representation with broad appeal. Interestingly, Lasky discusses the time-liness of the film as well:

> Up to this point we believe we have succeeded in telling the story of a man who had every reason for not going to war, but who did go to war in defense of his country, and we believe that we are presenting a very strong and vital lesson at this time.[41]

The Pictorial Events Films package pairs seventy film stills with a lecture script (courtesy of Warner Bros. Entertainment Inc.)

This is a telling sentiment, being somewhat at odds with the officially countenanced position of the film's supposed neutrality. Whereas most of the correspondence about *York* – by its writers, producer and studio boss – downplays any implication that the film might be seen to advocate American involvement in the war, this private correspondence between Lasky and Major Tillman draws a distinct parallel between York's reluctant World War I service and America's potential entry into World War II.

Of course, the discourse surrounding the film changed radically following Pearl Harbor. With America suddenly at war, Warner Brothers actively sought to connect the film to the Allied Forces campaign, with publicity materials that effectively cross-promoted both *Sergeant York* and the US war effort, involving an array of strategies, ranging from educational presentations with stills of the film, posters for war bonds, radio spots and local advertising opportunities that would be arranged in collaboration with nearby military offices. Such paratextual content demonstrates how, after Pearl Harbor, *Sergeant York* was reconfigured with a didactic role and realigned with the ideological agenda of America at war.

We can see an example of such material in an advertisement from Pictorial Events Films, a company formed in cooperation with Warner Bros. to promote the educational value of certain releases. The *York* educational programme is designed not only for schools but also for other public venues and community organisations. The blurb reads: 'Here's a concrete plan to exploit your showing in classrooms,

school assemblies, Parent-Teacher meetings, women's club film discussions, social gatherings, Boy Scout meetings and employees' get-togethers.'[42] Crucially, this programme includes discussion guides and illustrative stills, but not a screening of the film itself, motivating educational-programme attendees to pay to see *York* at a local theatre. The advertisement notes that this is 'Not a motion picture' and has 'NO SOUND'.[43] Instead, it is composed of '70 selected scenes from the actual picture', designed to be 'projected on screen at intervals to illustrate [an] accompanying lecture'. The 'Teacher's Guide' accompanying the Pictorial Events film includes a 'Test' that covers, with the example of *York*, 'American History, Government, Citizenship, [and] World History'. The message at the bottom of the Teacher's Guide draws on a rhetoric of grandstanding nationalism: 'Such Loyalties As These Have Made America Great'.[44] The advertisement provides an illuminating example of paratextual ballyhoo, demonstrating how *York* could be quickly and efficiently repackaged by Warner Bros. as a 'public information' text, one effectively linked to wartime national values.

Also illustrative of *York*'s adaptability to America's entry into the war were ads making a case for the film's enduring popularity as a box-office attraction and the tie-in posters that promoted not only the film itself but war bonds as well. For example, one war bond/*York* lobby display with cartoon-style propaganda includes a cartoon depicting Hitler, Mussolini and Hirohito, being chased away by Cooper's York. The caption in the

This poster cross-promotes *Sergeant York* and war bonds (courtesy of Warner Bros. Entertainment Inc.)

middle of the poster reads, 'KEEP 'EM FLEEING', and '*As Long as there are Men Like Him there Will Always be a Free America!*' Above this, the film is advertised, and below, the purchase of war bonds.[45] Here, the World War I hero is anachronistically 'updated' to take on America's World War II enemies on the strength of enduring American values. Even paying to see the film – at 'POPULAR PRICES' – becomes in itself a patriotic act.

The text proposes various means to enhance its potential: 'Set up display in lobby as shown as part of your war bond and stamp selling campaign', and 'If obtainable, place a real bayonet in the life-size blow-up of Gary Cooper.'[46] The text conveys that the film's patriotism could be emphasised in support of the war effort, with suggestions to 'Rig up a large Honor Scroll in lobby or in frame outside with blow-up of Cooper as Sergeant York at top and clippings from local newspapers detailing the heroic experiences of today's war heroes listed below' came with the advice to enlist other neighbourhood services: 'Your sign shop can prepare a number of red, white and blue plaques for spotting around house and inside lobby.' Theatre owners were also instructed to 'Use review quotes and catchlines from the ads (see inserted section) as copy for the inside of plaques.'[47]

Other suggested advertising techniques were even more ambitious, following up on a header promising that, 'ARMY WILL WORK WITH YOU! – *and so will WARNERS!*'[48] This section promises exhibitors that

YOUR LOCAL ARMY RECRUITING OFFICER will eagerly cooperate with you in the suggested promotions . . . as well as in providing ballyhoo for your showing in all other Army publicity media, including radio, recruiting offices, printed material and 'A' boards around city. See him early![49]

Theatre managers were also encouraged to 'CONTACT LOCAL PATRIOTIC GROUPS ... such as the Veterans of Foreign Wars, American Legion, Gold Star Mothers, Daughters of the American Revolution, etc., for their cooperation', and to contact 'your local Army Recruiting Officer' to obtain copies of 'A special 8-page illustrated folder' which 'sells the action and romance of Sergeant York's amazing life story . . . and was designed to be used as a giveaway by the U.S. Army as a recruiting drive accessory.'[50] We can see here a strategy by Warner Bros. to exploit local interest and support in a national promotional/propaganda campaign.

Local campaigns that went to even greater lengths to actively involve current or former military personnel were also promoted. Moreover, for anyone who might think that the 'flash mob' is a recent phenomenon, the '"YORK" HONORS CUE THESE STUNTS!' section proposed staging the following bally event:

Sergeant York captured 132 German prisoners single-handed. Most people can hardly visualize how many 132 persons really are. For a flash street bally dress a tall Cooperish man in 1917 khaki with rifle escorting 132 men to theatre. Signs at front and rear state the fact that each of these men represents one of the prisoners captured by York in

★ ★ ★

YORK'S MEDALS DISPLAY...

— drew widespread attention from passersby when used at the New York Astor Theatre. Make your own display by blowing up still SY X47 (shown below). Color the medals and you'll have the nearest thing to the actual medals. Better still, possibly you can borrow these medals from local Army offices or other service headquarters.

MEDALS AWARDED TO SERGEANT YORK

War Medal Montenegro | U S Congressional Medal of Honor | Medal of Valor State of Tennessee | Croix de Guerre France

Medaille Militaire France | Croce de Guerra Italy | Allies War Medal | United States Liberty Medal | Special Medal State of Rhode Island

Order still SY X47 — 10c — from Campaign Plan Editor, 321 W. 44 St., N.Y.C.

Theatre owners are encouraged to 'borrow' medals 'from local Army offices' to enhance this display (courtesy of Warner Bros. Entertainment Inc.)

the Argonne, alone and at one time. The matter of getting 132 men together for such a bally is not one for the theatre to work out on its own, but should be left to an organization such as the American Legion, or perhaps the local Air Warden Service, which may provide these men as part of a street bond-selling drive.[51]

With continuing emphasis on persuading the local community to become involved, the same section exhorted promoters to 'HONOR [THE] MOST FAMOUS VETERAN' in their own town. The accompanying text advised on promotional strategy: 'Each town has its own local World War hero. With the co-operation of the town's American Legion Posts, or via a newspaper search, find and fete this man.' The term 'hero' here is broadly defined: 'The man you select should have a son in the armed forces, or should now be working in some vital war job.'[52] Ten ideas follow: 'Invite him to make personal appearances at your theatre during the run of the picture. During picture breaks, he can deliver short talks' and 'Local organizations — Rotary Club, Elks, women's welfare league, etc. –

[can] sponsor luncheons at which he is guest of honor.'[53] Frequently cited is a display of 'Medals Awarded to Sergeant York'. Theatre owners are given two suggestions to make this display more attractive. 'Color the medals and you'll have the nearest thing to the actual medals,' it says. 'Better still, possibly you can borrow these medals from the local

6-DAY CONTEST

These pictures of Great American Heroes
run in your newspaper for six consecutive
days. Readers who correctly identify these
heroes get free tickets for "Sergeant York."
Correct answers shown in parentheses un-
der each mat. Order Mat SY 402B-60c--
from Campaign Plan Editor, 321 W. 44th
St., New York City.

[FIRST DAY]

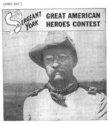

HERO OF SAN JUAN HILL:
His name is (Theodore Roosevelt.)

[SECOND DAY]

NAVAL HERO:
His name is (John Paul Jones.)

[THIRD DAY]

INDIAN FIGHTER:
His name is (Gen. George Custer.)

[FOURTH DAY]

"MESSAGE TO GARCIA":
His name is (Lieut. Andrew Rowan.)

[FIFTH DAY]

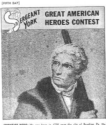

FRONTIER HERO:
His name is (Daniel Boone.)

[SIXTH DAY]

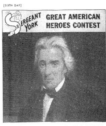

HERO OF NEW ORLEANS:
His name is (Andrew Jackson.)

★

Win 'Sergeant York' Movie Tickets!

This contest connects York with other 'Great American
Heroes' like Teddy Roosevelt and Daniel Boone (courtesy
of Warner Bros. Entertainment Inc.)

Army offices or other service headquarters.'[54]

Additionally, local newspapers were advised to run a '6-Day Contest' of 'Great American Heroes', each identified with a photograph or portrait together with a potted biography. Anyone who writes in and correctly identifies all six heroes wins a free ticket to *Sergeant York*. This pantheon of heroes, all framed under the rubric of 'SERGEANT YORK', featured Teddy Roosevelt, Daniel Boone, Andrew Jackson, George Custer, John Paul Jones and Andrew Rowan, each speaking to a different aspect of America's historical 'heroism' and all tied here explicitly with York's.

Finally, theatre owners were encouraged to use short scripted spiels to sell the film via local radio. These came close to openly connecting the film with the current war effort. One text begins, 'It's dramatic … . It's timely … . It's thrilling – Gary Cooper in SERGEANT YORK, returning for a new engagement.' Another text, echoing Warner Bros.' reputation for topical subjects, declares that 'It's as timely as the latest news flash.' That most of this copy also mentions the film 'returning for a new engagement' at 'Popular Prices' also underscores America's entry into the war as having boosted the film's popularity so much that it played in the same markets on multiple occasions.[55]

Sergeant York, then, as a biographical film, occupies an anomalous place in Hawks's oeuvre: hugely popular on its release, yet dismissed and understudied ever since. Critics like Mast, Sarris and Wood dismissed *York* as being less authentically

'Hawksian' than his other more critically validated films. And though the biopic has not been widely studied or much admired by academic critics, it remains an enduringly popular genre. If Hawks's biopic *York* came to seem 'unHawksian' to its auteurist critics, it nevertheless remains Hawks's most profitable and successful film. By contextualising *Sergeant York* as both a prewar and war-era biopic, we can come to see Hawks in a new light: as a director working within the industrial, social and political contexts of his time, a time before the advent of auteur theory and criticism and the influence of a critical agenda, which would find the film 'unHawksian'.

Notes

1. These quotes appear in the film's trailer.
2. Todd McCarthy, *Howard Hawks: The Grey Fox of Hollywood* (New York: Grove Press, 1997), p. 315.
3. See, for example, the American Film Institute catalogue entry on the film: http://www.afi.com/members/catalog/DetailView.aspx?s=&Movie=27041.
4. For example, *Rio Bravo* (1959) is Hawks's highest-ranked film in the latest edition of *Sight and Sound*'s Critics Poll (2012), with *Bringing Up Baby* (1938) the next highest.
5. See, for example, the chapter 'The Lure of Irresponsibility', in Robin Wood, *Howard Hawks* (1968, rev. edn, Detroit, MI: Wayne State University Press, 2006), pp. 52–82.
6. George Custen, *Bio/Pics: How Hollywood Constructed Public History* (New Brunswick, NJ: Rutgers University Press, 1992), p. 33.
7. Steve Neale, *Genre and Hollywood* (London: Routledge, 2000), p. 60.
8. George Custen, 'The Mechanical Life in the Age of Human Reproduction: American Biopics, 1961–1980', *Biography* vol. 23 no. 1 (Winter 2000), p. 139.
9. Dennis Bingham, *Whose Lives Are They Anyway? The Biopic as Contemporary Film Genre* (New Brunswick, NJ: Rutgers University Press, 2010), p. 10.
10. 'Sergeant York (1941) – Box Office Mojo': http://boxofficemojo.com/movies/?id=sergeant york.htm.
11. Hawks lost out to John Ford who won both Best Picture and Best Director Awards for *How Green Was My Valley* (1941). See McCarthy, *Grey Fox*, p. 316.
12. Gerald Mast, *Howard Hawks, Storyteller* (New York: Oxford University Press, 1982), p. 357.
13. Ibid., p. 16.
14. Andrew Sarris, *The American Cinema: Directors and Directions, 1929–1968* (New York: Dutton, 1968), p. 56.
15. Wood, *Howard Hawks*, p. 10.
16. Ibid., p. xxii.
17. Ibid., p. xxi.
18. Ibid., pp. 160–1.
19. Ibid., p. 162.
20. Mike Chopra-Gant, *Hollywood Genres and Postwar America: Masculinity, Family and Nation in Popular Movies and Film Noir* (New York: I. B. Tauris, 2006), p. 10.

21. Chopra-Gant notes the 'almost total absence of attention to the contemporary films that were among the most popular at the time and which have subsequently all but disappeared from our historical consciousness of the period'. Ibid., p. 175.

22. Hawks repeatedly described himself as a storyteller and entertainer. He also liked to repudiate attempts by critics to attribute auteur status to him. See, for example, Joseph McBride, *Hawks on Hawks* (Berkeley: University of California Press, 1982), p. 8.

23. Quoted in McCarthy, *Grey Fox*, p. 300.

24. Ibid., p. 301.

25. Ibid.

26. Internet Movie Database, 'Sergeant York – Box Office and Business': http://www.imdb. com/title/tt0034167/business?ref_=tt_dt_bus.

27. Michael E. Birdwell, *Celluloid Soldiers: The Warner Brothers' Campaign against Nazism* (New York: New York University Press, 1999), pp. 154–5.

28. David D. Lee, *Sergeant York: An American Hero* (Lexington: University of Kentucky Press, 1985), p. 111.

29. 'US Senate Subcommittee Hearings on Motion Picture and Radio Propaganda, 1941', in Steven Mintz and Randy W. Roberts (eds), *Hollywood's America: Twentieth-century America through Film*, 4th edn (Oxford: Blackwell, 2010), p. 172.

30. Ibid., p. 173.

31. Julian Josephson and Harry Chandlee, Letter to Jesse Lasky, 8 May 1940, p. 24. Warner Brothers Archive, USC. Box: 'Sergeant York' – Research [3 of 3].

32. Ibid.

33. Ibid., p. 28.

34. Ibid., p. 25.

35. Wood, *Howard Hawks*, p. 162.

36. Ibid., p. 160.

37. The eventual screenplay is credited to Chandlee, Abem Finkel, John Huston and Howard Koch (Hawks's own contribution went uncredited). Though Warner Brothers did not use Chandlee and Josephson's script as the final version, their notes on 'the problems which the story presents' must have figured in the ongoing consideration of the story outline and script. For more on the scriptwriting process (including Hawks's contribution), see McCarthy, *Grey Fox*, pp. 302–5.

38. Jesse Lasky, 'Sergeant York' Letter to Major J. M. Tillman (24 October 1940). Warner Brothers Archive, USC. [Box: 'Sergeant York' Picture File [1 OF 5]. It remains unclear how Tillman obtained such information when the film was still in pre-production.

39. Ibid.

40. Ibid.

41. Ibid.

42. Pictorial Events Films advertisement for *Sergeant York*, Warner Brothers Archive, USC. *Sergeant York* (Box 2/2, Promotional Materials), p. 15.

43. Ibid.

44. Ibid.

45. *Sergeant York* War Bonds Lobby Display, Warner Brothers Archive, USC. *Sergeant York* (Box 2/2, Promotional Materials), p. 9.

46. Ibid.

47. Ibid.

48. *Sergeant York* Promotional Materials, Warner Brothers Archive, USC. *Sergeant York* (Box 2/2, Promotional Materials), p. 21.

49. Ibid.

50. Ibid.

51. Ibid., p. 14.

52. Ibid., p. 13.

53. Ibid., p. 13.

54. Ibid., pp. 13, 20.

55. Ibid., p. 16.

4 'A Poisonous Picture'

The Big Sleep, the Hollywood Left and the Postwar Thriller

Mark Jancovich and Robert Manning

The Big Sleep (1946), one of Howard Hawks's most fondly remembered films, has acquired the status of a cinematic classic. Not only is it seen as a 'quintessential' film noir,[1] and 'a certifiable hard-boiled classic',[2] but it has also achieved canonical status beyond generic categories, appearing in both the Sight and Sound poll of the 'Greatest Films of All Time' and as a subject in the BFI's Film Classics series.[3]

However, this reputation wasn't inevitable. On its release – and despite Hawks's claim that 'I never got such good reviews of a picture in my life'[4] – the critical reception was far from positive. Bosley Crowther attacked the film in the New York Times as 'a poisonous picture'.[5] Also, figures on the Hollywood left such as producer John Houseman saw it as symptomatic of all that was wrong with postwar film.[6] In his account of Houseman's critique of The Big Sleep, Richard Maltby argues that Houseman and others condemned the film as part of a more general opposition to the period's 'tough' movies – those that would later become known as film noir – an opposition based on the presumption that such films 'embodied a particularly virulent form of postwar malaise, establishing a tradition within which film noir has continued to be interpreted'.[7]

Houseman saw The Big Sleep as representative of 'the "tough" movie' more generally, a film type in which 'Today's Hero' had 'no discernable [sic] ideal to sustain him' and for whom '[t]he sum of his desires appears to be a skinful of whiskey and a good sleep'.[8] Houseman accuses 'tough' films like The Big Sleep of an 'absolute lack of moral energy' and 'listless, fatalistic despair'.[9] If, as we will see, there was a common complaint about the violence of these films, Houseman was careful to stress that 'it is not violence and spasmodic savagery that are the outstanding features of the "tough" movie', but rather its suggestion that 'life in the United States of America in the year 1947 is hardly worth living at all', with a 'hero' who 'holds human life cheap, including his own'.[10] Violence itself is not the problem, Houseman is saying, but rather the view of life that defines it.

For Maltby, Houseman's attack on The Big Sleep was related to a more general antipathy to film noir by 'disillusioned liberals' and to their wider concerns with 'the broken wartime dream of liberal rationalism'. This was a central anxiety for the postwar left, many of whom worried that reason was no longer seen as a solution to social problems and that violence and repression were filling the vacuum.[11] In his account of

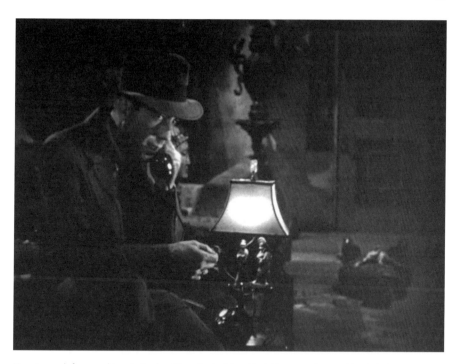

'A not very lofty moral tone': Bosley Crowther's *New York Times* verdict on Hawks's 'poisonous picture' *The Big Sleep* (1946)

Houseman's attack on the 'tough' movie, Maltby is careful not to claim that the 'postwar malaise' that so worried Houseman and others on the postwar left actually existed, or that 'these films did by some unexplained osmosis embody a Zeitgeist'. Instead, he shifts his concern to the 'more answerable question' of 'why they were taken to do so by liberal critics of the period'.[12]

Maltby also draws attention to 'a climate of concern about the effects of movies on their audiences, and about the social responsibility of the industry in representing America to itself and to the rest of the world'.[13] Here, then, was a shift in some sections of Hollywood from a view of cinema as no more than 'pure entertainment' to one stressing its capability to contribute to society along the lines established during World War II when Hollywood had been recruited for the war effort. Rather than avoiding contentious issues by claiming that film should be innocuous and unthreatening, many in Hollywood were beginning to stress cinema's ability to educate and inform, along similar lines to those defending journalistic 'freedom' or artistic 'seriousness'.

Furthermore, as Maltby details, the break-up of the wartime consensus created a debate over the uses of cinema that inevitably led to a variety of condemnations:

> Conservatives were concerned with the question of 'Communist infiltration of the motion picture industry'; disillusioned liberals like Houseman were directing their

concern elsewhere, at the 'tough' movie and the horror film. What they seemed to see in *film noir* in particular was their own worst nightmare enacted on the screen for the casual titillation of the urban transient audience: the maladjusted veteran in full, paranoid flight from the broken wartime dream of liberal rationalism.[14]

However, despite the force of Maltby's account, there is a real problem with the ways in which he associates the object of Houseman's attack with another object, an object called film noir.

Of course, Maltby acknowledges that Houseman's attack is not '*exclusively*' [our emphasis] on 'those movies now commonly identified as *films noirs*'.[15] He acknowledges an association with horror, although not much is made of this point. He even criticises Houseman and later noir commentators for the ways in which their responses to these films involved 'a process of historical distortion which comes about from the practice of generic identification, and has the effect of imposing an artificial ideological homogeneity on Hollywood production'.[16]

However, there is a sense in which Maltby too falls into the same trap and he seems to conflate the object of Houseman's attack with film noir. As Maltby notes, film noir didn't exist as a generic category in 1946 and would not be invented (and retroactively applied to the period) until several years later. Nor is this simply an issue of naming: it isn't just that film noir didn't exist as a term, but that the films that have since come to be known as films noir weren't seen as a unified or distinct group of films in 1940s' America. To the extent that many of these films were associated with one another at all, they were usually seen as part of a larger category of 'horror'. This category, as Siegfried Kracauer suggests in an article in *Commentary* on 'Hollywood's Terror Films', brought together films that would now be separately classified by the terms horror, film noir and the Gothic (or paranoid) woman's film.[17]

Maltby also overestimates the significance of the objections of Houseman and Kracauer who he sees as 'representative of a critical movement which sought to employ psychoanalytic and anthropological insights into the study of culture', a movement for which these 'tough' movies 'provided ideal material for those students of mass communication who wished to use the metaphor of movie as dream as the basis for a psychoanalytic interpretation of American culture through its shared day dreams'.[18] For Maltby, Houseman's attack on *The Big Sleep* was linked to that critical perspective.[19] However, while these elements may have laid one foundation for later studies of film noir, as Maltby argues, figures such as James Agee and Manny Farber challenged other aspects of Houseman's approach to these films.

Agee and Farber not only represent a different type of critical response to Hawks's film, but also one that was at least as influential on later studies of film noir. It is in their writings that one finds a positive evaluation of the 'darkness' of these films, an evaluation that presents their 'darkness' and 'cynicism' *as* social criticism rather than as a failure of social criticism in the ways that Houseman and others claimed. Furthermore, this position developed as a challenge to the types of criticism that Houseman and others represented. If Houseman's writing bemoaned 'the broken wartime dream of lib-

eral rationalism', both Agee and Farber were critics of that 'dream' and had long complained about the 'affirmative culture' of the wartime liberal alliance. For them, this affirmative culture was a form of propaganda that not only promoted a particular vision of America, but also necessarily involved a form of censorship that forbade an investigation of the dark and troubling aspects of life in America. Consequently, Agee and Farber tended to celebrate those films that could be seen as an antidote to this affirmative culture, films that depicted the sordid, squalid underbelly of America. Furthermore, their celebratory response was also in accord with a surrealist challenge to social verisimilitude, a challenge that sought to define realism in ways that weren't associated with a faithful transcription of the surface appearance of everyday life but rather with an analysis of the processes that were often hidden and repressed by these appearances. Moreover, this was a position that differed from the now commonly accepted opposition between realism and the fantastic.

Consequently, while Maltby claims that the writings of Houseman and others laid the foundation for contemporary discourses on film noir, Agee and Farber were at least as influential: they formulated the key terms within which *The Big Sleep* would come to be understood and celebrated, thereby laying the foundations on which the canonical status of Hawk's film would be established.

In this chapter we will try to locate the precise focus of Houseman's attack on *The Big Sleep* by identifying the similarities between the reception of the film and Houseman's own contribution to another 'tough' movie, *The Blue Dahlia* (1946), while also teasing out the subtle distinctions that critics made between them. We will examine the association between the two films through the figure of Raymond Chandler, who wrote both of them, and the contemporary perception of them as 'tough' or violent films. We will also explore how discourses of realism were related to these films, particularly to Houseman's own distinction between the documentary realism of many 'horror-thrillers' and the absence of this stylistic technique in *The Big Sleep*, an absence which, Houseman claims, 'marks a violent and deplorable retrogression'.[20] Finally, we will account for the critical reception of *The Big Sleep*, particularly on how for figures such as Agee and Farber the very lack of documentary realism was seen as a positive feature, allowing them to associate the film with a 'surrealistic' quality that challenged the documentary realism championed by Houseman.

John Houseman, *The Big Sleep* and *The Blue Dahlia*

Houseman was himself the producer of several key films noir – *The Blue Dahlia*, *They Live by Night* (1949) and *On Dangerous Ground* (1952) – so it should hardly be surprising that he didn't direct his attack on *The Big Sleep* at 'film noir' in general but rather at a more specific category of films. At the same time, *The Blue Dahlia* shared much in common with *The Big Sleep*, even those qualities Houseman specified as belonging to the 'tough' movie. It is therefore important to unpick precisely what Houseman saw as the point of distinction between his own film on the one hand and some other examples of the 'tough' movie on the other.

Both films were associated with Raymond Chandler who wrote the script for *The Blue Dahlia* and the novel on which *The Big Sleep* was based. Houseman makes a distinction between Hawks's film and Chandler's novel, finding Chandler to have 'a fine contempt for his characters and the sordid world they inhabit'.[21] In other words, Chandler's novel has a moral attitude to the world that it depicts, an attitude that he saw as absent in Hawks's film. Nor was the association with Chandler lost on other critics, many of whom made much of his contribution as scriptwriter on *The Blue Dahlia*. Crowther even described it as a 'Raymond Chandler tale', a recognition of authorship that was rare in his film reviews.[22] Manny Farber in the *New Republic* didn't go quite as far but he still saw the film as not simply a Chandler script but an 'adaptation' that comes nearest to capturing the qualities of Chandler's fiction: 'the neatest treatment that has been done on a Raymond Chandler novel'.[23] If Farber's review mistakenly sees the film as an adaptation of a Chandler novel (rather than as his original screenplay), William R. Weaver in the *Motion Picture Herald* mistakenly told his readers to 'make special note of the picture as the first screenwriting done by Raymond Chandler'.[24]

However, the associations between the two films don't stop there: *The Blue Dahlia* was also seen as an excessively violent film. *Variety*, for example, noted that its 'stark and brutal' fight scenes were 'tremendously effective' and that Alan Ladd 'has a cold, steel-like quality that is potent'.[25] Similarly, the *Hollywood Reporter* saw it as 'the latest contribution to the hard-boiled, kick-'em-in-the-teeth murder cycle'.[26] For such critics – especially those with an eye on box-office revenues – this violence was an asset rather than a fault so that, while its 'indestructible hero … survives beatings and bruisings enough to lay low a corporal's guard', it was noted that 'customers love this'.[27]

Other critics, however, were less positive. Crowther, for example, described the film as 'a honey of a rough-'em-up romance', but criticised the violence, claiming that, 'bones are being crushed with cold abandon, teeth are being callously kicked in and shocks are being detonated at close and regular intervals'. If this makes for 'a brisk, exciting show', says Crowther, the film had to be 'severely questioned' about '[t]he tact of all this'.[28]

Even Farber, who usually appreciated tales of violent low-life, claimed that the film's characters 'do violence to each other with the dispatch and unconcern of a person stamping an envelope'. He also objected to the trend in movie violence becoming 'run-of-the-mill and all but boring'. But he also praised the film as 'beautifully accurate in showing [its characters] tensions, controlled behavior, suspiciousness and the personalities of people who don't expect to live long'.[29]

Here, we return to one of the central points of Houseman's critique of *The Big Sleep*: the sense that the film presents life in 1940s America as being cheap and ugly, with characters who don't expect to live long or have much to live for. This position also raises another central issue of this debate: while Farber didn't see this bleak picture as purposeless but as a dark indictment of the postwar world, others accused it of amorality. Crowther, for example, saw *The Blue Dahlia* as an example of 'the present expanding cycle of hard-boiled and cynical films'. Here, the word 'cynical' gives some sense

of his belief that the film had no moral allegiances and that it was ultimately amoral.[30] But these issues became most pointed in James Agee's criticism of John McManus's review of the film in the leftwing newspaper, *PM*. As Agee saw it, John McManus, *PM*'s main film reviewer, 'objected to [*The Blue Dahlia*] and similar seamy melodramas, accusing Hollywood of neglecting to make films which can possibly interest, open, or influence honest minds on any social or political issue'.[31] But Agee challenges McManus's criticisms by claiming that good values don't necessarily make good pictures and that 'there is at least as much to be dreaded as desired in American films taking up such editorial "responsibilities" instead of just leaving it to Harry Warner and Eric Johnston to sound off about them'.[32] The reference to Warner and Johnston here makes a clear connection between the leftist call for socially responsible cinema and censorship imposed by the Production Code Administration (PCA).[33] For Agee, censorship was a threat to good film-making. Rather than censoring 'seamy' subject matter in favour of positive messages, Agee championed the depiction of the ugly side of life as a challenge to the 'affirmative culture' of the war years, a culture with which figures such as McManus were associated. Agee even goes so far as to claim that *The Blue Dahlia*

> does carry a certain amount of social criticism. For it crawls with American types; and their mannerisms and affectations, and their chief preoccupation – blackmail and what's-in-it-for-me – all seem to me to reflect, however coolly, things that are deeply characteristic of this civilization.[34]

Realism, Social Criticism and the Documentary Style

The reception of both *The Big Sleep* and *The Blue Dahlia* was therefore shaped by a larger debate over the representation of social life, and particularly by discourses of realism. Indeed, 1946 also saw the American release of Roberto Rossellini's *Roma, citta àperta* (*Rome, Open City*, 1945), the Italian neorealist film that is usually seen as pivotal to the shift in critical tastes by which many film critics – including Bosley Crowther – came to champion realism.[35] But, as has been argued elsewhere, this shift was already evident from 1944, where it largely developed in relation to horror-thrillers such as *Double Indemnity* (1944), *The Woman in the Window* (1944), *The Strange Affair of Uncle Harry* (1945) and *The Lost Weekend* (1945).[36] However, 'realism' at this time didn't simply denote 'verisimilitude' but rather implied a frank confrontation with the ugly side of life for the purpose of social criticism. For its champions, realism was supposed to involve a representation of that which had been previously repressed or seen as taboo in order to investigate social problems with a view to diagnosing their causes and hence to identifying a solution or a cure.[37] Thus, while leftist critics such as McManus often deplored the new realist films for their depiction of the ugly side of life and called for films that were positive or affirmative, critics such as Bosley Crowther championed realism on the grounds that it was necessary for genuine social criticism while deploring those films he saw as simply plumbing the seedy depths in pursuit of mere sensationalism.

If Houseman wasn't simply of the McManus camp, he also took a very different position to Agee, Farber and even Crowther. In this context, his final paragraph becomes particularly significant, given that this is the point at which he most clearly distinguishes *The Big Sleep* from other films commonly identified today as film noir, thereby revealing that his critique wasn't of some general object subsequently seen as film noir, but was one precisely founded on a question of realism. According to Houseman, 'the "Whodunit" has achieved a special kind of quality in its preoccupation with genuine atmosphere and realistic detail'. This has given such films a particular importance for Houseman, who identifies in them a 'tradition of carefully selected, significant realism' that 'lent distinction to many of our suspense pictures, e.g., *Double Indemnity, Murder, My Sweet* [1944], *The House on 92nd Street* [1945], and the Third Avenue scenes of *The Lost Weekend*'.[38] The reference to *The Lost Weekend* is particularly pertinent here because rather than championing the film's supposed investigation of alcoholism as a social problem – the position taken by many critics (including Crowther) in defence of its realism – Houseman focuses instead on its use of documentary techniques in certain sequences, techniques that were also central to *The House on 92nd Street*. In other words, Houseman's condemnation of *The Big Sleep* is associated with a defence of specific stylistic techniques which that film lacks: in contrast to the documentary realism of these thrillers of distinction, *The Big Sleep*

> marks a violent and deplorable regression. Its southern California characters wander through a fairyland of studio back lots and sound-stage exteriors as unreal as the squares and mansions inhabited by the gentry in Metro-Goldwyn-Mayer's British upper-class romances.[39]

Instead of a realism that is legitimated through its investigation of social life, Houseman ultimately ends up with a distinction which is purely stylistic, based on a leftist faith in the inherently progressive political values of documentary techniques. This faith was neither fulfilled nor justified and would be significantly undermined by the release a couple of years later of *The Iron Curtain* (1948), another semi-documentary thriller, which caused outrage on the left due to its use of a documentary style for anti-communist purposes.[40]

For Houseman, where *The Blue Dahlia* differs from *The Big Sleep* isn't in its violence nor in its depiction of the ugly side of American life, but rather in the visualization of its seedy underworld. Agee, too, highlighted its settings, notably the 'Hollywood half-world' in which assorted characters 'and the sets and moods they move through all seem … convincing and entertaining in a dry, nervous, electric way'.[41] However, despite this, realism was understood not as an absence of style (as is often claimed in many contemporary attacks on realism), but rather as a product of Chandler's 'craftsmanship'[42] or his 'crafty script'.[43] Agee also saw the film as 'neatly stylized',[44] and even Farber seems to have found Chandler's script a bit *too* 'stylized and arty', as it 'turns everyone into a sophisticate – even the man in a union suit who operates a cut-throat flophouse'.[45]

Realism, Fantasy and *The Big Sleep*

If some critics were overtly hostile to *The Big Sleep*, the film also had its champions, who often relished the very features that Houseman and others condemned. For example, instead of bemoaning its lack of documentary realism, Agee celebrated the film as an antidote to the affirmative values advocated by certain sections of the left. Farber even went so far as to praise the film for its association with the fantastic, a feature that wasn't then necessarily opposed to its realism, but rather one distinguishing it from the documentary realism of other thrillers, an aesthetic with which Farber didn't have much sympathy. A couple of years later, his *New Republic* colleague Robert Hatch would argue that the 'documentary style' was concerned with 'verisimilitude rather than realism' and that 'film documentation ... developed from the propaganda needs of the recent war'.[46] In other words, Hatch saw the style as simply conveying a 'naturalistic' replication of the surface appearances of social life rather than a 'realistic' investigation of the underlying processes that produce those appearances. Furthermore, rather than simply failing to investigate social life and provide a criticism of it, the realistic style – as propaganda – was instead implicitly supportive of government institutions. Hatch cites the example of the film noir, *The Street with No Name* (1948), which appears to be in awe of the FBI: 'Hoover himself never appears, but his words spill like Holy Writ from the teletype.'[47]

Certainly, Crowther, as we have seen, dismissed *The Big Sleep* as a 'poisonous picture' and he did so on the grounds that it featured a sordid world of 'tramps and tough guys' and 'a not very lofty moral tone'. 'Much of the terseness and toughness of ...Chandler's style has been caught in the movement and dialogue of William Faulkner's and Leigh Brackett's script', says Crowther, but the underworld story has no purpose beyond sensationalism. 'Students of underworld minutiae will find plenty of it here.'[48] However, Crowther's biggest complaint concerned an incomprehensible storyline 'in which so many cryptic things occur amid so much involved and devious plotting that the mind becomes utterly confused'.[49] On the one hand, the implication is that the film is so dizzying in its action that there is no time for thought or contemplation and, on the other, that it is a detective story that wasn't concerned with reason but only with action, a film in which the detective's deductive process is never explained or explored: 'the brilliant detective in the case is continuously making shrewd deductions which he stubbornly keeps to himself'.[50]

Other sections of the press were more ambivalent. *The Motion Picture Herald*'s Weaver, for example, acknowledged that the film was 'conceived and executed strictly and forthrightly for the adult consumer', predicting that 'it's hard to see how it can do less than top business'.[51] If Weaver's main criterion seemed to be a commercial one, the *Hollywood Reporter*'s Grant also saw *The Big Sleep* as a potential hit. He acknowledged the film as a vehicle for Bogart as the prototype that 'started the cycle of hard-bitten detective characters' from 'private eye, Sam Spade, in Dashiell Hammett's rough and tough "Maltese Falcon"[1941]' to 'Philip Marlowe in Raymond Chandler's "The Big Sleep"'. He was also the best of the type: 'But nobody socks over these guys better than Bogart.' Bogart's starring role 'coupled with the keen and knowing direction by

Howard Hawks will take "The Big Sleep", to the pinnacle of boxoffice attractions', Grant predicted. 'It can't miss with what it has to offer a discriminating whodunit public.'[52]

Like Crowther, Agee also noted the difficulties of following the story:

> one of those Raymond Chandler Specials which puts you, along with the cast, into a state of semi-amnesia through which tough action and reaction drum with something of the nonsensical solace of hard rain on a tin roof.

Agee concedes that 'PM is probably correct in rating it as a new high in viciousness; but', he continues, 'I can't bring myself to mind this sort of viciousness, far less to feel that it shouldn't be shown.' Again, he uses the film to bash the affirmative values of McManus and others on the one hand, and the supposedly healthy norms of Hollywood's respectable dramas on the other. For Agee, if The Big Sleep is 'a dream world', he also acknowledges how 'Bogart and several proficient minor players keep anchoring it to some sufficient kind of reality'. But if the film is 'often brutal and some-times sinister', it hardly compares with 'the really bottomless vileness of films like ... To Each His Own [1946], which walk the streets unchallenged and never even pass a serious medical inspection'.[53]

Here, a respectable, PCA-approved, moral melodrama about a woman who gives her child up for adoption but dedicates her life to mothering him at a distance is associ-ated by Agee with the moral and physical corruptions of prostitution. It not only 'walks the streets' but might even require a 'medical inspection' to check that it isn't spreading a dangerous social disease. Furthermore, Agee implies that The Big Sleep may be not only less 'vile' than supposedly respectable Hollywood products like To Each His Own, but may even be a welcome antidote to such films. As he put it, when compared to films such as To Each His Own, The Big Sleep seemed 'about as toxic as a package of Tums'. This reference to 'Tums', a well-known brand of antacids, suggests that Hawks's film might even provide a remedy for audiences with few alternatives to an unhealthy diet of overly sweet items.

Like Agee, Farber also emphasised the film's dreamlike quality, although this wasn't for him necessarily at odds with its realism, nor did he see it as a negative, praising the film as 'an unsentimental, surrealist excitement'. Indeed, Farber particularly admired what he described as the 'super-realistic' set-up of the hothouse scene with General Sternwood (Charles Waldron).[54] Like Crowther and Agee, Farber also draws attention to the complicated plot that 'winds as crazily as a Greenwich Village street' and this only adds to the 'fantastic' quality. 'It all has the feeling of an opium smoker's fantasy', says Farber, 'where the exotic subject matter is woven with straight naturalisms' and the film 'in an odd way is a realistic portrait of big-city life with "Arabian Nights" over-tones.'[55]

If The Big Sleep is commonly seen as a classic of film noir today, it clearly had a far more precarious reputation at the time of its original release. For figures such as Houseman, it was even a dangerous film. However, it's also clear that Houseman's crit-

icism of the film wasn't being levelled at the object we now call film noir: those films commonly categorised as noir today were certainly not seen as a unified, coherent or discrete group of films in 1940s' America. Houseman was making films that would later be seen as classics of film noir at the same time that he was attacking *The Big Sleep* while many of the films that he made, or which he championed, actually shared key features with *The Big Sleep*. While he explicitly objected to the morality of *The Big Sleep*, he actually distinguished Hawk's film from other 'tough' movies on the grounds that it didn't employ the documentary style of realism that was being advocated by some sections of the postwar left, an absence that he described as 'a violent and deplorable regression'. As our examination of the reception of *The Big Sleep* has revealed, commentaries on the film can be seen to relate to larger stylistic and political debates that cut across questions of genre.

Notes

1. Steve Neale, *Genre and Hollywood* (London: Routledge, 2000), p. 161.
2. James Naremore, *More Than Night: Film Noir in Its Contexts* (Berkeley: University of California Press, 1998), p. 167.
3. David Thomson, *The Big Sleep* (London: BFI, 1997).
4. Joseph McBride, *Hawks on Hawks* (Berkeley: University of California Press, 1982), p. 148.
5. Bosley Crowther, 'The Screen; "The Big Sleep", Warner Film in Which Bogart and Bacall Are Paired Again, Opens at Strand', *New York Times* (24 August 1946), p. 6.
6. John Houseman, 'Today's Hero: A Review', *Hollywood Quarterly* (January 1947), pp. 161–3.
7. Richard Maltby, '*Film Noir*: The Politics of the Maladjusted Text', *Journal of American Studies* vol. 18 no. 1 (April 1984), p. 58. See also Robert Manning, *Re-examining the Maladjusted Text: Post-war America, the Hollywood Left and the Problem of Film Noir*, PhD Thesis, University of East Anglia, forthcoming.
8. Houseman, 'Today's Hero', p. 162.
9. Ibid., p. 163.
10. Ibid., pp. 162, 163.
11. Maltby, '*Film Noir*', p. 66.
12. Ibid., p. 58.
13. Ibid., p. 55.
14. Ibid., p. 66.
15. Ibid., p. 52.
16. Ibid., p. 57.
17. Siegfried Kracauer, 'Hollywood's Terror Films: Do They Reflect an American State of Mind?', *Commentary* no. 2 (1946), pp. 132–6. This article was highly influential on Houseman. See also Sheri Chinen Biesen, *Blackout: World War II and the Origins of Film Noir* (Baltimore, MD: Johns Hopkins University Press, 2005), pp. 15–17, 191; Mark Jancovich, '"Thrills and Chills": Horror, the Woman's Film and the Origins of Film Noir', *New Review of Film and Television* vol. 7 no. 2 (June 2009), pp. 157–71.

18. Maltby, '*Film Noir*', p. 59.

19. Despite the rhetoric of Houseman's essay, he doesn't develop a comparable critique in relation to any other films and actually uses most examples of the 'tough' movie in contrast to *The Big Sleep* rather than to demonstrate the more general application of his critique. In other words, *The Big Sleep* actually emerges as an exception rather than the rule.

20. Houseman, 'Today's Hero', p. 163.

21. Ibid., p. 161.

22. Bosley Crowther, 'The Screen in Review; "Blue Dahlia", of Paramount, With Alan Ladd and Veronica Lake in the Leading Roles, Proves an Exciting Picture', *New York Times* (9 May 1946), p. 27.

23. Manny Farber, 'Crime without Passion', *New Republic* (3 June 1946), p. 806.

24. William R. Weaver, 'Review of *The Blue Dahlia*', *Motion Picture Herald* (2 February 1946), p. 2829. Chandler had actually cowritten other scripts before *The Blue Dahlia*, notably *Double Indemnity* (1944), *And Now Tomorrow* (1944) and *The Unseen* (1945).

25. Bron, '*The Blue Dahlia*', *Variety* (30 January 1946), p. 10.

26. Jack D. Grant, '"Blue Dahlia" Crack Drama', *Hollywood Reporter* (28 January 1946), p. 3.

27. Weaver, 'Review of *The Blue Dahlia*', p. 2829.

28. Crowther, 'The Screen in Review', p. 27.

29. Farber, 'Crime without Passion', p. 806.

30. Crowther, 'The Screen in Review', p. 27.

31. James Agee, 'Films', *The Nation* (8 June 1946), p. 701.

32. Ibid.

33. In 1946, Johnston became President of the Motion Picture Producers and Distributors Association and an influential figure in shaping PCA policy.

34. Agee, 'Films', p. 701.

35. See, for instance, Janet Staiger, *Interpreting Films: Studies in the Historical Reception of American Cinema* (Princeton, NJ: Princeton University Press, 1992), pp. 187–90.

36. See Mark Jancovich, '"Master of Concentrated Suspense": Horror, Gender and Fantasy in Lang's 1940s Films', *Studies in European Cinema* vol. 5 no. 3 (2008), pp. 171–83; '"Realistic Horror": Film Noir and the 1940s Horror Cycle', in Karen McNally (ed.), *Billy Wilder: Movie-Maker, Critical Essays on the Films* (Jefferson, NC: McFarland, 2011), pp. 56–69; '"A Former Director of German Horror Films": Horror, European Cinema and the Critical Reception of Robert Siodmak's Hollywood Career', in Patricia Allmer, Emily Brick and David Huxley (eds), *European Nightmares: Horror Cinema in Europe since 1945* (London: Wallflower Press, 2012), pp. 185–93; and '"Frighteningly Real": Realism, Social Criticism and the Psychological Killer in the Critical Reception of the Late 1940s Horror-Thriller', *European Journal of American Culture* vol. 31 no. 1 (April 2012), pp. 25–39.

37. Jancovich, 'A Former Director of German Horror Films' and '"Frighteningly Real"'.

38. Houseman, 'Today's Hero', p. 163.

39. Ibid.

40. See Will Straw, 'Documentary Realism and the Postwar Left', in Frank Krutnik, Steve Neale, Brian Neve and Peter Stanfield (eds), *'Un-American' Hollywood: Politics and Film in the Blacklist Era* (New Brunswick, NJ: Rutgers University Press, 2008), pp. 130–41.

41. Agee, 'Films', p. 701.

42. Weaver, 'Review of *The Blue Dahlia*', p. 2829.

43. Crowther, 'The Screen in Review', p. 27.

44. Agee, 'Films', p. 701.

45. Farber, 'Crime without Passion', p. 806.

46. Robert Hatch, 'Movies: The New Realism', *New Republic* (8 March 1948), p. 27.

47. Robert Hatch, 'Movies: Troubled Times', *New Republic* (26 July 1948), p. 29.

48. Crowther, 'The Screen in Review', p. 6.

49. Ibid.

50. Ibid.

51. William R. Weaver, '*The Big Sleep*: Bogart, Bacall and Murder', *Motion Picture Herald* (17 August 1946), p. 3149.

52. Jack D. Grant, '"Big Sleep" Hits BO Hard', *Hollywood Reporter* (13 August 1946), p. 3.

53. James Agee, 'Films', *The Nation* (31 August 1946), p. 250.

54. Manny Farber, 'Journey into the Night', *New Republic* (23 September 1946), p. 351.

55. Ibid.

PART 3
THE HAWKSIAN WESTERN

5 Hawks and the Western

Tom Ryall

There are not very many stories that you can do about the West that are any good.

Howard Hawks[1]

First of all, the western is American history.

Jim Kitses[2]

In the 1950s Hawks emerged as a key director for the *Cahiers du cinéma* critical grouping and his films, along with those of Alfred Hitchcock, were of central import-ance to the development of the *politique des auteurs*. This has overshadowed his con-tribution to the Western somewhat, despite his director credit on a number of titles featuring the genre's biggest star, John Wayne. At the beginning of his career in the 1920s he worked as a producer and second-unit director on a handful of Westerns; in the 1930s he directed *Barbary Coast* (1935), a kind of Western (set in San Francisco during the Gold Rush), and was initially hired as director for *Viva Villa!* (1934); in the 1940s he worked briefly on *The Outlaw* (1943). However, it is the five Westerns he made subsequently – *Red River* (1948), *The Big Sky* (1952), *Rio Bravo* (1959), *El Dorado* (1967) and *Rio Lobo* (1971) – on which his status as a Western director rests.

The Hawks Westerns were made during what many regard as the 'Golden Age' of the genre, from the late 1940s until the early 1970s. It has been described by Stanley Corkin as 'the period when the Western became a central genre of popular entertain-ment – perhaps the most important one',[3] and by Richard Slotkin as 'a 25-year period, regularly punctuated by the appearance of remarkable films, that saw the genre achieve its greatest popularity and that ended with its virtual disappearance from the genre map'.[4] Much recent writing on the postwar Western is based on the notion that the genre acquired a special significance in American culture as a conduit for ideological discussion and debate about postwar American life, morality and politics.[5] It has been argued specifically that its prominence in the postwar period was due to its suitability for expressing Cold War concerns. The Western, in Corkin's words,

has the mythic power to define the past not simply as a body of material and ideological events that are recognizable and subject to analysis but as a triumphal moment when a compendium of quintessentially American traditions took hold.[6]

Key ideological concepts such as 'American exceptionalism' and 'manifest destiny' were embodied in the tales of westward expansion, conquest and settlement. Such concepts were linked to the values of freedom and individualism central to liberal cap-italist democracies such as the US and underwrote the positive presentation of a nation fulfilling its destiny.

The genre was built on history with even the most routine and formulaic Westerns having some reference, often explicitly, to American history through costumes, environ-ment, and to actual events and historical figures. Much of the critical literature on the genre echoes Jim Kitses's often quoted comment, '(f)irst of all, the western is American history.'[7] Furthermore, that history is often explicitly marked in individual films; as Corkin noted, it

> is typical of the movie Western to name its historical moment, usually through stating the precise date and place in which the plot is set. Westerns that fail to provide some chronological and geographic point of reference are exceptions.[8]

Most Westerns are set during a period of about forty years or so, roughly the second half of the nineteenth century from the Civil War to the 1890s, embracing the drive westward, the opening up of the frontier and the establishment of 'civilisation' in the wilderness. However, the depiction of history rejoins the other and, for many, the pri-mary, dimension of the genre – its role in terms of the present. As Slotkin suggests, '(a)lthough the real-world referents of these films were nominally of the past, the new historical Western presented them as part of "genetic myth" that would clarify present-day ideology dilemmas by explaining their origins.'[9] Western films use aspects of late-nineteenth-century American history as 'raw material' for the melodramatic stories, adventure narratives and revenge dramas through which key currents in American life, politics and culture are mediated using the potency of the 'genetic myth'. It is this per-spective, joining historical realities and historically grounded myths to contemporary realities, that many writers have seen as the crucial feature of the genre, providing a dynamic conduit for present-day preoccupations.

Hawks and the Postwar Western: The Classic Phase

Most writers on the genre, even while stressing the crucial role played by history, are obliged to account for the numerous films which, though recognisably Westerns in the sense that they feature cowboys, native Americans, frontier towns, lawmen and out-laws, nevertheless do not readily invite analysis in terms of their relationship to frontier history. Critical analysis, as Douglas Pye has noted, has favoured 'films with a pro-nounced social or historical dimension – films in which the representation of White westward expansion, settlement and social development is central'.[10] On the face of it, Hawks's Westerns occupy a position on the generic spectrum some distance from the historical material thought by many to lie at the foundations of the form, which might explain why his Westerns have not featured prominently in critical discussion. Although both *Red River* and *The Big Sky* do nod towards historical material, especially in their

opening titles, the notion that 'the western is American history' seems less relevant to Hawks's Westerns, especially when compared to those of either John Ford when dealing with historical incident, or Sam Peckinpah's handling of the 'end of the frontier' period. Hawks's interests and preoccupations are in cross-generic themes, as one writer has suggested:

> Hawks is, first and foremost, a director of adventure films. He subordinates the Western, for instance, to the adventure film at large. In this he is unlike, say, John Ford, for whom the Western as such is paramount, because it expresses his fervent interest in pioneer American history. Hawks has little historical sense.[11]

However, the idea that the fundamental impulse of the genre concerns the mobilisation of scraps of history mixed in with the conventions of drama and entertainment in the service of contemporary comment and reflection, and of the promotion of a distinctly American ideology, may provide a more fruitful opening onto Hawks's Westerns than an approach which foregrounds the historical in a more explicit fashion. In terms of Hawks's contemporaries, *Red River* and *The Big Sky* belong to the traditional phase of the genre dominated by Ford, while *Rio Bravo*, *El Dorado* and *Rio Lobo* are from what some have called the genre's 'revisionist' phase, most closely associated with Peckinpah and with the Italian Western. How do the Hawks Westerns relate to the general contours of the genre in the postwar period? To what extent do Hawks's first two Westerns, *Red River* and *The Big Sky*, conform to the classic traditions of the genre, and to what extent do the later films participate in that self-conscious meditation on the generic conventions signalled by films like *The Man Who Shot Liberty Valance* (1962), *Ride the High Country* (1962) and *Once Upon a Time in the West* (1968)?

The context for Hawks's first two Westerns is the re-emergence of the A Western in the late 1930s and its consolidation as a key feature of Hollywood production in the 1940s. The postwar films, though derived from the Westerns of the 1920s and 30s, introduced a range of new dimensions to the simple frontier stories found in the films of Gene Autry and Roy Rogers, and in the B pictures and the series Westerns which constituted the bulk of the genre before World War II. Films such as *The Outlaw* and *Duel in the Sun* (1946) introduced sex into a hitherto chaste genre; *The Ox-Bow Incident* (1942) sketched out the moral complexities of frontier law and justice; Ford's *My Darling Clementine* (1946) and *Fort Apache* (1948) were based on historical events with the latter film in particular displaying a remarkable degree of historical self-consciousness. There was also a darkening psychological quality in a handful of noir Westerns such as *Pursued* (1947), *Ramrod* (1947), *Yellow Sky* (1948) and *Devil's Doorway* (1950), aligning the genre with a key stylistic and thematic strand in the American cinema of the 1940s. The new dimensions were significant to the development of the genre. Lawrence Alloway argued that such films 'maintained the traditional contour of the Western while transforming it internally: motivations became more tangled, violence more specific, locales more diverse, and fancy dress disappeared'.[12] Such films were sometimes dubbed 'adult Westerns' or 'intelligent Westerns' and Hawks saw himself

in the vanguard of the development claiming, in a 1956 interview with *Cahiers du cinéma*, that '(w)hen I made *Red River*, I thought an adult Western could be made for mature audiences, and now everyone is making "intelligent" Westerns.'[13] However, Alloway, who had included *Red River* in his list of transformational Westerns, suggested that the director 'was exaggerating his independence'[14] in the development of a trend which can be traced back to the early years of the decade.

Both of Hawks's early Westerns incorporate historical material, with *Red River* having 'some tenuous connections with actual events – the founding of the vast King ranch in Texas and the creation of the Chisolm [sic] Trail'.[15] Indeed, its opening titles claim to tell 'the story of the first drive on the famous Chisholm Trail' and the film displays a certain degree of geohistorical accuracy in the plotting of the course of the thousand-mile cattle drive initially from Texas to Missouri but eventually to Abilene in Kansas when Matt Garth (Montgomery Clift) replaces Tom Dunson (John Wayne) as leader of the drive. As Corkin noted, most Westerns provide some 'chronological and geographic point of reference',[16] some minimal anchoring of the fiction in historical terms, a convention adhered to by *Red River* which, it is argued, gives it a special distinction in the director's work in the genre. As John Parris Springer writes, 'with its framing device of the expository titles and the manuscript called "Early Tales of Texas", Hawks announces a much larger historical and cultural frame for the film than is typical of his work'.[17] Yet, that historical dimension is best approached in terms of the thematic orientation of the film. For Hawks's biographer, the film was about history, about 'how the creation of a cattle empire helped build a nation', but the gladiatorial battle between its protagonists, Dunson and Garth, was more philosophical, depicting a 'contrast of an old authoritarian ethic with a newer and more democratic one'.[18] This substantive theme is also noted by political philosopher, Robert Pippin:

> There are no sheriffs or judges or gunfighters in this movie, so it is not a classic Western about the inauguration of the law or its psychological grip. Rather, it is about the transition between an autocratic, charismatic, largely pre-modern or feudal form of authority to a much more humanistic, consensus-oriented, prudent, more recognizably modern mode of rule and civic order.[19]

Although *Red River*'s historicity may be tenuous in terms of the depiction of actual events, the film nevertheless captures important strands of the political and philosophical struggles that define the frontier era in American history. A case can also be made for the film as a key title in what Corkin terms the 'conceptual bridge between frontier mythology and Cold War imperatives' provided by the postwar Western.[20] Early in the film, Dunson establishes himself on a plot of territory in Texas claiming ownership and killing a representative of its Mexican 'owner' thereby endorsing Robert Sklar's suggestion that the film is about 'the issues of empire. It is a film about the territorial expansion of one society by the usurpation of land from others.'[21] In that respect, Hawks's film promotes notions of territorial expansion, of individualism and heroic endeavour, of trade and commerce, central to American national identity, and relevant in the context

of postwar international politics. Corkin contends that *Red River*, along with other Westerns of the period, promotes 'a view of the American nation that allows for acts of empire or hegemony to be seen as the expression of a rational and moral imperative that will ensure progress and promote the development of civilization'.[22]

The theme of transition between forms of authority, forms of behaviour and codes of morality, is one which finds different outlets in a number of postwar Westerns which either focus upon, or have some place for, Western heroes who are being superseded by the establishment of order in frontier life. The figure of the displaced hero is closely associated with the films of Sam Peckinpah and with John Ford's *The Man Who Shot Liberty Valance*, but its lineage can be traced back to the early postwar years and, even earlier, to another Ford film, *Stagecoach* (1939). The outlaw hero, the Ringo Kid (John Wayne), rides off into the sunset with Dallas (Claire Trevor), the outcast saloon girl, fleeing 'the blessings of civilization' in the ironic words of Doc Boone (Thomas Mitchell). Characters in Westerns often embody the contradiction between the civilisation, the taming of the wilderness, and the violent uncivilised means by which this state is brought about. Complicated Western protagonists such as Colonel Thursday (Henry Fonda in *Fort Apache*), Ethan Edwards (John Wayne in *The Searchers* [1956]), and Tom Doniphon (John Wayne in *The Man Who Shot Liberty Valance*), play a crucial role in the establishment of order and are central to the 'celebratory, nation-building, quasi-historical tradition'[23] of the genre in many respects. However, their actions, their heroic feats, often render them dispensable to the social order which they help to bring about. Douglas Pye outlines the elements of the films as follows:

> these are films that are centrally concerned with social questions and explore the consequences of embedding the fantasy figure of the hero in contexts of social and historical change. In a way, the question they ask is how (or whether) such a figure can enter history. As he does and is given a social part, the residual accretions of the old fantasy are increasingly seen as desperate assertions of an impossible identity (*The Searchers* is a key example).[24]

Hawks presents variants on this perspective, on the notion of 'impossible identity', most clearly in *Red River*. Dunson, the driving force of the film, forfeits his authority to the younger Matthew Garth. Though implicitly the heroic pioneer, Dunson undergoes a transformation, becoming the 'classic progressive empire-builder who metamorphoses into a megalomaniac tyrant in the course of masterminding the first great cattle drive from Texas to Kansas'.[25]

Red River can be aligned, however loosely, with the traditional Western but *The Big Sky* relates to a small group of what might be called 'pre-Westerns', films set before the Civil War, outside the usual historical framework of most Westerns, but nonetheless concerned, in part at least, with the prominent generic theme of empire-building and the westward trajectory of American history. *The Big Sky* has echoes of the emblematic Lewis and Clark expedition of 1804–6, 'traditionally treated as the inaugural episode of far Western history' in the words of one historian.[26] The film depicts

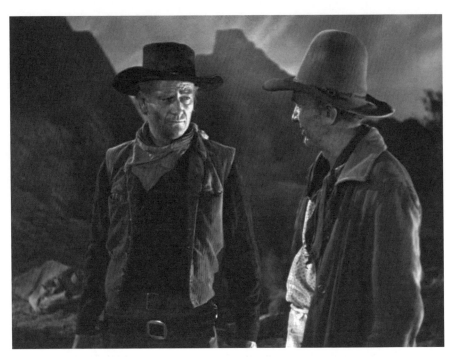

The classic phase: Tom Dunson (John Wayne) as the 'empire-builder' turned 'megalomaniac tyrant', with Groot Nadine (Walter Brennan) in *Red River* (1948)

an epic trading venture by keelboat that traces an itinerary roughly similar to that of Lewis and Clark (from St Louis to the Northwest) and even includes a native American woman as was the case in the historical expedition. *The Big Sky*, however, is set in the 1830s and draws upon the exploits of the mountain men, trappers and explorers, peripheral figures in the iconography of the genre. Also, the expedition is a fur-trading journey, albeit a long one that aims to go further than previous traders have gone, rather than the Thomas Jefferson-inspired pioneering-and-surveying project of the Lewis and Clark expedition. The two protagonists, Jim Deakins (Kirk Douglas) and Boone (Dewey Martin) join up for a venture with a twofold challenge. First, the epic nature of the mission, the vast distance to be travelled up the Missouri river; second, the tricky task of trading with the Blackfoot Indians. The key to the former is the 'Hawksian' professionalism of the crew. The key to the latter is the Indian woman, Teal Eye (Elizabeth Threatt), daughter of a Blackfoot chief, who had been found by Jourdonnais (Steven Geray), skipper of the keelboat, after her capture by another Indian tribe. He is confident that returning her to her people will enable a successful trading mission.

The film also has centres of interest that relate to previous Hawks films, to the cluster of themes and motifs commonly associated with Hawks the auteur rather than Hawks the genre director. At its core is the relationship between Deakins and Boone, a relationship reminiscent of that between Tom Dunson and Matthew Garth though

without the strong father/son dimension of the previous film. Deakins and Boone, with less of an age difference between the actors than between Wayne and Clift in *Red River*, are more like the brawling buddies Spike (Victor McLaglen) and Salami (Robert Armstrong) of Hawks's silent film, *A Girl in Every Port* (1928). Indeed, the film repeats a motif from that film in which one of the men pulls the other's finger back into joint after a fist fight. *The Big Sky* also repeats a theme from the two films in which women come between the men, affecting their relationship in various ways. In *The Big Sky*, Deakins and Boone are both attracted to Teal Eye. She declares that she loves Deakins, though 'like a brother', and then receives Boone into her tepee which, according to custom, means that he has married her. When the trading party leaves the Indian camp Boone goes with them, but the film ends with him returning to the Blackfoot camp, to Teal Eye, while the rest of the men begin the journey back down the river to St Louis.

To return, however, to generic matters, the interracial romance is very much of a piece with a small number of Westerns from the early 1950s, including *Devil's Doorway* (1950) and *Broken Arrow* which depicted such relationships sympathetically from a liberal point of view, moving beyond the stereotyping of native Americans as hostile savages more typical of the genre. In *The Big Sky*, Zeb Calloway (Arthur Hunnicutt), the wizened trapper, talks about what he calls 'the white man's sickness', the 'grabbing' of Indian land, in a muted critique of the predatory nature of the westward movement and an implicit paean to the native American way of life.

As in *Red River*, the personal stories are set within an epic framework, the lengthy river journey paralleling the cattle drive. Both titles are what Michael Coyne has termed 'Odyssey Westerns', in which an epic journey houses 'narratives of personal obsession'.[27] This is more pronounced in *Red River* with Tom Dunson's tyrannical trail boss, but Boone in *The Big Sky* has an obsessive hatred of Indians whom he believes killed his brother and he carries around a scalp from the Indian who committed the crime. His romance with Teal Eye, however, cures his obsession and he eventually tosses the scalp onto a fire. The framework, however, remains significant and impressive in its own right, reflecting the more generalised and generic themes of westward expansion and 'manifest destiny', in which the West is seen

> as a refuge from tyranny and corruption, a safety valve for metropolitan discontents, a land of golden opportunity for enterprising individualists, and an inexhaustible reservoir of natural wealth on which a future of limitless prosperity could be based.[28]

Hawks and the Postwar Western: The 'Twilight' Era

Hawks's later Westerns – *Rio Bravo*, *El Dorado*, *Rio Lobo* – belong to a turbulent, sometimes adventurous phase of the genre; yet it was a time when the form had declined in prominence in Hollywood cinema. Much of the cinematic genre had migrated to television with series such as *The Life and Times of Wyatt Earp* (ABC, 1955–61) and *Wagon Train* (NBC, 1957–62; ABC, 1962–5) occupying the space previously filled by the B Western. But it was also the era of John Sturges's *The Magnificent*

Seven (1960), which presented its Western heroes as a professional elite drawing inspiration not only from the tales of the pioneers but also from a Japanese film, Akira Kurosawa's *The Seven Samurai* (1954). In addition there was the European Western, with films made in Germany, Spain and, especially, Italy, mobilising the thematic world of the traditional Western often in innovative and highly stylised ways, and often using American actors such as Henry Fonda, Clint Eastwood, Eli Wallach and Lee Van Cleef, to great effect. The period saw the advent of the variously titled 'twilight' or 'revisionist' or 'elegiac' Westerns associated particularly with the director, Sam Peckinpah, and with the central theme of the decline of the Western hero. There were other currents in the genre, a general focus on the encroachments of civilisation, the ageing of the heroes prompted in part by the actual ageing of the key Western stars, and a geographic shift to the Southwest and Mexico.

Rio Bravo predates such developments by a year or so, hovering between the classic phase of the genre and the innovative currents of the 1960s. *El Dorado* and *Rio Lobo* were made when those currents of influence had become well established. Hawks himself has claimed that *Rio Bravo* was a reinvigorating force for the genre, suggesting that the film 'was very popular, started westerns all over again'. He has also suggested that '*Rio Bravo* was made because I didn't like a picture called *High Noon*'.[29] Whereas Will Kane (Gary Cooper), the sheriff in *High Noon* (1952), spends much of the film trying to persuade the citizens of Hadleyville to help him deal with an outlaw gang, John T. Chance (John Wayne), the sheriff in *Rio Bravo*, faced with a similar problem, refuses many offers of help relying instead on his makeshift team of Dude (Dean Martin), his recovering drunkard deputy, and the disabled 'Stumpy' (Walter Brennan), though they are later joined by a young expert gunfighter, Colorado (Ricky Nelson). Hawks's critique of *High Noon* was based on the film's depiction of the Western hero as somewhat weak, desperate and dependent. Hawks's hero looks back to the classical traditions of the genre in which self-sufficiency, what Robert Warshow called 'repose',[30] is the paramount and definitive personal value. In contrast, *High Noon*, with its troubled hero, alienated from both his wife and the society which he serves, desperately seeking help, looks forward to the cynical, flawed and historically outdated heroes of the 'twilight' Westerns of the 1960s.

Yet *Rio Bravo* can also be regarded as a forward-looking film, for example as a generic predecessor of such films as *The Magnificent Seven*, *The Professionals* (1966) and *The Wild Bunch* (1969), which have been categorised by Will Wright as built around 'the professional plot' and featuring small groups of professional gunfighters. In the classical Western the lone hero battles against the antisocial forces (outlaws, cattle barons, big landowners and businessmen) on behalf of social justice and equity for the ordinary citizenry, and for a stable and ordered society; in the professional Western the perspective on society is very different:

> The heroes are now professional fighters, men willing to defend society only as a job they accept for pay or for love of fighting, not from commitment to ideas of law and justice. As in the classical plot, society is portrayed as weak, but it is no longer seen

as particularly good or desirable. The members of society are not unfair and cruel, as in the transition theme; in the professional plot they are simply irrelevant.[31]

Rio Bravo's small group of professionals, three lawmen and Colorado, the wagon train guard, operate in an almost hermetically sealed-off world in which their ethics and their expertise are tested but to no specifiable social end. In the film, as Robin Wood has argued, the 'social background is kept to the barest minimum below which we would be *aware* of stylisation'.[32] The Hawks film is somewhat stark and pared down, especially when compared to the social and historical detail in the work of other film-makers, and especially in the Westerns of John Ford. As Wood suggests, 'there is never the least attempt to evoke that sense of community that is one of the finest and most characteristic features of the work of Ford'.[33] If there is no sense of society, there is also no sense of history. There is a reference to the Alamo but that is in the context of the haunting music of the 'Degüello', reputedly played by the Mexicans at the iconic battle, indicating that 'no quarter' would be given in the impending attack, and played in the saloon as a warning to Chance and his team. The historical resonance, however, is minimal and, ironically, it is while listening to the mournful tune that Dude pulls himself together, pouring a glass of whisky back into the bottle without spilling a drop. 'Hotel Alamo' is also the name of the hotel where Chance stays but, again, this is a minimal and non-significant allusion. The absence of historical references, however, shifts the film's focus to the characters, to their interaction, to an existential realm of choice and self-definition. As Wood has suggested:

> The virtual removal of a social framework – the relegating of society to the function of a *pretext* – throws all the emphasis on the characters' sense of *self*: on their need to find a sense of purpose and meaning not through allegiance to any developing order, but within themselves, in their own instinctual needs.[34]

The values associated with the 'professional' Western converge with the Hawksian universe, with the notions of 'Self-respect and Responsibility', the title of Wood's chapter on the key films – *Only Angels Have Wings* (1939), *To Have and Have Not* (1944), *Rio Bravo* – which define the Hawksian world. Indeed, Michael Coyne describes *Rio Bravo* as 'the director's paradigm paean to professionalism in a tightknit male group'.[35]

El Dorado and *Rio Lobo* are often written about as reprises of *Rio Bravo*. Common to the three films are John Wayne and the screenwriter, Leigh Brackett, and the continuities have to do with character depiction and thematic and narrative development. *El Dorado* depicts an array of very similar characters, the professional gun (Wayne), the drunken lawman (Robert Mitchum), the youngster (James Caan) and the old man (Arthur Hunnicutt) are effectively Chance, Dude, Colorado and Stumpy, though the terms of their relationship are slightly altered. However, *El Dorado* has more of a stress on age and physical decline, especially in respect of the central characters which suggests a film in the developing 'twilight' Western strand. Like Steve Judd (Joel McCrea) and Gil Westrum (Randolph Scott) in *Ride the High Country*, both Cole Thornton (John

The 'twilight' era: 'a stress on age and physical decline'. Cole Thornton (John Wayne) and J. P. Harrah (Robert Mitchum) in *El Dorado* (1967)

Wayne) and J. P. Harrah (Robert Mitchum) are conscious of their physical vulnerabilities embodied in the concluding image of them patrolling the town streets on crutches. It is an aspect of the 1960s Western which reflects the fact that many of the actors associated with the classic Western – John Wayne, Robert Mitchum, Joel McCrea, Randolph Scott – were approaching old age and were often cast somewhat self-referentially in ageing roles, mobilising their own histories within the genre to add resonance to the tales of decline. Perhaps what's missing from the Hawks Westerns is the sense of the ageing 'heroes' being overtaken by social developments, that their very success in establishing social order has rendered them redundant.

Rio Lobo, on the face of it, is the most historically specific of Hawks's Westerns. It begins in the final stages of the Civil War with a Union train carrying a shipment of gold hijacked and robbed by Confederate soldiers working on information supplied by a Union officer. The film unfolds as a detective tale of sorts in which Colonel Cord McNally (Wayne) tracks down the informant after the war has ended with the help of his adversaries from the war, Captain Pierre Cordona (Jorge Rivero) and Sgt Tuscarora Phillips (Chris Mitchum). In the course of his investigations, McNally becomes involved in the battle against a large landowner, Ketcham (Victor French), involving Phillips and his father (Jack Elam) together with the townsfolk of Rio Lobo. Ketcham is terrorising the town with a team of a corrupt sheriff and his deputies and is eventually unmasked by Cordona as the wartime informant. It is only in the final stages of the film that the similarities with *Rio Bravo* and *El Dorado* emerge and even then the crucial details differ. McNally and Phillips take over the town jail briefly while Cordona is captured as he rides to get help. Then, as in *Rio Bravo*, the film ends with a trade of hostages during which McNally and his allies dispose of Ketcham and his gang.

Hawks and the Western

The bulk of the influential writing on Hawks's Westerns has come from auteur critics with the generic dimension either subordinated to, or aligned with, the key themes and motifs that define what Lee Russell refers to as 'the Hawksian ideology'.[36] Yet, the Westerns can be seen as important contributions to the genre with *Red River* and *Rio Bravo*, in particular, constituting significant interventions in the course of the Western's development in the postwar period. *Red River* draws upon the classic 'historical epic' strand of the genre, celebrating the achievements of the cattle drives. However, the film also taps the darker cultural currents of the period in its depiction of Tom Dunson as a 'megalomaniac tyrant', an obsessive character, doomed but for the film's somewhat forced reconciliatory ending. In this respect, *Red River* is an important film for the 'redundant hero' motif to be found in the postwar Western. Its complexity in relation to the morality of the genre anticipates subsequent films such as *The Searchers*, *Ride the High Country*, *The Man Who Shot Liberty Valance* and many other titles featuring heroes whose time has come and whose actions 'are increasingly seen as desperate assertions of an impossible identity'.[37] *The Big Sky*, though an epic Western with the attendant celebratory dimensions, can also be understood as a contribution to the more liberal depictions of native American life and culture making a dent, albeit a slight one, in the generic stereotyping of the 'Red Indian'. The later films also have significant relationships with the generic world of the Western. *Rio Bravo* has been positioned as the first 'professional' Western centred on the elite group of gunfighters, though an ensemble of the skilled can be readily absorbed into the familiar Hawksian trope of 'a group sealed off from the outside world, forming a self-sufficient hermetic society with its own values'.[38] *El Dorado* has elements of the ageing Westerner strand with its stress on the physical shortcomings of Thornton and Harrah and looks forward to John Wayne's last film, *The Shootist* (1976) centred on a Western character dying of cancer. *Rio Lobo* also has muted indications of the ageing hero when McNally is described as 'comfortable' by Shasta (Jennifer O'Neill) in contrast to the younger, more physically potent Cordona.

Some of Hawks's own comments on the Western indicate a scepticism about its potential; some, in contrast – his claim for *Red River*'s 'adult' qualities – suggest that he was happy to take credit for a significant contribution to Hollywood's premier genre. He was, however, a shade bemused by the developments in the genre in the late stages of his career despite the fact that his final two films were Westerns, and commented, '(t)hen when all this bunch of new stories came in, with sick people and psychopaths and nudity and everything like that, I didn't know where the devil it was gonna go'.[39] Though nudity was foreign to Hawks apart from a shot or two in *Rio Lobo*, it can be argued that the 'sick people and psychopaths' were at least anticipated in *Red River*, and that a significant part of the interest of both *Rio Bravo* and *El Dorado* lies in the 'sick' (alcoholic) characters of Dude and Harrah. Hawks's late Westerns do have a somewhat archaic look, and are far removed from the strident iconography of Peckinpah and the pyrotechnics of the Italian Western; also, they have none of the self-conscious meditation on Western myths to be found in Ford's

The Man Who Shot Liberty Valance. Nevertheless they remain a key part of the agenda for the study of the Western, for the understanding of what André Bazin called 'the American film par excellence'.[40]

Notes

1. Quoted in Joseph McBride, *Hawks on Hawks* (Berkeley: University of California Press, 1982), p. 112.
2. Jim Kitses, *Horizons West* (London: Thames & Hudson/BFI, 1969).
3. Stanley Corkin, 'Cowboys and Free Markets: Post-World War II Westerns and U.S. Hegemony', *Cinema Journal* vol. 39 no. 3 (2000), pp. 67–8.
4. Richard Slotkin, *Gunfighter Nation: The Myth of the Frontier in Twentieth-Century America* (Norman: University of Oklahoma Press, 1998), p. 347.
5. See, for example, Brian Henderson, 'The Searchers: An American Dilemma', *Film Quarterly* vol. 34 no. 2 (Winter 1980/1), pp. 9–23.
6. Corkin, 'Cowboys and Free Markets', p. 68.
7. Kitses, *Horizons West*, p. 8.
8. Stanley Corkin, *Cowboys as Cold Warriors: The Western and U.S. History* (Philadelphia, PA: Temple University Press, 2004), p. 37.
9. Slotkin, *Gunfighter Nation*, p. 311.
10. Douglas Pye, 'Introduction: Criticism and the Western', in Ian Cameron and Douglas Pye (eds), *The Movie Book of the Western* (London: StudioVista, 1996), p. 10.
11. Lee Russell, 'Howard Hawks', in Jim Hillier and Peter Wollen (eds), *Howard Hawks: American Artist* (London: BFI, 1996), pp. 83–4.
12. Lawrence Alloway, *Violent America: The Movies, 1946–1964* (New York: Museum of Modern Art, 1971), p. 54.
13. Quoted in Jacques Becker, Jacques Rivette and François Truffaut, 'Howard Hawks Interview', trans. Andrew Sarris, in Scott Breivold (ed.), *Howard Hawks: Interviews* (Jackson: University of Mississippi Press, 2006), p. 8.
14. Alloway, *Violent America*, p. 54. Alloway was writing in the early 1970s but the trends that he discusses echo those noted by André Bazin and Robert Warshow writing in the 1950s. See Bazin, 'The Evolution of the Western', in *What Is Cinema Vol. II*, trans. Hugh Gray (Berkeley: University of California Press, 1971), pp. 149–57; and Warshow, 'Movie Chronicle: The Westerner', in *The Immediate Experience: Movies, Comics, Theatre, and Other Aspects of Popular Culture* (New York: Doubleday, 1962), pp. 135–54.
15. Robert B. Pippin, *Hollywood Westerns and American Myth: The Importance of Howard Hawks and John Ford for Political Philosophy* (New Haven, CT: Yale University Press, 2010), p. 26.
16. Corkin, *Cowboys as Cold Warriors*, p. 37.
17. John Parris Springer, 'Beyond the River: Women and the Role of the Feminine in Howard Hawks's *Red River*', in Peter C. Rollins and John E. O'Connor (eds), *Hollywood's West: The American Frontier in Film, Television, and History* (Lexington: University of Kentucky Press, 2005), p. 117. Two versions of the film were made, one with a voiceover commentary, one with the expository titles mentioned by Springer often known as the

'Diary' version. See Todd McCarthy, *Howard Hawks: The Grey Fox of Hollywood* (New York: Grove Press, 1997), p. 441.

18. McCarthy, *Grey Fox*, pp. 408–9.
19. Pippin, *Hollywood Westerns and American Myth*, p. 40.
20. Corkin, 'Cowboys and Free Markets', p. 70.
21. Robert Sklar, 'Empire to the West: *Red River*', in Hillier and Wollen, *American Artist*, p. 152.
22. Corkin, 'Cowboys and Free Markets', p. 74.
23. Michael Coyne, *The Crowded Prairie: American National Identity in the Hollywood Western* (London: I. B. Tauris, 1997), p. 52.
24. Pye, 'Introduction', p. 19.
25. Slotkin, *Gunfighter Nation*, p. 334.
26. Elliot West, 'Thinking West', in William Deverell (ed.), *A Companion to the American West* (Oxford: Blackwell, 2007), p. 26.
27. Coyne, *The Crowded Prairie*, p. 7.
28. Slotkin, *Gunfighter Nation*, p. 30.
29. Quoted in McBride, *Hawks on Hawks*, pp. 112, 130.
30. Warshow, 'Movie Chronicle', p. 137.
31. Will Wright, *Sixguns and Society: A Structural Study of the Western* (Berkeley: University of California Press, 1975), p. 85.
32. Robin Wood, *Howard Hawks* (London: Secker & Warburg/BFI, 1968), p. 38 [emphasis in original].
33. Ibid.
34. Ibid., p. 39 [emphasis in original].
35. Coyne, *The Crowded Prairie*, p. 137.
36. Russell, 'Howard Hawks', p. 83.
37. Pye, 'Introduction', p. 19.
38. Wood, *Howard Hawks*, p. 17.
39. Quoted in McBride, *Hawks on Hawks*, p. 112.
40. André Bazin, 'The Western: Or the American Film Par Excellence', in *What Is Cinema? Vol. II*, pp. 140–8.

6 Gestures, Movements and Actions in *Rio Bravo*

Steve Neale

In what may be the only essay on gesture in classical American cinema, Joe McElhaney focuses in particular on the films of Howard Hawks.[1] Among the gestural motifs he discusses are those that involve hands, the use of hands, and the traumatic effects of their mutilation or loss in films such as *Scarface* (1932), *Tiger Shark* (1932), *Only Angels Have Wings* (1939), *The Big Sleep* (1946), *The Thing from Another World* (1951) and *The Big Sky* (1952). Among the scenes he explores in detail is the one in which Hildy (Rosalind Russell) visits Earl Williams (John Qualen) in prison in *His Girl Friday* (1940), and the one in which Billy the Kid (Jack Buetel) makes his first appearance in *The Outlaw* (1943). Both involve the handling of cigarettes. In the latter, 'Buetel ... pulls a match out of his pocket, strikes it against a column, lights a cigarette, then holds the cigarette while speaking his lines in a low-voiced, somewhat off-hand manner, his body frequently held in an angular position.'[2] This 'manner of slowly working over an object allows,' he argues, 'for a strong erotic component to emerge. Buetel does not simply hold the cigarette but seems to be fondling it, as though it were an extension of his body,' while at the same time his 'eyelids are slightly hooded, giving him an insolent and erotic look'.[3] The prison scene in *His Girl Friday* is longer and more complex, one in which the cigarette, 'a privileged object in Hawks',[4] performs an array of different functions. It establishes a link between the characters, as when Earl automatically accepts the cigarette proffered him by Hildy even though he is not a smoker. But the fact that he does not smoke, the fact that they do not share the cigarette, also serves to highlight 'a fundamental gulf between the innocent, slow-witted but violent world of Earl and the fast-paced, fast-thinking world of Hildy', who, having had the cigarette returned to her, and having used it as 'an extension of her thought processes' during the remainder of the scene, marks the end of her conversation with Earl by discarding it.[5]

Some of McElhaney's points echo those to be found in 'Hawks and Co.' by John Belton.[6] Belton himself is less concerned with classical American cinema and more concerned with Hawks. Indeed, he contrasts Hawks with directors such as Hitchcock, Ford and Lang. Belton asserts that 'Howard Hawks's characterization is rooted in the physical'; that 'Hawks's actors, unlike Hitchcock's, act with their whole bodies.'[7] For him, therefore, movements and gestures are crucial. While 'isolated gestures and movements only stand out within the context of each character's total physical presence',[8] the space they occupy, the task, role or profession in which they are engaged,

and their relationship with those around them, they do indeed stand out. In *Tiger Shark*, for instance, 'Mike (Edward G. Robinson) repeatedly scratches Pipes's (Richard Arlen) back', an action that helps define 'the paternalistic nature of their relationship',[9] and in *Only Angels Have Wings*, Geoff Carter's (Cary Grant) gestures repeatedly reveal 'a dependence on those around him'.[10] Thus when

> Carter first appears (in a doorway), he's giving flight instructions to Joe Souther (Noah Beery, Jr). While doing this, he starts to light a cigarette and strikes a match against the doorway. The match breaks. He walks to the middle of the bar, looks around for a second or two, sees Bonnie's (Jean Arthur) cigarette, and takes it to light his own. All this is done quite naturally and without dramatic effect; the focus of the scene, after all, is on the orders and the characters' reaction to those orders. But at the same time, Hawks immediately establishes a physical relationship between Geoff and Bonnie *before* they are actually introduced. Geoff continues talking to Joe and, as he's about to return Bonnie's cigarette, starts gesturing with his hand. Bonnie tries to get her cigarette back but Geoff's gesture pulls it away from her. Bonnie finally grabs her cigarette out of Geoff's hand and gives him a dirty look. This simple piece of business sets up and informs Geoff and Bonnie's whole relationship.[11]

This particular example is cited here because some of its ingredients are central to *Rio Bravo* (1959). Cigarette smoking is a major motif in the film and the rolling and proffering of cigarettes to Dude (Dean Martin) by Chance (John Wayne) is a famous incidence of this, one which marks the quasi-paternal relationship between the latter and the former, and one which intersects with a wider set of motifs involving hands, especially insofar as Dude's inability to roll his own cigarettes is caused by his drinking, leading him to ask, 'What can a man do with hands like that?' as he gazes at his shaking hands not just once but twice. Insofar as these motifs centre on Dude, they culminate in a scene near the end in which he rolls his own cigarette (in a barely marked manner, which helps make the point that rolling cigarettes is now something he can do without even thinking) while joking with Stumpy (Walter Brennan) about Chance's relationship with Feathers (Angie Dickinson). But cigarette smoking – and steady or unsteady hands – are gestural motifs that involve other major characters too. Colorado (Ricky Nelson), for example, rolls and smokes cigarettes (despite the fact that Nelson did not smoke and had to be taught to do so by Hawks himself).[12] While he does not fondle them as Billy does in the opening scene in *The Outlaw*, Colorado's posture and gestures are frequently imbued with the same quasi-insolent, quasi-cool, quasi-camp qualities. A particularly marked example of this is the slow, outstretched hand gesture he uses as he turns and walks away from Chance and Wheeler (Ward Bond) after turning down the opportunity to help. This gesture, like nearly all of Colorado's (and like the rolling of the cigarette by Billy), is deliberate, languid and slow. It is thus the very opposite of most of the gestures used by Stumpy, who is occasionally slow but never languid, and practically all the gestures used by Carlos (Pedro Gonzalez-Gonzalez) and Consuela (Estelita Gonzalez), whose gestures are nearly always rapid and expansive.[13]

Rio Bravo (1959):
Colorado's outstretched
hand gesture

Chance proffers a
cigarette to Dude

'What can a man do
with hands like that?'

Dude, finally able to
conquer 'the shakes'

There are five occasions where we witness Colorado smoking, each of variable prominence, and each performing different functions. The first is the shot showing Feathers and a group of men playing cards in the Alamo Hotel. Colorado is seated to the right holding his cards, a barely noticeable cigarette placed between his fingers. The presence of the cigarette is unmarked and plays no further part in the events that ensue. However, it does inform us that Colorado smokes, thus setting up the shot in which, following Chance's confrontation with Feathers, an amused Colorado is framed on the lefthand side of the screen slowly rolling a cigarette as an embarrassed Chance heads for the hotel door, pauses, looks back at Colorado, then opens the door and leaves. Colorado's cigarette here helps to underline his amused self-possession – and to mark by contrast the flustered embarrassment felt by Chance. The third example occurs in another bar. Colorado is seated on his own, rolling a cigarette. He is separated visually (and in every other way) from those we see in subsequent shots, most notably Nathan Burdette (John Russell) and the band that Burdette instructs to play the 'Degüello' (music supposedly played at the siege of the Alamo). The fifth example occurs when Colorado, Chance and Stumpy are waiting in the jail for news from Carlos about the arrangements for swapping Dude for Joe Burdette (Claude Akins). Here Colorado lights a cigarette, his legs outstretched on the table. He is wearing a sheriff's badge and is now an integral part of Chance's team. His former lone or independent status has changed, and this has been signalled earlier on in the scene in which the fourth example of his smoking occurs.

This scene begins outside the hotel, just prior to the attempt made by three of Nathan's henchmen to force him into freeing Joe. Chance is walking down the street carrying his rifle. He sees the men on horseback in the distance. One of them appears to be sick and so seemingly not dangerous, but a closer shot of the men is accompanied by a line of dialogue that allows us to anticipate trouble: 'He's coming down the street now.' At this point we cut back to Chance, who is still walking down the street (but who is too far away from the men to have heard what they say), then to a reverse-angle long shot of Colorado, who is stepping onto the sidewalk outside the hotel clutching a tobacco pouch. As Colorado steps off the sidewalk and into the street, Chance enters the frame from right to left and Colorado begins to tell him that he has been 'hearing a lot of talk. I thought you might be interested.' A reverse-angle medium shot reframes the two men as Colorado sprinkles tobacco onto a cigarette paper then uses his teeth to pull the drawstring on his tobacco pouch shut while telling Chance that Nathan is frustrated by the threat to kill his brother should there be any trouble at the jail. A further reverse-angle medium shot places Colorado on the lefthand side and Chance on the righthand side of the frame as Colorado continues talking while putting the pouch back into the pocket of his leather vest. 'Got enough there for another?' asks Chance as he gestures toward the tobacco pouch and turns to rest his rifle against the wooden pillar behind him. 'Sure,' replies Colorado as Chance rests the rifle with his right hand while reaching across to take the tobacco pouch from Colorado's pocket with his left. As the conversation turns to the reasons why he uses a rifle rather than a handgun, Chance takes the pouch and begins to roll a cigarette for himself while Colorado licks

his own cigarette, places it between his lips and feels for a match. At this point, Chance looks up and off screen left, setting up a cut to the three men on horseback who are approaching and now nearby. On cutting back to the previous set-up, Colorado declares that he is out of matches and turns to enter the hotel to get some. As he leaves the frame, the camera pans almost imperceptibly to the right to centre on Chance, who, just like Colorado, uses his teeth to pull the drawstring on the pouch shut.

It is at this point that the men ride up, draw their guns and demand that Chance take them to the jail to release Joe. And it is at this point too that Colorado and Feathers act to help him. As Colorado saunters back outside, Feathers throws a plant pot through the window to distract the men on horseback, Colorado throws Chance his rifle and draws his own gun, and both fire in unison at the men, killing two of them at once before the third rides off into the distance and is eventually shot by Chance. Despite previous tensions, decisions and misunderstandings, Feathers has helped and Colorado has now committed himself to Chance's cause. The gunplay, the throwing of the rifle, and the throwing of the pot through the window are the actions that mark this. But in Colorado's case at least, they have been prefigured not just by the friendly words exchanged with Chance outside the hotel, but by the exchange of tobacco, by the fact this exchange involves a set of coordinated gestures, and by the fact that these gestures (and the characters that perform them) are framed together in a set of medium two-shots.

Ensemble Scenes

It would be possible to focus further on smoking and cigarettes or to discuss the gestures and movements associated with each of the characters in *Rio Bravo* in turn. Indeed, the mix of self-possession and bravado, vulnerability and courage, amusement and anger, reflective calm and emotive spontaneity, and flustered tipsiness and effortless grace evident in the gestures and movements deployed by Angie Dickinson at various points in the film could easily form the basis of an essay on their own.

However, as the gunfight scene discussed above makes clear, individual gestures, movements and actions can function as threads in a much more complex tapestry in *Rio Bravo*, and this is particularly evident in ensemble scenes or scenes that culminate in ensembles. The scene that begins with the exchange of Dude for Joe and ends in the blowing up of the Burdette ranch is a key example. As the number of characters who turn up to help Chance, Colorado and Dude increases, so the number and scale of coordinated actions and gestures such as firing guns and rifles and throwing sticks of dynamite increases too. As John Belton has pointed out, this scene is markedly climactic, reversing as it does the 'increasing confinement of the characters' in a 'final, explosive, exterior action sequence' as they 'move out of the bars, hotel and jail that previously isolated them from the surrounding world'.[14] However, as he also points out, '*Rio Bravo* does not end when Chance, Dude, Colorado and Stumpy, all knit together into a single, interdependent unit by the action, blow

up their enemies. It ends with the dissolution of tensions in the interiors.'[15] As such, the final interior sequences, notably the conversation scene between Dude and Stumpy referred to above, and, of course, the scene between Feathers and Chance in Feathers's hotel room, are particularly crucial. The use of props and gestures in these scenes is vital too: the rolling of the cigarette by Dude, the respective movements and stances of Chance and Feathers, and the emphasis placed on Feathers's clothing. Her outfit, and the way she wears it, not only provides a pretext for the discussion of her relationship with Chance, but also works through the motif of her clothing that begins when she appears with a feather boa in her hand and reacts with amusement when she sees Chance and Carlos with a pair of bloomers, and ends when Chance throws her tights into the street – where they are picked up by Stumpy and slung around his shoulders as he whoops with laughter and walks away with Dude. But in addition to the scene in which Colorado is sworn in as a deputy and in which Dude is finally able to conquer 'the shakes' – a scene in which the throwing and catching and the putting on and taking off of sheriff's badges is almost as important as the pouring and drinking of alcohol – perhaps the most striking focus on gestures and actions can be found in the film's opening scene.

This scene includes thirty-eight shots spread across three distinct settings and segments. The first consists of twenty-six shots, lasts approximately two minutes twenty-six seconds and is set in a saloon; the second, a single tracking shot followed by a stationary medium long shot, lasts approximately fifty-four seconds, and is set in the street outside the first saloon and the entrance to a second; and the third comprises eleven shots, lasts approximately one minute four seconds, and is set inside the second saloon. Although divided up in this way (for reasons that will be touched on later), fictional time and the actions that take place within and across all three settings are in fact continuous. As is well known, the most evident (and unusual) feature of the first two segments is that they are wordless. Diegetic sounds and Dimitri Tiomkin's musical score can be heard, but the first line of dialogue does not occur until the scene's third segment, when Chance walks unsteadily into the second saloon carrying a rifle and tells Joe Burdette that he is under arrest – more than three minutes after the film's first shot.[16]

This scene has multiple functions: it introduces a number of principal characters; it provides exposition as to time, place and circumstance; and it sets the narrative in motion by depicting Joe committing murder in the first bar and being arrested by Chance for doing so in the second. One of its most prominent stylistic hallmarks is its economy: in contrast to the leisurely pace of most of the later scenes, the events that occur in the opening scenes (particularly in the opening segment) are presented so concisely that (in my experience at least) audiences sometimes find themselves laughing at their rapidity or because they are unaccompanied by any form of dialogue and thus look particularly pantomimic. Either way, as framed by the camera and articulated through the editing, gestures, expressions and actions are clearly marked as aesthetically crucial and the opening segment in particular is thus worth looking at in detail.

The Opening Segment

The segment opens with a medium shot of a closed interior door. The door opens inward and Dude, dishevelled and unshaven, enters slowly, his eyes darting first to his right then to his left as he inches his way along the wall. A cut to a long shot from Dude's diagonal point of view reveals a busy saloon with groups of people seated at tables and others (among them Joe Burdette) standing at a bar in the middle distance on the righthand side of the frame. This is followed by a cut back to Dude in medium long shot. Two male customers seated at the edge of a table are visible in the foreground. One is smoking, the other drinking. But Dude does not notice them. He is looking off right. He raises his left hand and rubs the stubble on his face as if preoccupied and anxious, then takes a few more steps as he continues to make his hesitant way into the saloon interior, the camera panning with him. As he does so, all four of the customers seated at the table in the foreground come into view and the nature of his preoccupation is signalled by what he sees when he looks down at the table and pauses to observe one of the men drinking from the glass of beer in his right hand then wiping his mouth with his left, then the woman to the man's left raising a glass to her lips and drinking too. Dude turns away and begins rubbing the stubble on his face again as he shuffles further into the saloon and the camera resumes its panning. He is now near the centre of the room. He stops amidst a group of three more tables of people, his attention caught by a waitress walking into frame with a tray full of drinks. He rubs his face again, resumes his hesitant walk away from the camera, then stops next to a large wooden pillar with a spittoon placed at its foot. Now in long shot, Dude darts a glance to left and right. He is still preoccupied and anxious. Behind him to the left are a barber and his customer. The customer is being shaved (something Dude has clearly not had done for some time.) Immediately behind him are two men in conversation. One is seated, the other is standing and drinking a glass of beer. Two more men are seated at a table on the right. They are also engaged in conversation. The one on the left reaches for the glass of beer in front of him as Dude directs his nervous gaze out of frame to the right, setting up a medium close-up of Joe, who removes the cork from a whisky bottle and begins to pour himself a drink while standing at the bar.

Thanks to the numerous incidental actions of several extras, and thanks to the movements, gestures and expressions performed by Dean Martin, it will be clear by now through both his appearance and demeanour that Dude is alcoholic and that his cravings have led him to the saloon. If not, the ensuing actions serve to spell it out explicitly. The shot of Joe and the whisky is followed by a cut to a close-up of Dude. Dude looks down, rubs his left hand across the lower half of his face, then looks up again, his gaze directed off-screen right at Joe and the whisky. Still framed in medium close-up, and still pouring his drink, Joe turns his head from left to right, looks off-screen centre-left, then raises his head so as to underline the direction of his gaze and to indicate that he has spotted Dude out of frame across the barroom. This is confirmed by a carefully matched close-up of Dude, who is still running his hand across the lower half of his face as the close-up begins, and who then drops his hand and adjusts his gaze downward in order to indicate that he is now looking not so much at

Joe but at the whisky he is pouring. As he does so, we cut back to Joe at the bar. He is still pouring whisky, looking down, then up, then down again as he finally fills his glass. Having done so, he turns to his right to place the bottle on the bar then back again. Then he lifts his head to look at Dude and raises the glass of whisky in his hand as if to offer him the drink. When we cut back to the close-up of Dude, it is clear from the eagerness evident in his gaze that he is tempted. He nods his head in acceptance. Joe transfers the glass of whisky from his right hand to his left, reaches into his waist-coat pocket with his right, pulls out a coin, and flings it toward the spittoon out of frame to the right. The coin lands in the spittoon in medium close-up. We cut back to Dude in medium long shot. He now stands helplessly, his arms by his side, as he looks down toward the spittoon then up again at Joe, who is next shown grinning in amused con-tempt at Dude's dilemma. Does he retrieve the coin from the spittoon or does he try to regain his self-respect by refusing to do so?

Dude tries but fails to resist. He rests his left hand against the pillar, rubs his face with his right as he tries to decide what to do to, then reaches out with the latter as he crouches down by the spittoon on the floor. As he does so, a pair of legs and the barrel of a rifle appear in shot to the right. The right leg kicks the spittoon away then a cut to a low-angle close-up reveals that the rifle and the legs belong to Chance, whose shak-ing head and disgusted expression unambiguously reveal his opinion of Dude's actions.[17] Facial expressions are particularly key here. Dude's expressions have been important throughout, as have Joe's from the point at which he first spots Dude. But the expression on Chance's face serves, along with the shaking of his head, to signal the climax of the segment, punctuating the flow of events with some significantly low-key reactions, even as the tossing of the coin and the kicking away of the spittoon function to motivate a passage of dramatic action in a much higher key. First, we cut to a close-up of Dude crouching by the pillar and looking off-screen right at Chance. Then we cut to Chance, who is still looking at Dude and who next turns his head to look off-screen right at Joe. Then we cut to Joe, who is looking off-screen left at Chance. At this point, we cut back to a long shot showing Dude crouching by the pillar on the left and Chance standing with his rifle centre-right. Chance turns away from Dude and begins walking in Joe's direction. Dude turns to the right, grabs a log of wood, rushes over to Chance, hits him over the head with the log and renders him unconscious. We cut to Joe, who is grinning in amusement, then back to Dude, who brandishes the log in his hand and lurches off in Joe's direction, only to be restrained by two of the men now standing behind him. We now cut to a side-on medium shot of Joe, the camera travelling with him as he steps from right to left across the barroom floor and begins punching Dude, still being restrained by Burdette's two henchmen. He takes a step back and swings his right arm back as if to deliver a telling blow. At this point, the camera pans to the right, emphasising the scope of the swing and bring-ing another man into frame on the righthand side. The man grabs Joe's wrist in order to restrain him. We cut to a close-up of Joe's waist as his hand pulls a pistol from his holster, then on to a diagonal two-shot as Joe shoots the man. Then we cut to a medium-long shot of Joe in centre frame in front of the bar, the man falling out of shot

on the right, Dude slumping down on the left as one of the men holding him walks across the frame and out of shot to the right (presumably to check on the condition of the man shot by Joe), while Joe himself places his pistol back into its holster, grins in callous amusement, then begins to walk off left, the camera panning with him. As he does so, we cut to long shot of the bar. Joe walks toward a door in the distance centre-right as the customers gather round. Many turn their heads to look at him (and to ensure that we see him leave through the door) as the devastation he has wrought is marked by the array of three dead or injured men (among them Dude and Chance) grouped near to one another on the floor centre-right.

As noted above, the remainder of the opening scene shows Joe in the street and his arrival at the second saloon and Joe entering the second saloon when he is arrested by Chance, who comes in alone, but is joined and backed up by Dude. The length of the first shot in the street as Joe accosts two different women in turn allows time for Chance to recover (and for Dude's change of heart). Whether or not they are prostitutes or women who just happen to be walking down the street is, as is characteristic of Hollywood films produced under the aegis of the Production Code, not made apparent. Either way, the manner in which he grabs at them, then pushes them aside in disgust, serves further to illustrate the nature of his character – and the importance of expressions and gestures not just here, but in the preceding and following segments and, indeed, in the film as a whole. A detailed look at almost any scene or sequence will bear this out, but I would like to conclude by focusing on a moment from the scene outside the jailhouse that follows on from that in which Nathan inaugurates the playing of the 'Degüello'.

Outside the Jailhouse

The scene outside the jailhouse is set in the evening. The 'Degüello' is still playing. As Chance begins to light the lamp outside the jailhouse, Dude, who has been on guard on the outskirts of the town, rides up and dismounts. At this point in the film, Dude seems to be recovering. He is still a little dishevelled (and he still occasionally rubs the stubble on his face). But he has sided with Chance in arresting Joe, played a key role in pursuing and killing Wheeler's assassin, performed his other duties with competence and care – and he now drinks beer not whisky. The harmony that characterises the relationship between Dude and Chance is at this point particularly marked, not just in the words that they exchange, but, as we shall see, in the choreography of actions, stances and movements that accompany them.

Having dismounted, Dude is framed in moving medium-long shot as he walks from left to right, bringing Chance into frame as Dude confirms that 'it's getting too dark to do any good. I'd just be a sitting duck.' By the time these lines have been delivered, the camera has stopped panning. Dude has walked past Chance and is now standing on the right. Chance is standing on the left. Both have their backs to camera as Chance asks whether anything has happened since Nathan Burdette left. As he does so, both turn from right to left at exactly the same time, Dude to face Chance, Chance to watch the match he has used to light the lamp as he flings it into the foreground.

'Nice as pie,' says Dude, describing Burdette's conduct, 'Didn't say a word.' By the time this line is completed, Chance has turned to look at Dude. They are now facing one another, the former framed in profile looking back from right to left, the latter head on and looking centre-left. Both are also now resting their right hands on or near the pistols in their holsters and their left hands on their hips. Chance asks, 'What was the shot when they came in?' As Dude replies, he moves his right hand from his hip, extends it into the foreground while letting his left fall by his leg, then returns his hands to his hips as he asks whether anything happened in or near or the jail. Chance replies, 'Not much.' At the same time, he turns to direct his gaze off-screen foreground right. The 'Degüello' is still playing and now becomes the object of his attention. He raises his right arm and gestures briefly off-screen right as he asks about the music. As he does so, he steps further into the foreground, his hands now on his hips, and Dude, his hands still on his own hips too, turns to look off-screen right as well. As Dude begins to identify the title and nature of the music, Chance steps forward to rest his right arm against a wooden pillar. Then both men hear the sound of someone approaching and turn in unison to look off-screen left. The person approaching is Colorado who asks about Nathan Burdette and who explains more about `Degüello`. Colorado is standing in the street, and Dude and Chance are still on the boardwalk outside the jail. Dude and Chance have their hands on their hips again, the former still in the doorway, the latter now leaning against the wooden pillar. We cut to a two-shot of Chance and Colorado framed from over Chance's shoulder, then to a medium shot of Colorado in the street looking up at Chance, with Dude still slightly further back on the right. Colorado's status as an outsider, albeit a friendly and helpful one, is here marked by the staging and the framing. As he leaves and the scene concludes, Chance and Dude turn to the right and walk toward the open door behind them in perfect unison, their right arms swinging, in equally perfect unison, as they enter the jail.

It was this particular scene that initially alerted me to the choreography of gestures, movements and stances in *Rio Bravo*, and especially to the ways in which it functioned not only to reveal the conditions and states of mind of individual characters at various points in the film, but also to show their compatibilities and incompatibilities and the established or evolving nature of their relationships. Thus at this point in the film, the scene outside the jail serves not only to provide more information about the 'Degüello', nor only to reinforce Colorado's status or Dude's rehabilitation, but to reinforce the fundamental compatibility between Dude and Chance as well. This compatibility is evident in the nature of their conversation. But it is marked above all by the patterns of unison and harmony apparent in the staging and performance of their actions and stances. For someone who claimed that a director should 'try not to annoy the audience', Hawks both here and elsewhere courted the possibility of overt stylisation – and hence of annoying audiences with self-conscious aesthetic devices.[18] The fact that he manages not to is largely due to the informal gestural vocabulary he employs and to the temporary rather than prolonged or static nature of the gestural patterns he so carefully constructs.[19]

Notes

1. Joe McElhaney, 'Howard Hawks: American Gesture', *Journal of Film and Video* vol. 58 nos 1/2 (Spring/Summer 2006), pp. 31–45.
2. Ibid., p. 35.
3. Ibid., p. 37.
4. Ibid., p. 42.
5. Ibid., pp. 42, 43.
6. John Belton, 'Hawks and Co.', in Joseph McBride (ed.), *Focus on Howard Hawks* (Englewood Cliffs, NJ: Prentice-Hall, 1972), pp. 94–108.
7. Ibid., pp. 94, 95.
8. Ibid., p. 95.
9. Ibid., p. 97.
10. Ibid., p. 104.
11. Ibid., pp. 104–5.
12. Todd McCarthy, *Howard Hawks: The Grey Fox of Hollywood* (New York: Grove Press, 1997), p. 558. On the same page, McCarthy reveals that Hawks 'decided to give him something [else] to do with his hands, notably rubbing the side of his nose with his index finger to show he was thinking, as [Montgomery] Clift had done in *Red River* [1948]'.
13. The gestures used by Carlos and Consuela are based on the stereotype of the excitable Mexican. Robin Wood's comments on Carlos are instructive here: 'I feel myself,' he writes, 'that Hawks is entirely free of racial feeling; with Carlos, with the Dutchman in *Only Angels Have Wings*, with the French-Canadians in *The Big Sky*, he is simply taking over genre-figures … and building on them. … He takes the stock figure of the comic, cowardly, gesticulating, garrulous Mexican and, by eliminating the cowardliness while playing up the excitability, builds up a character whose dauntlessness and determination win our sympathy and respect even as we laugh at him. Hawks's handling not only revives and humanises the stock type, but greatly increases his dignity and (moral!) stature.' Robin Wood, *Howard Hawks* (London: Secker & Warburg/BFI, 1968), p. 43.
14. John Belton, 'Howard Hawks', in *The Hollywood Professionals Vol. 3: Howard Hawks, Frank Borzage, Edgar G. Ulmer* (London: Tantivy Press, 1974), p. 47.
15. Ibid., pp. 48–9.
16. According to McCarthy, the first part of the opening sequence was 'lifted' from Joseph von Sternberg's late silent gangster film *Underworld* (1927), co-scripted by Jules Furthman, who worked with Leigh Brackett and Hawks on *Rio Bravo*'s script. McCarthy, *Grey Fox*, p. 551.
17. Of course, we do not know the names of any of the characters on a first viewing of the film's first two segments. We respond to the characters as we encounter them and we scrutinise what they do and how they do it, though we also respond to the personae as well as the performances of well-known stars such as Dean Martin and John Wayne.
18. Quoted in Joseph McBride and Michael Wilmington, '"Do I Get to Play the Drunk This Time?" An Encounter with Howard Hawks', in Scott Breivold (ed.), *Howard Hawks: Interviews* (Jackson: University of Mississippi Press, 2006), p. 63.

19. Informality and the absence of prolonged or static postures and gestures are crucial to Hawks's aesthetic. This is one reason why *Land of the Pharaohs* (1955) is largely unsuccessful. Hawks himself claimed that one of the reasons for its failings was that neither he nor screenwriters William Faulkner and Harry Kurnitz knew how pharaohs talked. See Joseph McBride, *Hawks on Hawks* (Berkeley: University of California Press, 1982), p. 60. This indeed was a problem. But the fact that Hawks did not know how pharaohs, slaves and servants posed, moved or gestured, and the fact that the court settings dictated formal protocols that left little room for spontaneous or individualised gestures, were in my view even more important. It is often said that the teams, groups or couples in Hawks's films constitute elites. If so, the compatibility of their members is marked not by formalised rituals, but by informal ones based on modes of speech, exchanges of dialogue, dedication to a task and the performance of gestures, movements and actions.

PART 4
HAWKS AND GENDER

7 'A Travesty on Sex'
Gender and Performance in *Gentlemen Prefer Blondes*

Ellen Wright

When discussing his 1953 musical *Gentlemen Prefer Blondes*, director Howard Hawks professed that he found it 'ironic' that audiences found the performances of its two female leads – Marilyn Monroe and Jane Russell – to be sexy: 'Actually to me they were very amusing,' he said, 'and it was a complete caricature, a travesty on sex.'[1] The film is more frequently discussed as a Marilyn Monroe vehicle than as a Hawks film.[2] When it is discussed in terms of Hawks's career, *GPB* is usually sidelined as not bearing his auteur stamp, despite the presence of his familiar themes, styles and performers.[3] The film is also often seen as generically atypical for Hawks, although while it is his only musical – discounting *A Song Is Born* (1948), which is not really a musical at all – it is also very much a comedy.[4] *GPB* has also been regularly dismissed as a relative 'failure' which – commercially at least – it certainly wasn't.[5] 'It has always been challenging for critics to fit the film into the context of Hawks's career,' suggests Hawks's biographer Todd McCarthy. Taken together with the director's *Monkey Business* (1952) and 'The Ransom of Red Chief' – one of the episodes in the portmanteau film *O'Henry's Full House* (1952) – McCarthy sees Hawks's 'early 1950s Fox period' as one 'of the least interesting of his career'.[6] None of these claims bears close scrutiny and in response to them I want to suggest that it is Hawks's own notion of travesty – a parodic or mocking performance of sex, sexuality and gender – which lays at the comedic, narrative and thematic heart of *GPB*.

This chapter will analyse the production in its historical context and with particular regard to an under-investigated concept: the performance of femininity. First, I look at how Russell and Monroe's notoriety as pin-ups was factored into the representations of femininity in *GPB*, and how Hawks (and Fox) mobilised those pin-up identities in both the film and its promotion. Second, I examine the stylised performance of femininity in *GPB*.

Pin-Ups: Jane Russell and Marilyn Monroe
Hawks was a director who liked to return to performers with whom he had worked successfully before and both leads in *GPB* were already known quantities to him. He had worked briefly with Russell in *The Outlaw* (1943), before being replaced by Howard Hughes, and with Monroe on *Monkey Business* the year before *GPB*. Discussing the preparation for *GPB*, Hawks said:

I had more or less a free hand, and it had the ingredients I thought a musical ought to have. The play was good and I am very fond of Jane Russell, so as soon as they got her in the thing was easy.[7]

This begs the question of what exactly Hawks felt Russell's (and Monroe's) star persona and performance style would bring to his recipe for a 'travesty on sex'. Both actors came to public prominence through high-profile scandals surrounding their respective reputations as erotic female spectacles. In Monroe's case, there was the infamous disclosure that she had been the subject of a nude photo shoot; in Russell's, there had been a salacious promotional campaign for her first film, *The Outlaw*. It is significant that at the time of the release of *GPB*, both Russell and Monroe still possessed greater cultural currency – and notoriety – as film-star pin-ups than as actors.

The pin-up photograph was a standard form of Hollywood representation, particularly during the studio era, an important constituent of what Richard Dyer terms 'the total star text'.[8] While desirability was a crucial component, pin-ups were more than just sexualised images. They were also intended to market the broader personality traits, associations and appeals that coalesce to form a star persona. They can subsequently be seen in relation to the more expansive discourses of representations surrounding the featured star.[9] As Maria Elena Buszek has argued, pin-up imagery can present an 'awarish' – that is, a deliberate, self-aware and self-confident – performance of sexualised femininity.[10] And, as cultural icons who were both adept at and strongly associated with such stylised performances, Russell and Monroe consequently were obvious casting choices for Hawks and Fox, not only to carry a narrative premised upon the economic and symbolic rewards offered by the effective performance of desirable femininity, but also for a director whose comedies frequently inverted and burlesqued gender roles and relations.

Despite Russell's first film, *The Outlaw*, being granted a Production Code Seal of Approval on 23 May 1941, it did not premiere until 5 February 1943, nor go on nationwide release until 1946. In this intervening period, and in the absence of a film to exhibit, the producer and eventual director of the film, Howard Hughes, embarked upon a costly and shameless advance publicity campaign centred heavily upon Russell's sexual allure.[11] Following objections to the film's advertising from the Motion Picture Association of America (MPAA), Hughes filed a suit for damages against the Association. Some of the provocative gimmicks exploited in his advertising campaign were cited in court proceedings. For example:

Late in April, 1946, it is alleged, and not denied, a sky-writing airplane wrote the words "The Outlaw" in the sky over Pasadena, and then made two enormous circles with a dot in the middle of each.

Also featured were such lewd slogans as: 'How would you like to tussle with Russell?' and 'What are the two great reasons for Jane Russell's rise to stardom?'[12] The MPAA objected to the film's 'outrageous' advertising as a 'violation of the industry's self-imposed

Jane Russell as Rio in one of the notorious 'hay' shots for
The Outlaw (1943), part of Howard Hughes's
'shameless' advance publicity campaign (BFI)

standards of good taste'.[13] Unperturbed, Hughes's campaign brazenly incorporated material from this censorship backlash into the film's promotional materials, simultaneously presenting Russell as the metonymic signifier of sex within the film's narrative. As Mary Beth Haralovich notes of the film's San Francisco premiere: 'A 24-sheet billboard consisted of a "full-length picture of Miss Russell, half recumbent and equivalently revealed in a sultry moment on a mound of hay" with the copy: "The picture that couldn't be stopped."'[14] Several of these pictures featured restaged 'hay' shots of Russell, many of them by the Hollywood glamour photographer George Hurrell.[15] The word 'picture' carried a dual implication here as both the motion picture itself and Russell's pin-up, which together had gathered overwhelming and seemingly irresistible media momentum with appearances in numerous publications from *Esquire* to *Ladies' Home Journal*.[16] These pictures made Russell a hugely popular wartime pin-up. By the end of the war, as Frank Miller suggests, 'she was a major star, even though nobody outside of San Francisco and a few local censor boards had seen her in the movies'.[17]

Russell's next film, *The Young Widow*, wasn't released until 1946 so, while her first film remained inaccessible, her pin-ups were ubiquitous, reinforcing in the public imagination the notion that her star persona was that of a Hollywood pin-up rather than that of an actor. As one magazine, *Show Girls*, put it some four years after the *Outlaw* ballyhoo began: 'Queen of all pin-ups is Jane Russell, glamorous Hollywood star who has never been in a motion picture. Jane's first cinematic vehicle, the much-censored *Outlaw*, is soon to be released.'[18] This 'pin-up' ideal became the foundation for Russell's subsequent star persona, shaping the roles she was later offered. For example, promotional materials for Paramount's *Son of Paleface* (1952) utilised a range of cheesecake images of Russell, many of which were literally 'pinned-up' within the poster image graphics. In one instance, the movie-poster insert (a fourteen by thirty-six inch format), utilised six 'pinned-up' images of Russell in recognisably 'awarish' cheesecake poses. The poster campaign for Russell's film immediately after *GPB*, RKO's *The*

French Line (1954), took a more direct approach, again with designs approved by Hughes: 'J.R. in 3D: Need we say more?' Then, sadly, they did: Hughes 'promised that the film would knock *both* your eyes out!'[19] Similarly, Bob Hope, Russell's Paramount co-star in the *Paleface* films – the original was *The Paleface* (1948) – and *Road to Bali* (1952), described her as 'the two and only Jane Russell' and also quipped that 'culture is the ability to describe Jane Russell without moving your hands'.[20] Even by the standards of the time, Russell was subject to such an extraordinary degree of bodily objectification that, as these quotations suggest, she became culturally defined as a sex object.

Being explicitly and repeatedly linked to pin-up sexuality was also a crucial element of Monroe's star persona and promotion. As Richard Dyer has discussed:

> Monroe = sexuality is a message that ran all the way from what the media made of her in the pin-ups and movies to how her image became a reference point for sexuality in the coinage of everyday speech. … She started her career as a pin-up, and one can find no type of image more single-mindedly sexual than that. Pin-ups remained a constant and vital aspect of her image right up to her death, and the pin-up style also indelibly marked other aspects, such as public appearances and promotion for films. The roles she was given, how she was filmed and the reviews she got do little to counteract this emphasis.[21]

Monroe's association with sexualised female imagery was first established in the public imagination by her appearance in 1948 in a series of nude photographs entitled 'Golden Dreams', which subsequently featured in several pin-up calendars. Even outside America her nude scandal was infamous. The widely syndicated gossip columnist Hedda Hopper referred to Monroe in her 1953 British *Photoplay* interview with the star as 'America's best undressed woman'. Hopper then proceeded to emphasise the notorious incident for her British readers: 'Naturally the first thing I asked about was her posing in the nude for the now-famous calendar.'[22]

But while public interest in Russell's *Outlaw* scandal had waned by the release of *GPB*, the scandal surrounding Monroe's 'Golden Dreams' pictures was still ongoing. As Dyer points out, 'in March 1952, the fact that this image was of an important new Hollywood star became a major news story'.[23] Just sixteen months later, *GPB* premiered, on 15 July 1953. Only five months after this, while the film was still on general release, the first edition of *Playboy* was launched with the 'Golden Dreams' image as its centrefold.[24]

Bearing this cultural context in mind, we should also remember that both women initially found fame as pin-ups during the World War II era when such images were in common circulation, especially among servicemen.[25] Monroe had been working in one of the war industries in LA when in the autumn of 1944 a crew of photographers from the Army's First Motion Picture Unit arrived at the factory in order to take morale-boosting photographs of women working on the assembly line. The photographs were intended not only for publications like the wartime Army weekly *Yank*, but also for commercial

magazines. Monroe subsequently found herself in high demand as a model and by the spring of 1946 she had appeared (as Norma Jeane Dougherty) on the covers of thirty-three magazines including *U.S. Camera*, *Parade*, *Glamorous Models*, *Personal Romances*, *Pageant*, *Laff*, *Peek* and *See*.[26] Monroe's emergent cover-girl image at this time prefigured her pin-up identity and subsequent stardom, just as Russell's magazine coverage had done.

Such was the ubiquity of the pin-up at this time that it formed a significant part of the iconography of wartime, displayed in Army camps and barracks across the world. This, as Robert Westbrook has pointed out, was in contrast to the 'naughty postcard' that American troops brought back from France in World War I, but rather 'circulated above ground' and with 'official sanction'. Pin-ups of stars such as Russell frequently decorated military hardware 'where they competed with and upstaged the insignias of state'.[27] Pictures of film stars such as Rita Hayworth depicted the epitome of Hollywood glamour while those of Betty Grable – the most popular wartime pin-up – presented her as the girl next door back home (not that the girl next door would be wearing that improbable combination of swimsuit and high heels).[28] These pin-ups were emulated on the home front where, as Elaine Tyler May points out, 'women sent their husbands and sweethearts photos of themselves in "pinup" poses'. Indeed, 'Grable herself urged women to send their men photos of themselves in swimsuits, to inspire them to fight on and come home to an erotically charged marriage.'[29]

The pin-up would become the focus for feminist concerns about sexualised representations of women. As an image of female sexuality on display for (masculine) consumption, it has often been seen as a site of oppression for women who are 'obviously' objectified by such images. However, as Joanne Meyerowitz has pointed out: 'As sexual images of women multiplied in the popular culture, women participated actively in constructing arguments to endorse as well as protest them.'[30] If women were 'objects of sexual representation', says Meyerowitz, they were also 'engaged and embattled participants in the construction of sexual meanings'. In debates about certain types of sexual image, some women 'welcomed a visual rhetoric that they read as a positive post-Victorian rejection of bodily shame and a healthy respect for female beauty'.[31] Similarly, in her cultural history of the pin-up, Maria Elena Buszek has argued for an alternative reading of the genre, one that recognises the subversive or transgressive potential in pin-up images:

As an image where explicitly contemporary femininity and implicit sexuality are both synthesized and intended for wide circulation and public display, the pin-up itself is an interesting paradox. It represents a space in which a self-possessed female sexuality is not only imaged but also deemed appropriate for exhibition. Yet Western mores have, since the rise of the pin-up, preserved the subject and display of self-aware, contemporary female sexuality as one for consumption that is private and guarded, if not downright threatening and therefore taboo. Is it possible, then, that the very representation of female sexuality can be interpreted not only as subordinate to oppressive cultural mores but also as potentially subversive?[32]

World War II pin-ups could appear as 'defiantly modern',[33] especially in the context of women working in the new war industries, exemplified by the iconography of 'Rosie the Riveter', discussed below.[34] With a wartime imperative to recruit a large female workforce, a magazine campaign coordinated by the new wartime agency, the Magazine Bureau, sought not only to encourage women to take up jobs in the war industries, but also to counter traditional prejudices against working women. 'To these ends,' writes Maureen Honey,

> the Magazine Bureau provided publishers with photographs of and detailed reports on women who had entered non-traditional fields in order not only to publicize those occupations but to saturate the media with new portrayals of women, images more appropriate to wartime demands.[35]

Pictures of working women did indeed 'saturate' the print media. One of the most popular was Norman Rockwell's famous *Saturday Evening Post* cover featuring 'Rosie the Riveter'.[36] Wartime produced a paradigm shift in the social and economic life of women and challenged prevailing attitudes about traditionally gendered patterns of labour. Images of working women became part of a discourse of patriotism. As Richard R. Lingeman suggests:

> It was almost *necessary* to the country's patriotic *amour proper* to see these pictures and newsreels of grimy-faced girls in slacks, handkerchiefs or turbans on their heads, doing unglamorous physical labor beside men, making a V for Victory sign as they drove their tanks off the production line to the testing ground. Working women became part of the human strength of the nation.[37]

Many of these women, employed outside the home for the first time, found themselves financially independent for the first time in their lives, and took advantage of opportunities that allowed them to grow more assertive and self-aware. But if there was an ideological imperative to reassign women from a domestic to an industrial role, this demographic shift engendered a change in sexual mores too. As Buszek describes it: 'A new kind of sexual ideal in which the independence, self-esteem, and ambition that the nation sought to groom in female workers spilled over into their sexual identities as well.'[38]

It is in the context of this 'new kind of sexual ideal' that we can situate the female leads of *GPB*. The identities of Russell and Monroe as, respectively, established and emergent film-star pin-ups, clearly function within both the narrative of *GPB* and its advertising as integral signifiers of a conventionally sexualised yet incipiently transgressive femininity and sexual agency. Cheesecake poses were commonplace in the popular media of the 1950s and the print advertising for *GPB* exploits a range of archetypal pin-up poses. These include rump-to-camera, 'a side-on tits and arse positioning',[39] hand-on-hip or hand-in-hair, often with revealing showgirl costuming. However, contextual features suggest that these images were simultaneously intended to capitalise upon Russell and Monroe's scandalous cultural currency. A full-page colour advertise-

ment appearing simultaneously in the industry publications *Box Office* and *Variety* alludes to both women's notoriety, featuring only a full-length shot of Russell and Monroe in showgirl costumes and heels situated above the text, 'THE BIGGEST ATTRACTION IN THE INDUSTRY TODAY!'[40] Another full-page advert in *Variety* features a three-quarter-length shot of Russell and Monroe, rump-to-camera, exclaiming 'The screen's two biggest attractions in one smash musical!'[41]

The *New York Times* reviewer Bosley Crowther was one of several critics who drew on the rhetoric of innuendo that frequently characterised commentaries on the two stars, making sardonic reference to their 'famous charms' and to 'the well-defined construction and the outgoing natures of the girls'. He also archly described Monroe as 'finding it difficult, for anatomical reasons, to squeeze her way through a porthole'. For Crowther,

> there is that about Miss Russell and also about Miss Monroe that keeps you looking at them even when they have little or nothing to do. Call it inherent magnetism. Call it luxurious coquetry. Call it whatever you fancy. It's what makes this a – well, a buoyant show.[42]

Crowther is alluding to a line in the film in which one of the characters asks of another which of the two women he would save from drowning if the ship sank, to which his companion replies: 'Those girls couldn't drown.' In similar rhetorical vein, a *Variety* correspondent described 'the *quadruple* threat of Jane Russell and Marilyn Monroe' [my emphasis].[43]

Given Russell and Monroe's pin-up notoriety and the public preoccupation with their physiques, the promotional materials for *GPB* presented its stars according to pin-up conventions while simultaneously exploiting their scandalous renown. Although these representations are, according to Buszek's term, 'awarish', this is not to suggest that they are necessarily subversive nor a 'travesty' *per se*. This is because these still, extracted images lack narrative context and can therefore can be read as self-contained or complete texts in their own right, readily lending themselves to readings informed by traditional misogynist rhetoric. In other words, they work by breaking down the components of film image, advertising and performer into a series of consumable body parts. However, in the moving picture of the film's narrative, Hawks sets these women and the characters they play within social and political context, generating a range of additional meanings and enacting a more nuanced and satirical treatment.

Performing Femininity
Laura Mulvey observes of Monroe's performance as Charles Cockburn's 'dumb blonde secretary' in Hawks's earlier comedy *Monkey Business*:

> On the screen, she acts out pure pin-up fantasy for the spectator and, in the story, for Charles Cockburn. With hindsight, she exists, even then, on the edge between *acting* a part and *being* the living sex symbol.[44]

Mulvey observes: 'by the time of *Gentlemen Prefer Blondes*, Russell was a major star, Hollywood sex symbol *par excellence*, and big enough box office to carry the relative newcomer, Marilyn Monroe'.[45] The enactment of these sex-symbol roles can be seen in terms of gender performance through which gender roles can be subverted even as they are being enacted. We can see here how Monroe and Russell are articulating a kind of feminine excess – as sex symbols *par excellence* – as the wider personas and performances of both women work as signifiers within both the narrative and the promotion of *GPB*. Here they enact, purposely or not, a performance of gender which destabilises and denaturalises the construct of femininity, as well as drawing attention to the skills with which that gender is performed.

Such concerns with the performance of gender were already being picked up by feminist film scholars in the 1970s. As Molly Haskell has observed of Hollywood's 'sex goddesses,' such roles were not necessarily played 'with a straight face' but might well contain comedic self-parody, such as in Pola Negri's 'vamping'. 'More often than not,' says Haskell, 'they were consciously playing a role, or "playing up" to a role.' Moreover, in a telling comparison to what she describes as 'the nigger antics of Stepin Fetchit', Haskell sees in these performances of femininity 'a subtle, skin-fitting camouflage by which not the slave but the master … is slyly ridiculed'.[46] While Haskell acknowledges that this is a strategy 'played out on a tightrope',[47] such a performance of femininity is self-aware of its contrariness. It is a performance which intends to misrepresent, either as a subversive or resistant act, or otherwise to misdirect as an act of self-preservation against the punitive consequences of failing to perform gender 'correctly', that is, in accordance with the prescribed mores and conventions which have determined how femininity should look or behave.

The performances in *GPB* have often been seen as 'parody', 'satire' and 'travesty', terms with subtly different implications, although with the common thread between them of being a notion of imitation with the intention to mock. However, they may not necessarily be read in this way. Certainly, there are numerous instances in which the performances of Russell and Monroe have been interpreted as 'straight' attempts to play up to stereotypical versions of femininity rather than to play against them. Robin Wood is one of several critics to see the performances in such terms:

> The women in Hawks's films, for all their vividness and idiosyncrasy, are clearly conceived from the male viewpoint: one would not wish to claim that women find a 'voice' in the films that is not male-determined. This is as true of the one Hawks film centred on women, *Gentlemen Prefer Blondes*, as of the rest: Marilyn Monroe and Jane Russell are there very clearly the embodiments of contrasted yet complimentary male fantasies.[48]

Molly Haskell, however, suggests a different reading of the women in the film, one that derives from feminist film theory and criticism of the 1970s. In her seminal study of women in film, *From Reverence to Rape*, Haskell takes issue with feminist writer Gloria Steinem who, claims Haskell, 'can write an intelligent and sympathetic article on Marilyn Monroe, and yet miss the satirical point of Howard Hawks' *Gentlemen Prefer*

Blondes, which consciously exposes Monroe's ooh-la-la image and the men who collaborate to maintain it'.[49] But while Russell and Monroe's femininities are indeed 'embodiments of … male fantasies', displayed within a male-directed text, Wood misses the point that these women were also contributing authors of that text. They can be justifiably credited as 'co-authors' not only through their performances and the particular resonances that each star persona brought to the text, but also through the contributions they both made on the set in the characteristic collaboration Hawks encouraged. Here, Monroe can be seen to expose, through satire and self-parody, the very artifice in her performance *of* Monroe.

Satire is generated in *GPB* in two ways. First, through the deliberately exaggerated performances of idealised, white, Western femininity: the sexually assertive, wise-cracking Amazonian (Russell) and the girlish but calculating virgin with 'mincing speech and wide-eyed wonder' (Monroe).[50] Second, through the typical Hawksian gender inversion by which the sexual and intellectual potency of the men in the narrative is repeatedly undercut. This is a characteristic trope in Hawksian comedy, as Laura Mulvey has pointed out: 'The theme of infantilism and male impotence that runs through certain Hawks comedies is diffused across the whole of *Gentlemen Prefer Blondes*, affecting its cinematic and comic aesthetic'.[51] Here, then, mockery is directed primarily towards the foolish men who buy into such constructs while being themselves no match sexually or intellectually for these women.

Hawks's 'travesty on sex', then, is a travesty of such gender constructions and the prevailing social and sexual mores that support them. As Hawks himself stated:

> We purposely made the picture as loud and bright as we could, and completely vulgar in the costumes and everything. No attempt at reality. We were doing a musical comedy, pure and simple…. There's no reality in the thing: the girls were unreal; the story was unreal; the sets, the whole premise of the thing was unreal. We were working with complete fantasy. I used to laugh every time I'd make a scene with those two walking together – white hair and black hair – they were just such complete caricatures.[52]

These performances by the female leads exploited caricature in a narrative rendered as unreal, exaggerated and incongruous.

Beyond the more obvious characteristics of the Hawksian 'voice', suggests Molly Haskell, there is often a gendered binarism at work,

> a feeling for character which, while rooted in sex-role expectations, goes beyond these to the reversals that are … the source of humor and peril in Hawks' view of a world precariously divided between the male and female principles. The masculine and feminine instincts are locked in perennial combat.[53]

In *GPB*, we can see in Monroe/Lorelei the evocation of universally recognisable feminine archetypes. These include the 'Dumb Blonde', with her connotations of dependency and passivity, and the 'Duplicitous Woman', whose seemingly witless and

deliberately contrived feminine façade actually disguises an intelligence and ambition, which allow her to get the better of her male counterparts. We should also bear in mind another archetype as well as the provenance of Hawks's film: the original character of Dorothy Shaw in the novel by Anita Loos.[54] As Laura Mulvey has pointed out, 'Jane Russell, with her tough, wise-cracking persona and straightforward, assured sexuality, has a lot in common with the type of 20s new woman that Anita Loos liked and used as a basis for Dorothy's character.' Moreover, both Russell and Dorothy, 'have a lot in common with the independent, sexually assertive women who appear in so many different Hawks films that they have condensed into the "Hawksian woman" – tough, smart and sexually experienced'.[55] Unlike Lorelei, Dorothy makes explicit her experience and intelligence (and her troublesome proclivity to match or to beat men). Her quick-witted verbal dexterity, particularly her witty asides or interior monologue, serves to reveal her sexual and intellectual potency.

At the same time, any sexually competitive threat to her fellow *female* characters is neutralised in various ways: by her sisterliness towards Monroe's Lorelei; by the way she acknowledges and includes female bystanders in numbers such as 'Bye Bye Baby' and 'Ain't There Anyone Here for Love'; and through her *bons mots*. By these means, Dorothy's transgressive *modus operandi* works as a challenge to *male* characters (but not to female ones). There is a deep and inviolable relationship between Lorelei and Dorothy. As Lucie Arbuthnot and Gail Seneca have pointed out, this relationship is characterised by 'the absence of competitiveness, envy and pettiness. Commercial films rarely depict important friendships between women,' they say, and 'when they do, the friendships are marred or rendered incredible by the film's polarization of the two women into opposite and competing camps.'[56] But in *GPB*, that 'important' friendship remains central, continuously and repeatedly emphasised through the way Hawks shoots all their scenes. As Gerald Mast describes it:

> Hawks ... conveys the essential spiritual similarity of the two women with his camera, which balances them perfectly in every frame they share; they occupy symmetrical halves of the frame, sitting still or stealthily moving (underscored by the familiar movement of Hawks's tracking camera) in perfectly framed unison.[57]

For those critics who discountenance the film as 'unHawksian' and who prefer instead the values of those Hawksian groups to be found elsewhere, it is difficult to think of any more powerful bond of friendship in a Hawks film than that between Dorothy and Lorelei.

This relationship represents a kind of bulwark against their more ostensible narrative ambitions: the pursuit of men. This has much in common with Peter Wollen's observation about Hawks's screwball comedies, in which 'relationships between men

'We were working with complete fantasy'. Marilyn Monroe with Hawks on the set of *Gentlemen Prefer Blondes* (1953) (BFI)

and women are portrayed as parodic versions of the relationships between predator and prey, full of outrageous innuendo and double entendre'.[58] Examples include the reasoning behind Dorothy's interest in the male Olympic team: 'I like a man who can run faster than I can,' she says. This is clearly a sexual metaphor, indicating a desire to be caught, but only after a challenge and – as a measure of her own 'sporting' prowess – an Olympic challenge at that. Or perhaps most tellingly is her proclamation, ostensibly to Gus Esmond (Tommy Noonan), but actually *through* him, with a deliberate flourish to the audience: 'The chaperone's job is to see that nobody *else* has any fun, but *nobody* chaperones the chaperone. That's why I'm so *right* for this job.' Dorothy's reasoning raises the question of who will guard the guardians. Here, Dorothy places herself outside the narrative's system of power and control, not only announcing herself as the unruly woman – unable and unwilling to exercise restraint, but also as the figure of the fool or jester – one permitted to speak truth to power, her sharp-witted commentary addressed directly to the audience, undermining the authority of those in power. Nowhere is this more evident than in the courtroom scene, with its travesty of the criminal justice system, whereby Dorothy impersonates Lorelei in a carnivalesque disruption of court proceedings. Here, the very nature of the imitation of the defendant, through Dorothy's exaggerated impersonation of Lorelei's exaggerated impersonation of herself, ridicules the masculine enclave of the power of the court.

In her discussion of the 'unruly woman', Kathleen Rowe briefly considers *GPB*, making a comparison between the performance and star persona of Monroe and of fellow 'blonde sex goddess' Mae West:

> Both control men through their sexual allure, but each represents a radically different conception of sexuality and the power relations between the sexes. West presents her sex appeal as something she is acutely aware of. Monroe's sex appeal, on the other hand, is tied to its apparent artlessness and innocence … . In Monroe, 'natural' female sexuality, in contrast to West's more stylised sexuality, appears entirely oriented towards male pleasure … . Monroe, unlike West, derives her sex appeal from weakness rather than strength.[59]

If Monroe plays a 'natural' sexuality here,[60] the heightened artificiality in her bodily acting and vocal delivery make for a highly exaggerated performance style in keeping with Hawks's 'unreal' film. In contrast, the comedic assertiveness and knowingness of West's star persona suggested by Rowe are similarly applicable to Dorothy's 'straight-man' characterisation and linked to the 'sexpot' star persona which had been attributed to Russell. There is also a sense in which Monroe's self-satirising of her sexuality was prefigured by West's own star persona which was itself based on a parody of a sex goddess. West's self-mocking burlesque performances can be seen in the handful of films she made before the strictures of the Production Code curtailed the excesses of her act. For example, *She Done Him Wrong* (1933), Paramount's screen version of her 1928 Broadway hit *Diamond Lil*, a *succès de scandale*, included such suggestively assertive numbers as 'I Like a Guy What Takes His Time' and 'I Wonder Where My

Easy Rider's Gone'. Moreover, Russell's knowing *bons mots* are also reminiscent of West's, whose epigrammatic wit is used in a forthright way to express female sexual desire on her own terms, terms which invariably conveyed a powerfully developed sense of female desire and which often denigrated the sexual inadequacies of male lovers. For example, Dorothy's reaction on discovering she will be sharing a liner with America's male Olympic team: 'The whole Olympic team Just for me? Wasn't that nice of someone?' Dorothy's quip is a knowing rejoinder to the 'sexpot' label assigned to Russell in the popular media.[61] While Russell had previously been marketed to virile young servicemen through pin-up images as billet or bedroom adornments (and, doubtlessly, as masturbatory aids), here Hawks threatens to deliver a fully realised version of the unruly, sexually voracious woman that the *Outlaw*'s promotion merely promised. Yet, in a complete comic reversal, we see the entire team of virile young men rendered ludicrously incapable of measuring up to the sheer scale of Dorothy's sexual desire.

Critics tend to mark down *GPB* as an atypical Hawks film and often as scarcely 'Hawksian' at all. Indeed, Wood placed it in an appendix of 'Failures and Marginal Works'.[62] It was his only musical comedy – excepting *A Song Is Born*, another poorly regarded Hawks film – and the only Hawks film with a female-centred narrative and, moreover, one which contravenes Hollywood's archetypal heterosexual romance in such a way as to appear queer.[63] In marked contrast to the characteristic 'Hawksian group', the men in *GPB* are consigned to secondary roles in which they variously appear as weak, ineffectual, juvenile or decrepit, all of them impotent characters. Hawks's 'travesty of sex' culminates – unusually for him – in a wedding, but here too the conventional happy ending is not quite what it seems. As Dorothy and Lorelei are getting married to their respective partners in the double wedding ceremony, Hawks shoots the scene with a tracking shot so that the bridegrooms, situated towards the edges of the frame, become excluded altogether as the focus shifts to the two women side-by-side who, sharing a glance, look as if they are getting married to each other which, by way of this Hawksian travesty of sex, they are.

Notes

1. Quoted in Peter Bogdanovich, 'Howard Hawks: The Rules of the Game', in *Who the Devil Made It? Conversations with Legendary Film Directors* (New York: Ballantine, 1997), p. 352.

2. Donald C. Willis, for example, sees the film as 'just a showcase for her'. Willis, *The Films of Howard Hawks* (Metuchen, NJ: Scarecrow Press, 1975), p. 148.

3. There is an interesting question about Hawks's 'stamp' in *GPB*. In contrast to his usual hands-on approach, Hawks delegated responsibility for the film's musical sequences to choreographer Jack Cole. According to various members of the cast and crew, Hawks himself had nothing to do with the production numbers and wasn't even on the set when they were filmed. Who, then, actually directed these sequences? According to Cole's assistant Gwen Verdon, it was Cole who decided on camera placement and cutting in consultation with director of photography Harry J. Wild and editor Hugh S. Fowler. See

Todd McCarthy, *Howard Hawks: The Grey Fox of Hollywood* (New York: Grove Press, 1997), pp. 504–5, 508–9.

4. See, for instance, François Truffaut, *The Films in My Life*, trans. Leonard Mayhew (London: Allen Lane, 1980), p. 71; Laura Mulvey, '*Gentlemen Prefer Blondes*: Anita Loos/Howard Hawks/Marilyn Monroe', in Jim Hillier and Peter Wollen (eds), *Howard Hawks: American Artist* (London: BFI, 1996), p. 217.

5. See, for instance, Robin Wood, *Howard Hawks* (London: Secker & Warburg/BFI, 1968), pp. 170–2; Peter John Dyer, 'Sling the Lamps Low', *Sight and Sound* vol. 29 no. 4 (Summer 1962), repr. in Joseph McBride (ed.), *Focus on Howard Hawks* (Englewood Cliffs, NJ: Prentice-Hall, 1972), pp. 90–1.

6. McCarthy, *Grey Fox*, p. 510.

7. Bogdanovich, 'Howard Hawks', p. 352.

8. That is, 'as read across all her/his different media manifestations'. Richard Dyer, *In the Space of a Song: The Uses of Song in Film* (London: Routledge, 2012), p. 85.

9. For further discussion, see Ellen Wright, 'Female Sexuality, Taste and Respectability: An Analysis of Transatlantic Media Discourse Surrounding Hollywood Glamour and Film Star Pin-Ups during World War II', PhD thesis, University of East Anglia, 2014.

10. See Maria Elena Buszek, 'Representing "Awarishness": Burlesque, Feminist Transgression, and the 19th-Century Pin-Up', *Drama Review* vol. 43 no. 4 (Winter 1999), pp. 141–62.

11. See, for instance, Frank Miller, *Censored Hollywood: Sex, Sin and Violence on the Screen* (Atlanta, GA: Turner, 1994), p. 127.

12. *Hughes Tool Co.* v. *Motion Picture Ass'n of America, Inc.* 14 June 1946. 66 F. Supp. 1006. For a transcript of the ruling, see http://law.justia.com/cases/federal/district-courts/FSupp/66/1006/1556049/ (accessed 30 June 2014.) The motion was denied.

13. Mary Beth Haralovich, 'Film Advertising, the Film Industry, and the Pin-Up: The Industry's Accommodations to Social Forces in the 1940s', in Bruce A. Austin (ed.), *Current Research in Film: Audiences, Economics, and Law, Vol. 1* (Norwood, NJ: Ablex, 1985), p. 144.

14. Ibid., p. 143.

15. Mark Gabor, *Pin-Up: A Modest History* (London: André Deutsch, 1972), p. 71. See also Hurrell's *Esquire* foldout of Russell (June 1941) in characteristic 'hay' pose. Ibid., CP 13.

16. Although *The Outlaw* remained unreleased, Russell acquired an unprecedented amount of publicity in a wide range of publications through the efforts of Hughes's indefatigable publicist Russell Birdwell. For a sample of the extraordinary range of her media coverage in 1941, see Haralovich, 'Film Advertising', p. 143.

17. Miller, *Censored Hollywood*, p. 128.

18. 'Pin-Up Parade', *Show Girls* (March 1945). Reproduced in Gabor, *Pin-Up*, p. 127.

19. Mark Thomas McGee, *Beyond Ballyhoo: Motion Picture Promotion and Gimmick* (Jefferson, NC: McFarland, 2001), p. 90.

20. Kira Cochrane, 'Jane Russell: Mean! Moody! Misunderstood!', *Guardian* (1 March 2011): http://www.theguardian.com/film/2011/mar/01/jane-russell-outlaw-gentlemen (accessed 30 June 2014).

21. Richard Dyer, *Heavenly Bodies: Film Stars and Society* (London: BFI/Macmillan, 1986), p. 20.

22. Hedda Hopper, 'Please Try to Understand Me', *Photoplay* (March 1953), p. 14.

23. Dyer, *Heavenly Bodies*, p. 29.

24. Monroe was also prominently featured on the cover of the first edition where she is pictured in a 'welcoming' pose, smiling and waving invitingly to the prospective reader. The cover also advertises the centrefold as 'FIRST TIME in any magazine FULL COLOR the famous MARILYN MONROE NUDE'. *Playboy* (December 1953), p. 1. See also in the same issue, 'What Makes Marilyn?', pp. 17–18. On *Playboy* culture, see Carrie Pitzulo, *Bachelors and Bunnies: The Sexual Politics of Playboy* (Chicago, IL: University of Chicago Press, 2011).

25. It was common practice for Hollywood press agents to send pin-ups of actresses in promotional campaigns to servicemen. See, for example, Susan M. Hartmann, *The Home Front and Beyond: American Women in the 1940s* (Boston, MA: Twayne, 1982), p. 199.

26. Donald Spoto, *Marilyn Monroe: The Biography* (London: Chatto & Windus, 1993), pp. 96–104.

27. Robert B. Westbrook, "' I Want a Girl, Just Like the Girl That Married Harry James": American Women and the Problem of Political Obligation in World War II', *American Quarterly* vol. 42 no. 4 (December 1990), pp. 592, 601–2. See also the photograph captioned 'Jane Russell and one of "her" planes' in which she poses on the wing of an aircraft labelled 'Russell's Raiders' next to a pin-up of herself on the cockpit. Ibid., p. 601.

28. Grable even starred in a film called *Pin Up Girl* (1944) which featured the production number, 'You're My Little Pin Up Girl'.

29. Elaine Tyler May, 'Rosie the Riveter Gets Married', in Lewis A. Erenberg and Susan E. Hirsch (eds), *The War in American Culture: Society and Consciousness during World War II* (Chicago, IL: University of Chicago Press, 1996), p. 140.

30. Joanne Meyerowitz, 'Women, Cheesecake, and Borderline Material: Responses to Girlie Pictures in the Mid-Twentieth-Century U.S.', *Journal of Women's History* vol. 8 no. 3 (Fall 1996), p. 9.

31. Ibid., p. 10.

32. Maria Elena Buszek, *Pin-Up Grrrls: Feminism, Sexuality, Popular Culture* (Durham, NC: Duke University Press, 2006), p. 12.

33. Ibid., p. 187.

34. Meyerowitz, 'Women, Cheesecake, and Borderline Material', p. 10.

35. Maureen Honey, *Creating Rosie the Riveter: Class, Gender, and Propaganda during World War II* (Amherst: University of Massachusetts Press, 1984), p. 47.

36. *Saturday Evening Post* (29 May 1943), p. 1.

37. Richard R. Lingeman, *Don't You Know There's a War On? The American Home Front, 1941–1945* (New York: G. P. Puttnam's Sons, 1970), p. 150. Lingeman describes how Russell also appeared in national magazine spreads which typically showed her in various military *mise en scenès* in order to promote the services and boost the war effort, invariably in ways that involved jocular exploitation of her physique. Ibid., p. 175.

38. Buszek, *Pin Up Grrrls*, p. 186.

39. Dyer, *Heavenly Bodies*, p. 21.

40. Twentieth Century-Fox, Advertisement for *Gentlemen Prefer Blondes*, *Box Office* (15 August 1953), p. 4; and *Variety* (12 August 1953), p. 12.

41. Twentieth Century-Fox, Advertisement for *Gentlemen Prefer Blondes*, *Variety* (1 July 1953), p. 15.

42. Bosley Crowther, 'The Screen in Review: *Gentlemen Prefer Blondes* at Roxy, With Marilyn Monroe and Jane Russell', *New York Times* (16 July 1953), p. 20.

43. Budd Lesser, 'Forum', *Daily Variety* (10 December 1953), p. 10.

44. Mulvey, '*Gentlemen Prefer Blondes*', p. 220.

45. Ibid., p. 221.

46. Molly Haskell, *From Reverence to Rape: The Treatment of Women in the Movies* (Chicago, IL: University of Chicago Press, 1987), p. 105.

47. Ibid.

48. Wood, *Howard Hawks*, pp. 171–2.

49. Haskell, *From Reverence to Rape*, p. 32.

50. Ibid., p. 105.

51. As Mulvey suggests, Mr Esmond (Tommy Noonan) is presented as a poor surrogate to carry the male gaze into the narrative: 'His thick glasses underline the weakness of his look and his timid wave is comic.' The American Olympic team is 'promptly deheterosexualized' in a parody of a Busby Berkeley-style 'chorus dance of physical fitness that is more a homoerotic display than a heterosexual celebration'. Malone (Elliott Reid) is 'subjected to one of "Hawks's deliberate role reversals" [when] Dorothy and Lorelei make him drunk, drug him, undress him and send him off in a dressing-gown'. Mulvey, '*Gentlemen Prefer Blondes*', pp. 225–6.

52. Bogdanovich, 'Howard Hawks', p. 352.

53. Molly Haskell, 'Howard Hawks', in Richard Roud (ed.), *Cinema: A Critical Dictionary: The Major Film-Makers, Vol. 1, From Aldrich to King* (London: Secker & Warburg, 1980), p. 476.

54. Anita Loos, *Gentlemen Prefer Blondes: The Intimate Diary of a Professional Lady* (New York: Boni & Liveright, 1925).

55. Mulvey, '*Gentlemen Prefer Blondes*', p. 221.

56. Lucie Arbuthnot and Gail Seneca, 'Pre-Text and Text in *Gentlemen Prefer Blondes*', in Steven Cohan (ed.), *Hollywood Musicals: The Film Reader* (London: Routledge, 2002), p. 82.

57. Gerald Mast, *Howard Hawks, Storyteller* (New York: Oxford University Press, 1982), p. 62.

58. Peter Wollen, 'Introduction', in Hillier and Wollen, *American Artist*, p. 5.

59. Kathleen Rowe, *Unruly Women: Gender and the Genres of Laughter* (Austin: University of Texas Press, 1995), pp. 179–80.

60. On the discourse of Monroe's 'naturalness', see Dyer, *Heavenly Bodies*, pp. 27–42.

61. Writing about the war years in her autobiography, Russell joked about 'being hailed as the "sexpot of the century", with my photographs plastered all over the country in newspapers and magazines. I was being included in the list of things that represented "home" to our

GIs. Along with Mom, apple pie, and Betty Grable's legs, there was also Jane Russell.'
She is referring to her notoriety following the ballyhoo around *The Outlaw*. Jane Russell,
My Path and My Detours: An Autobiography (New York: Franklin Watts, 1985), p. 81.

62. Wood, *Howard Hawks*, pp. 164–6.

63. For a queer reading of the film, see Alexander Doty, 'Everyone's Here for Love:
Bisexuality and *Gentlemen Prefer Blondes*', in *Flaming Classics: Queering the Film
Canon* (London: Routledge, 2000), pp. 131–53.

8 Adapting to Women
Hawks, Comedy and Gender

Jeffrey Hinkelman

Scholars have displayed a degree of ambivalence about Hawks's comedies, which are often treated as a category separate from his typical portrayals of masculine protagonists. During the 1960s and 70s, Hawks's directorial themes were becoming established by auteurist scholars, who identified as a signature characteristic the focus on a group of professional men performing frequently dangerous jobs and adhering to a masculine code of honour, which demanded complete commitment to their work. Women might achieve conditional acceptance within this group if they could demonstrate comparable competence to their male counterparts, but never full membership. As Peter Wollen put it:

> For Hawks the highest human emotion is the camaraderie of the exclusive, self-sufficient, all-male group … [which] strictly preserves its exclusivity. It is necessary to pass a test of ability and courage in order to win admittance … [and] too much 'individualism' threatens to disrupt the close-knit circle.[1]

Unlike the work of John Ford, the Hawksian ideal never bends to the needs of society, family or history. Rather than accepting his archetypes as upholders of a dying tradition as Ford does, Hawks's films portray them as a vital – if marginalised – part of contemporary life.

Most of Hawks's comedies, however, either do not contain the conditions that allow these groups to exist, or else violate the basic tenets necessary for their function. Should they then be seen as a separate category, without significant thematic connection to the rest of Hawks's films? In his 1968 book on Hawks, Robin Wood gathered together what he felt were the most significant of the comedies in a chapter tellingly titled 'The Lure of Irresponsibility'.[2] In doing so, he was making a comparison with the 'responsible' behaviour of Hawks's typical male groups, but only by placing the comedies in opposition. Fourteen years later, in a chapter titled 'Comedies of Youth and Age', Gerald Mast suggested connections between Hawks's comedies and Shakespeare's, but he began by neatly encapsulating (then ignoring) the inconsistencies of critical opinion about all of Hawks's comedies.[3] In both these cases, the comedies are treated as a separate entity and attempts to draw them closer to the predominantly masculine thematic concerns of the entire oeuvre do not entirely convince.

It is my contention that, by examining four of Hawks's comedies spanning the course of his career, the assumed divisions between the two dominant and ostensibly polarised strands of his work – what Wollen calls the 'adventure drama' and the 'crazy comedy'[4] – can be nearly eliminated. An evaluation of the original stories on which the director based *The Cradle Snatchers* (1927), *Bringing Up Baby* (1938), *I Was A Male War Bride* (1949) and *Man's Favorite Sport?* (1964), along with a close analysis of the films themselves, demonstrates that Hawks used these works to generate a coherent critique of the pitfalls which emerge in the absence of his 'exclusive, self-sufficient, all-male group'. This analysis suggests something quite the opposite to Mast's contention that Hawks's works 'lack a conscious and systematic critique of the political and economic structures which shape the lives of his characters and control the flow of his narratives'.[5] In fact, these films delineate a clear attitude towards the social dangers inherent in ignoring the Hawksian, masculine ideal, especially when that ideal is sacrificed at the behest of a woman in pursuit of economic advancement.

There are three key elements that define the parameters of this critique. The first is the dominance of economic considerations as a driving force in the decision-making of male characters in need of money or a job. The second is their willing submission to women in order to fulfil their economic needs. Lastly, Hawks follows these first two aspects to their most extreme conclusion by suggesting that women and money of necessity reduce his male characters to buffoons. The tendency to sexual inversion as a method of redefining male/female relations is a constant theme of Hawks's comedies, but this is usually interpreted as a method of roughly equalising the genders, not as a tool for enabling the dominance of women, or as a critique of the effects of their influence. This is seen most strikingly in the scenes of cross-dressing which occur in all of the films under examination. The men are not simply brought into an equal plane, or subjected to a gendered 'comeuppance'. They are, instead, humiliated by the female characters in a way which may have been 'fun' (Hawks's habitual justification) as a comic idea, but which also decisively comments on the problematic social consequences of putting aside the ethic inherent in Hawks's traditional masculine group. In each of the examples under discussion here, Hawks began with a source which did not exhibit these qualities, and he consistently modified the original material quite specifically to include them. These concerns are raised at crucial junctures in Hawks's career, as well as at key moments of social flux in American history, allowing us to draw Hawks's entire body of work together into a coherent critique of the social and economic conditions of contemporary American society.

At Fox, following his directorial debut *The Road to Glory* (1926), Hawks made the romantic comedy *Fig Leaves* (1926) and the Ruritanian romance *Paid to Love* (1927).[6] These early works pointed to the budding film-maker as something of a comedy specialist. He was subsequently assigned to the adaptation of Russell Medcraft and Norma Mitchell's 1925 Broadway hit, *Cradle Snatchers*.

As originally written, *Cradle Snatchers* is a fairly conventional drawing-room comedy. In the first act, three middle-aged husbands go hunting, leaving their wives behind. One of the women determines that the 'hunting' involves carousing with young

'flappers' and procures a college-age companion to match her husband's indiscretion. When the young man joins her to play cards with the other wives, they too decide to retaliate with companions of their own. The second act comprises the awkwardly uncomfortable meeting of the other two wives with their hired gigolos. In the third act, the husbands arrive and confront their wives, but their protestations of innocence are quickly derailed by the appearance of the flappers. The play concludes with the wives going out on the town with their young companions while their husbands are admonished to treat their wives with more respect and romance.

The play itself is a charming, sometimes biting, comment on the prevalence of the double standard, which stakes out a position on male/female relations sympathetic to the women, but also treats the situation as one to be understood from both sides of the gender divide. The film adaptation, *The Cradle Snatchers*, largely adheres to the text of the play, but Hawks and his co-writer, Sarah Y. Mason, made several key alterations which complicated the sexual politics of the original, first, by adding a prologue sequence, second, by altering the source of the women's entire plan and third, through their attitude towards the male characters.

Hawks's version begins with an extended prologue set in a fraternity house which establishes the centrality of economic motivations throughout the film.[7] Though this is also key to the stage play, the original version uses money as a convenient means for the women to acquire younger companions. Hawks inverts this by first demonstrating that the young men are in constant, desperate need of funds, particularly to finance their own romantic pursuits. Henry (Nick Stuart) is dating Ann (Dione Ellis), whose family is wealthy. In order to meet her social expectations, he must borrow from his fellow students. One of the first shots of the film is of Henry looking at the paltry amount of change in his hand, followed closely by a shot of Henry and Joe (Joseph Striker) with their empty pockets pulled out. The first intertitle of the film shows dialogue of Henry importuning Oscar (Arthur Lake): 'Hey Swede – I've got a date with a new girl. Lend me ten dollars.' Thus, in just two shots and an intertitle, Hawks immediately emphasises the crucial role of economics in the plot. He continues to drive this point home and adds a second important point as the prologue continues.

While Joe is using the telephone in the hall, the College Drama Club is practising a dance in the room opposite that is shared by the three lead characters. Dressed as a woman, Sam Ginsberg (Sammy Cohen) is challenged to get Joe to ignore the woman he's talking to on the phone in favour of Sam in drag. Sam, a caricatured Jew, pulls a stole over his face, wiggles his hips, drops his kerchief – and completely convinces Joe that he's female. It's only when Joe grows overly ardent that Sam reveals the truth. With Joe established as foolish, the next scene is used to prove the same of Oscar. Sam (still in drag) is sent into the boys' room where Oscar, because of his fear of women, jumps on a chair and calls for help. Henry, Joe and Sam all use Oscar's fear and discomfort to extort money from him, neatly encapsulating the connection between money and humiliation which Hawks will continue to develop throughout the film.

In a second divergence from the play, this humiliation will be visited on all three young men via Hawks's use of Ann as the instigator for the hiring of the gigolos, rather

than as a simple ingénue. Her suggestion that Henry is the 'solution' to the problem of the errant husbands manipulates the fiscal needs of Henry and his friends, placing them in a subservient position to the women. This subservience for the sake of money shows a not quite self-sufficient male group humiliatingly selling themselves for financial gain, but Hawks goes a step further in the depiction of the parallel group of the three husbands. If Mast is correct in arguing that in Hawks's (best) films, 'the stars are the characters and the characters are the story',[8] *The Cradle Snatchers* demonstrates that point through both the casting and performances of the older male trio.

In the play, the husbands are depicted as stolid, chauvinistic characters, perhaps comically disorganised and long-suffering, but not buffoons. Even when the men discover their wives with the college boys, they remain adamantly in control. The older women, though not helpless, clearly defer to their husbands. It's only when the men's position is undermined by the arrival of the flappers that the situation becomes unsettled, and even then the older men demand that their younger counterparts repair the situation – rather than simply discussing matters with their own wives. The play makes it clear that the older women wish only to teach their husbands a lesson, not to indulge themselves or denigrate their spouses. As Susan puts it: 'You've shown plainly that you think we're back numbers. But we're going to show you tonight that we're not.'[9]

The younger men are also clearly self-controlled and presume the necessity of defending the women. They have freely undertaken the task at hand and make careful calculations regarding their need for money. When the delicacy of the situation becomes apparent, they unilaterally decide to defend the women's marriages by returning their fees and they make every effort to repair the potential rift between the couples. At the same time, however, they are willing to see the women's perspective regarding the double standard and they support the wives' decision to assert themselves.

Though we cannot precisely know what leeway Hawks may have had over casting, it is evident that he disrupts the balance of the relationships seen in the text of the play by his choice of male actors. Of the three actors portraying the college students, each is representative of a distinct masculine type prevalent during the period. Joseph Striker plays a caricature of the effete 'Latin lover'; Nick Stuart is (unusually for Hawks) a typically bland version of an Arrow shirt-collar model; and Arthur Lake is a comic bungler.[10] None of them has the ability to dominate a scene in a way conducive to the demonstration of any sort of moral suasion over the other characters, and all are far from the manly professionalism that would later become a Hawksian hallmark.

This is even more true of the husbands. Former leading man J. Farrell MacDonald (as George), Franklin Pangborn (as Howard) and William B. Davidson (as Roy) were hardly stars and they were then playing secondary roles and bit parts. In each case, then, Hawks undercuts the original dynamic of the play by casting male performers without the requisite gravitas to compete with the women. The women, while not quite top flight performers in the Hollywood pecking order, could therefore more than hold their own against their rather inadequate male counterparts in this battle of the sexes.

I am not suggesting that the film version strays far from the play as written. Fox expected Hawks to deliver a reliable version of the story for the studio, close to the

original in spirit and letter. Both play and film abound with economic language in relation to 'the perfect job'[11] for which the young men have been hired. There is talk in both versions of 'renting' and 'subletting', being 'in your service', and earning money. However, Hawks's alterations and additions to the material reveal a particular approach, which would be repeated in his later comedies. Minor examples here include the use of a close-up of a cheque to motivate comically extreme male 'affections' and a flattering shot of a woman to establish her dominance over the men. Such instances indicate the attitude Hawks commonly portrays through the representation of male buffoonery, motivation and performance, a trope that would be reiterated throughout his career.

Though *The Cradle Snatchers* is the most obvious early example of this pattern, other early Hawks films such as *Fig Leaves*, *Fazil* (1928) and *A Girl in Every Port* (1928) all demonstrate a similarly disruptive approach to gender relations. With *The Dawn Patrol* (1930), Hawks eliminated women entirely from the narrative and over the next decade he regularly created variants of the 'exclusive, self-sufficient, all-male group', which remains the most consistent theme in his entire body of work.[12] Stronger-than-usual women might approach equal status with male characters, but never quite achieve absolute acceptance.

In the 1930s, as the Great Depression roiled the traditional social conventions which defined the roles of men and women, Hawks abandoned this established formula and returned to the female-dominated world of *The Cradle Snatchers* with *Bringing Up Baby*. In an interview with Joseph McBride, Hawks discussed the dominance of the women in his comedies, and the specific tendency to humiliate the men, specifically Cary Grant. This was then a radical departure from the norm. 'It's unusual on the screen to have men be so shy and women be so aggressive,' McBride suggested to Hawks. 'Yet you were doing it in the 1920s and 1930s before that kind of thing was seen much in comedies.' As Hawks put it:

> I will admit that in most of the comedies, the woman had the dominant part. ... The girl was playing a part of someone without a care in the world, and everything that she did got him farther and farther and farther into trouble. ... she just put him on a hook. ... Anything we could do to humiliate him, to put him down and let her sail blithely along, made it what I thought was funny. I think it's fun to have a woman dominant and let the man be funniest.[13]

Ironically, of course, this humour is in direct opposition to the pattern Hawks established throughout the 1930s. It is doubtful that the men of *The Dawn Patrol* or *Ceiling Zero* (1936) would find female dominance a comfortable situation. And yet Hawks, in a period of social and economic tumult in America, returned to the same themes he had covered earlier in *The Cradle Snatchers*. After a decade honing depictions of a male-centred world on screen, however, these concerns take on a new significance. They directly criticise the model of masculinity (or non-masculinity) portrayed in the film. By utilising the same basic formula by which he converted the earlier play into a film, Hawks's approach to the conversion of 'Bringing Up Baby'[14] into *Bringing Up*

Bringing Up Baby (1938): Alice (Virginia Walker), having stipulated to her fiancé David (Cary Grant) that their marriage 'must entail no domestic entanglements of *any* kind', about to exit as his ex-fiancée (BFI)

Baby suggests a consistent narrative pattern.

With 'Baby' we are once again presented with a source story which does not suggest female dominance. Suzan (in the Wilde story) is certainly 'smart', often with what David recognises as a familiar expression: "She wore it when she'd outwitted somebody.'[15] Her actions suggest benign dizziness, but never the implacable flightiness of the film's depiction. And although David is a bemused observer, he also demonstrates his superior competence by capturing the leopard Baby himself. As with the stage version of *Cradle Snatchers*, the story leaves the man – if not in an unambiguously dominant position – at least in complete control of himself.

Working directly with the author of the story, Hagar Wilde, to create his initial script, Hawks's screen version again shifts the focus of the original. As with *The Cradle Snatchers*, he adds a layer of economic motivation, converts the male character into an object of extreme ridicule and relies on casting to enhance his alterations. In the process he transforms the story of a quirky couple confirming their engagement and corralling an escaped panther into a comment on social and economic relations, an adaptation which works in concert with the larger body of his work.

The prologue sequence of *Bringing Up Baby*, which doesn't appear in the original story, efficiently introduces the main issues which Hawks will develop throughout the film. The first exchanges of dialogue establish the supremacy of a female character, Alice (Virginia Walker), as she tells her fiancé David (Cary Grant) that his suggestion for the placement of a bone in the tail of the brontosaurus skeleton is 'nonsense'. This characterisation is further intensified as she suppresses David's excitement at the discovery of the 'intercostal clavicle', putting off his kiss, then declaring that their ensuing marriage 'must entail no domestic entanglements of *any* kind' (neatly indicating her dominance of their impending sexual relationship, or perhaps its repudiation). Much has certainly been made of the latter point in interpreting the film (and Hawks's comedies generally) as a

battle between the sexes, but what is more interesting is that Hawks has once again introduced a motivation (David's work) for which the male character willingly subjugates his masculinity in the face of a domineering female. Alice expressly states this when she declares: 'I see our marriage purely as a dedication to your work.' This comment segues immediately into the second aspect of David's work, which is his need to cultivate relations with a potential benefactor in order to secure a million-dollar grant essential to his project. Here again, David's concern with his imminent honeymoon is foreclosed by Alice's reminder that he has other important tasks to which he must attend.

As in *The Cradle Snatchers*, the male characters are befuddled while the woman is clear of purpose. The pattern is established within the first minutes of the film and continues throughout. Of course, part of the impression of David's professorial eccentricity is a result of Alice's harshness, but the pattern continues with the introduction of Susan (Katharine Hepburn). Unlike Alice, Susan does not appear to be focused on any particular task, and drifts aimlessly. To procure the necessary funding, however, David voluntarily subordinates himself to her ever-increasing looniness. None of this matches the story as written, in which David has no need of money and eventually captures 'Baby' unassisted.

Once again, one of the key moments improvised by Hawks to demonstrate the complete subordination of his male lead character is an instance of cross-dressing. The scene has been frequently cited as a case of gender-bending, but what is more significant is its situational cause. In *The Cradle Snatchers*, Hawks used a man in drag to establish the male characters' subordinate relationships to women, and how those relationships are related to money. Here he does the same. David is unclothed at Susan's suggestion (though she lets him believe that it is his own idea), and ends up in a woman's robe because Susan entraps him by sending his clothes out to be cleaned. David is thus neatly controlled by Susan as a result of her desire to love him, but he justifies himself *to* himself as acting in order to obtain the desired funds. This is a complication of the approach of *The Cradle Snatchers* in which essentially everyone was working for purposes which everyone else understood (the men for money, the women to elicit jealous responses from their husbands). A decade later, Hawks gives us a man manipulated beyond his understanding who believes that he is merely subordinating himself for monetary gain.

Key to the success of this portrayal of befuddlement is the casting of Cary Grant as David. Though both Grant and Hepburn could have straightforwardly transferred the characters of the written story to the screen, Hawks instead encouraged them to apply extreme improvisation to comic effect. While Hepburn's Susan has a dizziness that equates to the original version, Grant pushes David's frustrated, clueless bumbling to new levels. Hawks certainly understood Grant's comedic value in the role: 'It's pretty hard to think of anybody but Cary Grant in that type of stuff,' Hawks said. 'He was so far the best that there isn't anybody to be compared to him.'[16] He also clearly believed that Grant was the best embodiment of a particular type of female-dominated, humiliated-male humour.

Hawks would later claim of Hagar Wilde's original story: 'It was such a funny story, it was easy to be funny in it. … I wanted to keep exactly the same thought, that method of treating it.'[17] While parts of the film are lifted wholesale from the story (including several lines taken verbatim from the original), 'keeping the same thought' is clearly not what happened. Starting with his added prologue, Hawks altered the relationship between the male and female leads, making David a comic target and encouraging Grant to push that development to an extreme. In doing so, he showed a professional man unhinged from any stable, self-sufficient male group and indicated the consequences of allowing women and money to intrude into the ethos established in virtually all of his 1930s films. The degree to which Hawks might have been commenting on the subversion of that ethos during the lingering years of the Depression is, of course, an open question. Once again, however, he had made his point, and he turned away from such issues back to more 'masculine' subjects during the next decade.

World War II generated new ways of thinking about masculinity, money and conventional gender roles. During the 1940s, Hawks refocused on more masculine concerns in films such as *Sergeant York* (1941), *The Big Sleep* (1946) and *Red River* (1948). Faced with financial problems in 1948, he elected to go to work for Twentieth Century-Fox and Darryl F. Zanuck.[18] Fox had been trying for some time to turn a brief postwar newspaper story into a film and Zanuck saw it as comparable to *Bringing Up Baby*. Grant was once again secured, as was the original writer of *Baby*, Hagar Wilde, and Hawks was handed the story in the hope that he could reproduce his earlier success.

Originally appearing in the *Baltimore Sun*, then as a condensed article in *Reader's Digest*,[19] Henri Rochard's autobiographical tale related the bureaucratic mishaps resulting when a male Belgian army captain married an American female army nurse. The original story consists entirely of sequences dealing directly with this issue, beginning with the initial request for official approval to marry and continuing through the couple's eventual arrival in New York. As with the adaptation of Wilde's earlier story, Hawks and his writer retained nearly the entire text of the original, including several lines of dialogue. Once again, however, they added an extensive prologue, here constituting nearly half the length of the film. Though he applies the same general scheme he had used in both of the comedies discussed earlier, *I Was a Male War Bride* demonstrates a slight change of focus in Hawks's approach. As before, his adaptation alters the story to add an economic motivation to the plot; has a dominant woman humiliate the man; and benefits from adroit casting.

Perhaps affected by the wartime unsettling of traditional gender roles, Hawks begins by establishing the basic equality of the male and female characters, here in a specifically military context. Captain Henri Rochard (Cary Grant) is a diligent French liaison officer to the American military. He has previously worked with Lieutenant Catherine Gates (Ann Sheridan), who makes it clear that she has repeatedly fended off his sexual advances. Unlike previous comic iterations, both characters here are professionals, and unlike either of the previous films, the male character is not initially depicted as a buffoon. As before, however, Grant becomes increasingly docile in the face of his female counterpart's growing dominance. The desire to successfully complete their assignment leads

him to mounting humiliations, including falling from an awning, covering himself in paint and being arrested while wearing lederhosen. Hawks seems to have found a way to include a woman of equal standing in his self-sufficient world – but at the expense of eliminating the cherished independence and competence of the man who forms the only other member of the group.

As Henri commits to the ultimate surrender of his independence by marrying Catherine, their self-sufficiency (and shaky equality) comes to an abrupt end. The red tape which requires them to be married three separate times shatters any sense that they are in control of their own destiny, and that sense of powerlessness is further reinforced by their continuing inability to consummate their marriage. Hawks underlines the hazards of their relationship when they visit the American consul to discuss Henri's emigration. The exchange which follows makes the economic facet of their relationship explicit:

> CONSUL: It's not gonna be easy. Take the matter of support. Captain, have you any money in the United States?
> HENRI: No.
> CONSUL: And the laws of your country forbid you taking anything but a nominal amount with you?
> HENRI: Yes, I'm afraid that's right.
> CONSUL: Then a visitor's visa would do you no good. You couldn't take a job. And unless your wife can prove that she's able to support you, you couldn't get a permanent visa.
> HENRI: Catherine isn't going to support me, so is there any other kind of visa?

In order to both be together and make a living, the couple must move to America, and in order to do that, Henri must navigate the bureaucratic nightmare of entrance into Catherine's world on terms that increasingly make him secondary to her. The decision to use 'Public Law 271 … regulating the immigration of war brides' is opposed by Henri, but enthusiastically promoted by Catherine. This is an especially fascinating narrative manoeuvre given the general insignificance of the wife as a character in the original story. In Rochard's original version, it is the man who narrates and who works his way through the various levels of military thinking which label him a male war bride. Hawks increases Catherine's role but makes her most important as an object of sexual frustration and as a puckish presence who can laugh at her husband's absurd predicament. As before, the man is left unmanned and becomes not merely a comic foil but a powerless buffoon.

This pattern reaches its peak as Grant's Henri is forced to dress as a woman in order to smuggle himself past a belligerent seaman. The Army/Navy conflict depicted in the film is drawn directly from the original story, but Hawks leverages the incident into a final humiliation for Henri. After allowing him to express sexual feelings throughout much of the film, Hawks demonstrates the absurd lengths to which Henri will go to be with his wife. He is completely in thrall to Catherine, and proves himself the opposite of the self-sufficient males who populate the majority of Hawks's work.

'I think it's fun to have a woman dominant and let the man be funniest'. Rock Hudson and Maria Perschy in *Man's Favorite Sport?* (1964)

Fifteen years later, in his final comedy *Man's Favorite Sport?*, Hawks once again returned to his reliable methods of adaptation in bringing a short story to the screen, at a period in American history when various social movements were about to upend the shifting models of gendered behaviour evident throughout his entire career. Here, Hawks added no prologue to his adaptation of Pat Frank's 'The Girl Who Almost Got Away',[20] but perhaps there was no need to do so with a story that presents itself from the beginning as an anachronism. Perhaps this tale of a fishing expert – 'the light-tackle specialist' – who has never fished appealed to Hawks's sporting interests, but the old *Cosmopolitan* story was hardly an obvious choice. Nevertheless, the pattern of adaptation remains unchanged. While the story presents the main character Roger Willoughby (Rock Hudson) as game but inexperienced, his focus changes almost immediately to winning the girl Abigail (Paula Prentiss) rather than the fishing contest he has entered. The first evening, in fact: 'He could not sleep for a long time after he got into bed ... he had to reconstruct his favorite vision ... so it would include a girl.'[21] He is unquestionably in control of their relationship, and while he cannot fish, her eventual assistance does not place her in a superior position, but merely confirms that he has made a conquest ('you'll never make a fisherman. But I love you').[22]

The film, following the pattern first seen thirty-seven years before, begins by positing an economic justification for all that follows. Roger must take part in the fishing tournament

or Abigail will expose his lack of experience. As she threateningly puts it, 'I figure that you could learn with the right incentive. Like keeping your job.' Thus Abigail is instantly dominant and Roger is increasingly subservient in the face of her control. Not only is he utterly inept as a fisherman, he is continually left flailing by the need to use unnecessary equipment, follow feminine fishing advice, and protect his reputation in the eyes of the other male characters. Though he never appears in drag, his experience with inflatable waders performs the same humiliating function, especially as he must be rescued by Abigail. None of this is true of the original story, where the woman has no interest in dominating the man, but rather functions as a laudable helpmate as he tries to protect his reputation. Finally, Hawks punctuates the man's buffoonery by having Roger repeatedly catch fish by sheer accident. It could be argued that Roger's eventual assertion of himself negates his inferiority, but the narrative doesn't entirely support this view. As the two characters float away on an inflatable bed, Abigail talks Roger into renewing their relationship, not the other way around. Indeed, Hawks punctuates the absurdity of his conclusion with the insertion of the sophomoric black-and-white 'serial' footage in which the woman announces that 'This is the end', presumably of both the film and of Hawks's forty years of filmed musings on the subject of male humiliation at the hands of a woman.

In 1971, in 'Fast Cars and Women', Gerald Peary argued that *The Crowd Roars* (1932) demonstrated that Hawks understood that '[t]he Hawksian hero needs both male friends and a good, strong woman'.[23] That same year, Molly Haskell suggested that Hudson and Prentiss 'are finally closer to each other than to those graceful members of society who establish rapports more easily', and that Hawks 'strikes a very modern note in the image of a couple united not by the attraction of opposites but the unanimity of similarities'.[24] An examination of the methods by which Hawks adapted his original source material mitigates against both of these approaches while at the same time drawing certain of the comedies into a much closer relationship with the male-dominated 'action pictures'. At key moments in his career, Hawks returned to a pattern first established in *The Cradle Snatchers*. By consistently altering his sources to emphasise both the dominance of women and the economic root of that dominance, Hawks provided a valuable counterpoint to the model of gender roles he otherwise so consistently portrayed. While strong women are to be preferred to weak women, it is dangerous to allow them too much control. While the male need for women may be unavoidable, their admittance into the true inner circle of male relationships is not a question of a desirable (if difficult) rapport, but a potentially dangerous weakness. While their eventual marginalisation in most of Hawks's films clearly demonstrates this argument, the apparent equality and gender inversions of the comedies are not merely a matter of his preference for strong women, but rather a warning against their possible detrimental effect on those things which men should value most – their honour, professionalism, independence and self-respect.

Notes

1. Peter Wollen, *Signs and Meaning in the Cinema* (London: Secker & Warburg, 1969), p. 82.

2. Robin Wood, *Howard Hawks* (London: Secker & Warburg/BFI, 1968), pp. 58–88.
3. Gerald Mast, *Howard Hawks, Storyteller* (New York: Oxford University Press, 1982), pp. 133–87.
4. Wollen, *Signs and Meaning in the Cinema*, p. 81.
5. Mast, *Storyteller*, p. 365.
6. Todd McCarthy, *Howard Hawks: The Grey Fox of Hollywood* (New York: Grove Press, 1997), pp. 64–75.
7. Available prints of the film are incomplete.
8. Mast, *Storyteller*, p. 349.
9. Russell G. Medcraft and Norma Mitchell, *Cradle Snatchers* (1931, New York: Samuel French, 1925), p. 73.
10. See Gaylyn Studlar, *This Mad Masquerade: Stardom and Masculinity in the Jazz Age* (New York: Columbia University Press, 1996), pp. 150–98.
11. Medcraft and Mitchell, *Cradle Snatchers*, p. 45.
12. Examples from the period include *The Crowd Roars* (1932), *Tiger Shark* (1932) and *Only Angels Have Wings* (1939).
13. Quoted in Joseph McBride, *Hawks on Hawks* (Berkeley: University of California Press, 1982), p. 70.
14. Hagar Wilde, 'Bringing Up Baby', *Collier's* (10 April 1937), pp. 20–2, 70.
15. Ibid., pp. 20–1.
16. Quoted in McBride, *Hawks on Hawks*, p. 69.
17. Ibid., p. 70.
18. McCarthy, *Grey Fox*, pp. 448, 451–2.
19. Henri Rochard, 'Male War Bride Trial to Army', *Baltimore Sun* (28 September 1947), reprinted in a condensed version as 'I Was a Male War Bride', *Reader's Digest* (November 1947), pp. 1–4.
20. Pat Frank, 'The Girl Who Almost Got Away', *Cosmopolitan* (1 July 1950), pp. 49, 72–9.
21. Ibid., p. 74.
22. Ibid., p. 79.
23. Gerald Peary, 'Fast Cars and Women', in Joseph McBride (ed.), *Focus on Howard Hawks* (Englewood Cliffs, NJ: Prentice-Hall, 1972), p. 115.
24. Molly Haskell, '*Man's Favorite Sport?* (Revisited)' in McBride, *Focus on Howard Hawks*, p. 138.

PART 5
HAWKS AND MUSIC

9 Scoring the West
Dimitri Tiomkin and Howard Hawks

Kathryn Kalinak

Howard Hawks directed five Westerns, three of which – *Red River* (1948), *The Big Sky* (1952) and *Rio Bravo* (1959) – were scored by Dimitri Tiomkin. In a telling moment in *Red River*, a young cowhand, Dan Latimer (Harry Carey, Jr) sings the old cowboy song 'I Ride an Old Paint' to quiet an uneasy herd. That isn't the only song in *Red River*: among the period music and folk tunes, there are two original cowboy choruses by Tiomkin: 'Settle Down [Little Dogies]' and 'On to Missouri'. And who can forget Tiomkin's lushly orchestrated cue for the Red River cattle crossing? Certainly not Carter Burwell who has written of its influence on his own river-crossing sequence in *True Grit* (2010).[1] Tiomkin composed what may be his most beautiful Western theme for *The Big Sky* along with another original composition, another cowboy chorus, 'Quand Je Rêve', in French! For *Rio Bravo*, Tiomkin changed gears, building the score around the sound of Mexican music – mariachi trumpets and flamenco guitars – and folk-like melodies, many with characteristically Latin American rhythms, simply orchestrated and often performed diegetically. There are two songs in *Rio Bravo*: Tiomkin's composition, 'My Rifle, My Pony, and Me', crooned by Dean Martin, and a folk tune, '[Git along Home] Cindy, Cindy', sung by Ricky Nelson. Tiomkin was forging new directions for the Western film score here and his music for *Rio Bravo* inspired film-makers around the globe: Masuro Sato, who composed for Akira Kurosawa, and Ennio Morricone for Sergio Leone, to name but two.

Although music is crucial to Hawks's Westerns, little has been written about it or about the working relationship between Hawks and the composer who gave such significant musical expression to his vision of the West.[2] In this chapter I have two goals: to illuminate that Hawks/Tiomkin collaboration, and to unpack what the music in *Red River* and *Rio Bravo* has to tell us.

Hawks and Tiomkin

Produced by his own Monterey Productions, *Red River* afforded Hawks greater freedom to choose cast and crew than previously. Although Hawks had trouble assembling the company, Tiomkin, significantly, was a key member of the team from the start. Despite the fact that Aaron Copland, who had recently won a Pulitzer for *Appalachian Spring*, had been suggested, Hawks chose a former collaborator, Tiomkin. It was a leap of faith in 1946.

A Russian émigré, Tiomkin had yet to score any of the famous Westerns that would identify him with the genre.[3] But Tiomkin knew how to work with large symphonic and vocal forces. He had scored Frank Capra's *Lost Horizon* (1937) to great acclaim; he had an established working relationship with Hollywood's best choral arranger and conductor, Jester Hairston; and – importantly – he had worked with Hawks before, on *Only Angels Have Wings* (1939). Tiomkin proved so adept at the genre that he became the go-to composer for Westerns, writing over a dozen Western film scores as well as the rousing title song for the television series, *Rawhide* (CBS, 1959–65). Tiomkin was Hollywood's most high-profile independent composer, shunning longterm studio contracts – like Hawks did – and hiring out on a film-by-film basis. He preferred to work for independent production companies, which were beginning to challenge the studio system after the war. 'If I have some success it is all on account of independent film,' he said.[4] He was eager to work with Hawks again.

Unlike John Ford, who was closely involved in the scores for his films and who chose many of the period songs, hymns and folk tunes heard in his Westerns, Hawks didn't involve himself intimately with the development of the score. Rather, as he did with other trusted crew members, such as editor Christian Nyby, Hawks let Tiomkin go his own way, surely a factor in Tiomkin's enthusiasm for Hawks. Said Tiomkin: 'Hawks let me completely alone.'[5] It wasn't until *Hatari!* (1962) that Hawks even attended a recording session. This doesn't mean, however, that Hawks didn't know what he liked when he heard it or that he didn't make decisions involving the music. For *Red River*, it was Hawks who determined that Dan Latimer should sing while on night watch with the herd, asking Carey if he knew any cowboy songs. Carey did and sang an old favourite of his father's, 'I Ride an Old Paint'.[6] For *Rio Bravo*, it was Hawks who decided that the authentic 'Degüello' wasn't working and directed Tiomkin to compose a new one, and it was Hawks who gave 'My Rifle, My Pony, and Me' to Dean Martin after it had been originally assigned to Ricky Nelson.

Hawks and Tiomkin got along: they were friends on set and off. It helped that Tiomkin's philosophy was to agree with every request – and then go off and do what he wanted. 'I feel we are a team,' said Tiomkin, 'the motion-picture maker and I. I go along with what he is doing, must never overpower his desire. But I write like I feel … .'[7] Although Tiomkin privately questioned the system that ceded power over the score to the director ('What does he know about music?'),[8] he adopted a genial affability and tried to be a team player. 'He yesses everybody but does what he believes', is how one producer put it.[9] This didn't work with everybody: Tiomkin fought with George Stevens on *Giant* (1956), for instance. But it worked with Hawks right up until the end of their collaboration when, all of a sudden, it didn't.

In all, Tiomkin scored six films for Hawks but the two men parted ways over *Hatari!* According to Tiomkin, when he met with Hawks to discuss the score, Hawks told him that he wanted authentic African instruments and Tiomkin should 'avoid strings and woodwinds'.[10] Tiomkin had in fact used authentic instruments before, native American instruments on *The Big Sky*, so incorporating African instruments wasn't something he was unwilling to do.

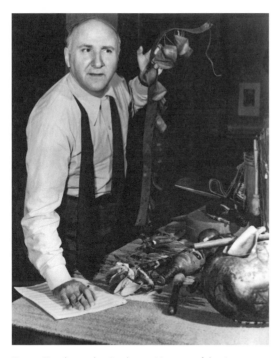

Dimitri Tiomkin at the Southwest Museum of the American Indian in Los Angeles. The publicity department churned out the following caption: 'Dimitri Tiomkin listens to bone rattles of great antiquity. The musical objects on the table represent 500 years of Indian handiwork' (courtesy Academy of Motion Picture Arts and Sciences)

But composing a score without strings or woodwind was another matter. Still, Hawks reports that Tiomkin responded in his usual fashion, 'That's a great idea, boss.'[11] Tiomkin later thought better of it and when he questioned Hawks, Hawks fired him. Tiomkin would frequently initiate such discussions with the benign opener, 'Please don't hate me but …'.[12] It seems unlikely that Tiomkin's mild insubordination was the determining factor here, but rather Hawks's desire for a more contemporary sound.[13] (*Hatari!* would be scored by Henry Mancini). Tiomkin and Hawks didn't work together again. The composer who defined the sound of the West for Hawks would not score his last two Westerns, *El Dorado* (1967) and *Rio Lobo* (1970).

Red River

Tiomkin's score for *Red River* both epitomises the characteristics of the traditional Western film score of the 1940s and simultaneously looks forward to the score of the 1950s. Tiomkin quotes period music and folk songs, often using traditional Western instruments, within a symphonic format (an orchestra of forty-five players and a chorus of twenty-eight men). But he also anticipates the Western title song of the 1950s, introducing the authentic-sounding but originally composed cowboy chorus, performed by an off-screen, non-diegetic male choir. There are two of them: 'Settle Down [Little Dogies]' and 'On to Missouri'.

The score for *Red River* is filled with cowboy tunes, folk and period music: 'Oh! Susannah' played on a banjo; 'I Ride an Old Paint', sung twice by Harry Carey, Jr, once with on-screen guitar and harmonica, and once a cappella; 'Turkey in the Straw' with guitar and harmonica; 'She'll Be Coming round the Mountain'; and 'Oh, Bury Me Not on the Lone Prairie' (aka 'The Dying Cowboy' as it is referenced in Tiomkin's sketches) heard, appropriately, at burials and, most affectingly, on cellos for Dan Latimer's. Such musical references lend a note of authenticity to the film, helping to convince us that

Hawks's filmic representation of the West is real. Period music and folk song take on a greater importance in a Western like *Red River* which, although it does incorporate location shooting in Arizona, also uses process work, particularly rear-projection.

The largest orchestral resources come into play, however, for the original material Tiomkin composed: a love theme heard for Tom Dunson (John Wayne) and Fen (Colleen Gray), recycled for Matthew Garth (Montgomery Clift) and Tess Millay (Joanne Dru); a strident theme for Dunson, marked in Tiomkin's sketches as 'heavy' and with 'menace',[14] played memorably by bass and percussion as Dunson walks through the cattle as they part like the Red Sea; and two originally composed cowboy choruses. The first is 'Settle Down [Little Dogies]', initially heard in the Main Title sung by a male choir and subsequently sung and hummed non-diegetically throughout the film. The second, 'On to Missouri', associated with the cattle, is largely deployed instrumentally, evocatively rendered as a non-diegetic male chorus at the inauguration of the cattle drive.[15] Tiomkin did his research when it came to creating 'Settle Down [Little Dogies]'. He was certainly aware of the tradition of the herding song – melodies sung to cattle to help control them – the most famous of which is '[Whoopee ti yi yo] Git Along, Little Dogies'. The melody of the authentic herding song bears little or no resemblance to Tiomkin's 'Settle Down', but there's a nod to it in Tiomkin's title as well as his incorporation of a cattle call: 'A kum a yip pa ki yi yay.'

'Settle Down' and 'On to Missouri' are each what I would describe as a cowboy chorus, to use Corey Creekmur's term.[16] Unlike later Western title songs such as 'Do Not Forsake Me, Oh My Darlin'', 'The Searchers', and 'Gunfight at the O.K. Corral', neither 'Settle Down' nor 'Missouri' was conceived of as a song *per se* (which is why they aren't constructed along the lines of standard popular songs). Still, 'Settle Down' and 'Missouri' function as cowboy choruses and they exemplify a key feature of later Western title songs: the ability to bring to the surface traces of repressed psychic states and unexpressed emotions.

First, a word about the instrumental and non-diegetic occurrences of 'Settle Down' and 'Missouri'. 'Settle Down' is especially interesting: there is an evocative orchestral storm iteration; a grandly romantic version when the cattle reach Red River; a folksy version with accordion and Jew's harp after the river crossing; and a telling rendition during Tess's angry tirade at the film's end where 'Settle Down' can be heard first in the minor, when she angrily calls out Dunson and Garth, and then in the major, when she softens and asks Dunson if he's hurt. 'Missouri' is also heard throughout the film, most memorably when the cattle cross Red River, with the brass section sounding like cows mooing. But it is the chorus that I want to focus on here.

Creekmur has argued that Western title songs, and the male choirs who sing them, function as a Greek chorus. In opposition to the realist aesthetic of Hollywood film, these non-diegetic cowboy choruses give vent to what the characters cannot express, functioning as 'a displacement of the silent cowboy's thoughts and emotions'.[17] Philip Drummond suggests as much for Tiomkin's 'Do Not Forsake Me, Oh My Darlin'' in *High Noon* (1952), where 'Cooper's laconic style' finds 'a sung rather than a spoken outlet

in the soundtrack', with the song's lyrics articulating sexual desires that both the protagonist as well as the genre keep in check.[18]

Indeed, the cowboy chorus typically expresses feelings and emotions that the characters don't show and often can't articulate. This function is first demonstrated immediately after Dunson takes leave of Fen (Coleen Gray) when the love theme which had been played instrumentally under their farewell is now augmented by a male choir's wordless vocalisations of its melody, an expression of Dunson's inarticulate regret and unarticulated desire for Fen.

The next chorus we hear is 'Missouri' at the inauguration of the cattle drive, succeeding a series of close-ups of cowboys whooping and yapping to prod the cattle forward. Their faces are expectant, full of optimism for the task ahead, but the lyrics reveal masculine anxieties which the cowboys' faces belie: the sexual deprivation of a long cattle drive and the arduous nature of the task ahead whose success is in doubt:

The nights are so long and the days are so weary
Ride slow boys the sun's high above
With a yippa Kiya, we'll be plodding all day
Oh, we'll be in Missouri some day.[19]

Hairston (more on him later) arranged the music and wrote three different sets of lyrics, and someone, probably Tiomkin, chose those heard in the film.

As if in anticipation of the cowboy chorus, Tiomkin has created an ominous musical cue to precede it, giving vent to these same anxieties instrumentally: tremolo strings, low brasses, chromaticism and dissonance, lack of melody and a downward trajectory to the musical line. This represents a musical correlation to the cinematographic projection of anxiety through the 360° pan which opens the sequence, an atypical and edgy shot incorporating, as it does, a highly unusual and disorienting perspective.

But the cowboy choruses in *Red River* have another function. The presence of black cowboys on the frontier is almost totally repressed by the classical Hollywood studio Western.[20] And yet a high proportion of the workforce on the Union Pacific railroad was black; 20 per cent of the postwar US cavalry was black; and, most pertinently here, black cowboys worked on cattle drives. Significantly, Jester Hairston was in charge of the chorus work for *Red River*, the first black musician to cross the colour line in a Hollywood music department (supported by Frank Capra and Tiomkin who wanted him for *Lost Horizon*). Hairston integrated every choir he worked with in Hollywood, relying upon many of the singers he knew from his concert work with the Hall Johnson Choir. Thus black singers provided voices for white cowboys in *Red River* (and other Westerns),[21] and the cowboy chorus represents not only a displacement of emotion but also an instance of the exclusionary racial politics of the genre.[22]

Throughout the first few weeks of the drive it is only Reeves (Hank Worden) who articulates any doubts, claiming things are 'going too good'. But cowboy choruses, and especially hummed choruses, of 'Settle Down' and 'Missouri' serve as musical reminders of the anxiety lurking beneath the genial camaraderie of the men. 'Settle

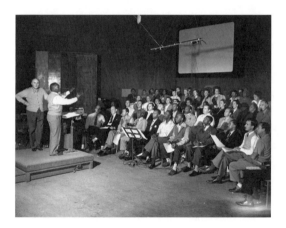

Studio publicity photo of Dimitri Tiomkin, composer, and Jester Hairston, choral arranger and conductor, at a recording session for *Duel in the Sun* (1946). Note the integrated choir, typical of Hairston's studio work (courtesy Dimitri Tiomkin: The Official Website)

Down' can be heard as the men make camp the first night where it continues as a hummed chorus during the comic business between Groot (Walter Brennan) and Quo (Chief Yowlachie). A hummed chorus of 'Missouri' precedes the ominous sequence where the men are unnerved by the sound of a coyote and discuss stampedes. It is as if the hummed chorus foreshadows the very disaster the men feared. At this point, the choruses disappear from the film. A cattle stampede kills Dan Latimer and destroys one of the chuck wagons, and from this point on the men are at each other's throats, complaining, plotting, attempting revolt. Once the men's anxieties and frustrations are unleashed, the choruses are no longer necessary. Only when the cowboys enter Abilene does the cowboy chorus return, now in a rousing version of 'Missouri' with a scratchy country fiddle and banjo that gives expression to the men's unspoken relief and unexpressed joy at journey's end. The hummed chorus returns too, to the tune of 'Settle Down,' after the showdown between Dunson and Garth, the barely disguised Oedipal confrontation stirring up something that cannot be articulated in words. Eventually the choir finds its voice again, singing the lyrics of 'Settle Down' full on to end the film.

Tiomkin considered 'Settle Down' as a commercial property. Hollywood composers often tried to get their music into publishable form as songs and marketed as sheet music and later as recordings to increase their income from a film score. Tiomkin frequently secured the rights to his own music, or tried to, and formed a series of music companies over the course of his career to promote music from his film scores. This was an unusual but forward-thinking practice in the studio era when the studio owned exclusive rights to the music for its films. Since Tiomkin worked largely for independent production companies, he could negotiate a different arrangement. In 1952, Tiomkin bought the rights to 'Do Not Forsake Me, Oh My Darlin'' when neither Stanley Kramer Productions nor Capitol Records were interested in promoting it, nor Tex Ritter (who sang it in the film) in recording it. Tiomkin produced the famous recording by Frankie Laine for Columbia Records himself and released it before the film premiered, an early example of synergy between the film and record industries.

That Tiomkin was thinking along these lines for 'Settle Down [Little Dogies]' is evidenced by two prototypes for a sheet-music version in the Dimitri Tiomkin

Archive: one entitled 'Red River (Theme from the Motion Picture "Red River")' and the other 'Settle Down (Song from the Motion Picture "Red River")'. With the exception of the title, they are identical and include new lyrics by Frederick Herbert. Although 'Settle Down' was copyrighted in 1948, with music by Tiomkin and lyrics by Herbert, I could find no evidence that it was published or recorded. Ultimately, Tiomkin's 'Settle Down' had neither the afterlife of the precedent-setting 'Do Not Forsake Me', nor its influence on the Western genre, although I do think it's an important precursor. Tiomkin was not done with the tune, however, as we shall see. He would re-arrange it, secure new lyrics, and recycle it in *Rio Bravo* as 'My Rifle, My Pony, and Me'.

Rio Bravo

Tiomkin's music for *Rio Bravo* both reflects transformations to Western film scoring precipitated by his own 'Do Not Forsake Me, Oh My Darlin'' and anticipates others occasioned by revisionist Westerns of the 1960s both inside and outside Hollywood. By 1959, Western scoring practices had changed and Tiomkin was changing along with them. Post-*High Noon*, Western scores had to accommodate the phenomenon of the title song; became less symphonic and leaner; incorporated more Western instruments; relied less on leitmotivic writing, depending more on iterations of the title song, often sung by off-screen, non-diegetic male choirs. Of course the older model wasn't extinct: think of Jerome Moross's score for *The Big Country* (1958). *Rio Bravo*, though, adapts to the new model. The music from its title song is woven instrumentally throughout a streamlined score with fewer orchestral cues and more Western musical ensembles. But the *Rio Bravo* score departs from this post-*High Noon* aesthetic too: featuring an increased use of solo instruments and more unusual instrumentation; less extended melody and shorter iterations of musical material; a shift in focus from an AngloAmerican folk idiom to a Mexican one, and thus more emphasis on Mexican and Latin American instruments. The cowboy chorus is absent and the title song, 'Rio Bravo', was virtually eliminated as a song. This was new territory indeed.

There is plenty of interesting instrumental music in the score: a leitmotif for Feathers (Angie Dickinson) often played on a saxophone, no less, the archetypal instrument of dangerous female sexuality; a love theme for Chance (John Wayne) and Feathers; and an iteration of the main theme whistled by the protagonists. However, it is the three songs Tiomkin created for *Rio Bravo* that form what David Arnold calls, 'the rhetorical spine of the film'.[23] The score opens with what was originally conceived as a title song, 'Rio Bravo'. However, what we hear in the Main Title of the final release is instrumental, performed predominantly on guitar, harmonica and temple blocks (percussion) with harpsichord at the end. It's heard as a song only in the End Title and with truncated lyrics. It's curious that the song was abandoned. Dean Martin recorded 'Rio Bravo' first for the score and later independently. It remained in his repertoire for years, appearing on many Martin compilations.

The lyrics tell of a failed love affair with a girl, probably Spanish:

All the birds in the cottonwood above her
Know I love her
Know I care
But my dreams, like the songs, she sang in Spanish
Seem to vanish
In the air.

These lyrics clearly relate to Martin's Dude, filling in the back story of the failed love affair that drove him to drink. Like a classic cowboy chorus, the lyrics voice what the character cannot, opening a window into Dude's emotional landscape:

And I wonder as I wander by the river
Where my love has flown.

But these lyrics weren't used. All the emotions in *Rio Bravo* seem tuned down to me and the film's emotional tenor is characterised by a coolness at odds with the lyrics. Was Hawks uncomfortable with such a blatant statement of a man's emotional duress? Drunkenness is one thing but lovesickness, in a Hawks film, is quite another. As late as 8 September 1958, Warner Bros.' publicity department was still touting the song: 'Two original songs are being sung in *Rio Bravo*, "Rio Bravo", and "My Rifle, My Pony, and Me".'[24] But, by the time of the film's release in March 1959, the lyrics are gone, appearing only in the End Title and there only the final refrain:

Must I live ever after
with the mem'ry of her song?
While the river Rio Bravo flows along.

Despite its attenuated role in the film, 'Rio Bravo' was published as sheet music, as was 'My Rifle, My Pony, and Me'.

Instrumental versions of the song recur throughout, often with the simple yet distinctive instrumentation associated with Mexican music: guitars, guitarons (literally, 'large guitar', a six-stringed Mexican bass guitar), trumpets and a battery of Latin American percussion. That Tiomkin wanted to capture the sound of Mexican music is reflected in his sketches where he notes when a 'flamenco guitar' is to be used, to differentiate it from the more familiar-sounding Western guitar that Ricky Nelson plays. Further, Tiomkin wanted the trumpets to 'flutter' in the style used in Mexican mariachi bands, and for the soloist for the 'Degüello' to play 'a la Hispanica. . . (Real Spanish Style)', presumably referencing the mariachi style; and he employs such Latin American percussion as the marimba, bass marimba, timbales and bongos[25] (and the domra, too, a Russian stringed instrument). It is telling that one of only two pieces of period music in the score is a Mexican folk song, 'Adios Mama Carlotta'.

Tiomkin interchanges Spanish, Latin American and Mexican instruments, traditions and performance styles. This is typical of Hollywood practice where musical traditions of

different ethnicities were treated as interchangeable and particularly true of Westerns where anything 'South of the Border' was put in service to the musical representation of Mexico. Such is the case here where flamenco guitars, Spanish-style playing and percussion more generally associated with South America can be heard in a Mexican border town. As Mark Slobin notes, 'for Hollywood, it's all just "Latin"'.[26]

Tiomkin incorporated traditional features of Mexican music in the score, particularly mariachi trumpets, and this predates their iconic appearance in 1960s Westerns. In Hollywood, composers for revisionist Westerns such as Jerry Fielding for *The Wild Bunch* (1969), reacting against the perceived romanticism of earlier Westerns, turned to Mexican music and the leaner musical ensembles reminiscent of mariachi bands, for a more realistic sound. In Italy, Ennio Morricone was doing the same for Sergio Leone's series of 'spaghetti Westerns' in the early 1960s. But Tiomkin led the way with *Rio Bravo*.

Another piece of music that plays a key role in the narrative is the 'Degüello'.[27] It was inspired by the legendary 'Degüello' that General Santa Ana supposedly ordered a bugler to play at the Alamo to unnerve the besieged Texans and signal that no quarter would be given. So we don't miss the significance of the song, Colorado (Ricky Nelson) explains: 'The Mexicans played it for those Texas boys when they had them bottled up in the Alamo ... played it day and night till it was all over.' A Warner Bros. publicity report highlighted the use of the song for the film's marketing campaign: 'Tiomkin composed tune Degüello for score of *Rio Bravo* – title "Degüello" stems from an Early Mexican bugle call which General Santa Anna [sic] used to notify the defenders of the Alamo that no prisoners would be taken.'[28]

In the film, the villainous Nathan Burdette (John Russell) attempts to use the tune to unnerve Chance and his deputies, instructing an on-screen (diegetic) horn player to begin the 'Degüello' which will consequently be sometimes diegetic and sometimes non-diegetic. At some points it is not entirely clear which it is. The film's refusal to specify for the audience the source of the music lends the film a modernist edge, and might be said to be within spittin' distance of mid-century modernist film scores, like those for several Godard films, which reject normative soundtrack conventions and blur the line between diegetic and non-diegetic. David Arnold argues that this blurring between 'incidental music and diegetic musics' with the 'Degüello' is characteristic of the way songs work throughout *Rio Bravo*, asserting that the performance of 'My Rifle, My Pony, and Me', similarly blurs boundaries between 'exegetical or incidental music and music with a plot-specific dramatic function'.[29] I will return to this point.

Tiomkin researched the 'Degüello' and found an authentic nineteenth-century version, 'No. 4 *Carja o degüello*' ('Charge or Cutthroat'), a likely candidate for the actual 'Degüello' performed at the Alamo. The problem was that it was rather uninspiring. Hawks deemed it 'terribly banal' and directed Tiomkin to compose a new one.[30] What Tiomkin devised utilises the syncopation of Latin American music along with a rhythm characteristic of Latin American folk music (the division of the beat into seven unequal note values) and the trumpet of traditional Mexican mariachi bands.[31] Tiomkin's 'Degüello', written in a minor key, is more melancholic, even mournful and, as Yuna de

Tiomkin, 'Degüello'

'No. 4, Charge or Cutthroat' ('No. 4, Carga ó Degüllo') from Special Bugle Calls for the
Cavalry (Toques Particulares por la Caballería)

Lannoy points out, seems 'more fitting to the scene than the dehumanized quality of
the original melody'.[32] Tiomkin's version passed muster with Hawks – but it is strikingly
ahistoric. A bugle doesn't have valves and thus could never have played what Tiomkin
wrote. Although brass instruments with valves did exist as early as 1836, there is no
evidence to suggest their presence at the Alamo at the time.[33] The smoking gun here
is a letter from Tiomkin claiming authorship of the 'Degüello'[34] (which released the
studio from any potential copyright liability) and a publicity release citing Tiomkin as the
composer of the tune. Ironically, the melody which is being played to unnerve the sheriff
and his deputies only steels their resolve.[35]

One of the most discussed sequences in *Rio Bravo* is the singalong among the
deputies where we hear the second of the songs conceived for the film. Tiomkin recy-

cled the melody of 'Settle Down' and Paul Francis Webster provided the lyrics for a song entitled 'My Rifle, My Pony, and Me'. It was intended for Ricky Nelson, in some ways the biggest star in the film. Nelson had virtually grown up on television on his parents' popular sitcom *The Adventures of Ozzie and Harriet* (ABC, 1952–66) and he was a recording star and teen idol. He assumed that Hawks would want him to sing a contemporary song. He balked at Tiomkin's Western ballad, preferring 'Restless Kid', a song Johnny Cash had written expressly for him and which Nelson had actually recorded for Capitol Records. Hawks and Tiomkin tried to reason with him, even enlisting Ozzie to help them, and ultimately Nelson backed down but not before Hawks decided to give what is unmistakably the star turn to Dean Martin instead. (It was Hawks's idea to bring in Nelson on harmonies.) Walter Brennan joins in on the harmonica. Nelson got to follow Martin with a rockabilly performance of the decidedly uncontemporary folk tune, '[Git along Home] Cindy, Cindy', joined by Brennan and Martin, arranged by Tiomkin.

These songs aren't cowboy choruses. They aren't sung by an off-screen male choir and they don't recur over the course of the film.[36] But they do function in a similar way: to give voice to the central tension between the stoic, unchanging masculinity necessary for the taming of the frontier, and the accommodation of femininity in the newly burgeoning civilisation, what Arnold describes as the tension between 'domesticated and undomesticated masculinity'.[37] The opening lyrics of 'My Rifle, My Pony, and Me' constitute an idyll to life on the open range away from domestic entanglements, and its title couples the nomadic life of the cowboy and his pony with the seductive allure of the rifle's violent power. As Arnold puts it, 'a life defined by unshackled mobility (the pony) and sporadic, unpredictable (implicitly attractive) violence (the rifle)'.[38] Initially the lyrics mirror these preoccupations but the song concludes on the side of hearth and home and the women who tend them:

> Gonna hang my sombrero
> On the limb of a tree
> Coming home, sweetheart darlin'
> Just my rifle, my pony, and me.

The tension in the song is delicately sustained, as it is in the film, between the expression of unrestrained masculinity and the acceptance, however limited, of femininity and domestication. Like the film, the song doesn't finally settle the matter: the cowboy sings of his desire for the comforts of woman and home, but he still imagines his rifle and his pony with him at the end.

I want to return briefly to *Rio Bravo*'s songs and their status in terms of the diegesis. Tiomkin's songs in *Rio Bravo* (and the same might be argued for all Tiomkin's songs in Hawks's Westerns) challenge the discrete boundaries between the diegetic and non-diegetic. Recognisable recording stars and show-business personalities perform as themselves as much for the audience as for the characters in the film. Is it Dude singing or Dean Martin? Colorado or Ricky Nelson? Martin immerses himself more fully

Rio Bravo has a successful box-office run in Japan in 1959

into his character than Nelson does, and this is widely regarded as Martin's best screen performance, but I agree with Arnold that 'the image he creates, lounging in the jail, with his hat low over his face, reeks of martinis and Vegas'.[39] Certainly, Martin's crooning singing style seems at odds with the bedraggled alcoholic cowboy he plays. And Ricky Nelson comes right out of character, 'incapable', according to Arnold, of 'stifling a specifically 50s pop-rockabilly simpering'.[40] What if these performances are not entirely credible in terms of diegetic realism? Does this really bother audiences? (It didn't bother Hawks who loved them.) Perhaps the problem is not the undefinability of these musical performances as diegetic or non-diegetic, but the terms themselves which cannot accommodate how music actually works in these films.

The influence of Tiomkin's *Rio Bravo* score has been profound. When Masuro Sato talked with Akira Kurosawa about the score for *Yojimbo* (1961), he mentioned *Rio Bravo* and *The Big Country* as models and Kurosawa was enthusiastic about capturing the Western sound of these scores. The opening of *Yojimbo* is particularly redolent of the sound of Tiomkin's *Rio Bravo*, Sato scoring here for timpani, bongo, maracas and saxophone, joined by a harpsichord, brasses and, when Sanjuro (Toshiro Mifune) himself appears, a banjo (and this in a film set in samurai-era Japan!). As Yuna de Lannoy demonstrates, Kurosawa and Sato struggled with issues of authenticity as they 'challenged the established conventions of Japanese period drama by borrowing the audio and visual grammar of the American western'.[41]

Rio Bravo casts an even longer shadow on the film work of Ennio Morricone whose paradigm-shifting scores for Sergio Leone's Westerns left an indelible imprint on the genre. According to several sources, it was Leone who brought Tiomkin's 'Degüello' to Morricone's attention for the climactic shootout at the end of *A Fistful of Dollars* (1964) where a mariachi-style trumpet can be heard.[42] Like Tiomkin's 'Degüello', Morricone's cue is in a minor key and is marked by the use of Latin American rhythms.

In *For a Few Dollars More* (1965), there is another mariachi-style trumpet solo, also in a minor key and also featuring syncopation. And in *The Good, the Bad, and the Ugly* (1966), the showdown between the three men of the title distinctively employs yet another mariachi-style trumpet. In fact, the appearance of a mariachi-style trumpet for moments of climactic confrontation in the Western became something of Morricone's musical signature. It isn't the only example of Tiomkin's influence on Morricone. Morricone's Western scoring style involves many of the instruments Tiomkin used in *Rio Bravo*: harmonica, Latin American percussion and, of course, whistling, which Tiomkin had used even earlier in *The High and the Mighty* (1954), in both instances by John Wayne).

After *Red River*, Tiomkin would claim 'If I never see another cow in my life, it will be too soon.'[43] Neither of the two remaining Westerns Tiomkin scored for Hawks contain cattle, but if a Hollywood composer has written better music for cows I'd like to hear it!

Special thanks to Warren Sherk, Academy of Motion Picture Arts and Sciences and co-editor of *The Dimitri Tiomkin Anthology* for his valuable help along the way and to Ian Brookes for his editorial insight.

Notes

1. According to Burwell, 'there was a Dmitri [sic] Tiomkin moment when Mattie crosses a river accompanied by brass, strings and timpani'. See '*True Grit:* Carter Burwell's Notes': http://www.carterburwell.com/projects/True_Grit.html (accessed 6 January 2011).

2. Exceptions include David Arnold, 'My Rifle, My Pony, and Feathers: Music and the Making of Men in Howard Hawks' *Rio Bravo*', *Quarterly Review of Film and Video* vol. 23 no. 3 (2006), pp. 267–79; Timothy K. Scheurer's commentary on *Red River* in his *Music and Mythmaking in Film* (Jefferson, NC: McFarland, 2008); some attention to *Red River* and *Rio Bravo* in William Darby and Jack DuBois's *American Film Music* (Jefferson, NC: McFarland, 1990); and Todd McCarthy's account of Hawks's collaboration with Tiomkin in *Howard Hawks: The Grey Fox of Hollywood* (New York: Grove Press, 1997).

3. Although *Duel in the Sun* (1947), a Western scored by Tiomkin, was released first, *Red River*, held up for two years by litigation from Howard Hughes, was actually Tiomkin's first Western film score. Tiomkin would score over a dozen Westerns, including *High Noon* (1952), *Gunfight at the O.K. Corral* (1957), *The Unforgiven* (1960) and *The Alamo* (1960). Tiomkin is credited with *The Westerner* (1940) but he did not write the score.

4. Quoted in Philip K. Scheuer, 'His Melodies Linger On', *Cue* (23 March 1957), np, Clippings file, 'Dimitri Tiomkin', Margaret Herrick Library, Academy of Motion Picture Arts and Sciences.

5. Quoted in Curtis Lee Hanson, 'An Interview with Dimitri Tiomkin', in *Dimitri Tiomkin: The Man and His Music* (London: National Film Theatre, 1986), p. 56.

6. McCarthy, *Grey Fox*, p. 426.

7. Quoted in Scheuer, 'His Melodies Linger On', p. 15.

8. Quoted in 'Tiomkin's Plea: Give Film Music More "Liberty"', *Variety* (31 January 1957), p. 63.

9. Henry Henigson quoted in Scheuer, 'His Melodies Linger On,' p. 15.

10. McCarthy, *Grey Fox*, p. 589.

11. Quoted in ibid.

12. The title, in fact, of Tiomkin's autobiography.

13. Mancini's biographer sees it differently. According to John Caps, Hawks presented 'boxes of African percussion' to Tiomkin. 'Initially, Tiomkin nodded, but he never really took the suggestion seriously. He was a two-fisted, large-scale, orchestral composer. . . . and no matter how the director re-explained his needs, Tiomkin remained intractable.' John Caps, *Henry Mancini: Reinventing Film Music* (Urbana: University of Illinois Press, 2012), p. 86.

14. Dimitri Tiomkin, *Red River*, sketches, Dimitri Tiomkin Archive, USC.

15. Nomenclature can be a bit confusing here. Tiomkin, in his sketches, referred to it as the 'beef theme', while the (uncredited) lyricist for the song version, Jester Hairston, entitled it 'Red River'. The cue sheet designates it by a shortened form of its lyrics and I'll use that: 'On to Missouri'.

16. See Corey Creekmur, 'The Cowboy Chorus: Narrative and Cultural Functions of the Western Title Song', in Kathryn Kalinak (ed.), *Music in the Western: Notes from the Frontier* (New York: Routledge, 2011), pp. 21–36.

17. Ibid., p. 26.

18. Phillip Drummond, *High Noon* (London: BFI, 1997), p. 63.

19. A copy of three verses for 'Red River' is in the Tiomkin Archive on Hairston's stationery with the heading 'Lyrics for "Red River" Submitted by Jester Hairston'. Dimitri Tiomkin Archive, USC.

20. Exceptions include some late studio-era films featuring Woody Strode, such as John Ford's *Sergeant Rutledge* (1960) and *The Man Who Shot Liberty Valance* (1962) and Richard Brooks's *The Professionals* (1962). *Sergeants 3* (1962) featured Sammy Davis, Jr. The 1930s saw so-called race movies produced with black casts and crews for black audiences which featured Herb Jeffries as a singing cowboy in a series of films beginning with *Harlem on the Prairie* (1937).

21. Hairston enjoyed a long career in Hollywood, much of it uncredited: in addition to *Duel in the Sun*, Hairston provided the choral arranging and conducting for John Ford's *3 Godfathers* (1948) and *She Wore a Yellow Ribbon* (1949); the Jester Hairston Singers sang in Ford's *Sergeant Rutledge*; and Hairston actually appears in John Wayne's *The Alamo,* a film scored by Tiomkin where I suspect that Hairston was responsible for the (uncredited) choral work. Hairston and Tiomkin later worked together with Hawks on *Land of the Pharaohs* (1955).

22. The irony, I believe, was not lost on Hairston. During a recording session for another Tiomkin-scored Hawks film, *Land of the Pharaohs*, Hairston quipped that 'the picture was about the Egyptians, the music was sung in Arabic language by a chorus of white and Negro singers under the direction of a Negro. . . and was composed by Dimitri Tiomkin, a Russian.' See 'Behind the Photograph: Hairston and Tiomkin', in 'Dimitri Tiomkin: The Official Website': http://www.dimitritiomkin.com/5984/may-2014-behind-the-photo-graph-hairston-and-tiomkin/ (accessed 8 January 2015).

23. Arnold, 'My Rifle, My Pony, and Feathers', p. 273.

24. Untitled Warner Bros. Publicity Department release, 8 September 1958, Warner Bros. Archive, USC.

25. Dimitri Tiomkin, *Rio Bravo*, sketches, Dimitri Tiomkin Archive, USC.

26. Mark Slobin, 'The Steiner Superculture', in Mark Slobin (ed.), *Global Soundtracks: Worlds of Film Music* (Middletown, CT: Wesleyan University Press, 2008), p. 24.

27. I would like to acknowledge here the extensive email correspondence about 'Degüello' that I shared with Charles Leinberger, Yuna de Lannoy and Robert Cumbow. For many insights here, I am indebted to this correspondence.

28. Warner Bros. Publicity Report, 3 July 1958, Warner Bros. Archive, USC.

29. Arnold, 'My Rifle, My Pony, and Feathers', p. 268.

30. McCarthy, *Grey Fox*, p. 558.

31. The 'Degüello' solo was played on the trumpet, a Besson 'Meha', by Mannie Klein. Thanks to Charles Leinberger for sharing this information.

32. See Yuna de Lannoy, 'Innovation and Imitation: An Analysis of the Soundscape of Akira Kurosawa's *Chambara* Westerns', in Kalinak, *Music in the Western*, p. 122.

33. Thanks to Charles Leinberger for pointing out this important information on the bugle to me.

34. That letter reads: 'The musical composition "Deguello" as used in the motion picture *Rio Bravo* is an original composition conceived and written by me' (18 January 1960), Warner Bros. Archive, USC.

35. Tiomkin's 'Degüello' was recycled in John Wayne's *The Alamo*. De Lannoy points out that the 2004 *The Alamo* returned to the original nineteenth-century version. See De Lannoy, 'Innovation and Imitation', p. 122.

36. Dean Martin does croon a line from 'My Rifle, My Pony, and Me' later in the film, but only a line.

37. Arnold, 'My Rifle, My Pony and Feathers', p. 273.

38. Ibid.

39. Ibid., p. 272.

40. Ibid., p. 271.

41. De Lannoy, 'Innovation and Imitation', p. 127.

42. See Charles Leinberger, 'The Dollars Trilogy: "There Are Two Kinds of Western Heroes, My Friend!"', trans. Didier Thanus, in Kalinak, *Music in the Western*, p. 141; Patrick Ehresmann, 'Western, Italian Style',: http://www.chimai.com/resources/specials/ehresmann-western.cfm?screen=special&id=3&language=en&page=all&nb_pages=10 (accessed 20 January 2014); and Philip Tagg and Bob Clarida, '*The Virginian* – Life, Liberty and the US Pursuit of Happiness', in *Ten Little Title Tunes: Towards a Musicology of the Mass Media* (New York: Mass Media Music Scholars' Press, 2003), p. 371.

43. Quoted in McCarthy, *Grey Fox*, p. 438.

10 'More Than Just Dance Music'
Hawks and Jazz in the 1940s

Ian Brookes

It is interesting, I think, to contemplate how art crosses color lines and gets around into places where the creators of the art themselves may not be welcome. In traveling through our prejudiced Middle West, I was struck by the large number of records by Negro bands – Duke, Lionel, Louis Jordan, Cab, on jukeboxes in cafes where Negroes are not served.

Langston Hughes (1946)[1]

It don't mean a thing if it ain't got that swing
Doo-wah doo-wah doo-wah doo-wah doo-wah doo-wah doo-wah doo-wah.

Ellington-Mills (1932)[2]

Air Force

Howard Hawks's *Air Force* (1943) opens on a musical note, a brass fanfare invoking the bugle's call to arms. The bugle refrain, with ensuing orchestral replication, provides a sombre accompaniment to the opening credits. Then, over the scrolling text of the Gettysburg Address, we hear an orchestral rendition of 'The Battle-Hymn of the Republic', its well-known verses by Julia Ward Howe unsung but implicitly inscribed in the music. From the outset, *Air Force* is presented as an official narrative, one that draws on venerated texts from American history. The 'Battle-Hymn' fuses the uplifting characteristics of the hymn with the rhythmic purpose of the military march, drawing on battle imagery and a prophetic, Old Testament tone of invincibility. The hymn demonstrates the power of music, co-opted here as a quasi-official national anthem, to fire up a nation at war. Also incorporated within Franz Waxman's orchestral score and heard throughout the film is the song popularly known as '(Off We Go) Into the Wild Blue Yonder,' accredited as the 'Air Force Song'.

Music has always been enlisted for official purposes during wartime. From the battlefield's fife and drums to the marches of John Philip Sousa, the American military tradition has recognised the capacity of music to raise morale, generate patriotic sentiment, galvanise courage and lend a note of gravitas to sombre events. It can also contribute to a unifying sense of national identity through a shared musical culture, especially during wartime hardship, loss and adversity. All these musical examples in

Corporal Weinberg's (George Tobias) gestural appreciation of Duke Ellington's music in *Air Force* (1943)

Air Force had an official narrative function of one kind or another. This is hardly surprising in a Hollywood war film produced in the aftermath of Pearl Harbor and conceived as an official production. *Air Force* was written and produced in cooperation with the War Department and the Army Air Corps, and with the approval of General Henry (Hap) Arnold, head of the Army Air Forces. The Air Force also appointed a technical adviser to the production, Captain Samuel Triffy, who spent eight weeks assisting screenwriter Dudley Nichols and Hawks 'in developing a story and writing accurate dialogue'.[3]

In a brief but telling scene, the crew of the *Mary-Ann* listen to a radio news broadcast on the eve of Pearl Harbor where they hear assurances that Japanese intentions are 'wholly peaceful'. There is little in the screenplay to indicate that the scene will be of much consequence: 'Peterson [Ward Wood] twists dial and a band program comes in. Nobody pays much attention to the radio.'[4] Corporal Weinberg (George Tobias) gestures dismissively to the radio operator who retunes the dial to another station, which is playing Duke Ellington's 'It Don't Mean a Thing (If It Ain't Got That Swing)'. The delighted Weinberg, obviously familiar with the tune, gives an impromptu interpretation of it, entertaining the crew with his own idiosyncratic hand-jive and percussive clapping. This scene, probably an example of Hawks's characteristic on-set improvisation, can be seen as a 'Hawksian moment', here involving a highly personalised gestural sequence by

Weinberg. Joe McElhaney has drawn attention to the fact that Hawks's films fore-ground a distinctive kind of screen acting revolving around gestures and, specifically, of 'the gesturing hand'.[5] The scene constitutes a particularly resonant gestural moment.

Several questions are raised by this 'Hawksian moment'. What is this scene doing in the narrative? Why that song rather than another? What are we to make of Elling-ton's fleeting performance on the *Mary-Ann*? If 'nobody pays much attention to the radio', why does it provoke such an animated response from the crewman? What racial implications does jazz music have in a segregated America where, as Langston Hughes has reminded us, jukebox records by black bands were playing in places off limits to the musicians who made them? And what are the racial implications of that music in an America that was being billed as a 'democracy at war?'

Jazz featured prominently in another 1940s Hawks film, *A Song Is Born* (1948), and in this chapter I consider how jazz functions in these narratives as a marker of racial discourse. I want to suggest that we can identify in these films a sense of musical hier-archy. Both films feature a variety of musical forms and styles, which are indexed to par-ticular value systems. These include official, classical and popular types of music while 'jazz' encompasses a spectrum of styles during a period when meanings of the term itself were being widely contested. Hawks's narratives often involve the inversion of traditional hierarchies, of power and authority, and here it's through the hierarchies of music and musical genre that he takes on racial hierarchies too.

The presence of 'It Don't Mean a Thing' in the narrative is racially significant in sev-eral ways. It was a hit record for Ellington in 1932, later becoming his signature tune, and serves as a portent of the ensuing swing era as well as a reminder of the black provenance of swing music. The song's title derived from a saying of Ellington's trum-peter Bubber Miley who, Ellington later recounted, was the first he had heard use the expression.[6] It was Miley who introduced the distinctive 'gutbucket' or dirty voicings into Ellington's orchestral sound-mix in the 1920s through his use of mutes, particularly his 'growl-and-plunger' technique. Trombonist 'Tricky' Sam Nanton developed Miley's technique to replicate the human voice and 'talk'. In the original 1932 recording of the song, vocalist Ivie Anderson used scat singing breaks too, her growling vocal matching the raucous brass voicings. The crew of the *Mary-Ann* only hear the song on the radio but the audience might well have been familiar with it in a live context and even seen it performed, as for instance, in the RKO band short *Duke Ellington and His Orchestra* (1943), released shortly after *Air Force*. The sequence demonstrates the performative use of mutes as members of the brass section are shown with synchronised hand movements, operating their mutes in unison in precisely the same sort of choreo-graphed hand-jive imitated by Weinberg.

The song's lyric also contributes to this performative effect. Its slangy phrasing and nonsensical scat chorus are at odds with syntactical niceties. In contrast to the quasi-official, religio-military musical excerpts at the beginning of the film, 'It Don't Mean a Thing' is interpolated in the narrative as a kind of vernacular call-up, drawing on a call-and-response pattern as the vocal line of the title is 'answered' by the repeated 'doo-wah' figure. The song's swinging, rhythmic momentum calls for a participatory

response from the listener and even in instrumental versions the urge to sing along with the title refrain or to join in the scat 'doo-wah' chorus is irresistible, as Weinberg demonstrates. His animated hand gestures mimic a trombonist's, here, suggestively, those of Ellington's sideman Nanton with his 'wah-wah' mute. It's clear that Weinberg has seen the song in performance as well as having heard it. It's significant too that the most appreciative listener on the *Mary-Ann* should be Weinberg, the working-class New Yorker who is also a Jew.

But the song that triggers Weinberg's ebullient reaction isn't merely a collection of novelty effects accompanying a danceable tune, nor is the scene simply an upbeat moment in an otherwise sombre war narrative. Rather, they constitute an assertion of racial identity. 'The music of my race is something more than the "American idiom",' Ellington wrote in 1931.

> It is the result of our transplantation to American soil, and was our reaction in the plan-tation days to the tyranny we endured. What we could not say openly we expressed in music, and what we know as 'jazz' is something more than just dance music.[7]

The song's performance is an illustration of the expressive nature of jazz derived from African American experience operating as a form of racial strategy, an encoded form of expression capable of speaking a musical language on behalf of what could not be said 'openly' by blacks. Wartime highlighted the conditions of racial inequality in the armed forces, which reflected those in American society at large. In *Air Force*, it seems scarcely remarkable that all the crewmen on the *Mary-Ann* listening to 'It Don't Mean a Thing' are white, effectively a segregated audience. This is because all branches of the armed forces were racially segregated and, at the beginning of the war, black ser-vicemen were excluded from the Army Air Corps altogether, only later being admitted to segregated programmes.[8] So much for a democracy at war. Perhaps there is a sense in which Ellington and his band are standing in for the absent black crewmen on the *Mary-Ann*, those denied their rightful place aboard.

The song on the radio is later accompanied by another sound, the steady drone of the aircraft engines. With the addition of this sonority to the tonal mix, there is an impli-cation that the song is being co-opted as a kind of unofficial soundtrack to the aircraft becoming mobilised for war. The radio provides the medium for official wartime announcements but the very reason we hear Ellington's song is because, at Wein-berg's insistence, it has displaced the official news that he instinctually distrusts. The song is conscripted as part of a cultural front of wartime Americanism and, as swing historian David Stowe suggests, 'the swing industry was in the forefront of the new ideology of pluralism and racial tolerance, demonstrating the virtues of integration in a highly conspicuous way'.[9] In *Air Force*, Ellington's appearance on the *Mary-Ann* may be only momentary, but it nevertheless draws attention to the racial meanings of swing music in a segregated America. Jazz has always played a political as well as a cultural role in challenging the racial status quo, a role it would fulfil again in Hawks's postwar musical comedy, *A Song Is Born* (1948).

A Song Is Born

A Song Is Born, starring Danny Kaye and Virginia Mayo, was poorly reviewed on its original release and has been critically disparaged or neglected ever since. It's often seen as an inferior and pointless remake of the director's earlier *Ball of Fire* (1942) starring Gary Cooper and Barbara Stanwyck.[10] Subsequent studies of Hawks usually rank the film as an also-ran in comparison with such critically validated films of the 1940s as *To Have and Have Not* (1944), *The Big Sleep* (1946) and *Red River* (1948). For example, in Robin Wood's seminal study of Hawks, the film fails to feature even in the appendix of 'Failures and Marginal Works', getting only a passing mention as a 'vastly inferior remake'.[11] Hawks himself spoke contemptuously about the film, disparaging both Kaye ('about as funny as a crutch') and Mayo ('pathetic'),[12] later describing the film as 'a disaster from every point of view'.[13] Hawks didn't attend the rushes and claimed he never saw the completed film.[14] Remarkably, the film even lacks a screenplay credit, citing only Billy Wilder and Thomas Monroe as the authors of the original story, 'From A to Z'. Having effectively disowned the production, Hawks often claimed in later interviews that he only agreed to make it because Samuel Goldwyn offered him so much money.[15]

Goldwyn wanted a new starring vehicle for his protégé Danny Kaye and came up with the idea of casting him in a remake of *Ball of Fire*. *A Song* features Kaye as Professor Frisbee, a musicologist working on an encyclopaedic history of music who finds himself unexpectedly brought into contact with jazz through a series of encounters with several leading jazz musicians of the day playing themselves: Louis Armstrong, Charlie Barnet, Tommy Dorsey, Lionel Hampton and Mel Powell, together with Benny Goodman as one of the scholars (Professor Magenbruch).

A stage performer with a vaudevillian background, Kaye had become a phenomenally popular star through a series of screen roles in musical comedies produced by Goldwyn and designed to exploit his novelty vocal performances.[16] Since his screen debut in Goldwyn's *Up in Arms* (1944), Kaye's roles had typically included speciality numbers that showcased his talent for frenetic energy and zany characterisations. He had appeared in *Lady in the Dark* on Broadway (1941), with songs by Kurt Weill and Ira Gershwin, including Kaye's show-stopping number 'Tschaikowsky (and Other Russians)', in which he rattled off at breakneck speed the names of some fifty Russian composers. The song was reprised in *Up in Arms*, which also featured 'Melody in 4-F' from Cole Porter's stage musical *Let's Face It!* (1941), a novelty track spoofing scat singing. Other speciality numbers included 'Otchi Tchorniya' from *Wonder Man* (1945), 'Pavlova' from *The Kid from Brooklyn* (1946) and 'Symphony for Unstrung Tongue' from *The Secret Life of Walter Mitty* (1947), all written specifically for Kaye by his then wife, Sylvia Fine.

But if these films had contributed to the spectacular rise of Kaye's stardom, reviews of *A Song* were overwhelmingly negative and Kaye bore the brunt of the criticism. Reviewers often expressed disappointment that his characteristic madcap performance style was constrained by a 'straight' role and, as the *Los Angeles Times* complained, 'without interpolating a single "scat" speciality'.[17] The *Washington Post*

similarly saw Kaye 'restrained' by the role and asked, 'Why hogtie him with an endless plot and why let that plot get in the way of all the jam sessions one might have enjoyed?'[18] The film, as *Time* put it, was 'designed as a starring vehicle for Danny Kaye, but he is almost drowned out in the blare' with a plot 'serving only as a link between jam sessions' and, 'when it brims over into outlandish muggajuggery … the yarn gets in the way of the hot licks'.[19] The *New York Times* described Kaye as 'but a shade of the scintillant comedian whom the screen fans have come to love' and 'something of a specter amid a hodge-podge of animated acts. And, to make it thoroughly depressing, he doesn't sing one song.'[20] Yet, despite these inauspicious pronouncements, *A Song* was commercially successful and in the first week of November became the number one film nationwide and Hawks's most popular since *Sergeant York* (1941).[21] There was, then, considerable disparity between box-office success and tepid critical reception.

Later, with the emergence of jazz studies, *A Song* was criticised for its narrative treatment of jazz. Kaye's Professor Frisbee provides a peculiar history of jazz which eschews any mention of its African American provenance. As Krin Gabbard has pointed out: 'All suggestions of racism, not to mention the slave trade, are scrupulously avoided in this history.'[22] Gabbard's reading of the film derives from his critique of Hollywood's racist practices of the 1940s that also saw a tendency to privilege white performances over black ones. Here, for example, he describes how

> [Louis] Armstrong's effortless crooning of 'A Song Is Born' … provides a striking contrast to the minor singing talent displayed … by Virginia Mayo in what was intended to be a culminating moment in the professors' recorded history of jazz.[23]

This, after all, was a period in which a white vocalist like Mayo could sing to an all-white audience without apparent irony the song 'Daddy O (I'm Gonna Teach You Some Blues)'.[24]

Although the film was disdained by contemporary reviewers, auteurist critics and jazz historians alike, if we look more closely at the historical moment of its production and critical reception from an African American perspective, a rather different picture emerges. Here, the film was so widely praised for its work on behalf of 'the race' that it often looked like a completely different film to the one being disparaged everywhere else. Hawks, of course, is the unlikeliest Hollywood figure to be associated with progressive racial politics. He isn't known for being sympathetic to African American interests or the civil rights movement. Indeed, in a 1974 interview in *Jump Cut*, Hawks's interviewers offer a neatly drawn case for understanding him as a traditionalist conservative, if not quite the rightwing ideologue that his friend John Wayne famously was.[25] And yet we can see in Hawks's 1940s films repeated instances of racial representations linked to musical performances which often appear radically at odds with the racist screen conventions of the time.[26] In *To Have and Have Not*, for instance, Hawks uses jazz, especially through scenes of interracial performance, to underscore the narrative's antifascist concerns.

Certainly, *A Song* made a significant racial impact. Shortly after its release, the following news story, filed from Memphis, appeared in the African American newspaper the *Chicago Defender*:

> The board of moving picture censors this week banned the showing of the musical comedy picture 'A Song Is Born', declaring it 'inimical to public welfare[']. The board charges first the picture story is untrue, 'it is supposed to be about the birth of jazz in New Orleans, when everybody knows that jazz and the blues actually had their beginning down on Beale Street in Memphis'. The second reason given was that 'it shows a rough and rowdy bunch of musicians of both colors. There is no proper segregation of the races.'[27]

The story raises some important questions about race and jazz in postwar America. First, there is the question of black visibility on screen. The main convention in Hollywood was one of racial exclusion by which blacks were largely denied access to screen roles. This prevailing condition of black invisibility was the consequence of Hollywood's own institutionally racist practices but it was aided and abetted by other institutional bodies empowered to regulate black appearances on the screen. When the Memphis Board of Censors banned *A Song Is Born* – a film on general release elsewhere – it represented but the latest instance of a concerted check on a burgeoning African American assertiveness, empowered by the experience of World War II, by a local white power base with the statutory power to suppress what it saw as the threat of incipient racial equality. Southern boards applied their own cuts to any and all films in which black representations deviated from what they deemed as acceptable, especially if there were any suggestion of interracial fraternisation.

Moreover, as Whitney Strub has pointed out, racial censorship in Memphis in the 1940s was enforced by the Chairman of the Memphis Board of Censors, Lloyd T. Binford, who zealously suppressed black visibility on the screen, 'frequently cutting black performers entirely from films, regardless of the narrative significance of their roles'.[28] Musicians were particularly badly hit. Following the outright banning of the all-black musical *Cabin in the Sky* (1943), Lena Horne was excised from the musicals *Ziegfeld Follies* (1946) and *Till the Clouds Roll By* (1946), Pearl Bailey from *Variety Girl* (1947) and pianist Art Tatum from the Dorsey brothers' biopic *The Fabulous Dorseys* (1947). In addition, Duke Ellington, Cab Calloway and the King Cole Trio were all cut in their roles as musicians.[29] Prior to the release of *A Song*, Binford also banned the screwball comedy *Brewster's Millions* (1945) which, he claimed, 'presents too much familiarity between the races ... too much social equality and racial mixture'.[30]

There was widespread condemnation of these practices in African American newspapers such as the *Chicago Defender*, the *Pittsburgh Courier* and in *The Crisis*, the magazine of the National Association for the Advancement of Colored People (NAACP). The 1940s also saw several new black publications including the academic journal *Phylon: The Atlanta Review of Race and Culture*, published by Atlanta University, together with various mass-market magazines such as *Our World* and the *Negro*

Digest. These publications provided new platforms for the dissemination of criticism of the racial politics of American culture, including the racist practices of Hollywood and the South. Furthermore, a major academic study of race relations and the mass media contained a survey of Hollywood films which codified in unprecedented scope and detail the stereotypical characteristics routinely assigned to blacks.[31] It concluded first, that 'the Negro is usually presented as a savage or criminal or servant or entertainer', and second, that 'the usual roles given to Negro actors call for types like Louise Beavers, Hattie McDaniels, "Rochester" [Eddie Anderson], Bill Robinson, Clarence Muse and various jazz musicians'.[32] These 'various jazz musicians' would play a crucial role in challenging Hollywood's racial status quo.

Commentators frequently attacked the continuing power of the South to determine both the maintenance of these racial stereotypes and the routine excisions of black per-formances. For instance, in August 1947, the year before the Memphis ban on *A Song*, an article in the *Negro Digest* lambasted the ways in which Hollywood's studio bosses remained in thrall to the Southern box office. 'Up to now', said Robert Jones, 'the sol-ution to protests against stereotyping the Negro has been quite simple for Hollywood; cut them out altogether.'[33] For Carlton Moss, writing in *Our World*, Hollywood's black stereotypes were themselves drawn from the tradition of an antebellum South. 'Since the days of the big house', writes Moss, 'when the master would allow his most tal-ented slaves to entertain his guests, the South has approved of Negro entertainment.' He finds an explicit link between the old racist fantasy of the South and the modern commercial imperative of its box-office potential: 'As long as the Negro portrays these "acceptable characters" there will be no objection from the 6,350 theatres in the South.'[34] The power of the South to influence Hollywood's racial practices to such an inordinate degree becomes more comprehensible, if no less repugnant, when those box-office demographics are taken into account.

It was in these circumstances, then, that *A Song Is Born* was anticipated in the African American press as a major event. This was partly due to its high-profile roles for Louis Armstrong and Lionel Hampton as popular black musicians, but also because of the crusading emphasis in the black press on interracial representation on screen. The film was still in production when it was heralded in the *Chicago Defender* for the 'sensational' fact that 'the movie band is interracial' and that 'Benny Goodman, long famous for his introduction of the Negro-white musician idea, has played a valuable role in working with Howard Hawkes [sic] and Danny Kaye in … giving Negro musicians full recognition for their contributions.' And, in a scarcely coded reference to the South, it reported how 'Negroes have been given straight parts without reference to pleasing any special section of the country.'[35] Also unstinting in its praise for the film's 'racial understanding' was the black monthly *Ebony*. *A Song*, it says, 'does for jazz music and its foremost colored exponents what movies … have failed to do for three decades. Brought together in one band, regardless of race or color, are the top jazzmen of modern music.' Even producer Goldwyn, generally constrained by the pragmatic racism necessitated by commercial interests, is singled out for his principled stand against 'the usual Southern bigot-banning of movies that give decent roles to

Negroes'.[36] Bearing in mind the mediocre critical reception of the film in the main-stream papers, the reaction in the black press was almost euphoric about what it saw as an iconoclastic film, 'absolutely revolutionizing the Negro's place in Hollywood'.[37]

Hampton, together with Benny Goodman, appeared together in the musical ensembles in *A Song*, but they also represent a highly significant interracial history rooted in the previous decade. Goodman, at the instigation of the impresario John Hammond, had been at the vanguard of forming racially integrated bands at a time when the very notion of racial integration in American society was widely seen as inconceivable. One of the first white bandleaders to hire black musicians, in 1935 Goodman enlisted pianist Teddy Wilson to join him in a trio with drummer Gene Krupa and the following year formed a quartet with the addition of Hampton on vibraharp. This was a racially radical act. As Hampton described it, 'An integrated band was such an unheard-of thing, even in New York in those days, that some people actually worried that there would be a race riot.'[38] Goodman was lauded in the black press because he had made such an impact on the racist conventions of the time, largely through musical means and, it must be said, at no small risk to his own career. His contribution to racial equality was incalculable. 'As the predominant white employer of black musicians in the 1930s and early 1940s,' swing historian Lewis Erenberg has noted, 'Goodman was the most visible symbol of racial integration in the music business.'[39] With his small-group recordings, big-band shows, radio broadcasts and film performances, Goodman had achieved phenomenal success as the 'King of Swing' and become a hugely influential figure in establishing new constituencies of recognition for jazz music.

All the same, we should note that the racial dimensions of Goodman's rise are more complex than they might appear from the pages of the *Chicago Defender*. Jazz historians have long been aware that Goodman's legendary performance at the Palomar Ballroom in Los Angeles on 21 August 1935 before a capacity audience and broadcast nationwide on network radio was something of a watershed. This show would come to be seen as the inauguration of the swing era, bestowing a musical defi-nition on the ensuing decade. The jazz writer Gary Giddins sees it rather differently. 'From the days of antebellum minstrel shows to the present,' says Giddins, 'the point at which indigenous American music becomes pop culture is the point where white performers learn to mimic black ones.'[40] Goodman is a case in point. He may have become the 'King of Swing' but, of course, his fabled Palomar date didn't see the invention of swing but rather the popularisation in a precise cultural moment of a music developed by blacks over several preceding years. Famously, Goodman had been on a dismally unsuccessful cross-country tour, where he was obliged to play 'sweet' dance music. He opened the Palomar show with the usual bland arrangements to an unrespon-sive audience until he let loose with what Giddins calls 'the good stuff', that is, a set of charts (arrangements) he had acquired from the great black bandleader Fletcher Henderson.[41] Goodman's claim to fame is ineluctably tied to the racial dimension of those Henderson charts and to the antecedents of black bands, especially Henderson's. 'Many of Goodman's biggest hits were virtual duplications of records that Fletcher Henderson and Chick Webb had recorded months, even years before.'[42]

Goodman's role in the film tells us a great deal about changing perceptions of jazz in the period. First, the bespectacled Goodman always looked professorial himself – he was actually nicknamed 'the Professor'. In the improvised 'Stealin' Apples' sequence, we see the clodhopping Magenbruch with no sense of rhythm, exaggeratedly stomping off the beat. 'Is this the music here?', he asks when called upon by Frisbee to join the jam session. 'Oh no, we don't use any music,' says pianist Mel Powell. 'We haven't got anything written down, Professor.' 'We can't play without music,' says Magenbruch, to which Hampton replies: 'Well Benny Goodman used to.' The joke is that neither Magenbruch nor anyone else at the academy has ever heard of the 'King of Swing' and the narrative is satirising the ivory-towered world of the professors who are entirely ignorant about jazz. When Magenbruch is asked to participate in the jam session, he says, 'Oh, then I'd better take my book along with me,' a book identifiable as Winthrop Sargeant's *Jazz: Hot and Hybrid*. The appearance of this book in the film was salient. *Hot and Hybrid* was the first major musicological study of jazz, published in 1938 with a second edition in 1946 (Magenbruch's edition). Sargeant's book drew on traditional musical notation in a formal analysis of 'hot' jazz, concluding with a discussion of 'jazz as a fine art'.[43] The book was a significant marker that jazz was being taken increasingly seriously as a subject for scholarly study. Also published the same year as *A Song* was Sidney Finkelstein's *Jazz: A People's Music*, another major study of jazz, from a Marxist perspective, which saw jazz as a folk/protest music.[44] Initial publication of Sargeant's book also coincided with the first of John Hammond's historic 'From Spirituals to Swing' concerts at Carnegie Hall ('Negro music from its raw beginnings to the latest jazz'), the prestigious venue itself an indicator of the increasing cultural and artistic status of jazz (and the first major concert in New York for an integrated audience).[45]

The Memphis censors who banned *A Song* and complained about its 'rough and rowdy bunch of musicians' were highlighting the longstanding connection between jazz and its seamy, lowlife reputation. Hollywood had long exploited representations of a jazz *demi-monde* – think of the jazzy soundtracks to the Prohibition-era speakeasies in the gangster film – and had used jazz as a ready signifier of sleaze, decadence and vice. In *It's A Wonderful Life* (1946), for example, the 'unborn sequence' shows a suicidal George Bailey (James Stewart) his home town of Bedford Falls transformed into Pottersville, the worst imaginable world. This is represented through the stylistics of film noir, the town's flashing neon lights signalling a chaotic city of prostitution, drunkenness and debased commercial attractions. The soundtrack for this nightmare vision is jazz and its issuing source a black piano player. Pottersville was one postwar version of jazz to bear the traces of its disreputable past but there were alternatives too. It's difficult to imagine Benny Goodman and Tommy Dorsey being 'rough and rowdy'. These bandleaders looked impeccably respectable in dress and demeanour. Indeed, they brought to jazz an image of respectability hitherto unknown at a time when, as Bernard Gendron has pointed out, jazz was undergoing a transformation from an entertainment music to an art music.[46] That transformation was linked to debates in the 1940s about the contested meanings of jazz itself. The term, of course, encompasses myriad forms and

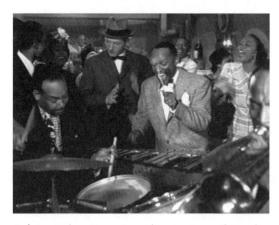

Professor Frisbee (Danny Kaye) keeping time with Lionel Hampton's band playing 'Goldwyn Stomp' in *A Song Is Born* (1948)

styles. According to the New Orleans revivalists in what Gendron calls the 'factional wars' of the period, 'swing' was actually antithetical to 'jazz'. The African American tradition of 'simultaneous improvisation' was being threatened by the 'European artifact of written arrangements'. Swing was also criticised for its standardised routines, flashy showmanship and, not least, its reliance on the riff.[47] It was against this condemnation of swing as ersatz jazz that the jam session was posited as the site of 'authentic' jazz, its cultural value created outside the commercial mainstream. Venues such as Minton's Playhouse in Harlem played a major role in the development of jam-session culture in the 1940s.[48]

Frisbee's fact-finding excursion into the world of jazz, then, takes him to a series of venues in which various types of jazz are being played, each with a different hierarchical value. The first is, significantly, the Dixieland Club, featuring Mel Powell.[49] Arriving early, Frisbee hears music coming from the back of the club and a waiter indicates it's okay for him to go in. Greeted by two cleaners on the way, he enters a crowded kitchen where a jam session is in full swing with musicians informally clustered around Powell's little piano. A pot is steaming in the background and two chefs are chopping vegetables in time with the music. The venue is an everyday workplace with ordinary working people made vibrant by the out-of-hours performance. However, the musical highpoint of Frisbee's trip comes during his last visit when he sees Armstrong and Hampton. Descending into a subterranean space, off the beaten track like the kitchen at the Dixieland, it's a far cry from the genteel white-chiffon ambience of Tommy Dorsey's supper-club appearance or Honey Swanson's sedate, undemonstrative audience. Here, the space is exuberantly crowded and animated, with the band playing a smoking jam-session version of 'Goldwyn Stomp'. The band and the audience, intermingled in the same space, are predominantly black. We can see here an example of the kind of collective, interracial musical space favoured by Hawks, also apparent in Gene Krupa's 'Drum Boogie' sequence in *Ball of Fire* and the musical numbers at the hotel in *To Have and Have Not*.[50]

Several musical forms are drawn together towards the end of the film in another instance of musical hierarchies in play. The widower Professor Oddly (O. Z. Whitehead) asks to hear the old Victorian song 'Sweet Genevieve' that his colleagues sing for him a cappella as he withdraws from the room, the song becoming for him a lament

for his lost wife. The poignant rendition follows his reminiscence of a marital union founded on a shared professional interest in music. Now, with his wife long dead, Oddly keeps a lock of her hair in a locket, an exquisite memory for him, but also a reminder of an unfulfilled marriage, lacking sexual expression. When afterwards the professors begin an impromptu rendition of the old Latin university hymn 'Gaudeamus Igitur', it is significantly at this very moment that Frisbee leaves the room, intending to talk to Oddly. No longer part of the collegial group, Frisbee realises that his life in the academy has been an emotional retreat from the outside world, as it has been for Oddly and the others. But now he has been irrevocably changed by the siren-song of Honey, who has brought not only her sexual allure into the academy, but jazz music too with its power to subvert the status quo and displace the *ancien régime*.

And it's jazz music itself which saves the day at the end of the film. In order to disarm the gangster holding them at gunpoint, the musicians improvise a musical solution and set about trying to create a crescendo that will topple a drum on a shelf above him. They abandon the plodding 'Anvil Chorus' from Verdi's *Il trovatore* in favour of Hampton's own signature tune in a barnstorming finale of 'Flying Home' which, in a Hawksian inversion of hierarchies, does the trick and brings the house down.

Notes

1. Langston Hughes, 'Art and the Heart', *Chicago Defender* (6 April 1946), p. 12.
2. 'It Don't Mean a Thing (If It Ain't Got That Swing)', Duke Ellington-Irving Mills (1932).
3. Lawrence Howard Suid, 'Introduction: Mythmaking for the War Effort', in Suid (ed.), *Air Force* (Madison: University of Wisconsin Press, 1983), pp. 14–15.
4. Dudley Nichols, '*Air Force*: Screenplay', in Suid, *Air Force*, p. 75.
5. Joe McElhaney, 'Howard Hawks: American Gesture', *Journal of Film and Video* vol. 58 nos 1/2 (Spring/Summer 2006), p. 33.
6. Duke Ellington, 'The Most Essential Instrument', *Jazz Journal* vol. 18 no. 12 (December 1965) repr. in Mark Tucker (ed.), *The Duke Ellington Reader* (New York: Oxford University Press, 1993), p. 371.
7. Duke Ellington, 'The Duke Steps Out', *Rhythm* (March 1931) repr. in ibid., p. 49.
8. See, for example, Neil A. Wynne, *The African American Experience during World War II* (Lanham, MD: Rowman & Littlefield, 2010), pp. 26–9, 44–6.
9. David W. Stowe, *Swing Changes: Big Band Jazz in New Deal America* (Cambridge, MA: Harvard University Press, 1994), p. 144.
10. See, for instance, Bosley Crowther's unfavourable comparison: 'The Screen in Review: "Song Is Born", Study of Modern Jaaz [sic] Starring Danny Kaye, Virginia Mayo, at Astor', *New York Times* (20 October 1948), p. 37, and 'Movie Review: "Ball of Fire" a Delightful Comedy, With Gary Cooper and Barbara Stanwyck in Lead Roles, Opens at Music Hall', *New York Times* (16 January 1942), p. 25.
11. Robin Wood, *Howard Hawks* (1968, rev. edn, Detroit, MI: Wayne State University Press, 2006), p. 99.
12. Quoted in Joseph McBride, *Hawks on Hawks* (Berkeley: University of California Press, 1982), p. 86.

13. Quoted in Peter Bogdanovich, *The Cinema of Howard Hawks* (New York: Museum of Modern Art, 1962), p. 27.

14. Quoted in John Kobal, 'Howard Hawks', in *People Will Talk* (New York: Alfred A. Knopf, 1985), p. 499.

15. See, for example, Alex Ameripoor and Donald C. Willis, 'Howard Hawks: An Interview', in Willis, *The Films of Howard Hawks* (Metuchen, NJ: Scarecrow Press, 1975), pp. 203–4.

16. See A. Scott Berg, *Goldwyn: A Biography* (New York: Alfred A. Knopf, 1989), pp. 381–3, 387, 420–2, 441–2.

17. Philip K. Scheuer, 'Jam Session Attended by Prof. Danny Kaye', *Los Angeles Times* (5 November 1948), p. A6.

18. Richard L. Coe, 'Hot Licks Lads Pine for a Plot', *Washington Post* (26 November 1948), p. 15.

19. '*A Song Is Born*', *Time* (1 November 1948), pp. 41–2.

20. Crowther, 'Song Is Born', p. 37.

21. Todd McCarthy, *Howard Hawks: The Grey Fox of Hollywood* (New York: Grove Press, 1997), p. 443.

22. Krin Gabbard, *Jammin' at the Margins: Jazz and the American Cinema* (Chicago, IL: University of Chicago Press, 1996), p. 120.

23. Ibid., p. 123.

24. Mayo's vocals were dubbed by an uncredited Jeri Sullivan. See Charles Emge, 'Movie Music: "Song" Muddles Through – With Recording Troubles', *Down Beat* (December 1948), p. 8.

25. Constance Penley, Saunie Salyer and Michael Shedlin, 'Hawks on Film, Politics, and Childrearing', *Jump Cut* (January/February 1975), repr. in Scott Breivold (ed.), *Howard Hawks: Interviews* (Jackson: University Press of Mississippi, 2006), pp. 100–2.

26. See Ian Brookes, '"A Rebus of Democratic Slants and Angles": *To Have and Have Not*, Racial Representation, and Musical Performance in a Democracy at War', in Graham Lock and David Murray (eds), *Thriving on a Riff: Jazz and Blues Influences in African American Literature and Film* (New York: Oxford University Press, 2009), pp. 203–20.

27. 'Memphis Mad on 2 Counts at Movie "Song Is Born"', *Chicago Defender* (11 December 1948), p. 1.

28. Whitney Strub, 'Black and White and Banned All Over: Race, Censorship and Obscenity in Postwar Memphis', *Journal of Social History* vol. 40 no. 3 (Spring 2007), p. 689.

29. Ibid.

30. Ibid.

31. L. D. Reddick, 'Educational Programs for the Improvement of Race Relations: Motion Pictures, Radio, the Press, and Libraries,' *Journal of Negro Education* vol. 13 no. 3 (Summer 1944), pp. 367–89.

32. Ibid., p. 380.

33. Robert Jones, 'How Hollywood Feels about Negroes', *Negro Digest* (August 1947), p. 4.

34. Carlton Moss, 'Your Future in Hollywood', *Our World* (May 1946), p. 10.

35. 'Goodman Sextet Revived for Danny Kaye Film: Goodman and Hampton Revive That Torrid Sextet of Past in Picture', *Chicago Defender* (16 August 1947), p. 10.

36. 'A Song Is Born: New Danny Kaye Picture Brings Together Top Jazzmen in Single Band', *Ebony* (May 1948), p. 41.

37. 'Hampton Triumphs in Pix "A Song Is Born"', *Chicago Defender* (24 July 1948), p. 9.

38. Lionel Hampton with James Haskins, *Hamp: An Autobiography* (New York: Amistad, 1993), p. 58.

39. Lewis A. Erenberg, *Swingin' the Dream: Big Band Jazz and the Rebirth of American Culture* (Chicago, IL: University of Chicago Press, 1998), pp. 82–3.

40. Gary Giddins, 'Benny Goodman (The Mirror of Swing)', in *Visions of Jazz: The First Century* (New York: Oxford University Press, 1998), pp. 156–7.

41. Although the provenance of jazz was primarily African American, it was usually its white performers who gained greater popular recognition, financial return and critical success. Fletcher Henderson was the most important and influential black bandleader of the 1920s and 30s, who, with Don Redman and Benny Carter, pioneered the arrangement template for big-band jazz. In 1934, the year before Goodman's Palomar triumph, Henderson's poor financial management of his band obliged him to sell his charts to Goodman. Relative to Goodman, Henderson remains little known. See Jeffrey Macee, *The Uncrowned King of Swing: Fletcher Henderson and Big Band Jazz* (New York: Oxford University Press, 2005).

42. Giddins, 'Benny Goodman', pp. 156, 157.

43. Winthrop Sargeant, *Jazz: Hot and Hybrid* (1938, New York: Dutton, 1946). The book includes a musicological analysis of Goodman's Trio recordings with Teddy Wilson and Gene Krupa.

44. Sidney Finkelstein, *Jazz: A People's Music* (New York: Citadel Press, 1948).

45. John Hammond with Irving Townsend, *John Hammond on Record: An Autobiography* (New York: Ridge Press, 1977), pp. 199–210.

46. Bernard Gendron, '"Moldy Figs" and Modernists: Jazz at War (1942–1946)', in Krin Gabbard (ed.), *Jazz among the Discourses* (Durham, NC: Duke University Press, 1995), p. 31.

47. Gendron, 'Moldy Figs and Modernists', pp. 31–3, 40.

48. See, for instance, Dizzy Gillespie with Al Fraser, *To Be, or Not to Bop* (1979, Minneapolis: University of Minnesota Press, 2009), pp. 134–51.

49. Powell's band is playing 'Muskrat Ramble', a well-known recording by Louis Armstrong and his Hot Five from 1926 and a frequently played song in the 1940s Dixieland revival.

50. The novelty reprise of 'Drum Boogie' with Krupa's matchbox percussion and Sugarpuss O'Shea's (Barbara Stanwyck) *sotto voce* vocal provided for a familiar Hawks touch: an enthusiastic audience, tightly crowded round the musicians, joining in on the number's chorus. The band version of 'Drum Boogie' featured trumpeter Roy Eldridge, one of the first black musicians to be on permanent engagement with a white band, although it's evident from the sequence that his performance was severely curtailed. It's certainly striking to see a black soloist in a white band in a 1941 Hollywood film, although Eldridge's account bears witness to the typical treatment of black musicians at this time. Writing nearly a decade afterward the experience still rankles. 'Krupa's band was bought for that flicker along with a couple of my original tunes, *Drum Boogie* and *Ball of Fire*', he

says. 'Yet the directors, from top man Howard Hughes [sic] down, completely disregarded my musical contributions to the movie when they started plotting scenes.' Eldridge also recounted that he 'vigorously protested' to Sam Goldwyn, but to no avail. '"The movie costs us millions of dollars", [Goldwyn] tried to convince me, 'and we can't afford to risk offending anybody, especially the South, by leaving you in the important scenes."' Roy Eldridge, with James Goodrich, 'Jim Crow Is Killing Jazz', *Negro Digest* (October 1950), p. 47. This is a different Goldwyn to the one championed seven years later in the *Chicago Defender*. On the racial *mise en scène* in *To Have and Have Not*, see Brookes, 'A Rebus of Democratic Slants and Angles', pp. 209–14.

PART 6
HAWKS, ANCIENT AND MODERN

11 *Red Line 7000*
Fatal Disharmonies

Joe McElhaney

1,000 ...

Five decades after its release, *Red Line 7000* (1965) remains the most polarising of Howard Hawks's films. A financial and critical failure, Hawks himself felt that the movie was 'no good'.[1] On the other hand, in reviewing *Red Line* for *Cahiers du cinéma* in 1966, Jean Narboni would write that the film engages in a 'masterly presentation of various ways of twisting convention – an epitome and treatise on deconstruction'.[2] And in his landmark 1968 study of Hawks, Robin Wood would find in *Red Line* a film that was 'intensely personal', exhibiting 'the degree of creative intensity that prompts a consistent exactness of touch, a tautness and economy and sense of relevance in the total organisation'.[3] Both Narboni and Wood were writing from an auteurist perspective, a methodology within which Hawks had, by the 1960s, assumed canonical status. Nevertheless, *Red Line 7000* remains resistant to widespread popularity as well as to decisive inclusion within the pantheon of Hawks films. Even at the time of its release, the leading American auteurist critic, Andrew Sarris, acknowledging that the film was 'as personal and meaningful as anything Hawks has ever done', would also conclude that the film 'just doesn't come off'.[4] More recently, in his 1997 biography of Hawks, Todd McCarthy, while aware of the film's favourable reputation among some Hawks critics, writes: 'To paraphrase Jacques Rivette: you only have to watch *Red Line 7000* to know that it is not a good film.'[5]

A 'common-sense' approach to the transparent failures of *Red Line 7000* is not one that I will be pursuing here. At the same time, my admiration for the film is not strictly in line with Wood or Narboni. Whatever the differences in their claims, Wood and Narboni are intent upon turning the film into something vibrantly expressive, 'an intensely modern film', as Wood puts it, and 'very much of the sixties'.[6] Narboni contrasts what Hawks is doing in *Red Line 7000* with the late works of Carl Dreyer, Fritz Lang, Kenji Mizoguchi and Jean Cocteau. For Narboni, these other ageing directors deal with disillusionment, loneliness, shame, death:

> In Hawks, there is nothing of that: no broadening of the point of view, no deepening of perception, no maturing of style, nor any new gravity of tone. *Red Line* seems like the work of someone ageless (it would not be quite accurate to call it the view of a young man). It's as if for Hawks everything, every element of a film and every film in the wider context of his *oeuvre*, was being presented once and for all in a unique present.[7]

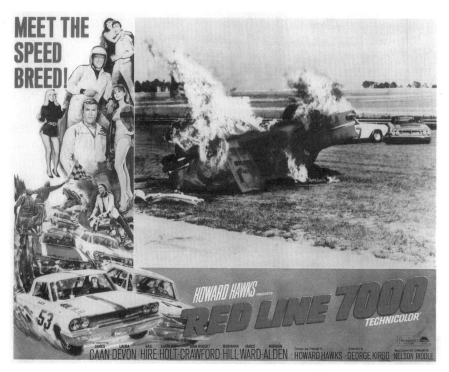

Red Line 7000 (1965): 'a very eccentric film'

For Wood, in addition to Hawks's new (or rediscovered) sense of economy – in con-
trast to the more relaxed rhythms of his preceding films, *Hatari!* (1962) and *Man's
Favorite Sport?* (1964) – *Red Line* demonstrates the director's development in charac-
terisation and relationships.[8] Nonetheless, in looking at the film from a more distanced
historical perspective, I would argue that *Red Line 7000* is best understood as a very
eccentric film, its eccentricity (and the film's ongoing divided reception) the result of a
seemingly incompatible network of elements in the film's style. *Red Line 7000* is indeed
'very much of the sixties' but not quite in the way that Wood claims.

 In its story situation of male race-car drivers and the women who love them, it is
the last of the Hawks films that concerns itself with a group of individuals united by a
profession tied to physical action and in which the formation of the male/female couple
assumes a central function: *The Crowd Roars* (1932), *Tiger Shark* (1932), *Ceiling Zero*
(1936), *Only Angels Have Wings* (1939), *The Thing from Another World* (1951) and
Hatari!. In all of these films, the pleasures to be had through collective professionalism
are also tied (as they are in virtually all of Hawks) to the creation of an ideal community,
one that sets the group apart from the dominant culture even while the activities them-
selves are often officially undertaken for the benefit of that culture. The sense we now
have of *Red Line* being at the end of this group, even as it is attempting to break new
ground, is central to the film's fascination.

2,000 ...

McCarthy lists a number of problems Hawks faced on *Red Line 7000*: the inability to find a young cast that lived up to his expectations; the inferior studio and technical work, especially apparent during the racing sequences; the old-fashioned pop score that fails to reflect any of the current music trends; and the use of three overlapping stories rather than a single plotline, resulting in a film in which, as Hawks put it, 'the audience got disgusted' due to the attentive and emotional shifts required as the film moved between stories.[9] But precisely because of these elements that often do not, by traditional standards, 'work', and for reasons very much bound up with the period in which the film was made, the fantasies and drives that underpin Hawks's cinema are more clearly exposed. *Red Line 7000* is a major example of a late auteurist film emerging from the declining years of Hollywood's original studio system, struggling to retain its connection to this practice even as it hesitantly attempts to embrace a very mid-sixties pop contemporary style and sensibility. Such a struggle is not unique to this film. As I have argued elsewhere, during the 1960s a dialogue between the forms of the past and the present may be found in the late works of several directors from the classical period of cinema.[10] *Red Line 7000*, though, invites its own particular accounting.

The degree to which any of the flaws listed by McCarthy constitute failings is a complex matter, bound up as they are with Hawks's paradoxical status as a classical film-maker. Hawks's formalist impulses, ones that repeatedly enter into a dialectical relationship with his penchant for improvisation, are fully on display in *Red Line 7000*: the attraction to a structure of exchange, replacement and circulation; the parallelism of actions and characters; the importance of the act of looking (as in most of Hawks, the eyeline match, shot/reverse shot becomes not just an editing device but a fundamental principle, if not an ethical system); and an impulse towards separating the spaces of the film through doors, in which the door becomes both a guarantee of continuity and the decisive limit point between the protective enclave and the violent world beyond. And yet Sarris believes that there is a 'fatal disharmony between the old movie myths [Hawks] seeks to perpetuate and the insistent iconography of the modern world he is unable to ignore'.[11] Such a disharmony, though, is only fatal if one believes that it is the task of a cultural object to testify to its historical moment in the most vividly fashionable way.

3,000 ...

Fashion-wise, *Red Line 7000* is notable for its use of product placement, a commercial strategy becoming prominent at this time. Some of these (such as the billboards at the racetrack) can be justified in terms of verisimilitude. Others, though, lean towards excess. The two most notable are the setting of the Holiday Inn where the drivers reside and the protagonists' consumption of Pepsi-Cola. Pepsi assumes particular prominence in an extended seduction sequence between Mike Marsh (James Caan) and Gabrielle Queneau (Marianna Hill) on the grounds of the Holiday Inn. Two years before the release of the film, Pepsi-Cola launched a campaign selling the 'Pepsi

Generation' to a young, modern and athletic consumer. Such an image would appear to be ideal for Hawks's universe, predicated as it had historically been on an art that is, as Henri Langlois wrote in 1963, 'rooted in contemporary America in its spirit as well as in its surface appearance'.[12] But Pepsi objected to the eroticised use of its brand in the seduction sequence, in which Hill not only drinks from the bottle in a provocative manner but also dances up to a Pepsi machine wearing nothing but an oversized man's shirt and high heels. McCarthy finds such product plugs to be 'so blatant as to be embarrassing'.[13] For Wood, though, the 'background of machines, transistor radios, pop music, and brand names' is crucial to the film's concern with 'impermanence'.[14] Embarrassing commercialism for Hawks? Or expressive (if not modernist) impulse?

Several months after the release of *Red Line 7000*, Jean-Luc Godard's *Masculin féminin:15 faits précis/Masculine Feminine* (1966) opened, announcing itself to be a document on the 'children of Marx and Coca-Cola'. This relationship between the immediacy of 1960s fashionable consumer culture and the revolutionary potential of the political informs the entire film, albeit in an ambivalent manner. Near the film's conclusion, the pop star Madeleine (Chantal Goya) is interviewed by a reporter who tells her that he has seen billboards all over America advertising the Pepsi Generation and he asks Madeleine if she is a member of this group. She answers in the affirmative while happily declaring her love for the beverage. In an early essay, 'Defence and Illustration of Classical Construction', Godard describes Hawks as 'the greatest American artist' whose classicism is, in fact, relative in its 'increasingly precise taste for analysis, a love for this artificial grandeur connected to movements of the eyes, to a way of walking, in short, a greater awareness than anyone else of what the cinema can glory in'.[15] These 'movements of the eyes' are on display again in *Red Line*, particularly in the close-ups of the women: Holly MacGregor (Gail Hire) sitting in her convertible and looking up at Dan McCall (James Ward) as they talk in the parking lot of the Holiday Inn; or Gabrielle slumped in the passenger seat of Dan's convertible as her eyes repeatedly look up and to her left towards Dan, or away from him as she talks about the attraction Dan now feels for Holly. Such moments achieve a beauty that slightly suspends them above the narrative, even though the dialogue has a clearly functional nature in terms of story and character development.

Still, the faces and eyes of *Red Line 7000* also fold back onto a particular conception of looking that dominates much of Hawks. 'I saw the way you looked at her,' Gabrielle says to Dan in the car, referring to Dan's obvious attraction to Holly. 'You never look at *me* like that.' Their imminent break-up is one that causes her to remember a moment when she was eight and her family was moving out of a house that she loved, when she 'turned around to look once more at the old house', a moment that filled her with sadness. In Hawks, there is a fundamental need for things to be visible, with little to impede the drive towards fluidity and forward movement. The 'economy' of *Red Line 7000* is one symptom of this, even if such a drive also makes the film seem, in comparison with the various definitions of modernist cinema of the period, somewhat classical. Much of sixties art cinema is concerned with the possibility of suspended meaning in relation to word or image, a shifting away from a 'simple' dramatic action,

one that may be true or false, towards an emphasis on more purely seductive images and sounds that demand to be interrogated: Michelangelo Antonioni's *Blow-Up* (1966) is the *locus classicus* of this strain. In Hawks, a lie or a secret is more clearly visible or, even if delayed, ultimately available to be uncovered, the lie exposed or confessed away. The fact that the revelation of Mike's psychotic jealousy, his inability to love Gabrielle because of her prior relationship with Dan, is withheld till very late in the film, forcing us to alter our initial perception of him, is uncharacteristic for Hawks. However, Mike is able to expunge his psychosis through a combined cathartic violence (almost killing Dan in a race with Dan later punching him in retaliation) and through a confession of his guilt and misdeed to Dan, Holly and Gabrielle. 'From now on, we start all over again,' a tearful Gabrielle says to Mike as they stand in the pouring rain. A deeply ingrained psychosis is introduced by the film only to have the film wash it away, as though it were a surface detail. Earlier, when Mike refuses to date Gabrielle because she is 'used goods', the team manager Pat Kazarian (Norman Alden) angrily responds to Mike with, 'See these eyeballs? They're not new. But they're good enough to see through you.'

Hawks's claim that *Red Line*'s use of overlapping storylines was a source of audience frustration is quite puzzling in this regard. At no point does this overlapping pose cognitive difficulties and, moreover, it is fluidly handled. All of the major characters are unified through their ties to the same spaces of work and leisure, and all of them befriend and interact with one another. Even though this is somewhat different from the ways that the other Hawks films of professional group action are structured, it hardly constitutes a radical rethinking of their implications. At the same time, such fluidity masks a relentless formalist logic. For example, after the death of Holly's boyfriend, driver Jim Loomis (Anthony Rogers), she is taken out to dinner by Mike and Pat to the restaurant owned by Lindy Bonaparte (Charlene Holt), a three-minute sequence allowing some insight into the film's structural components of exchange, circulation and replacement: greetings exchanged between Lindy, Mike, Pat and Holly upon arrival, and greetings exchanged between Mike, Pat and others; menus passed from another worker in the restaurant to Lindy and then to Mike, Pat and Holly; objects, such as Jim's lighter, which Lindy (at this point oblivious to Holly's relationship to Jim) attempts to pass on to Pat (who refuses the offer so the lighter sits on the table), or a watch that was once owned by Lindy's late husband, a driver also killed on the job, and that Lindy wears as a necklace; Lindy's own last name, passed on to her by the same husband (she draws attention to this in her initial exchange with Holly); the two young drivers who approach Pat at the table to discuss the possibility of replacing Jim as a driver. Throughout a conversation that occurs here between Mike and Holly, Mike plays with Jim's lighter, as though the film is setting him up as a potential replacement for Jim in Holly's affections. If so, it is a false gestural foreshadowing, as Mike and Holly never become romantically involved. Instead, Mike becomes reluctantly involved with Gabrielle after Dan leaves her for Holly. It is Holly and Lindy who will become tied to one another, not through romance but through Holly buying into Lindy's restaurant, becoming a co-partner (in yet another instance of circulation) through money left to her

in Jim's life insurance policy. If the film must so hastily expunge Mike's psychotic jeal-
ousy, it may be because this psychosis, manifested in his refusal to accept Gabrielle,
threatens to halt the need for exchange and circulation.

But the sequence depends on another form of exchange and that has to do with
the expressions of the characters. Hawks handles the possibilities for filming looks in
at least three different ways here: through the exchange of looks in wide, mobile and
reframing group shots (Holly, Mike and Pat arriving at the restaurant and exchanging
their initial greetings with Lindy, who takes them across the floor of the restaurant and
seats them), achieved in three separate camera set-ups; and through two basic types
of eyeline match, shot/reverse shots. The first of these occurs when Lindy realises who
Holly is, as we move from a low-angle single of Lindy to a two-shot of Mike and Holly;
these are followed by alternating two-shots of Mike and Holly alone at the table, seated
at 45° angles from one another. The eyeline match, shot/reverse shot is fundamental
for Hawks in that the myopia of individual characters is much more clearly exposed by
a formal system that sees logically and consistently, and in which connections between
looks, gestures, and events form what Rivette has described as 'a rhythm like the puls-
ing of blood'.[16] The final shot of the sequence returns to the basic idea contained in
the first: the exchange of looks among the principals in a wide shot, one that (through
a toast among all four principals) reconfirms the solidity of the group.

In *Masculin féminin*, a resistance to this kind of fluidity is constantly being mani-
fested: actors will be placed at a great physical remove from one another as they con-
verse; or characters carry on conversations in an extended wide shot that
de-emphasises eye contact; or shot/reverse shots place the actors in entirely separate
frames as they carry on a conversation but the principle of alternation becomes so
extended that the sense of a fluid exchange vanishes. Characters do not have 'real'
conversations in Godard but instead speak to one another across an implied abyss, a
world of monologues and interrogations. In Hawks, on the other hand, we find an over-
riding principle of looks caught up in a more classical circuit of exchange – but a circuit
that is fundamentally ruthless.

4,000 …

In a sequence in *Masculin féminin*, introduced by the intertitle 'Dialogue with a Com-
mercial Product', Paul (Jean-Pierre Léaud) interviews a young female magazine contest
winner and asks her to define what it is to be an American. She says that it is 'a very
fast-paced life, probably, very free', and that to be an American means always being on
the run. 'Here Comes the Speed Breed!' the posters for *Red Line 7000* declared. The
film uses speed as a structuring principle, taking its cue from the profession of the male
characters and then playing this out in relation to issues of time and space: the speed
with which decisions are made; the ways that the romantic attractions develop or dis-
solve; the remarked-upon speed with which Pat's sister, Julie Kazarian (Laura Devon),
seems to 'grow up' in the eyes of those around her after she meets driver Ned Arp
(John Robert Crawford). 'You don't have too much time,' Mike says to Jim as Jim is get-
ting dressed for the race, which will soon kill him, giving Mike's line a clear ironic fore-

shadowing. A particular American form of energy is at work here, built upon a principle of freedom even while it is equally tied to chaos, repetition and death.

The profession of the drivers by definition requires them to go 'nowhere' very fast within a compressed time frame, a strategy that the film itself mimics. The film predominantly traverses the same handful of spaces over and over again: the motel, the racetrack, Lindy's and the insides of cars. If Hawks is committed to making an 'intensely modern film', he is doing so through highly artificial means that are at odds with many of the definitions of modern cinema of the period. Such definitions would depend upon (among others) a more extended attempt to get out of the studio and, as in Godard and Antonioni, confront the phenomenological reality of a rapidly changing sixties social landscape. Instead, what acknowledgments there are of this changing landscape are made artificial, as though the film wishes to withdraw from this new world as quickly as it acknowledges it. The relationship between open and closed doors in the film is crucial to this anxiety. In the opening sequence, the simple act of passing through the open door of Pat's office achieves a formality, if not a sense of fatalism. First Jim and then Pat pass through the door through two different shots (but each of them taken from exactly the same camera set-up). Both men step into the office and have a brief interaction with Mike, handled in what Narboni has described as 'a few extraordinary but simple shot/reverse shots',[17] the open door framed on the left and several locker-room doors framed on the right. But this door that looks out upon the track is not so much a marker of fluidity between inside and outside as it is of a potential movement towards death. Jim moves through the open door at the end of the sequence, from office to the track, only to meet his demise in the race that immediately follows. From this point on, the film will play with the possibilities of open and closed doors in relation to various states of movement, passage and exchange. The padded red leather door of Lindy's, a restaurant for which we are never given an exterior shot becomes, like the similarly padded doors to the Arctic outpost in *The Thing from Another World*, a barricade against the terrors beyond it.

A gag in the opening sequence of *Masculin féminin* involves Paul sitting in a café and attempting to read as other patrons enter and exit, leaving the door open, causing an exasperated Paul to repeatedly shout at them, '*La porte!*' Paul's precarious universe is threatened by the cold wind of what lies outside, a somewhat Hawksian universe in its creation of a small, idealised community built upon shared principles and by profession. But work in Godard's film is a matter of exhaustion and low wages rather than one of collective and individual dignity through labour. In Hawks, we find micro-cultures built as a type of defensive response to the limitations of the world just beyond it, in which the political and the material are kept at bay, if not entirely so then as long as possible until a reluctant (if elegantly executed) participation occurs. Godard's direct engagement with politics is foreign to Hawks. In the first sequence in *Red Line 7000*, in which we see Gabrielle newly arrived in America from France, she is asked by two men at Lindy's what the French think of Charles de Gaulle. She demurs by stating that an adequate response would 'take a very long time'. We are in a world of suspended history.

Throughout the film we see the drivers at different racetracks in the American South. But it is unclear if, when we see them at the Holiday Inn afterwards, they are staying at the same motel continuously or if it is another Holiday Inn that looks exactly like all the others. But if the latter, why do they still socialise at Lindy's after the races? The film is engaging in repetitive gestures, serialising and mass-producing its own locations. McCarthy's unhappiness with the racing sequences is of some significance in relation to this. He finds the result to be 'pathetically poor, with a truly unpalatable mix of raw documentary footage, awful process work, and phony "exteriors" shot in the studio'.[18] When placed alongside of the racing-car sequences of other contemporaneous films, such as John Frankenheimer's 70mm, split-screen Grand Prix (1966), or a low-budget film such as Roger Corman's The Young Racers (1963), the second-unit footage assembled by Hawks may, to some eyes, look technically primitive. The specific methods that Hawks employs here, though, are quite similar to those of his previous racing-car film, The Crowd Roars: a combination of second-unit and stock footage with shots of the principal actors done in the studio with mock-ups and rear-projection, occasionally broken into by actual location work with the actor in the car. By contrast, Frankenheimer and Corman achieve an immediacy in their respective racing sequences through the placement of the cameras inside of, behind and in front of the cars as both cars and cameras plunge into space. However, even though I disagree with McCarthy's evaluation of this racing footage, I would like to retain the basic outline of his response to it. Hawks's unabashed use of techniques that can be traced to a film made more than thirty years earlier leads to another 'fatal disharmony' for the film. The racing sequences have neither a raw immediacy nor a sense of grandiose spectacle. Instead, they reinforce or, to be more precise, are of a piece with the overall flatness of the film.

Such flatness, though, points towards the film's paradoxically modernist force. The muted visceral dimension to the racing footage prevents it from taking precedence over the dramatic actions beyond the racing arena. Hawks thereby avoids the problems that Grand Prix and The Young Racers give themselves, in which the technical achievements of the racing material overwhelm the surrounding narratives. In Red Line, the racing sequences and the surrounding dramatic footage meet on an even playing field, allowing for the film to more easily insist upon parallels between the world of racing and the romantic relationship of the characters, a parallelism that, as Wood notes, 'pervades the film, determining its structure'.[19] Moreover, the clearly constructed nature of Hawks's racing scenes allows them to seem less failed Hollywood spectacle than modernist gesture. This is particularly apparent in the sequence in which Mike allows Gabrielle to drive his car on an otherwise empty track. Here, the drive is elevated to metaphor, Gabrielle equating the car with 'some kind of great animal, like a lion that roars as though proud of its speed. ... I wasn't driving a car I was taming a lion.' As she drives at top speed, the car spins around briefly, the movement even further stylised through the use of obvious rear-projection. Such moments bring the film more in line with the deliberately artificial car rides of sixties art cinema, epitomised by Federico Fellini's 'Toby Dammit' episode from Histoires extraordinaires/Spirits of the Dead

(1968), but also by the explosive car ride in another major classical/modernist Holly-wood film of the decade, Vincente Minnelli's *Two Weeks in Another Town* (1962). In any case, we are not dealing with questions of realism or verisimilitude but with artifice and abstraction that are far less dependent on the fetish for polished technique.

5,000 ...

Years later, referring to the film in passing, Wood would pose a more interesting rhetor-ical question as to whether the film should be seen as a 'crystallization of Hawks, or the essential Hawks in comic-strip?'.[20] Exploring the latter possibility would allow us to move away from the limitations of seeing the film through literary notions of depth and fullness and instead pursue the implications of a compelling flatness. Sarris's review of *Red Line* shares a column with his favourable review of a recent Andy Warhol film, *The Life of Juanita Castro* (1965), a 'relatively impersonal' film[21] that Sarris nonetheless prefers to Hawks's since Warhol's slapdash and indifferent production methods are more closely in tune with the prevailing social and aesthetic climate than those of Hawks. But my concern here is less with *Juanita Castro* than with the kind of sensibility in painting of which Warhol was a central figure. The brilliant imagery of Warhol's Pop Art, with its frequent use of commercial logos multiplied and refracted in numerous ways, elevating this commercial raw material to the mythic and the ironic, while not perfectly analogous to what Hawks achieves in *Red Line 7000*, is not entirely foreign to it either.

The advertising imagery in Hawks's film consists not simply of logos but of written language (billboards, commercial messages painted on the sides of cars, along with more functional information, such as the name of the driver and the number of the car), turning *Red Line* into a film of literal signs, evoking the word paintings of Edward Ruscha, whose famous work, *Standard Station* (1966), would appear a year after the release of Hawks's film. A typical example of this use of commercial graphics: in the first meeting between Julie and Ned in front of Pat's office, a Firestone sign hangs prominently on the wall of a building behind them, the sign sometimes fully visible as Julie, Ned and Pat converse, at other times visible through the reflections of the window of Pat's office. But the sign shares this space with the two signs declaring the pres-ence of Kazarian Engineering, one hanging over the office, the other hanging over a garage to the right of the office. The outside commercial world lives side by side with the enclosed reality of the fictional world of the film and the 'fatal disharmony' of *Red Line 7000* prevents these products from achieving the parasitic commercial energy they desire by being exhibited in a Hollywood film. Pepsi's displeasure with how its product was eroticised by Hill, far exceeding the cheerfully chaste image designed for the Pepsi Generation, is only the clearest indication that something is 'off' in the film's desire for a commercial modernity. All of this advertising imagery becomes absorbed by the film's formalist strategies, resulting in something close to what Antonioni achieves with the use of advertising billboards in *Zabriskie Point* (1970) – itself directly influenced by Ruscha – elevating them to the level of graphic abstraction and rendering irrelevant what is being sold.

Within such a Pop atmosphere, assessing the actors in standard terms would scarcely be a project of great urgency. As even the film's detractors have argued, Caan and Hill give, within the traditional logic typically used to assess such matters, strong performances. Yet the presence of the other actors is no less essential. Hawks's tendency to cast unknown or inexperienced actors, in some cases fashion models (on this film, Hire and Holt), suggests not only the inevitable myth of the Svengali but also his attraction to a figure who, above all, embodies an idea, has a photogenic style and way of moving that is both fashionable and singular. This discovery of a new face, though, is predicated on the assumption that some kind of stardom or widespread recognition for their contribution will ultimately be achieved and in *Red Line 7000*, this did not occur. A sense of failure hovers over the entire project, the actors embodying less a vision than a void: most of the actors blur into a general image. 'They seem fine to me,' Wood somewhat defensively writes of these actors.[22] Fair enough. But with their physical beauty and chiselled features, these young faces also suggest something a little too perfect, closer to the stunning but vacuous comic-book figures of Roy Lichtenstein, caught up in their emotional dramas from which we stand back and view with detachment.

Similarly, it scarcely matters whether the musical score is 'authentic' rock 'n' roll (however such a musical category might be defined). Nelson Riddle combines several different styles, from the jazz orchestra used under the credits and for various other sequences to the electric guitar and percussion music employed for contrast. For this world of the young, when tastes and forms in popular music were rapidly changing, it sounds distinctly odd to hear conventional rock arrangements of 'Bill Bailey, Won't You Please Come Home?' or 'I've Been Working on the Railroad,' which bring the film's score perilously close to that of a bad Elvis Presley movie of the period. This contrasts markedly with the up-to-the-minute presence of Chantal Goya in *Masculin féminin* or Antonioni's use of the Yardbirds in *Blow-Up*. At the same time, Hawks has often relied upon the 'old song' as a method for reinforcing the ties, through shared musical knowledge, among the inhabitants of his tiny civilisations: the group performance of 'Some of These Days' in *Only Angels Have Wings* is the perfect exemplar. But more specific to the overall project of *Red Line 7000*, an 'inauthentic' music, much of it assembled by a middle-aged composer/arranger, is closer to the strange contemporaneity of a film in which the modern and the fashionable are constantly being transformed by Hawks's obsessive vision, one that cannot stop drawing upon its past even as it attempts to remain rooted in the present day. The 'Wildcat Jones' song, performed by Holly at Lindy's, backed up by a chorus of four waitresses singing and furiously dancing about, is the most tortured and hilarious instance of this. Hire talk/sings her way through the piece, which resembles a late fifties 'girl singer' novelty pop tune such as Dodie Stevens's 'Pink Shoe Laces'. The spectre of Lauren Bacall's songs from *To Have and Have Not* (1944) and *The Big Sleep* (1946), central in establishing Bacall's persona as a new star, casts a shadow here. Sadly, the number and the film as a whole failed to perform a similar transformative function for Hire. This breathtaking sequence deserves its own detailed analysis (which I shall not give here). Its sheer oddness, though – is

the humour intentional or not? – and its mildly anachronistic atmosphere push the film in the direction of camp.

6,000 …

In Godard's *Notre musique/Our Music* (2004), Godard himself declares to a room of students that the shot/reverse shot is one of the basics of film grammar. As he says this, two stills from Hawks's *His Girl Friday* (1940) are held up by an unseen figure in the foreground. In one, Cary Grant is on the telephone; in the other, Rosalind Russell. But Godard instructs us to look closely. These two shots are, in reality, the same thing twice because 'the director is incapable of seeing the difference between a man and a woman'. In *Masculin féminin*, the two states implied by the title are borne out by the structure of the film, in which masculine and feminine remain two distinct worlds. Throughout *Red Line 7000* though, exchange and circulation are manifested in the treatment of not simply the various couplings but also in terms of masculine and femi- nine. On one side, the masculine space of the racetrack; on the other, the feminine space of Lindy's. Men and women must enter into both of those spaces, their functions as agents or spectators exchanged depending on gender. At the racetrack, the women largely observe the men; at Lindy's, the men largely observe the women.

Nevertheless, for Hawks, binary oppositions between masculine and feminine cannot hold and instead must enter into a circuit. Gabrielle must transgress into the male domain of the racetrack by driving Mike's car with a speed and agility that astonishes even Mike, just as she must assume a traditionally masculine function by pursuing and seducing Mike while she is wearing a man's shirt. The first meeting between Laura and Ned is built upon Ned taunting Laura about her masculine qualities. Her response that 'anybody with half an eye can see' that she is not a boy would suggest that such qualities are immediately visible. In fact, they *are* visible, since this circulation of gender identity must not go so far as to actively confuse matters, to create an image that would offer a firm alternative to this element of masculine/feminine play. When Paul in *Masculin féminin* goes into a public toilet at a movie theatre, he opens a stall to find two men kissing and he is angrily told by one of the men to close the door. In response, Paul writes on the door, 'Down with the republic of cowards.' During Gabrielle's seduction of Mike, she discusses the significance of names in relation to individual personality and destiny: Napoléon Bonaparte (the film's second Bonaparte, after Lindy, the drive towards parallelism again manifesting itself) 'had to be emperor, George Washington had to be president, Oscar Wilde had to be a ...'. Before she can finish, Mike nervously interrupts her. In different ways, overt homosexuality is 'too much' for both Godard and Hawks.

The men kissing in the Godard film is not simply an image of two homosexuals but also an image of covert activity, hiding behind a door, ideal for the Gaullist political land- scape, but also positioned in a sequence that culminates with Paul's anger over the film he is watching being projected in the wrong aspect ratio. In either case, we are dealing with a 'bad' image in a film based upon the fundamental principle that men and women never speak to one another. Hawks is comparatively modern (if not 'queer') in his treatment of these issues and Godard's clear admiration for Hawks's refusal to see

a difference between men and women is one that Godard himself has enormous diffi-
culty in realising, a case of the ostensibly modern artist being less radical than the osten-
sibly classical one. At the same time, the extraordinary citation and abrupt withdrawal of
Wilde's name suggests that Hawks's universe has its own dark continents into which it
dare not journey, since Wilde's name not only immediately connotes the male homosex-
ual but also another kind of world of suspended meaning, one tied to decadence and
camp. *Red Line* remains attached to questions of ethical behaviour through shared
values, missteps that are soon recognised as such and apologised for, even as this
same universe cannot stop circulating and exchanging its own various obsessions. The
culminating activity of the film is Ned's loss of a hand in a racing accident, an implied
punishment for his hubris (he leaves the closed world of racing established by the film
in favour of another racing world outside it), but also for his unethical treatment of Julie.
His masculine bravado must meet its logical end in a form of castration. Such a loss of
limbs or of eyes is crucial to a number of Hawks's male characters and, whatever their
other functions in the films, these losses of bodily mobility also have the effect of sym-
bolically feminising the men. The hook that Ned wears in the final sequence as he
returns to driving his car, while Julie watches him from the stands, restores him to his
original micro-culture, one that is clearly more important for the film than Ned's biological
background in a farming family – a detail that is about as far as the film ventures in pro-
viding any traditional back story. Here, Mike's anxiety about Gabrielle's sexual past is not
simply sexual possessiveness but also part of a general anxiety in Hawks that one will
be unable to live in anything beyond a perpetual present tense.

7000

At the end of the opening credits, the words 'Directed by Howard Hawks' are placed
over an image of a car catching fire and exploding, the auteur explicitly linked with
destruction. The film itself ends not with a whimper but with a bang: as the women
watch their men racing, a car belonging to a minor figure spins out of control, shown
in a series of shots, the words 'The End' suddenly appearing over this as a rising dust
covers the car. (In its dry, matter-of-fact and yet also epic quality, these final shots are
like a cinematic rendering of one of Warhol's 'Disaster' paintings.) Immediately prior to
this action, the three women, in response to the track announcer stating that the next
race will be in Daytona Beach, ironically and mechanically recite the future list of cities
in which these racing activities will occur. In a sense, the film has gone nowhere for 110
minutes, the end not so much replying to and expanding upon the beginning as con-
firming and repeating it. *Masculin féminin* ends with the off-camera death of Paul, the
result of an ambiguous fall from a building, as Madeleine, pregnant with their child, now
contemplates an abortion. Godard ends with the word 'féminin' against a black back-
ground, followed by a removal of all letters so that only 'fin' appears. End of film, a
negation in which the feminine is implicated. Such a gesture is unimaginable in Hawks,
who acknowledges the inevitability of the disaster, of the end, but who must always
return to the possibilities of constant play within these fragile utopias, even if what lies
just beyond this world is death itself.

Notes

1. Joseph McBride, *Hawks on Hawks* (Berkeley: University of California Press, 1982), p. 141.

2. Jean Narboni, 'Against the Clock: *Red Line 7000*', trans. Diana Matias, in Jim Hillier (ed.), *Cahiers du Cinéma: The 1960s: New Wave, New Cinema, Reevaluating Hollywood* (Cambridge, MA: Harvard University Press, 1986), p. 218.

3. Robin Wood, *Howard Hawks* (London: Secker & Warburg/BFI, 1968), p. 140.

4. Andrew Sarris, 'Films', *Village Voice* (9 December 1965), p. 21.

5. Todd McCarthy, *Howard Hawks: The Grey Fox of Hollywood* (New York: Grove Press, 1997), p. 616. McCarthy is referring here to Rivette's review of Hawks's *Monkey Business* (1952) and its opening sentence: 'The evidence on the screen is the proof of Hawks's genius: you only have to watch *Monkey Business* to know that it is a brilliant film.' Jacques Rivette, 'The Genius of Howard Hawks', trans. Russell Campbell and Marvin Pister, *Cahiers du cinéma* no. 23 (May 1953), repr. in Jim Hillier (ed.), *Cahiers du Cinéma: The 1950s: Neo-Realism, Hollywood, New Wave* (Cambridge, MA: Harvard University Press, 1985), p. 126.

6. Wood, *Howard Hawks*, p. 150.

7. Narboni, 'Against the Clock', p. 217.

8. Wood, *Howard Hawks*, pp. 141–50.

9. McBride, *Hawks on Hawks*, p. 141.

10. See my book *The Death of Classical Cinema: Hitchcock, Lang, Minnelli* (Albany: State University of New York Press, 2006).

11. Sarris, 'Films', p. 21.

12. Henri Langlois, 'The Modernity of Howard Hawks', trans. Russell Campbell, *Cahiers du cinéma* no. 139 (January 1963), repr. in Joseph McBride (ed.), *Focus on Howard Hawks* (Englewood Cliffs, NJ: Prentice-Hall, 1972), p. 66.

13. McCarthy, *Grey Fox*, p. 610.

14. Wood, *Howard Hawks*, p. 149.

15. Jean-Luc Godard (as Hans Lucas), 'Defence and Illustration of Classical Construction', trans. Tom Milne, *Cahiers du cinéma* no. 15 (September 1952), repr. in Jean Narboni and Tom Milne (eds), *Godard on Godard: Critical Writings by Jean-Luc Godard* (London: Secker & Warburg, 1972), p. 29.

16. Rivette, 'The Genius of Howard Hawks', p. 73.

17. Narboni, 'Against the Clock', p. 218.

18. McCarthy, *Grey Fox*, p. 616.

19. Wood, *Howard Hawks*, p. 143.

20. Robin Wood, 'Howard Hawks: The Grey Fox of Hollywood', *CineAction* no. 45 (February 1998), p. 29.

21. Sarris, 'Films', p. 21.

22. Wood, '*Grey Fox*', p. 29.

12 Professionalism, the Protestant Ethic and the New Deal
Hawks in the 1930s

Michael J. Anderson

With the yammering protests of the prison yard rising into his penitentiary office, Warden Mark Brady (Walter Huston), the lead of Howard Hawks's *The Criminal Code* (1931), makes one of the more concentrated declarations of the director's professional values:

> Yeah, well let me tell you something: I've been taking the taxpayers' money for a long time. When my name was on the district attorney's door, I was district attorney. It was my job to get convictions and I got it. If I'd been elected governor, I would have governed. Maybe that's why I wasn't elected. Well, here I am, warden. And that's what I'm going to be, warden.

Huston's Brady immediately puts his professional code into a reckless if still 'Hawksian' form of action as he steps out alone amid the revenge-minded convicts, having refused his yard captain's offer to enlist the protection of armed guards. Working with cinematographer Ted Tetzlaff, Hawks's camera frames Brady in a tight medium shot as he coolly draws a match across his hip, lighting his cigar as he leers at the antagonistic masses.[1] The scene then cuts out to a longer framing shot of Brady as he proceeds down a concrete staircase, moving forward toward the backward-tracking camera as both cut through the belligerent crowd. Here, Brady seemingly controls the camera in much the same manner that he does the situation, by imposing his authority through the courage of his confrontational gesture and fearless stride. As he approaches the ringleader Tex, one of his many successful prosecutions, the chattering subsides, leaving only the silence in which Brady will greet the prisoner: 'Hello, Tex.'

The film cuts to a tension-filled close-up of the steely-eyed convict, and back to an identical framing of the implacable Brady as he stares down his would-be murderer. The subsequent reverse shot brings relief and resolution to the showdown, with the less restricted medium close-up of Tex providing a visual correspondence to his relenting response: 'Hi, Mr. Brady.' As the prisoner turns and walks away from the confrontation, the camera cuts out to another full framing of Brady who, by resuming his forward progress, claims victory and asserts his unimpeachable authority over his vocational sphere. By putting his life at risk in the service of his profession, Brady demonstrates his individual mettle.

Warden Brady (Walter Huston) faces down the yammering protesters in the prison yard in *The Criminal Code* (1931)

Brady is also evincing a form of professionalism that has often been seen as a Hawksian trademark, at least since Peter Bogdanovich first made note of it in relation to *Only Angels Have Wings* (1939) during his landmark 1962 interview.[2] Yet, if the theme of professionalism is a familiar one in the critical literature on Hawks, it often appears to exist outside of history, as some kind of accident of the film-maker's personality that scarcely deserves further scrutiny. In fact, Hawks's negotiation of professional values marks a deep historical connection to a Protestant national ancestry. This essay seeks to situate and historicise Brady's speech in relation to Hawks's professional code within the context of the larger body of his work in the 1930s, and to the broader currents of a Protestant, twentieth-century American culture. While the emphasis on a professional vocational ethos would continue as a trope in his films, from the attitudes of the air-mail pilots in *Only Angels Have Wings* to the hazardous work of the safari animal catchers in *Hatari!* (1962), it was in the first half dozen years of the Depression-era 1930s where Hawks's signature concern with the values of professionalism began to take shape.

The Dawn Patrol, Nerve and World War I

By connecting the successful performance of one's job to the demonstration of courage in the face of personal danger, *The Criminal Code* replicates the thematic approach of *The Dawn Patrol* (1930), where a greatly outmatched squadron of British flyers is sent into daily combat against a superior German force. In both films, the steadiness of the hero, in his actions as in steely acting style, is contrasted with the

trembling, silent-era pantomime routine of another character, one who has lost his nerve. In *The Criminal Code*, it is the prison 'squealer' Runch (Clark Marshall) who provides a kind of gestural contrast to Huston's Brady, and who ultimately dies as a result of his transgression of the criminal code. In *The Dawn Patrol*, Ralph Hollister (Gardner James) is the most conspicuous outsider, not only through his nervous jittery behaviour and tortured facial contortions, but also in his position within the picture's elite environment. Although he is a member of the squadron, Hollister is frequently forced to occupy his own plane and he is often subject to isolated framing. There, he suffers alone while his fellow airmen share in mutually cathartic communion.

Hollister's primary deficiency is his inability to put himself in the right combat mindset, one that doesn't dwell on past battlefield losses but instead allows for concentration on the present combat arena. In *The Dawn Patrol*, professional competence takes the form of a psychological compartmentalisation imperative for the health and welfare of the entire squadron. (That psychological 'tactic' famously recurs in the steak scene in *Only Angels Have Wings*.) Hollister's inability to get over his best friend's death will inadvertently bring about the death of his fellow airman. Nowhere is it more important for the Hawksian protagonist to do all that is required of him by his vocation – and to do it well.

If *The Criminal Code* thus provides a definition in both word and gesture of Hawks's professional ethos, *The Dawn Patrol* also indicates a Hawksian proclivity for competence. Hawks's experience of World War I was as a military flight instructor at a Texas air base. While he would not see combat duty alongside the 'Lost Generation' cohort, he was introduced here both to the male homosocial community that would become a key characteristic of his action films and also to a military ideology that would emphasise the significance of each and every wartime task.[3] Hawks's advocacy of professional values also emerged more obliquely out of a family tragedy that marred the pre-production phase of *The Dawn Patrol*. On 2 January 1930, Hawks's younger brother Kenneth was killed while shooting an aerial sequence for his own Fox picture, *Such Men Are Dangerous* (1930), one of ten crew members killed in the mid-air collision. Remembering the tragic loss many years later, Hawks said that 'Ken wasn't much of a flyer,' and recalled that he had warned his brother that the man he was flying with 'isn't much good'.[4] Although the inquest found no-one specifically responsible, the accident was indisputably precipitated by some kind of professional failure. This served, perhaps, to personalise *The Dawn Patrol*'s representation of group expertise and in time would become a central Hawksian preoccupation.

Vocation, the 'Protestant Ethic' and John Singleton Copley's *Paul Revere*

Hawks's attraction to the professional ethos of Warden Brady and *The Dawn Patrol*'s World War I flyers didn't simply reflect a 'Lost Generation' zeitgeist or the emotional impact of his brother's death. It also spoke to a transatlantic, Protestant cultural tradition that Hawks, as the ethnic WASP Calvinist and descendant of colonial Americans, had come to inherit.[5] Recalling Brady's opening declaration, Hawks's signature

hero exemplifies a worldview with origins that can be located in Martin Luther's sixteenth-century conception of the 'calling'.[6] For Luther, the calling or 'vocation' (as the German *beruf* more closely translates) represented a 'task set by God' in the manner of a 'defined area of work'.[7] According to the Protestant creed, the 'fulfillment of duty within secular callings' belonged to the 'absolutely *highest* level possible for moral activity'.[8]

Furthermore, Calvinism's culturally far-reaching conception of man's vocation, building on Luther's original foundation, put additional emphasis on one of Protestantism's most distinctive characteristics: double predestination. In the words of the Westminster Confession of 1647, 'some men … are predestined unto everlasting life, and others foreordained to everlasting death'. Consequently, double predestination presented a special problem to Calvinists who, unlike Roman Catholics, couldn't rely upon membership in the church and participation in the Eucharist to assure their eternal salvation.[9] The doctrinal heirs to Calvin, particularly those of the Presbyterian faith (which included Hawks's maternal grandparents), reconceptualised the 'calling' as a means to achieve that assurance.[10] Consequently, in Max Weber's words,

> a religious value was placed on ceaseless, constant, systematic labor in a secular calling as the very highest ascetic path and at the same time the surest and most visible proof of regeneration and the genuineness of faith.[11]

Few film protagonists would show, as Brady and his fellow Hawksian heroes do, such single-minded pursuit of vocational goals.

Added to this 'Protestant ethic' or 'gospel of work' was a 'doctrine of prosperity' in which the 'fruit of labor in a calling' was interpreted as a 'blessing from God'.[12] Since prosperity therefore reflected 'God's favor', middle-class Protestants came to hold the conviction that 'neither the acquisition of wealth nor advancement in social status was inherently evil, except if carried to excess'.[13] Consequently, this belief gave rise to the view that the accumulation of profit 'for its own sake' could be pursued in the name of a calling and thus for God's glory, which remained the ultimate end for all things within a strict Calvinist (and colonial American) framework.[14] Together with the work ethic, this doctrine of prosperity produced a 'spirit of capitalism' that thrived, notably within the Hawks family, who by the late nineteenth century were the leading entrepreneurial capitalists in Goshen, Indiana, a small city in the American Midwest. As Todd McCarthy describes it: 'If you did business in Goshen in 1896 [when Hawks was born], you had to do business with the Hawkses; they had basically made the town, and they virtually owned it.'[15] Moreover, the Hawks ancestry was deeply rooted in early American history: two brothers, John and Adam Hawks, were early settlers in the New World, arriving in Salem in 1630, ten years after the Pilgrims first landed at Plymouth.[16]

Back in Hawks's ancestral colonial New England, this same spirit had taken hold even before the region would experience any 'capitalist development', thanks to the Calvinist preachers, 'graduates' and lower-middle-class craftsman and yeomen who settled the region 'for religious reasons'.[17] While, according to American art historian

Wayne Craven, the 'original Puritan austerity ... and religious control soon broke down under the success of mercantilism in the second and third generation of colonists', both the Protestant ethic and spirit of capitalism remained powerful cultural forces throughout the colonial period, shaping not only the economic life of New England, but also its visual culture.[18] With displays of wealth gaining wider cultural acceptance in the seventeenth century as they could be made to correspond to the Puritan values of 'industry and prosperity', affluent middle-class patrons in the New World began to commission portraits that would serve an almost iconic function.[19] For Craven, these portraits comprised a distinctively American style that was deeply influenced by New England's Calvinistic worldview with the 'doctrine of prosperity, acceptance of such virtues as industry and moderation, and commitment to one's calling' all finding conspicuous representation.[20] By the eighteenth century, New England's extraordinary wealth had become the increasingly secularised society's exclusive 'source of power, influence, and social standing', creating a stratification within what Craven describes as a 'middle-class affair from one end of the scale to the other'.[21] Topping this society was a 'better sort' of merchant-aristocrat who in Boston provided the patronage and subjects for the portraits of John Singleton Copley, in whose oeuvre this style of colonial American portraiture reached its zenith.[22]

Perhaps the most iconic of his colonial-period canvases, Copley's painting *Paul Revere* (1768–70)[23] is inscribed with the Calvinistic code and ethic that 'had become secularized and welded into the pattern of life' by the time of its creation in the lead-up to the American Revolutionary War.[24] Revere, already a prominent silversmith at the time of the painting, sits wigless in modest work apparel as he holds a teapot of his creation in his left hand. Copley also identifies Revere with his silversmithing vocation with the three engravers' tools that rest on the lacquered table before the sitter's right elbow in the otherwise objectless canvas. While the bravura varnish of the table is rhetorically Copley's own – a stylistic seal of the painter's personal professional mastery – the gleaming silver teapot serves a double function in attesting to the skill of sitter and portraitist alike, insisting in Revere's case that he is not only to be identified by his vocation, but that he is exceptionally capable in the field of his calling. Revere's teapot is Brady's fearless walk into the prison courtyard, the surest sign of his professional excellence – much as Copley's surface sheen is Hawks's graceful, mobile framings: both are confirmations of visual mastery.

Copley's *Paul Revere* exemplifies a particular portrait style of colonial New England as it captures the virtues of industry and modesty in its acknowledgment of the sitter's craftsmanship and costume, while also suggesting the cardinal place that the 'calling' played in pre-Revolutionary American culture. Where Copley's work departs somewhat from the norms of the colonial group style is in its depiction of labour *per se*, as opposed to its economic or material fruits, a more common preference among the period's sitters.[25] However, by choosing to depict his sitter in his work rather than amid his wealth, Copley manages to convey the notion that colonial society erected 'no real barriers' to social advancement for its white European settlers.[26] Revere's depiction in his work clothes with the products and tools of his labour frames its subject as a pros-

perous artisan who made his place in society by his own hard work. Copley's Revere is not someone who seeks to be viewed according to an elevated social position, but rather as a middle-class labourer who, 'far from being ashamed' that he 'labored as a craftsman', was instead 'proud of the fact'.[27] In a similarly egalitarian vein, Revere's reciprocal gaze confers equality between sitter, artist and even beholder in much the same fashion that Hawks's eye-level camera would, at least between film-maker and his own workingman subjects.

Documenting the 'Perilous' Hawksian Profession

In the year following *The Criminal Code*, Hawks turned to a world of dangerous manual labour with *The Crowd Roars* (1932) and *Tiger Shark* (1932), narratives that presented their respective professions through lengthy, documentary-style passages, shot partially on location. In both films, the protagonists live in what is for Weber another dimension of Protestantism, that of 'a perilous, exciting life' in the pursuit of 'honors and riches', whether it is as Joe Greer's (James Cagney) auto-racing lead in the former, or Captain Mike Mascarenhas (Edward G. Robinson), the 'professional fisherman' of the latter.[28]

In the third of four documentary-style deep-sea passages in *Tiger Shark*, a lengthy sequence exceeding five minutes shows a group of professional anglers as they begin to pull their abundant catch out of Mexican coastal waters. The film cuts to a diagonally composed full shot of seven of the fishermen who balance themselves against a shin-high railing as they labour with their backs, forearms and shoulders. The scene provides an interval of pure manual spectacle with the on-screen subjects doing the real-world work of commercial fishermen. According to one contemporary account, in an effort to save on production expenses, Warner Bros. leased a tuna boat and 'instructed the men to actually catch the fish to pay for the rental of the boat'.[29] Hawks's crew 'stayed out until they had 85 tons, which they sold ... and made expenses'.[30] In other words, if audiences sense that they are watching the real (professional) work of commercial tuna-fishing, they actually are.

Following Hawks's subsequent cutaway to Captain Mike – an edit that momentarily suspends *Tiger Shark*'s impression of non-fiction – the film returns to the water as a single tuna is pulled out and swung into a nearby holding container, shot at an oblique angle. The film then cuts to an overhead of two fishermen as they join together to pull in a single large fish with one pole. This occasions an additional cutaway to the Captain who chastises the two men for using a single fishing rod. We see the fishermen continue their work as they tie their lines together in response to Mike's command. Here, Hawks's film seeks to convey an understanding of how commercial fishermen work and, in particular, how they land their largest catch.

At this point in the non-narrative action, *Tiger Shark* reminds its spectators of the dangers faced by the crew as two of the tuna fishermen inadvertently hook a large shark. The camera swivels with the thrashing shark as the men strain to hold onto their equipment. As the shark speeds to the far side of the boat, it enters the same frame as the fishermen, bringing them into hazardously close contact with the killer fish. By emphasising the inherent dangers of commercial tuna-fishing, Hawks evokes again the

same Protestant worldview evident in Brady's unwavering pursuit of a vocational goal as well as a sense of Weber's 'perilous, exciting life'.

Cutting back to the men labouring alongside the low railing, we see one of the fishermen pulled into the same choppy waters through which the shark has just passed. The scene then begins to cut between the adjacent shark-filled waters and the professionals/stunt performers as they attempt to harpoon the shark and save their submerged colleague. *Tiger Shark* thus trades on its carefully cultivated sense of authenticity through the exploitation of locations, performers and camera angles, all contributing towards the 'real-world' of Hawks's documentary fiction. As we witness the fisherman's accident and rescue, we are asked to believe that this stunt is dealing with the real hazards of the commercial fishing profession. Of course, the perceived danger also has a real-world equivalent in the stuntwork contained within the sequence. That is, while we might not actually see a fisherman in shark-infested waters, we do see the stuntman plunge into the violent Pacific surf, risking his life for the sake of his own vocation. Hawks, in this way, transforms his own film-making profession into a danger-filled vocation, into the very subject of his film-making, as he would do again in such films as *Hatari!*

If this sequence documents what it is like for these men in the most danger-filled moments of their professional lives, lives that Weber connects to a Protestant spirit of adventure, an earlier sequence depicts the more mundane work of their vocation. Hawks begins the sequence with Pipes (Richard Arlen) and a second figure having returned from an off-screen fishing trip, digging their catch out of the ice. From here, the camera shows the process of unloading the tuna, with Robinson and his fellow actors performing various tasks on deck. However, with the catch being dumped on a conveyor belt, *Tiger Shark* departs from the credited actors and follows the fish as they progress toward a processing area where they are rinsed and then propelled down a long wooden flume. These scenes are followed by the assembly-line process of gutting the fish. These documentary-style shots appear more than two minutes and thirty seconds into a sequence that contributes nothing to the narrative development, except to reassert Captain Mike's professional authority with his new wife Quita (Zita Johann), watching from the docks. Rather, they help to contextualise *Tiger Shark*'s depiction of the fishing business, one which above all centres on its commercial fishermen. The film therefore concerns not only tuna-fishing as a dangerous profession, but also the more menial aspects of the commercial industry in which these men operate.

A nearly identical passage to *Tiger Shark*'s interval of pure industrial spectacle appeared four years later in Hawks's adaption of Edna Ferber's 1935 novel, *Come and Get It* (1936), co-directed by William Wyler.[31] Here, during the film's second work-centred set piece, the narrative pauses for four minutes as we see second-unit footage, shot by *Tiger Shark*'s assistant director Richard Rosson, of the logging industry, from the dynamiting of a frozen lake to the dangerous work of the 'pond monkeys' as they labour on top of floating logs. As in the *Tiger Shark* set piece, the on-screen narrator quickly disappears from the scene, thereby allowing the gracefully shot spectacle to come to the fore. Large trees float down flumes similar to those in *Tiger Shark* and tor-

pedo dramatically off the edge of an exposed hillside en route to the Hewitt paper mill. Once again, Hawks juxtaposes spectacular scenes of a perilous occupation with its more mundane manufacturing processes, as he had in *Tiger Shark*. In so doing, Hawks moves from the domain of the Protestant work ethic into the more personally familiar realm of entrepreneurial capitalist activity.

Anti-New Dealism: *Come and Get It, Barbary Coast* and *Ceiling Zero*

During the breakfast scene in *Come and Get It*, Barney Glasgow (Edward Arnold) stares at a newspaper caricature of President Theodore Roosevelt's toothy grin and declaims: 'This Roosevelt!' Cutting to Barney's face, he continues without pausing: 'It's a wonder he wouldn't attend to his own business, running the government instead of sticking his nose in other people's affairs!' His son Richard (Joel McCrea) interjects, offering a tepid defence of the President: 'Something has to be done with the country, the state it's in.' Barney responds: 'What do you expect with a lot of radicals in Washington! Won't be long before they'll be passing a law taxing us on the money we earn.'

Barney's anti-Roosevelt rhetoric represents an oblique expression of anti-New Deal feeling. His annoyance with Teddy Roosevelt, 'sticking his nose in other people's affairs', suggests the intense period of Executive Orders and legislative activity that characterised Franklin Delano Roosevelt's first hundred days in office in 1933. Barney's antipathy to 'radicals in Washington' implies FDR's so-called Brains Trust, whose 'progressivism went beyond the progressivism of … Theodore Roosevelt'.[32] And his resentment about taxation can be seen as a reflection of criticism of FDR's tax policies, including the 'undistributed profits tax'.[33]

Hawks's own antipathy toward the New Deal had already become apparent to his collaborators during his earlier production, *Barbary Coast* (1935), which featured *Tiger Shark*'s Robinson and *Come and Get It*'s McCrea in antagonistic roles. In his autobiography, Edward G. Robinson describes the *Barbary Coast* set as 'highly politicised', with the production dividing into 'two warring camps': one that favoured Roosevelt and the New Deal (including Robinson and screenwriters Ben Hecht and Charles MacArthur), and one that didn't (including Hawks and actors McCrea, Walter Brennan, Miriam Hopkins and Harry Carey).[34] According to Robinson, 'the arguments on the set were appalling; as a result there was little socializing among us. There was a good deal of polite freezing and occasional bursts of rage.'[35] *Barbary Coast*, then, reflects something of the schism of a nation deeply divided by the politics of the New Deal.

The screen portrait of corrupt local politics mirrored these production conditions as it proved to be one of the angriest films of Hawks's career. Yet despite the unwillingness of McCrea's Richard to accept a handout, Hawks's film might as easily speak to Hecht's Chicago or even the Warren G. Harding scandals of a dozen years earlier. The fact that it is difficult to identify *Barbary Coast*'s politics, save for its 'apolitical' opposition to public corruption, confirms the picture's divided loyalties and ultimately its political incoherence. Not until later would Hawks collaborate with the more likeminded screenwriter, Frank Wead on the follow-up to *Barbary Coast*, *Ceiling Zero* (1936), allowing further expression of this anti-New Deal sentiment.

Ceiling Zero, a Warner Bros. production, was adapted by Wead from his own 1934 play which was produced in the immediate aftermath of FDR's decision to cancel all private air-mail routes. The President's decision to annul, effective ten days from the 9 February 1934 edict, represented his administration's response to Alabama Senator Hugo Black's then ongoing investigation of former Postmaster-General Walter F. Brown's procedures for awarding air-mail contracts, and his agency's payment of subsidies to the nation's airlines following the Air Mail Act of 1930.[36] The core of Black's criticism resided in the monopolistic implications of Postmaster-General Brown's consolidation of the industry. According to aviation historian F. Robert van der Linden, the Southern Democrat believed that a 'terrible injustice had been committed' by Brown and his allies on behalf of 'bankers, brokers, promoters and politicians', who effectively had managed to wrest control of the airlines from 'men who could fly'.[37] The irony and scandal of the cancellation decision, a decree that 'suddenly gave the pent-up dissatisfaction with the New Deal seemingly legitimate outlet', according to Roosevelt scholar Arthur M. Schlesinger, was its hasty implementation using the Army Air Corps: drastically under-prepared and facing a 'savage' bout of February weather, five Army flyers would lose their lives within the first week.[38] Indeed, by the time the Roosevelt administration reversed their decision later that May, seven more pilots had died.[39]

Ceiling Zero takes place on the cusp of the present, in a moment of tension between the ageing pioneers of the industry (to whom the film is dedicated) and a newer generation of college-educated flyers. The setting for *Ceiling Zero* is a private air firm, Federal Airlines, which old-timer Jake Lee (Pat O'Brien) has built into 'the most important thing in commercial airlines today'. Of course, it would be successful private firms just like Jake's that would be eliminated as a result of FDR's Executive Order and this point alone suggestively casts Hawks's post-cancellation feature as a critique of what to its opponents was the President's unjustified intervention into the private sector (albeit from a moment after Roosevelt reversed his decision).

As the picture opens, Jake's renegade best friend and 'the best cockeyed pilot on this airline or any other', Dizzy Davis (James Cagney), returns following a faked emergency landing. From the beginning, Dizzy shows himself to be the prototypically reckless, if supremely talented, Hawksian professional, a man of immense sexual appetite, who thrives in the most perilous of professions. The gutsy Dizzy soon becomes Federal's anti-Washington mouthpiece after the firm is harassed by administration officials. With a lobbyist suggesting to Jake that he might be able to deflect government interference in the airline's operations, Dizzy speaks out on behalf of his friend: 'He's going to do things for us in Washington! All we want them to do is to leave us alone!' Dizzy, in much the same fashion as Barney in his anti-Teddy Roosevelt speech, opposes government intrusion. Dizzy's sentiment also echoes FDR's many post-cancellation critics inside the aviation industry from Charles A. Lindbergh to Eddie Rickenbacker. In a similar fashion, Jake closes with his own pro free enterprise rhetoric that applies not only to FDR's Washington but also, perhaps, to the studio's New York headquarters: 'Yup, I'm going to stay. But how I run this line and how pilots fly is my business.' In both, the

wish is to be left alone, for private commercial enterprise (and the film production) to succeed or fail on its own terms.

Ceiling Zero's insistence on economic freedom places us in the political domain of the Protestant ethic. Having just experienced its latest peak during the 'pro business' 1920s, an era that sociologist E. Digby Baltzell has described as the 'Anglo-Saxon decade', a secularised, capitalist American Protestantism was beginning to lose its clout under the more heterogeneous New Deal coalition.[40] Within the collective enterprises of the New Deal were those who were not white, not capitalist and not Protestant, thus ensuring that its own ideological agenda would not only diverge from, but often conflict with, that of traditional American Protestantism. Practically, the rise of New Deal factions meant a shift away from the pro business ethos that had long defined the politics of Calvinistic America to the kind of pro government interventionist philosophy that Hawks's heroes would oppose in *Come and Get It* and *Ceiling Zero*.[41] It was a time (quite unlike Copley's) of unparalleled crisis for the Protestant ethic and its commensurate spirit of capitalism.

Hawksian Auto-Critique

It was this very crisis that in part would give rise to the uncertainty that emerges even in Hawks's most direct articulations of a Weberian Protestant worldview. To return to *The Criminal Code*: while Warden Brady, a government official, is the perfect Hawksian professional, the man against whom future incarnations can be defined, he does not finally pursue his professional code to the exclusion of all else, in the manner of the Calvinistic ideal, but instead chooses to seek his daughter's welfare and happiness – even if it means that he fails ultimately to fulfil his professional duties. Then there is *Ceiling Zero*: while Dizzy is the best at what he does in quintessentially Protestant terms, he proves fundamentally unprofessional by skipping out on his assignment, which leads to the death of a close friend. Dizzy must consequently find redemption for all his irresponsibility, which he does in the form of Christ-like self-sacrifice. There is also the deeply boastful (and very Catholic) Mike Mascarenhas in *Tiger Shark* who will ultimately lose his life as a result of the deep-sea accident that followed his attempt to kill his best friend. Finally, there is Barney Glasgow's titan of industry and free-market champion whose heart is broken by the younger Lotta (Frances Farmer) whom he adulterously pursues.

In each of these filmic expressions of the Protestant ethic, Hawks undercuts, ironises or even debunks, in profoundly 'Lost Generation' fashion, the very ethic of professionalism that was so central to his broader cultural and ethnic identity. Indeed, while Hawks never fully renounces his ancestral value system, he is willing, in these and other examples, to explore and expose the limitations of the Protestant worldview that began to take shape in *The Dawn Patrol*. Hawks, in this sense, is beginning to confront precisely those cultural values which his body of work almost uniquely articulates. The director's Depression-era action-adventure work thus emerges as something even more nuanced and historically precise: it is an art made in the time of, and with a somewhat ambivalent feeling for, the crisis in white Protestant culture.

Notes

1. Tetzlaff shot all the prison scenes after James Wong Howe, the film's original cinematographer, left the production.
2. Peter Bogdanovich, 'Interview with Howard Hawks', in Jim Hillier and Peter Wollen (eds), *Howard Hawks: American Artist* (London: BFI, 1996), pp. 56–7.
3. Todd McCarthy, *Howard Hawks: The Grey Fox of Hollywood* (New York: Grove Press, 1997), p. 467.
4. Hawks quoted in ibid., p. 107.
5. See ibid., pp. 18–33.
6. Max Weber, 'The Protestant Ethic and the "Spirit" of Capitalism', in Peter Baehr and Gordon C. Wells (eds), *The Protestant Ethic and the 'Spirit' of Capitalism and Other Writings* (New York: Penguin, 2002), p. 28.
7. According to Weber, there was no equivalent among Latin Catholic populations. Ibid., p. 28.
8. Ibid., p. 29.
9. Or, we might ask, how can one be certain of his or her election, when assurance no longer relies upon receipt of the sacraments? Ibid., pp. 70, 76.
10. McCarthy, *Grey Fox*, p. 29.
11. Weber, 'The Protestant Ethic', p. 116.
12. Ibid., pp. 13, 116.
13. Wayne Craven, *Colonial American Portraiture: The Economic, Religious, Social, Cultural, Philosophical, Scientific, and Aesthetic Foundations* (Cambridge, MA: Harvard University Press, 1986), pp. 9–10.
14. Weber, 'The Protestant Ethic', p. 19.
15. McCarthy, *Grey Fox*, pp. 18–19, 21.
16. Ibid., p. 19.
17. Weber, 'The Protestant Ethic', p. 14.
18. Craven, *Colonial American Portraiture*, p. 13.
19. Ibid., p. 16.
20. Ibid.
21. Ibid., p. 310.
22. Ibid., p. 311.
23. The painting is at the Museum of Fine Arts, Boston, MA: http://www.mfa.org/collections/object/paul-revere-32401.
24. Craven, *Colonial American Portraiture*, p. 310.
25. See, for example, Copley's *John Hancock* (1765), also at the Museum of Fine Arts, Boston: http://www.mfa.org/collections/object/john-hancock-30882.
26. Craven, *Colonial American Portraiture*, p. 257.
27. Ibid., p. 259.
28. Weber contrasts this Protestant mode of existence with that of the Catholic who 'places more value on a life which is as secure as possible, even if this should be on a smaller income'. As Weber puts it, 'the Protestant likes to eat well, while the Catholic wants to sleep soundly'. Weber, 'The Protestant Ethic', p. 5.

29. 'Cal York's the Monthly Broadcast from Hollywood', *Photoplay* (August 1932), p. 111.

30. Ibid.

31. Following disagreements with Goldwyn, Hawks quit the production and was replaced by Wyler. See McCarthy, *Grey Fox*, pp. 238–41.

32. Amity Shlaes, *The Forgotten Man: A New History of the Great Depression* (New York: HarperCollins, 2007), p. 52.

33. Ibid., p. 334.

34. Edward G. Robinson with Leonard Spigelglass, *All My Yesterdays: An Autobiography* (New York: Signet, 1973), p. 179.

35. Ibid.

36. It is important to note that only three holders of the thirty-four cancelled air contracts were formally accused of any wrongdoing, and even these firms were fully acquitted in 1941. See James P. Duffy, *Lindbergh vs. Roosevelt: The Rivalry That Divided America* (Washington, DC: Regnery, 2010), p. 42.

37. F. Robert van der Linden, *Airlines and Air Mail: The Post Office and the Birth of the Commercial Aviation Industry* (Lexington: University of Kentucky Press, 2002), pp. 261–2.

38. Arthur M. Schlesinger, Jr, *The Age of Roosevelt: The Coming of the New Deal, 1933–1935* (Boston, MA: Houghton Mifflin, 2003), pp. 451, 452.

39. Duffy, *Lindbergh vs. Roosevelt*, p. 8.

40. E. Digby Baltzell, *The Protestant Establishment: Aristocracy & Caste in America* (New York: Random House, 1964), pp. 197–8, 229.

41. More Americans in the Depression era tended to favour a social safety net than in the boom years of the 1920s. However, it is a precondition of Hawks's action films that no safety net exists. The Hawksian hero must pursue his chosen vocation with 'ceaseless, constant, systematic labor', and with the continual awareness that a mistake or incompetence may have fatal results.

PART 7
DARK CIRCLES: HAWKS, WAR AND AVIATION

13 *The Dawn Patrol*
The Once and Future Hawks

Tony Williams

Despite the fact that *The Dawn Patrol* (1930) was the first sound film directed by Howard Hawks, it has received relatively little attention. Robin Wood didn't include it in any edition of his Howard Hawks monograph due to the fact that it was not available on 16mm nor at any National Film Theatre screening in England when he was writing.[1] However, a small and dedicated group of critics such as John Belton, Blake Lucas and Brian Wilson has recognised its importance.[2] Otherwise, like James Whale's *Journey's End* (1930), *The Dawn Patrol* has often been inaccurately categorised among those early sound films in which the confinement of the camera in a sound booth only allowed for static shots.

To his credit, Belton critiques such rigid assumptions when he notes that *The Dawn Patrol* actually

> *appears, at least initially*, severely limited by primitive sound technique: the immobile camera imprisoned within a soundproof glass booth imposes a static look on many of the interior scenes. On closer analysis, however, it becomes quite clear that the film contains a great deal of camera movement – most obviously in the exterior action sequences [italics mine].[3]

While noting that Hawks uses camera mobility and immobility thematically in *The Dawn Patrol*, Belton observes that during the second interior sequence, there is little camera or character movement. 'This sort of editing, holding the characters in the same position in the frame, accentuates the taut, impersonal formality of their actions in a restricting environment.'[4] However, a detailed analysis of the interior sequences of *The Dawn Patrol* reveals camera movement of a more subtle variety, a style that characterises one significant early sound World War I film, *Journey's End*, adapted from R. C. Sherriff's play (1929), directed by James Whale. There, the camera also moves in a seemingly imperceptible manner, drawing a contrast between the restrictions imposed upon a character's agency in confined spaces, whether they be dug-outs near the trenches or 'The Throne' inhabited by the flight commander in *The Dawn Patrol*, and the potential he has to break such restrictions should he choose to disobey orders from the usually unseen forces of military command. If Brian Wilson sees *The Dawn Patrol* as 'an early example of Hawks's ability to rework an established generic structure in unique and

creative ways',[5] the same holds true for the visual style of the film. The film itself is an exemplar of what I would term 'the once and future Hawks' as it not only exhibits distinctive visual and dialogue tropes emblematic of Hawks's authorship, but also anticipates features that will appear in the director's more mature works from *Only Angels Have Wings* (1939) to *Rio Bravo* (1959).

The Dawn Patrol provides an early instance of Hawks's accomplished techniques in the development of performance, dialogue and verbal delivery that would characterise future films, such as *Scarface* (1932), *Only Angels Have Wings* and *Rio Bravo*.

Journey's End as Parallel Text

The Dawn Patrol has much in common with James Whale's *Journey's End*. Both films share the same sort of disillusionment with 'the war to end all wars'. Although Hawks probably never saw the film of *Journey's End* (which appeared the same year as *The Dawn Patrol*), he may have been familiar with the stage version. However, the genesis of *The Dawn Patrol* is more complicated. The original story is credited to John Monk Saunders. Having served in World War I as a flying instructor, like Hawks he had never gone overseas but had heard a lot of war stories from veterans after the conflict. Belonging to the self-destructive 'Lost Generation' group of writers, he had written an original story in 1923 that became the basis of William Wellman's *Wings* (1927), the first film to win the Academy Award. Saunders had also written a 'Lost Generation' novel, *Single Lady* (1929), which became the basis of William Dieterle's *The Last Flight* (1931), also starring Richard Barthelmess of *The Dawn Patrol*. Although in later life Hawks claimed total authorship of the idea behind *The Dawn Patrol*, the project appears to have been a collaborative one, with Hawks suggesting a story idea to Saunders that would sell on his name alone. Saunders worked on the story during filming and Hawks probably also contributed to the project along with scenarists Dan Totheroh and Seton I. Miller.[6] Totheroh was a World War I combat flyer who had completed work on *The Virginian* (1929) and was brought in to work on dialogue during the shooting while Miller had collaborated with Hawks on the silent films *Paid to Love* (1927), *A Girl in Every Port* (1928), *Fazil* (1928) and *The Air Circus* (1928).[7] Despite the fact that Saunders provided sworn testimony for Howard Hughes's allegations that *The Dawn Patrol* plagiarised material from his own production, *Hell's Angels* (1930), Saunders's original eighteen-page treatment focused upon an eternal triangle theme that is a staple of World War I films such as *What Price Glory?* (1926), *Wings* and *Hell's Angels*, but of little interest to Hawks. Certainly, these narratives give as much space to the romantic triangle as to the exciting air combat sequences.[8]

See, for example, the triangle involving Jean Harlow, James Hall and Ben Lyon in *Hell's Angels* and, similarly, in *What Price Glory?* – with its Quirt (Edmund Lowe)/Flagg (Victor McLaglen) rivalry over Charmaine (Dolores Del Rio) – as well as similar romantic entanglements in *The Last Flight* and *The Lost Squadron* (1932). Although Todd McCarthy suggests that this motif may have been a Hawks contribution, it is more likely attributable to Saunders since the Richard Arlen–Charles 'Buddy' Rogers–Clara Bow romantic triangle forms a key part of *Wings*. *The Dawn Patrol* saw the elimination of all

women (and therefore the romance) from the final script, a factor which, as Todd McCarthy points out, 'made the film so unusual at the time'[9] apart from a verbal foot-note, where a character states that the rivalry between Brand (Neil Hamilton) and Courtney (Richard Barthelmess) began over a girl they met in Paris. However, this is tossed aside and immediately forgotten in a film that suggests other more relevant reasons for the Brand–Courtney rivalry, reasons concerned with questioning the need for the endless sacrifice of a younger generation, the inhumane nature of high com-mand, and the psychological devastation inflicted on those who serve. Although shell-shock or post-traumatic stress disorder does occur in rare instances in films such as *What Price Glory?*, more often than not the dubious nature of psychological exits pro-vided by alcoholic indulgence links both *Journey's End* and *The Dawn Patrol*. This is not to claim that one film influenced the other, but rather to emphasise the fact that common motifs were in the air in an era when the after-effects of the conflict on the survivors were well known. Here, *Journey's End* forms an interesting parallel to *The Dawn Patrol*.[10]

Although America entered World War I at a late stage, it nonetheless experienced the seriousness of the conflict in incidents such as the Belleau Wood slaughter in France in June 1918, depicted in King Vidor's *The Big Parade* (1925), as well as the aftermath of returning veterans who would soon be 'forgotten men', such as Tom Holmes (Richard Barthelmess) in William Wellman's First National Warner Brothers production *Heroes for Sale* (1933). *The Dawn Patrol* deals with the Royal Flying Corps (the future Royal Air Force) in the early years of the war. Although Americans fought in the conflict well before their country's official participation in units such as the Lafayette Escadrille (the subject of William Wellman's *The Legion of the Condemned* in 1928 as well as his last film, *Lafayette Escadrille*, in 1958), *The Dawn Patrol* chooses instead to focus upon a group of British professionals played mostly by American actors. This could be explained by American anglophilia, especially concerning its cinema of empire, which a supposedly democratic and non-imperialist nation looked at with envy.[11] But other reasons are possible. Like *All Quiet on the Western Front*, which safely displaced American anxieties over World War I onto a group of German youths (played by young American actors), *The Dawn Patrol* could also equally represent the dark side of American involvement, especially if the victims belonged to another national group. By contrast, *Journey's End*, based on a play popular both in England and America, used British actors, many of whom belonged to the original stage company. Despite the difference in directors and acting ensembles, common stylistic features link both films, features which related to the contemporary mood of disillusion-ment and cynicism about the old idea of 'the war to end all wars' that culminated in American isolationism.

Although *Journey's End* was remade in 1976 as *Aces High*, a film combining echoes of those old World War I aviation films such as *The Dawn Patrol* with James Whale's original film version, the remake lacked the deliberately designed visual claustrophobia of its predecessor, with its lingering memories of 'the war to end all wars', the war that ended up as a slaughterhouse of whole generations of combatants often powerless

before the overwhelming forces of twentieth-century war technology. The opening sequences of *Journey's End* parallel those of *The Dawn Patrol* in certain specific ways. While Hawks's film begins with exhilarating aerial combat, Whale opens out the original play with shots of British infantry against the trenches in darkness with displays of explosions and snatches of dialogue. The camera moves during these scenes to show the anonymous soldiers progressing slowly within the confining trenches before dissolving to the dug-out officer's quarters of the original play. Although the interior scenes match those in the play, it is untrue to say that the camera is always static. When Lieutenant Osborne (Ian MacLaren) arrives as Captain Hardy (Robert A'Dair) is about to go, the camera pans right as he goes to the table to take up Hardy's offer of a drink. It will also tilt up and pan right as Hardy gets up and speaks further to Osborne after Whale has varied the framing of this scene with two separate mid-close-ups of Hardy and Osborne. This form of subtle, almost imperceptible camera movement also occurs in 'The Throne' scenes of *The Dawn Patrol*. It is a common strategy in early sound films about World War I, but is not found in *Hell's Angels*.

Eventually credited to Howard Hughes and begun as a silent film before Hughes realised it was imperative to release it with sound, *Hell's Angels* utilises a combination of camera movements of silent cinema. This can be seen, for instance, in the introductory dissolves showing the occupants of the beer garden, the violinist serenading customers and the arrival of the cuckolded German officer outside his home a few sequences later, with static shots of the two leads. *Hell's Angels* functions as a hybrid production incorporating dialogue scenes 'staged' by James Whale (obviously supervised by Hughes) with remnants of silent footage of aerial combat and additional shots of Roy (James Hall) and Monte (Ben Lyon) on the same plane fighting Von Richthofen and his Flying Circus before they are gunned down behind enemy lines. *Hell's Angels* weaves together silent and re-shot dialogue scenes in an artificial manner whereas *Journey's End* and *The Dawn Patrol* combine static shots and subtle camera movement in a more coherent manner. Both films have static camera set-ups but *The Dawn Patrol* contrasts this feature with the potential for movement that is not entirely frustrated as with *Journey's End*.

R. C. Sherriff's play begins and ends in the dug-out. It never goes outside. By contrast, Whale's film does 'open out' the play to include new scenes to illustrate what the play only describes. This is what is normally referred to as 'opening out' the play and the film benefits, with sequences that break away from the claustrophobic confines of theatrical productions. At the same time, they stand out from the rest of the film as 'inserts' and do not integrate with the other footage as the external scenes in *The Dawn Patrol* do. While they are much better integrated than those in *Hell's Angels*, they still appear as abrupt intrusions in a film lacking the more coherent blending of interior and exterior of the sort achieved by Hawks in *The Dawn Patrol*. Although *Aces High* manages to combine interiors and exteriors in a different way to operate as a 1970s action film, it does not convey the claustrophobic intensity endemic to *Journey's End* and *The Dawn Patrol*, that contemporary audiences (including World War I veterans with experience of

the more confining aspects of combat and the endless waiting entailed) could identify with.

Style and Dialogue in *The Dawn Patrol*

In contrast to the opening of *Journey's End*, *The Dawn Patrol* begins with an exciting sequence of aerial combat.[12] Fragilely constructed planes contest the open territory of the sky filmed in long shot with intercut shots of pilots such as Courtney savouring the exhilaration of battle like knights of old. Instead of armour and jousting poles, they fly in the new twentieth-century version of aerial horseless carriages with machine guns replacing broadswords and streamers attached to their helmets substituting for those more elaborate knightly signifiers worn in the age of chivalry to distinguish one knight from another. The conflict that Courtney so enjoys is a substitute for that lost Western frontier, the only place where a Hawks professional can avoid the world of civilised restrictions. It is a world of professional expertise as well as danger, where death would usually result from the victim not being 'good enough' – a term evoking that familiar Hawksian value. This would be the epithet applied to the unfortunate Joe (Noah Beery, Jr) in *Only Angels Have Wings*. Here there is no 'lure of irresponsibility', in Robin Wood's terms, but only the tragic circumstance of young, often inexperienced, flyers sent off to battle by an inhumane military bureaucracy with a slaughterhouse war-of-attrition mentality, executed through the decimating strategies of Generals Haig and Pershing. Yet, despite their circumstances, all the flyers have the opportunity to prove themselves in the dangerous world above ground. Experienced flyers such as Courtney and Scott (Douglas Fairbanks, Jr) can relish the risk while others such as Hollister (Gardner James) must search for the chance to acquit themselves as useful members of the elite, even if only for a short duration.

Hawks then fades in to the office of Major Brand. Located on the ground and enclosed by confining walls, the environment is ironically known as 'The Throne' (designated by a chalk inscription on the door). On the other side of the office is Captain Phipps (Edmund Breon).[13] Phipps is the film's counterpart to the senior officer in *Journey's End*. In no danger of being sent 'over the top' on an aerial mission, Phipps tries to alleviate Brand's anxieties. Although 'The Throne' room might appear to resemble the static set typical of theatre, supposedly characteristic of early sound cinema, camera and actors both move but in a very restricted manner.[14] This parallels both their restrained feelings of confinement in their different roles of senior officers (one, a former flyer elevated to high command, the other an older man only suited to a desk job), but also the restricted type of movement they are subject to. This is the inevitable result of the World War I situation where characters were either trapped in trenches as in *What Price Glory?*, *Journey's End*, the wartime sequence of John Ford's *Pilgrimage* (1933), or were powerless against heavy armaments as in Eisenstein's metaphorical depiction of trench warfare following the resumption of hostilities by the Provisional Government in *October* (1927).

This sense of being trapped and restricted, as Belton suggests, is a condition of professional space in war:

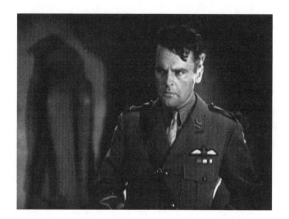

The Dawn Patrol (1930): Major Brand (Neil Hamilton) under stress in 'The Throne'

Characters remain trapped by the professional roles they must perform. This can be felt most dramatically in the acting style, especially in the mixture of rage and emotional resignation in the character's repetition of the reply, 'Right!' to orders they would rather not obey. ... After Brand's departure, we see Courtney in the same position, performing similar actions (answering the telephone and carrying out its impersonal orders) and using similar gestures. Courtney is trapped into becoming Brand by performing Brand's role, just as Scott becomes somewhat like the earlier Courtney. The friendship between the two becomes strained by their roles, and this tension reinforces the film's overall structure, which consists of alternation between movement and static set-ups, between the freedom of personal idiosyncrasy/individuality and the stasis of professional necessity, between mobility and immobility, between an organic exercise of free will and a schematic pattern of inevitability.[15]

Camera movement can occur in interior as well as exterior scenes. Interiors are more restrictive and this can be linked to the particular ideological demands of the World War I movie where duty and service are paramount as opposed to the more democratic world outside where involvement in the professional group is more a matter of choice than anything else. In *The Dawn Patrol*, this involvement is a matter of dire necessity due to the oppressive nature of the wartime situation that will jeopardise the friendship between Courtney and Scott that began when they were in school together. The first interior scene reveals Brand and Phipps seated separately within 'The Throne' waiting for planes to return as well as orders for further deadly raids issued on the phone by the never seen High Command. A whisky bottle is prominent on Brand's desk. Like Captain Stanhope (Colin Clive) in *Journey's End*, he resorts to alcohol to cope with his daily existence, no longer having the therapeutic escape of flying on missions to relieve his tension. Confined behind the desk with alcohol his only solace, to drown his feelings of guilt for sending inexperienced flyers to their deaths like an executioner, Brand unburdens his feelings to the father-confessor figure of Phipps. The camera then subtly moves when Brand walks over to Phipps's desk. It then subtly tracks back. When the phone rings, the camera pans right and then tilts down as Brand returns to his desk. An obvious contrast appears between the two opening sequences in *The Dawn Patrol*. In the first, the pilots are confined within their planes

as they engage in deadly combat with the enemy. Those on the ground are also con-
fined to 'The Throne' and feel the loss of downed pilots even more than those above,
who have no time to dwell on the losses but must either manoeuvre themselves out of
vulnerable positions, help each other or avenge the deaths of their comrades. When
they return, they can indulge in alcohol or sing a tribute to the dead. Those in 'The
Throne' do not have this escape valve. They can only hide their feelings behind seem-
ingly indifferent masks (Phipps), or move in confined positions of restricted impotence
(Brand). After several losses on one mission the camera tilts up slightly as Brand reacts
angrily to Courtney's criticism of a situation he has neither caused nor can do anything
about, a movement revealing the emotional angst Brand usually conceals within his
leadership persona.

These introductory scenes demonstrate Hawks's polished integration of visual style
and narrative theme. Blake Lucas believes that the film reveals Hawks moving towards
a 'deceivingly informal style, defined by a camera which would feign unobtrusiveness
and by playing what would seem spontaneous and free from self-consciousness' in a
manner that is 'present but not pronounced'.[16] The film is culturally and historically con-
ditioned by contemporary feelings involving the entrapment of America by Woodrow
Wilson in a 'noble crusade' that turned out to be compromised and resulted in an iso-
lationist mood that lasted until Pearl Harbor.

Although Brand and Courtney do appear together occupying different parts of the
frame in the bar in one scene after Scott's presumed death in action, they are tightly
framed as if they are still in the claustrophobic confines of 'The Throne'. Brand has now
broken his custom of not joining the men at the bar since he senses how Courtney
feels about Scott's loss and offers him consolation: 'Can I do anything, old man?'
Rather than rejecting his approach, Courtney accepts Brand's gesture and the two
men stand together at the bar in the very same positions as Courtney and Scott earlier.
This not only anticipates Courtney's future inheritance of 'The Throne' but also hints at
the friendship they once had before romantic rivalry and the divisions of command sep-
arated them. When the men bring in the captured German flyer who has supposedly
killed Scott in combat after the latter tried to help the inexperienced Hollister, Brand
has to restrain Courtney from attacking the man and breaching their code of profes-
sionalism: 'Steady, old man!' This brief scene presages the later more realised role of
friendship within Hawks's characteristic professional group, whose members attempt
to operate not only in a collective sense of their best interests, but also to prevent their
leader succumbing to his darkest emotions. Later examples of this Hawksian trope of
protective intervention will include Geoff (Cary Grant) lighting a match to prevent the
Kid (Thomas Mitchell) attacking Bat MacPherson (Richard Barthelmess) in *Only Angels
Have Wings*; similar actions performed by Eddie (Walter Brennan), Slim (Lauren
Bacall) and Frenchy (Marcel Dalio) to forestall any violence by Harry Morgan
(Humphrey Bogart) in *To Have and Have Not* (1944); Tess Millay (Joanne Dru) with Tom
Dunson (John Wayne) and Matthew Garth (Montgomery Clift) in the final scenes of
Red River (1948), as well as Dude (Dean Martin) and Carlos (Pedro Gonzalez-
Gonzalez) in different scenes in *Rio Bravo*.[17] Although Courtney appears about to

strangle Hollister after he accuses him of seeming callousness over the death of Scott, he suddenly stops and apologises for his behaviour. Courtney's restraint here evokes the later self-recognition of Harry in *To Have and Have Not* when he realises that he could have murdered the Vichy policeman. However, it was Brand's earlier intervention that stopped Courtney resorting to violence, anticipating the role of Tony Camonte (Paul Muni) in *Scarface* who succumbs to his own version of a dangerous 'lure of irresponsibility'.

In the fishing-boat sequence of *To Have and Have Not*, Eddie prevents Harry from assaulting Mr Johnson (Walter Sande) by mentioning the money he owes them for hiring the boat. The larger goal is always more important in Hawks's universe than the short-term, limited gains of emotional release. By forestalling an assault on von Muller (uncredited), Brand not only prevents Courtney's breach of professional decorum but also allows him to see the values of emotional restraint, something he exercises with Hollister a few scenes later. As a result, Hollister is able to live up to the professional ideals of Courtney, something he expresses joy over when he later learns that somebody originally 'no good' died 'like a man'.'

Helping one another represents the highest value of a Hawks professional group. When Courtney's plane is shot down after he and Scott have avenged von Richter's humiliation, Scott lands to pick up his friend. On the return journey, enemy fire penetrates the oil container of Scott's plane and oil is splashed into his face, temporarily blinding him. Courtney is able to help his friend pilot the plane to a safe landing behind French lines. This sequence is another intriguing example of the 'once and future Hawks presaging that later motif of two members of the professional group overcoming various types of disabilities and uniting to overcome whatever obstacles confront them. It anticipates, among others, the concluding scenes in *Only Angels Have Wings* and *El Dorado* (1967).

When Hollister reacts hysterically to the friendship shown to von Muller by Courtney and others, he anticipates Bonnie's (Jean Arthur) response in *Only Angels Have Wings* to the group's apparently heartless attitude to Joe's death. She has yet to learn what the professional group is all about. So has Hollister, who combines Bonnie's initial *Bildungsroman* female role in the later film, with that of the failed professional hero given a second chance to prove himself, like Bat MacPherson. As a potential young sacrificial victim of the conflict, Hollister is the film's equivalent to the 'Mother's Boy' of *What Price Glory?*. During the second sequence, when Brand and Phipps anxiously await the return of the daily dawn patrol, they discuss the flyers' psychological survival techniques. While Brand speaks of them 'pretending they won't come back tomorrow', Phipps replies that Hollister is the one exception and that, 'He'll never fit in.' Brand counters, 'He'll have to learn, or …'. Hollister returns traumatised, having lost his best friend in action. The camera tracks right as the survivors return, entering the bar area for the first time in the film. They accompany the distraught Hollister. After reporting to Brand, Courtney goes to an upper room, an area representing the private as opposed to the public space of the bar (the kind of space that will later be seen in *Only Angels Have Wings*, *To Have and Have Not* and *Rio Bravo*), to offer Hollister some brandy.

The Dawn Patrol: naive enthusiasm. One of several 'new replacements' in Hawks's 'zip-pan' sequence

This private space is one where personal feelings can be shared, as in Courtney's speech to Gordon 'Donny' Scott (William Janney) later and his touching farewell to Scott before the final mission. The camera tilts down to Hollister as he remarks of his deceased friend, 'He didn't have time to unpack.' Downstairs in the public space of the bar, Hollister is outside the group as they drink to the gramophone record 'Poor Butterfly' that Scott plays interminably. The repetition of this music on a gramophone seen endlessly playing the record represents both a striking visual metaphor for the circular structure of this film and the endless, repetitive cycle of missions that eventually end in death. It is an early instance of Hawks's use of objects as symbolic devices in his films.[18] The camera frames the occupants of the bar in long shot before tracking right past Hollister, whose emotional condition isolates him from the group, to emphasise the friendship existing between Courtney and Scott. Although Hollister lets the group down in one combat mission, he later redeems himself. 'He was trying to help Thornby. He died like a man.' Courtney expresses his relief, 'Oh, I'm glad. I'm glad,' after learning that Hollister fulfilled all the conditions necessary to win a second chance to prove himself worthy of membership of the professional group.

When Courtney learns the names and flying experience of new arrivals, the camera rapidly moves to reveal each new individual member in a zip-pan, anticipating the camera technique of some three decades later. As well as contrasting with the restricted mobility of veteran flyers on the ground, this unique camera movement expresses the naive enthusiasm of the newcomers who have never engaged in combat before and who will have a rude awakening the next day. When Donny Scott arrives, there is no need to repeat this particular camera movement. Hawks has already made his point.

Close-ups are used sparingly to convey different meanings. Two instances involving the role of matches and Donny's boat-crew medal exemplify this strategy. Closeups of the matches need to be seen within the context of two preceding scenes showing the return of planes from their dangerous missions. Hawks engages in a particular creative variation whenever he employs a certain technique. During two sequences depicting the landing of the planes, Brand and Phipps wait anxiously in 'The Throne' for the planes to return. The first scene intercuts shots of the two men *and* the planes returning. Brand totals the score aloud, 'Five out of Seven', the missing two planes being piloted by Blane and Machen, the latter a close friend of Hollister. The

next sequence shows no planes and nothing is said, instead concentrating on the repressed tensions of the two men as they listen to the engines of the returning planes, which will reveal how many have survived the latest deadly mission. So, Hawks engages this aural device to convey meaning, relying on sound rather than image to deliver the message. This is quite a sophisticated use of sound technique for early cinema. The third sequence not only uses the second key close-up in the film, but varies the 'returning-plane motif' in a significant way. A close-up emphasises the matches in Phipps's hand as he 'rolls the dice of fate' to discover how many will return. He flicks his hand so that six matches become three but only two planes return, an irony noted by Courtney who by now has become flight commander: 'Two! The matches were wrong, Phipps.' On this occasion, there are exterior shots of the return-ing planes. Both these exterior shots and the lines spoken by Courtney show how much he has become entrapped in the same deadly position as Brand was during the film's first sequence. He not only becomes Brand's version of an 'executioner' but suf-fers the same type of emotional entrapment as his predecessor, bitterly feeling the loss of his men. The restrictive device of the close-up of the matches flicked on Phipps's hand not only symbolises the arbitrary nature of existence suffered by the Dawn Patrol itself, but also the feelings of enforced claustrophobia now experienced by Courtney, who wishes to be with his men on the daily patrol. When Scott lands his plane follow-ing the death of Donny, he proceeds immediately to Courtney's office. His emotional anguish becomes expressed by a close-up of his boots as the camera tracks right to him moving towards the door of 'The Throne'. When he enters, the image cuts to a long shot with the camera tracking in to frame him and Courtney in tight mid-shot, the two no longer being friends but antagonists in the eyes of Scott.

The next significant use of this technique occurs after Courtney occupies Brand's position and has sent Scott's inexperienced younger brother off on a deadly mission. Two other close-ups reveal Donny's boat-crew medal, an object he gives to Courtney before his final flight and which last appears from Courtney's point-of-view during his final mission. It is important to recognise that the medal does not designate an individ-ual achievement but a collective one. Ironically, although Donny is far too inexperienced to go on his first and final mission, the medal represents his potential to be a part of the professional group, one which is destroyed by the arbitrary choices of the High Command deciding to send inexperienced young pilots on deadly missions without giving them sufficient training. When Courtney speaks to Donny on his last night before his first dawn patrol, he articulates the underlying philosophy of the professional group, one that contains the very essence of Hawks's understanding of this concept: 'If you should lose, be a good loser just as you would be in school. … But it isn't really so bad that, if you go, you know you've done all you can to help.' Courtney's lines contain no phony patriotic spin doctoring but are what he believes personally and sincerely. Later, he will get Scott drunk so that he cannot fly on a suicidal mission and hears his friend forgive him before he relapses into a drunken stupor: 'Sorry, I understand. Brass. It's orders. I can't go out there without saying I'm sorry.' Relief appears on Courtney's face, the same expression he had when he learned of Hollister's sacrificial act to help

Thornby. He gently touches Scott's head. 'Happy landings, Scott.' By doing this, Courtney not only atones for the act that he was forced to carry out by the unseen High Command but also allows Scott some more time before he, too, will have to be 'going west', a term meaning death in action that also occurs in *Journey's End.* After his successful bombing mission, he looks again at Donny's medal clasped in his hand as if he has achieved this mission not on his own but in collaboration with the deceased young pilot.

Courtney's sacrificial mission could have ended up as a sentimental war-movie cliché. To his credit, Hawks avoids this in a very revealing epilogue showing Scott as the new flight commander sending other young, inexperienced pilots on their last missions. He will have no possibility of further 'happy landings'. *The Dawn Patrol* ends on this grim note, the wheel having turned full circle.

Notes

1. Personal phone message (5 November 2008). We must remember that Robin Wood wrote his monograph in the pre-VHS and DVD era. The film remained inaccessible for many years. It is now available on DVD in the Warner Bros. Archive series.

2. John Belton, 'Howard Hawks', *The Hollywood Professionals Vol. 3: Howard Hawks, Frank Borzage, Edgar G. Ulmer* (London: Tantivy Press, 1974), pp. 8–73; Blake Lucas, '*The Dawn Patrol*', *Magill's Survey of Cinema. English Language Films. Second Series. Vol. II COB-HAL* (Englewood Cliffs, NJ: Prentice Hall, 1981), pp. 578–82; Brian Wilson, 'The Dawn Patrol', *Senses of Cinema* no. 49 (2009): http://sensesofcinema.com/2009/cteq/dawn-patrol/ (accessed 9 January 2015).

3. Belton, 'Howard Hawks', p. 15.

4. Ibid., pp. 15, 16.

5. Wilson, 'The Dawn Patrol'.

6. See Todd McCarthy, *Howard Hawks: The Grey Fox of Hollywood* (New York: Grove Press, 1997), pp. 102–5.

7. Ibid., pp. 111–12.

8. Ibid., pp. 103–5.

9. Ibid., p. 105.

10. The conflict would also have an influence on James Whale's *Frankenstein* (1931). See David. J. Skal, *The Monster Show: A Cultural History of Horror* (London: Plexus, 1994), pp. 128–36. See also Christiane Gerblinger, 'James Whale's Frankensteins: Re-Animating the Great War', *CineAction* nos 82/3 (2010), pp. 2–9.

11. See Jeffrey Richards, *Visions of Yesterday* (London: Routledge & Kegan Paul, 1973), pp. 2–220.

12. A remake, *The Dawn Patrol* (1938), directed by Edmund Goulding, made extensive use of the aerial footage from Hawks's original.

13. Breon later appeared in Hawks's *The Thing from Another World* (1951) where again he plays a supportive background figure, Dr Ambrose.

14. See Lucas, 'The Dawn Patrol', p. 580.

15. John Belton, 'Hawks and Co.', in Joseph McBride (ed.), *Focus on Howard Hawks* (Englewood Cliffs, NJ: Prentice-Hall, 1972), pp. 100–1.

16. Lucas, 'The Dawn Patrol', p. 581. Lucas also notes here that 'the screenplay, which [Hawks] adapted with two others from John Monk Saunders's admirably spare story, and the direction reveal his distinctive artistic voice at this relatively early stage'.

17. The ugly 'other side of the coin' appears in Marlowe's (Humphrey Bogart) indirect execution of Eddie Mars (John Ridgely) at the end of *The Big Sleep* (1946), an action paralleled by Cole Thornton (John Wayne) in *El Dorado* (1967), and the brutalisation of Ketcham (Victor French) by Cord McNally (John Wayne) in the second half of *Rio Lobo* (1970).

18. See Gerald Mast, *Howard Hawks, Storyteller* (New York: Oxford University Press, 1982), pp. 49–50, 83–4, 92–4, 194, 257–9. This song played on a gramophone also occurs in a similar context in one sequence of *Today We Live* (1933).

14 Irresolvable Circularity
Narrative Closure and Nihilism in
Only Angels Have Wings

Doug Dibbern

Some of Howard Hawks's most prominent exegetes consider him an artist with an ameliorating, humanist vision, as a storyteller whose protagonists learn moral lessons and evolve as human beings by forming closer bonds with their fellow men. Robin Wood, for instance, writes that *Only Angels Have Wings* is structured around the characters' struggles between responsible self-respect and irresponsibility, and he sees the achievement of an adult sense of self-respect as a kind of moral victory:

> By the end of *Only Angels Have Wings*, almost every character has undergone a process of improvement. … [Hawks] is able convincingly to portray creative relationships in which the characters help each other, and through which they develop towards a greater maturity, self-reliance, and balance.[1]

Gerald Mast is more explicit in his contention that Hawks is a moral artist. He sees Hawks primarily as a storyteller, too, a kind of narrative engineer who represents what he calls an 'implicit moral system'. Like Wood, he sees Hawks's films as stories in which the protagonists make discoveries about themselves and learn to become better people:

> Since the narrative structures of Hawks's actions bring his characters to a discovery, the potential seriousness and intellectual richness of his stories can only reside in what it is they discover and why and how – if the moral system that allows Hawks's stories to proceed is a complex and stimulating one … the power of Hawks's moral vision becomes even more compelling if these underlying moral systems are consistently, carefully, and complexly related to one another. To demonstrate this consistency is to demonstrate the importance and value of Howard Hawks.[2]

There is certainly an element of truth in these critics' descriptions – Hawks's all-male groups do cultivate a sense of communal responsibility, after all – but they ignore a recurring strain of amoral nihilism central to his work. The notion of character development is intrinsically related to narrative closure because it is the story's resolution that ultimately determines what evolution – if any – the characters have undergone. But in many of Hawks's films, his protagonists are actively opposed to their own moral

improvement, ending the movie in the same problematic situation that they were in before it began. I call this type of conclusion the closure of irresolvable circularity.[3]

In *His Girl Friday* (1939), for instance, Walter Burns (Cary Grant) manipulates his ex-wife to return to a life that she says she doesn't want, hires then fires other news-men for his own gain, complains about hiring someone with a disease, frames his ex-wife's fiancé for stealing a watch, for mashing and for passing counterfeit money, orchestrates the kidnapping of an elderly woman and later seems excited at the thought that the old woman might have been killed because of his scheme. By the final scene, Walter has convinced Hildy Johnson (Rosalind Russell) to marry him once again, even though she's called him 'loathsome' and a 'murderer' and noted acidly that he'd be willing to double-cross anybody. In the final shot, they do not kiss or even embrace as they walk together out of the room; they don't even look longingly into each other's eyes. Though Hildy longs for a two-week honeymoon this time around, Walter quickly nixes the idea when he hears that there's a strike in Albany, rearranging their schedule so that they can cover a breaking story together instead of wasting time on a romantic getaway – just as they did the last time they wed. And we know how that marriage turned out. As they walk towards the stairs, Walter strides ahead of her – just as she complained a gentleman shouldn't do at the beginning of the movie – leaving her to carry her own suitcase. This remarriage, it seems, is fated to struggle with the same problems that infected it the first time around. It is this conclusion that inspired David Bordwell to select *His Girl Friday* as his paradigm of a classical film narrative that doesn't have an orthodox 'closure' but merely a 'closure effect'.[4] Walter Burns's failure to evolve is not unusual in Hawks's body of work. Many of his protagonists, in fact – especially in the first half of his career – revel in their own amorality, and they conclude the movie by beginning another cycle of the same conflict which propelled the plot that has seemingly just come to an end.

While Hawks does use this type of circular ending in comedies like *His Girl Friday*, it appears most emphatically in his movies about war and aviation in the 1930s. In *The Dawn Patrol* (1930), for instance, the movie ends with Doug Scott (Douglas Fairbanks, Jr) coming out of the flight commander's office and giving orders to a new squadron of pilots, repeating almost exactly the same speech that his friend and commander, Dick Courtney (Richard Barthelmess), had given earlier, which had repeated almost exactly the same speech that the previous commander, Major Brand (Neil Hamilton), had delivered at the beginning of the film. Since Scott and Courtney had argued about the ethics of sending pilots up in risky conditions – repeating the same argument that Courtney had had earlier with Brand – Scott's acceptance of his new promotion in the end is both a surrender to the inherent amorality of this type of professionalism and an acknowledgment that this cycle of promotion, death and replacement will go on indefi-nitely. *The Road to Glory* (1936), Hawks's movie about World War I in the trenches, and *Ceiling Zero* (1936), his film about a civilian airline, have remarkably similar endings. In these films, the conclusion does not resolve the conflict, but implies instead that the protagonists have reconciled themselves to the fact that the conflict will continue exactly as it has in the past for the foreseeable future. And, most importantly, this lack

of resolution is directly related to the notion that most of these protagonists – and most of the professionals who work for them – will eventually die in their line of work, only to be replaced by someone very simililar. By choosing not to escape this current situation, then, these men have submitted to their own mortality. Their choice is, in fact, a passive form of suicide. Hawks does not portray these suicidal tendencies, though, as despairing. His pilots are rambunctious and free-spirited, gathering around pianos to belt out tunes together. Cary Grant perfectly embodies their *joie de vivre*. If anything, Hawks makes his characters' decisions about their own deaths seem honourable. It is this patina of dignity in Hawks's unresolved conclusions that makes some critics stress a sense of moral amelioration while overlooking the nihilism – an idealistic nihilism, admittedly – that is the essence of these endings.

Hawks's irresolvably circular endings should not be confused with the traditional narratological notion of a story that returns in the end to the state of equilibrium that existed when the movie began. Rather, his conclusions return to a state of disequilibrium that the protagonists have experienced before and most likely will experience again after the movie concludes. In this sense, a satisfying closure is impossible since the beginnings and endings of the plot are merely arbitrary points on a circle, and the characters are fated to continue moving relentlessly along its perimeter. In this chapter, I will concentrate on *Only Angels Have Wings* since I think that this movie – perhaps better than any other – demonstrates Hawks's particular handling of narrative resolution. While this form of unsettled narrative circularity does lend itself to an amoral fatalism, Hawks makes these endings even more intellectually complex – and aesthetically satisfying – by tempering the possible despair with an idealistic vision. In this film, it is this tension between the amoral and romantic aspects of nihilism that defines what one of the film's protagonists calls the other protagonist's 'screwy ideal', and it is the irresolvable conflict inherent in these two modes of nihilism that propels the narrative ceaselessly forward.

The conclusion of *Only Angels Have Wings* leaves many of the protagonists' psychological and emotional conflicts unresolved, leaving them in the same state of instability that has defined them for as long as we can imagine them. In the final scene, Bonnie Lee (Jean Arthur) comes in to say goodbye to Geoff Carter (Cary Grant). Geoff is a pilot, running an airline that delivers the mail over a dangerous pass from a South American outpost called Barranca. Bonnie Lee is a woman who considers herself one step up from a chorus girl – she says she does a 'specialty' – who just got off the boat when the movie began. They've fallen for each other, but they're too hardboiled to admit it. Throughout the movie, they've both maintained that they would never ask anyone else to make a sacrifice on their behalf. When Bonnie asks him about the woman from his past who hurt him so badly, Geoff says, 'Listen, I wouldn't ask any woman to …' and then trails off, as if the words 'stay with me' or 'marry me' are so repugnant he can't even bring himself to utter them aloud. And later, when Geoff's best friend Kid (Thomas Mitchell) tells Bonnie that Geoff will never quit flying, she nods sagely: 'I wouldn't ask him to.' Now, in the final scene, Bonnie obviously wants to stay with Geoff, but she doesn't want to ask him and she's afraid that he will never ask her. 'Geoff', she says.

'Do you want me to stay or don't you?' But Geoff won't ask her to stay. Just at that moment, the call of the lookout station from up in the mountain pass comes over the wireless. The storm has cleared. If Geoff's outfit makes just one more delivery, he and his business partner Dutchy (Sig Rumann) will get a contract for another year. But the last attempt to make this final delivery ended in the death of his best friend, Kid. Inspired rather than intimidated by this danger, Geoff strides around the room excitedly, shouts orders at his men, puts on his raincoat, and comes back to kiss Bonnie perfunc-torily as he heads out the door. 'So long, Bonnie,' he says. The last time he'd tried to go up in the air, earlier that evening, Bonnie had shot him in the arm in a vain attempt to keep him safely on the ground with her, and they're both aware that Kid may have died instead of Geoff because of what she did, just as they're both aware that a pilot named Joe (Noah Beery, Jr) may have died at the beginning of the movie because of her as well. Now, as he's almost out the door, Bonnie tells him that she won't be there when he gets back because she's leaving on the next boat. 'Nobody asked me to stay,' she says. 'You wouldn't ask anyone to do anything, would you?' 'That's right,' he says, and tries to hand her a coin. 'Tails you go, heads you stay.' He flips it and it comes up heads. But she won't stay that way, giving him one of the lines that pops up more than once in a Hawks film: 'I'm hard to get, Geoff. All you have to do is ask me.'[5] But he refuses to ask. He says so long, hands her the coin and walks out the door. It's only then that she examines the coin and realises that it's double-headed, Geoff's round-about way of assuring that she'd stay. Her eyes brighten, the string section on the soundtrack swells and she runs to the door, where she looks out into the rain as Geoff prepares for takeoff once more. The movie ends there, though, before we learn whether or not he returns safely or whether Geoff and Bonnie will ever develop into the kind of mature adults who are able to express their feelings for each other directly.

The ending is ambiguous on a number of levels. For one thing, it makes us question whether or not they have actually formed a happy couple. Geoff has not asked Bonnie to stay and she has not agreed to anything. Like Walter Burns and Hildy Johnson, they do not embrace as the credits roll; instead, they are physically separated amid the dark-ness and rain of what might be a waning squall or merely a temporary reprieve in the eye of the storm. Though Bonnie seems happy, just hours earlier, she had threatened to shoot Geoff, so on one level this is not a victory for the stability of domestic bliss, but an acquiescence to his unrelenting games with death. The coin in her hand has ambiguous connotations as well – positive in that it does represent Geoff's willingness to break his ethical code and ask her to stay, but negative in that it represents his unwillingness to treat her with enough respect to actually articulate his feelings. Finally, the coin is also a reminder of Kid. We've seen Kid flipping it throughout the film: he used it earlier that evening, in fact, playing the same trick on Geoff that Geoff is now playing on Bonnie, using it to convince Geoff to let him go up in the storm. A one-sided coin would symbolise chance, but a coin with two heads must represent destiny. Even when the pilots have fair odds, the notion of chance is seen as inherently dangerous. Both Dutchy and Bonnie refuse to pick a random number to determine whether Joe or Les (Allyn Joslyn) will go up on a mission. But in this case, because Kid's coin led

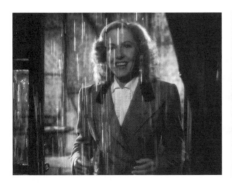

The happy ending: Bonnie (Jean Arthur) looks out into the rain as Geoff (Cary Grant) prepares for another takeoff

directly to his death, Hawks makes us question whether Geoff has a fair chance or whether he, too, is destined to die in this final flight of the film.

The concept of fate is important throughout the movie, since the major characters are all repeating the same conflicts in the present that they faced in the past, which makes one wonder if they are destined to repeat those conflicts again in the future. The characters themselves seem aware that their conflicts are rooted in the relationship between the past, the present and the future. Bonnie describes Geoff's 'screwy ideal', for instance, as 'No looking ahead, no tomorrows, just today.' But this way of living only in the present is simply an illusory shield that Geoff has built for himself against the pain of the past and the possible pain of the future. It is only by embracing the future that he might be able to heal himself and become the kind of improved human being that Wood and Mast describe. But as he takes off into the air in the movie's final scene, it is apparent that this hasn't happened yet.

Because the notion that Hawks is a nihilist seems so contrary to the vision of critics like Mast and Wood, it may help to contrast Hawks's worldview with the dominant cultural conception of aviation at the time. In 1939, most Americans had still never been up in a plane; aeroplane pilots were still considered an elite group of adventurers akin to explorers. Newspapers ran headlines every week about some new achievement in the air – the first trans-Pacific flight in 1935, for instance, or the first woman to win the Bendix air races in 1937. More than just a source of alluring excitement, though, aviation was also the font of what the scholar Joseph Corn has called 'The Winged Gospel'. According to Corn, the first half of the century saw the emergence and solidification in America of a cultural consensus that flight augured a new era in the history of human civilisation. It's difficult today to understand the level of excitement that flight engendered. When Charles Lindbergh crossed the Atlantic in 1927, Corn writes that his flight 'catalyzed a celebration unlike anything ever witnessed in American public life'.[6] When he returned to New York, 4 million people lined the streets for his ticker-tape parade.[7] Presidential candidate Charles Evans Hughes was not unusual when he declared that the day Lindbergh landed was 'the happiest day of all days for America'.[8]

There was something about his achievement – indeed, of achievements in the air in general – that inspired the creation of art. Regional newspapers published more than a thousand poems about Lindbergh's flight in just the first few months after he landed in Paris, most of which compared him to mythic figures like Apollo, Prometheus and historic ones such as Columbus. The most common allusion by far, though, was with Jesus Christ.[9] This excitement gave rise to a popular philosophy known as 'airminded-ness': 'to be "airminded," as contemporaries used the word,' Corn writes, 'meant having enthusiasm for airplanes, believing in their potential to better human life, and supporting aviation development'.[10] This airminded ideology was permeated with the same divine aura that appeared in the popular poetry on aviation. Though it seems far-fetched now, leading thinkers of the day 'widely expected the airplane to foster democracy, equality, and freedom; to improve public taste and spread culture; to purge the world of war and violence; and even to give rise to a new kind of human being'.[11]

Hawks himself had been intimately involved in the cultural excitement of flight from an early age. On 5 November 1911, Calbraith P. Rodgers became the first person to fly across the continental United States when he landed in Pasadena, California, where the fifteen-year-old Hawks lived. Rodgers was met by a crowd of 20,000, which must have made it the biggest event of the year in what was then still a small town miles from Los Angeles.[12] Just a few years later, Hawks was already an avid aeroplane enthusiast. He spent World War I in Texas teaching cadets to fly. One reason his attitude towards flight was more cynical than most Americans was, ironically, precisely because he was so intimately involved with planes; he knew many people who had died in the air. He had learned to fly with three other men during the war, but by the early 1930s, all three were dead.[13] His younger brother Kenneth died in a 1929 plane accident while shooting aerial stunts for a film he was directing, *Such Men Are Dangerous* (1930), about an Englishman who fell from a plane above the English Channel.[14] In *The Dawn Patrol*, a pivotal conflict emerges when a flight commander sends his best friend's younger brother on a dangerous flight that results in the brother's death.[15] In *Only Angels Have Wings*, Kid Dabb also has a younger brother who recently died in a plane crash.

With this historical grounding, one begins to see just how unusually pessimistic Hawks's vision was. In *Only Angels Have Wings*, Hawks stages a struggle between two opposing views of flight: Bonnie Lee represents the dominant, airminded conception of aviation in America; Geoff Carter represents the cynical, minority opposition. When Bonnie sees the first plane take off from Barranca, she marvels at the sight: 'Oh … that's the most wonderful thing I've ever seen.'[16] But because Hawks favours the thrill of danger rather than the safety of domesticity, he de-emphasises aviation's potential beauty: he doesn't allow the audience to see the marvel that Bonnie has just witnessed, for example. He shows us instead the bar-turned-air terminal enveloped in darkness that serves as the home for the dream of flight in this film. Geoff Carter makes Hawks's attitude explicit when he comments sarcastically on Bonnie's observation. 'Yes,' he says, holding the word a second too long in wry disapproval. 'It reminded you of a great big beautiful bird, didn't it?' But Geoff's cynicism doesn't contaminate Bonnie – at least not yet; she hasn't yet fallen in love with him. 'It's really a flying human

being,' she says quietly to herself. For the rest of the film, these two protagonists strug-
gle to reconcile their conflicting worldviews. Bonnie Lee, the airminded representative
of the civilised world eventually accepts Geoff Carter's unsentimental ennui. To win
Geoff's love, Bonnie must accept life on his terms. By staying, Bonnie tacitly agrees to
withhold her feelings, to supress her hope for the future and refrain from marvelling at
the poetic spectacle of men who are able to fly in the air. But in Hawks's world,
Bonnie's acquiescence has much in common with the ultimate acceptance of fate by
the protagonists of *The Dawn Patrol*, *The Road to Glory* and *Ceiling Zero*, surrendering
her will to an idealistic way of living but at the same time succumbing to her lover's
drive toward death.

Hawks reinforces the theme of circularity by making the narrative's conclusion point
back into the past and forward into the future. With Hawks especially, narrative resol-
ution doesn't occur only at the end of the film, but is instead embedded as a range of
possibilities or as a perceived inevitability throughout the course of the movie. Because
of classical Hollywood's generic formulas, the audience had a fairly good idea of any
movie's narrative arc before the movie began. In their analysis of classical Hollywood,
for instance, David Bordwell, Kristin Thompson and Janet Staiger argue that 95 per
cent of movies featured a plotline involving a romantic couple, that almost every movie
had a happy ending and that more than 60 per cent of movies concluded with the hetero-
sexual couple prominently displayed for the spectator's approval.[17] Thus, anyone who
saw a poster for *Only Angels Have Wings* outside the box office knew instinctively that
Cary Grant and Jean Arthur would feel a romantic urge for each other from the moment
they met, but that their love would be thwarted until the end of the film when they would
finally be able to express their desires freely, perhaps kissing in a passionate embrace
as the screen faded to black. Thus, the happy resolution of their relationship is implied
in the moment they meet and hinted at continuously throughout the film, even when cir-
cumstances tear them apart and their possible union seems most imperilled. In this
sense, though narrative resolution is manifested at the end of the film, it has a temporal
dimension as well, existing as a narrow range of possibilities at every moment through-
out the movie.

Hawks plays with this temporal aspect of the movie's resolution by continually
demonstrating that his characters' conflicts play out similarly in the past, present and
future. The movie has five main characters: the couple of Geoff Carter and Bonnie Lee
is paralleled by and interwoven with the couple of Bat MacPherson (Richard
Barthelmess) and his wife Judy (Rita Hayworth). Meanwhile, each of these couples has
interactions or conflicts with Geoff's best friend and fellow pilot, Kid. These five char-
acters are all haunted by the past, and yet, ironically, they each find themselves replay-
ing the past throughout the movie. Geoff, for instance, has exiled himself to Barranca
partly because he's an idealist living out a philosophy that cherishes adventurous inde-
pendence above all things, but also because he's been injured in love. We might say,
in fact, that his individualist ideology is the logical product of these past romantic
wounds. After Bonnie and Geoff are alone together for the first time, she's taken aback
by his cynicism. 'Say, someone must've given you an awful beating once,' she says,

understanding instinctively that that someone must have been a woman. 'What was she like, anyway? That girl that made you act the way you do?' But Geoff's answer returns once again to the movie's recurring theme of perpetual repetition. 'A whole lot like you,' he tells her. And though he insists to Bonnie that he'll never get burned twice in the same place, later he does literally burn himself twice with a boiling coffee pot she's set up in his room. Thus, from the first, it seems that the Geoff–Bonnie relationship will replay the same conflicts that troubled his last affair, but because that past relationship was never resolved, Hawks hints that this current liaison might not be resolved either. Bonnie Lee is similarly rehashing an unsettled conflict from her past when she develops feelings for Geoff. After the death of Joe, she tells Kid and the mechanic Sparks (Victor Killan) that the group's attitude to flying reminds her of her father. He was a trapeze artist, who insisted on performing his act without a safety net. Then one day he fell and died. Thus, the death of Joe – or the possible death of Geoff in the future – reminds her of the death of her father, and she's forced in the present to confront once again her unresolved feelings about his death in the past. Kid later makes the connection between Geoff and her father explicit when he senses her anxiety at watching Geoff flying. 'What do you want to do?' he says. 'Put a net under him?'

The parallel couple of Bat and Judy are also replaying the past. More than any other character in the film, Bat needs to redeem himself by overcoming his history. A couple of years earlier, he bailed out of a plane as it went down and left his mechanic to die in the crash alone. That mechanic, it turns out, was Kid's younger brother. When Bat arrives in Barranca, the other pilots are disgusted by his reputation, so Bat volunteers for the most dangerous flights to prove himself to them. He makes a daring landing atop a mesa to rescue an injured miner; he takes a box of nitroglycerin up into the mountains during a storm; and at the film's end he replays the traumatic flight from his past when he goes up in another storm with Kid. In this last flight, a bird crashes through the window and knocks Kid out cold. After the engine catches fire, Bat turns the plane back to Barranca. Then, in a re-enactment of the earlier incident with Bat and Kid's brother, Kid urges Bat to bail out of the plane to save himself from certain death, but this time Bat refuses and lands the plane safely. Bat's wife, Judy, is also replaying her past. She had previously had an affair with Geoff, but left him because she couldn't handle the anxiety she felt waiting for him to return from a flight. She is the girl who gave Geoff 'the awful beating' that made him the cynical loner that he is now. But, like the others, she seems unable to escape her past: she fled one pilot only to marry another, condemning herself to wait nervously for her husband's return in the same way she had previously with Geoff. And like her husband, she wants to let go of the past: she wants to understand and support Bat in a way that she was unable to do with Geoff. Finally, Kid too is burned by an ordeal from the past and must try to overcome this pain in the present. He believes that Bat was responsible for the death of his brother. His final flight with Bat is a way for him – just as it is for Bat – to re-enact his brother's death and thus come to terms with it, but it is also a way to relieve Bat's pain by challenging him to relive and so overcome his trauma.

Hawks demonstrates that his characters' conflicts may not be resolved by allowing the conclusion to remain ambiguous, with several possible futures available to them. The future is a dominant and recurring theme throughout, often tied explicitly to another recurring theme: that of death. Bonnie has already articulated Geoff's philosophy as one that won't allow any planning for the future. 'Did you ever know a woman who didn't want to make plans?' he asks Bonnie when they first meet. 'Map out everything? Get it all set?' That's not the woman – or the type of life – for him. Other characters, too, make dour references to the future. After Joe's death, for instance, Bonnie stands outside looking up at the sky, wondering why the pilots would come to a place as dark, isolated and dangerous as Barranca. 'It's like being in love with a buzz saw,' she says. The mechanic Sparks nods in agreement: 'Not much future in it.'

Hawks makes the idea that pilots have no future quite concrete, portraying flight not just as dangerous, but as almost certainly doomed to failure, and possibly death. The threat of death hangs over Barranca, in fact, even before Bonnie arrives. Sparks tells her that two other pilots besides Joe died in just the last two months.[18] For an airline that seems to have only six pilots working at a time, the death of three pilots in a two-month period gives the impression that the remaining pilots have a 50 per cent chance of dying themselves in just the next couple of months. We see pilots take eight individual flights in the movie, and because the eighth flight remains unresolved at the end as Geoff goes up in the storm, we know the results of just seven of these trips. Remarkably, only three of these seven can be considered successful: Bat rescues the miner from the mesa, and Geoff and Bat each deliver the mail once – though Hawks shows the audience only a brief glimpse of one of these successful deliveries. But in three flights, the pilot is forced to turn around before he can successfully fly over the pass in the mountains; in another flight while testing a plane, Geoff almost dies when a windshield temporarily knocks him out; and two flights end with men dying in fiery crashes. The film has six pilot characters: Joe, Les, Kid, Geoff, Gent (John Carroll) and Bat. Of these six men, two end up dead, one has been grounded for refusing to fly, and the other three are injured so badly that they can't fly alone.[19] With odds like these, flying is not just dangerous, but downright suicidal.

Despite Hawks's protestations that he didn't respect people who killed themselves, suicide plays a significant role in many of his films – especially in the same movies from the first half of his career that also feature irresolvably circular endings. He was characteristically terse and unemotional talking about the fact that his friend Ernest Hemingway had taken his own life: 'I don't like suicide,' was all he would say to Joseph McBride.[20] He was more forthcoming with Peter Bogdanovich, telling him that suicide was a cowardly thing to do. While he admitted that suicide did appear in his cycle of aviation films, he claimed that the characters in those films 'were dying for a reason – they had a definite purpose – I don't think I've ever made one where someone just didn't want to live anymore.'[21] But one has to take Hawks's words with a grain of salt. His characters often do seem to sacrifice themselves for a reason, giving their own lives so that others may live; but in *The Dawn Patrol*, *Today We Live*, *The Road to Glory* and *Ceiling Zero*, this sense of purpose comes about as a serendipitous byproduct of the protagonist's decision to take his own life for personal reasons.

Though no one uses the word itself, the idea of suicide plays a significant role in *Only Angels Have Wings* as well. The whole movie is organised around the possibility that Geoff is using flight as a means to kill himself. This is why Bonnie pulls the gun on him that final night. 'I won't let you go,' she tells him. 'I won't let you kill yourself.' Geoff doesn't dispute the fact that suicide seems inevitable or that he's even opposed to the idea. 'So you're going to do it to keep me from doing it,' he says. In fact, the whole movie is pervaded by the concept of suicide. Every single pilot knows the chance that he will die in a plane crash is quite high. Why are they there, then? They don't get paid particularly well, given the extraordinary risks. Their living conditions are dingy. Barranca itself is a backwater, a metaphorical space for the characters' collectively embraced spiritual isolation. Joseph Walker's lighting is uncharacteristically dark for a Hawks film; his emphasis on chiaroscuro effects actualises Hawks's nihilism.[22] Every scene shot outside is suffused with inky blacks; Dutchy's restaurant-saloon-airplane lobby-hotel is lit almost exclusively with low hanging lanterns, and Geoff's small back office materialises his ennui with slanted shadows from his window blinds. Geoff is not the only one who embraces flight as a form of suicide. Kid, too, wants to go up in the air at the end of the film precisely because its perilousness seems to augur his own demise. Just before the final night, Geoff has told Kid that he can't fly any more because he's losing his eyesight. But Kid, like Dizzy Davis (James Cagney) in *Ceiling Zero*, cannot imagine himself in a world in which he can't fly. For Kid, as for Dizzy, the choice to die in a plane at the end of the movie is not a sacrifice made so that others may live, but a decision to live by the creed of idealistic nihilism he shares with Geoff or not to live at all.

Of all the characters, Bat is the one who most adequately validates the analyses proposed by Wood and Mast in that he overcomes his past demons and achieves some sort of positive resolution. The other characters, though, seem to be continuing past mistakes. Geoff, for instance, will continue flying – probably until he dies in a plane; Bonnie will continue to wait for him; and Kid's future, of course, no longer exists. But, on further examination, even Bat's future with Judy is not as content as it might initially appear. While Bat does land his plane successfully at the end and is treated as a hero by the other men, on a practical level, this flight doesn't conclude any differently than the flight that it is re-enacting. Once again, he has piloted a plane in which he has survived while his co-pilot has died. His is a moral victory related to a tacit honour code, not a victory over death. Now the other men respect him. But one must question what kind of value this honour code has. At the end of Bat's 'victory', one side of his face is terribly burned, and his hands are so disfigured that they are completely bandaged up. In the final scene in the bar, each of the surviving pilots is injured so badly that he is incapable of flying alone, but Bat is the most severely injured. It's not quite clear, in fact, if he will ever heal well enough to fly again. In terms of their romance, his future with Judy also looks cloudy. In the past, Judy's relationship with Geoff failed because she couldn't face the worry about what might happen to him up in the air. But now, her anxieties have become reality: her husband has been crippled by his flight, which renders her future doubtful. On the one hand, she may finally escape her fears, though she

can only realise this dream if her husband is, in fact, permanently disabled. On the other hand, if her husband is not permanently disabled, we know that she will continue her role as dutiful wife, waiting nervously for her husband's safe return, with further injury or death a constant threat.

As Bonnie gazes out at Geoff in the final sequence, the movie may be over, but their relationship – if, in fact, that is even what it is – has only just begun. They have started another cycle of conflict that they have both lived through before. Geoff will continue to live out his screwy ideal, convincing himself that he's living only in the present, without any burdens from the past or constraints from the future. He will be content with this philosophy, lost in the fog, playing games of chance with fate; Bonnie, too, will continue to convince herself of it, as she waits, night after night, for Geoff to return once again.

Notes

1. Robin Wood, *Howard Hawks* (London: Secker & Warburg/BFI, 1968), p. 24.
2. Gerald Mast, *Howard Hawks, Storyteller* (New York: Oxford University Press, 1982), p. 35.
3. Though Wood and Mast's conception of Hawks's work doesn't jibe with my own, there is one scholar whose discussion of nihilism and suicide in Hawks's films – albeit brief – does come close to my understanding of his oeuvre. See Peter Wollen, 'Introduction', in Jim Hillier and Peter Wollen (eds), *Howard Hawks: American Artist* (London: BFI, 1996), pp. 6–10. See also Peter Wollen, 'Who the Hell Is Howard Hawks?', *Framework: The Journal of Cinema and Media* vol. 43 no. 1 (Spring 2002), pp. 14–17.
4. David Bordwell, *Narration in the Fiction Film* (Madison: University of Wisconsin Press, 1985), p. 159.
5. Lauren Bacall uses the same line on Humphrey Bogart in *To Have and Have Not* (1944), for instance.
6. Joseph J. Corn, *The Winged Gospel: America's Romance with Aviation, 1900–1950* (New York: Oxford University Press, 1983), p. 17.
7. Ibid., p. 22.
8. Laurence Goldstein, *The Flying Machine and Modern Literature* (Bloomington: Indiana University Press, 1986), p. 97.
9. Ibid., pp. 98–104.
10. Corn, *The Winged Gospel*, p. 12.
11. Ibid., p. 34.
12. Ibid., p. 10.
13. Peter Bogdanovich, 'Howard Hawks: The Rules of the Game', in *Who the Devil Made It? Conversations with Legendary Film Directors* (New York: Ballantine, 1997), p. 272.
14. His brother's death in the air was one factor that solidified his friendship with William Faulkner, since Faulkner also had a brother who died in a plane crash, in 1935. See Todd McCarthy, *Howard Hawks: The Grey Fox of Hollywood* (New York: Grove Press, 1997), pp. 106–10.

15. The theme of the endangered brother also appears in *The Crowd Roars* (1932), a movie about the dangerous thrills of auto racing that has much in common with Hawks's war and aviation pictures of the 1930s.

16. In this sense, Bonnie Lee is re-enacting the role of the young woman Tommy (June Travis) in *Ceiling Zero*, who even more explicitly represents the airminded ideal. 'Do you remember the day that Lindbergh came back from Paris?' she asks the older pilot played by James Cagney, her face beaming. 'I'll never forget it. They wrote "Welcome Home" in smoke across the sky … . You oughtta feel proud of the way you feel and all the flying you've done.' Tommy in turn is a recreation of Douglas Scott's eager young brother Gordon (William Janney) from *The Dawn Patrol*.

17. David Bordwell, Janet Staiger and Kristin Thompson, *The Classical Hollywood Cinema: Film Style & Mode of Production to 1960* (New York: Columbia University Press, 1985), p. 16; see also Bordwell, *Narration in the Fiction Film*, p. 159.

18. In typically Hawksian three-cushion dialogue, Sparks tells her, 'We've drawn spades twice in the last two months.'

19. Similarly, in *The Dawn Patrol* and *Celing Zero*, the success rate for each flight is about 50 per cent by my calculations.

20. Joseph McBride, *Hawks on Hawks* (Berkeley: University of California Press, 1982), p. 96.

21. Bogdanovich, 'Howard Hawks: The Rules of the Game', p. 264.

22. McCarthy, *Grey Fox*, p. 271. See also 'Walker Wins May Camera Award', *American Cinematographer* (July 1939), p. 299.

Notes on Contributors

MICHAEL J. ANDERSON earned his PhD from Yale University in 2013 with a dissertation entitled 'The Early Hawks: Howard Hawks and His Films, 1926–1936'. His previous publications on Hawks include '*Hatari!* and the Hollywood Safari Picture' and '*Tiger Shark*', both for *Senses of Cinema*, and 'Howard Hawks' in the *Oxford Bibliographies Online* series. He has published essays on Ernst Lubitsch's silent cinema, Tony Scott's *Déjà Vu* and Keisuke Kinoshita's Occupation-era cinema. He also has essays in *Directory of World Cinema: Iran* (2012), including 'Abbas Kiarostami: Style and Themes', Michael is currently Curator of Film and American Art at the Oklahoma City Museum of Art, where he has also managed a series of exhibitions, including *Warhol: The Athletes*.

IAN BROOKES teaches at the Department of Culture, Film and Media at the University of Nottingham. His previous work on Hawks includes '"A Rebus of Democratic Slants and Angles": *To Have and Have Not*, Racial Representation, and Musical Performance in a Democracy at War', in Graham Lock and David Murray (eds), *Thriving on a Riff: Jazz and Blues Influences in African American Literature and Film* (2009). He has published essays on American and British cinema in the *Journal of Popular Film and Television* and *Adaptation* and contributed several entries to *The Grove Dictionary of American Music* (2013). He is also the author of *Film Noir: A Critical Introduction* (2016).

HARPER COSSAR is Visiting Lecturer at Georgia State University. His publications include *Letterboxed: The Evolution of Widescreen Cinema* (2010). His essays have appeared in *Lonely Places, Dangerous Ground: Nicholas Ray in American Cinema* (2013) and *The Screen Media Reader: The History, Theory, and Culture of the Screen* (forthcoming). Harper's research interests include the aesthetic and formal poetics across media platforms, mediated sports coverage, technology and culture, and the interplay of authorship and genre.

ADRIAN DANKS is Director of Higher Degree Research in the School of Media and Communication, RMIT University. He is co-curator of the Melbourne Cinémathèque and was an editor of *Senses of Cinema* from 2000 to 2014. He has published

essays in *Senses of Cinema, Metro, Screening the Past, Studies in Documentary Film, Studies in Australasian Cinema, Australian Book Review, Screen Education, Quarterly Review of Film and Video, 1001 Movies You Must See Before You Die, Traditions in World Cinema, Melbourne in the 60s, 24 Frames: Australia and New Zealand, Contemporary Westerns, B Is for Bad Cinema, Cultural Seeds: Essays on the Work of Nick Cave, Being Cultural, World Film Locations: Melbourne* and *Sydney* and *Twin Peeks: Australian and New Zealand Feature Films*. He is the author of *A Companion to Robert Altman* (2015) and *Australian International Pictures*, with Con Verevis (forthcoming). Adrian is currently writing a monograph on home movie-making in Australia.

JAMES V. D'ARC, PhD is Senior Librarian at Brigham Young University's Harold B. Lee Library, where he is Curator of the BYU Motion Picture Archive, the Arts & Communications Archive and the BYU Film Music Archive. He has acquired for BYU the collections of Merian C. Cooper, Cecil B. DeMille, Jerry Fielding, Hugo Friedhofer, Howard Hawks, Henry Koster, Max Steiner and James Stewart. He is the author of *When Hollywood Came to Town: A History of Moviemaking in Utah* (2010) and producer of a series of limited edition archival motion-picture soundtrack CDs of Hugo Friedhofer, Max Steiner and Dimitri Tiomkin on the BYU Film Music Archive/Screen Archives Entertainment label.

DOUG DIBBERN is an occasional film critic for the *Daily Notebook* at Mubi.com and has recently published scholarly work on Fritz Lang. His first book, *Hollywood Riots: Violent Crowds and Progressive Politics in American Film*, was published in 2016. He earned a PhD in Cinema Studies from New York University and currently teaches there in the Expository Writing Program.

JEFFREY HINKELMAN holds a PhD in Literary and Cultural Studies from Carnegie Mellon University. His dissertation was a study of films dealing with World War I made between the Armistice and the active enforcement of the Production Code. Jeff has taught courses on film history, East Asian film, and film and race, and is especially interested in silent cinema, Asian cinema and pre-1950 studio film-making around the world.

MARK JANCOVICH is Professor of Film and Television Studies at the University of East Anglia. He is the author of *Rational Fears: American Horror in the 1950s* (1996); *The Place of the Audience: Cultural Geographies of Film Consumption* (with Lucy Faire and Sarah Stubbings, 2003); *Approaches to Popular Film* (with Joanne Hollows, 1995); *Horror, The Film Reader* (2001); *Quality Popular Television: Cult TV, the Industry and Fans* (with James Lyons, 2003); *Defining Cult Movies: The Cultural Politics of Oppositional Taste* (with Antonio Lazaro-Reboll, Julian Stringer and Andrew Willis, 2003); *Film Histories: An Introduction and Reader* (with Paul Grainge and Sharon Monteith, 2006); and *Film and Comic Books* (with Ian Gordon and Matt McAllister, 2007). Mark is currently writing a history of horror in the 1940s.

KATHRYN KALINAK is Professor of English and Film Studies at Rhode Island College. She is the author of numerous articles on film music as well as *Settling the Score: Music and the Classical Hollywood Film* (1992); *How the West Was Sung: Music in the Westerns of John Ford* (2007) and *Film Music: A Very Short Introduction* (2010). She is editor of *Music in the Western: Notes from the Frontier* (2011) and of *Sound: Dialogue, Music and Effects* in the Rutgers Behind the Silver Screen series (2015). In 2011, Kathryn was named the Mary Tucker Thorp Professor at Rhode Island College.

ROBERT MANNING has recently completed a PhD at the University of East Anglia. His thesis considers how many of the films now known as film noir were mobilised politically in terms of their reception. His additional research interests are Middle Eastern cinema; gender in film and television; and the horror and *giallo* genres. Robert is Associate Tutor in the School of Art, Media and American Studies at UEA.

JOE McELHANEY is Professor of Film Studies at Hunter College/City University of New York. His books include *The Death of Classical Cinema: Hitchcock, Lang, Minnelli* (2006); *Vincente Minnelli: The Art of Entertainment* (2009); *Albert Maysles* (2009); and *A Companion to Fritz Lang* (2015). Joe has also published numerous essays on aspects of American, European and Asian cinema.

STEVE NEALE is Emeritus Professor of Film Studies at the University of Exeter. He is the author of *Genre and Hollywood* (2000); co-author (with Sheldon Hall) of *Epics, Spectacles and Blockbusters: A Hollywood History* (2010); editor of *The Classical Hollywood Reader* (2012); co-editor (with Frank Krutnik, Brian Neve and Peter Stanfield) of *'Un-American' Holly-wood: Politics and Film in the Blacklist Era* (2007); co-editor (with John Belton and Sheldon Hall) of *Widescreen Worldwide* (2010); and editor of *Silent Features* (forthcoming).

TOM RYALL is Emeritus Professor of Film History at Sheffield Hallam University. He is the author of *Anthony Asquith* (2005), *Britain and the American Cinema* (2001) and *Alfred Hitchcock and the British Cinema* (1996). He has contributed various articles on British and American cinema to collections such as *The Routledge Companion to British Media History* (2015), *Modern British Drama on Screen* (2013), *A Companion to Film Noir* (2013), *Film Noir: The Directors* (2012), *A Companion to Hitchcock Studies* (2011), *The British Cinema Book* (2009), *The Cinema of Britain and Ireland* (2005) and *The Oxford Guide to Film Studies* (1998).

JESSE SCHLOTTERBECK received his PhD in Film Studies from the University of Iowa and is currently Assistant Professor of Cinema at Denison University. His research focuses on American film genres, particularly the musical, the biopic and film noir. His recent publications include 'Masculinity, Race, and the Blues in the Bizpic *Cadillac Records*', in *Anxiety Muted: American Film Music in a Suburban Age* (2014); '*I'm Not*

There: Transcendent Thanatography', in *The Biopic in Contemporary Film Culture* (2013) and 'Radio Noir in the USA', in *A Companion to Film Noir* (2013). Jesse's essays appear in the *Journal of Popular Film and Television*, *M/C – A Journal of Media and Culture* and *Other Modernities*.

TONY WILLIAMS is Professor and Area Head of Film Studies in the Department of English, Southern Illinois University at Carbondale. He has recently published the second editions of his *Hearths of Darkness: The Family in the Modern Horror Film* (2014); *Larry Cohen: The Radical Allegories of an Independent Filmmaker* (2014); and *The Cinema of George A. Romero: Knight of the Living Dead* (2015). He is currently co-editing with Esther Yau an anthology, *Hong Kong Neo-Noir*, for Edinburgh University Press, and he has edited a collection of essays on Evans Chan for Hong Kong University Press. As well as seeing the second edition of his co-edited *Vietnam War Films* (2011) in print, he has completed a sabbatical project on the writings of James Jones, author of *From Here to Eternity*.

ELLEN WRIGHT is the Vice Chancellor's 2020 Lecturer in Cinema and Television History at De Montfort University, Leicester. Ellen recently obtained her PhD at the University of East Anglia with a thesis entitled 'Female Sexuality, Taste and Respectability: An Analysis of Transatlantic Media Discourse Surrounding Hollywood Glamour and Film Star Pin-ups during World War II'. She is also the author of 'Glamorous Bait for an Amorous Killer! How Audiences Were *Lured* by Lucille and the Working-Girl Investigator', in *Frames Cinema Journal* (2013).

Filmography

Between 1917 and 1923, Howard Hawks worked in various capacities on a number of film productions, although it is difficult to ascertain precise details about this early stage of his career in the absence of screen credits or documentary sources. His first substantive credits began to appear in 1923.

Silent Period

Quicksands (1923)
Director: Jack Conway
Screenplay: Howard Hawks, from an original story by Howard Hawks
Production Company: Agfar Corp. for American Releasing Corp.
Producer: Howard Hawks
Cinematography: Harold Rosson, Glen MacWilliams
Cast: Helene Chadwick, Richard Dix, Alan Hale, Noah Beery Jr, Farrell MacDonald, George Cooper
Running time: 6–7 reels
Black & white

Tiger Love (1924)
Director: George Melford
Screenplay: Howard Hawks
Production Company: Famous Players-Lasky/Paramount
Producer: Adolph Zukor, Jesse L. Lasky
Cinematography: Charles G. Clarke
Cast: Antonio Moreno, Estelle Taylor, G. Raymond Nye, Manuel Camero, Edgar Norton, David Torrence
Running time: 6 reels
Black & white

The Dressmaker from Paris (1925)
Director: Paul Bern
Screenplay: Adelaide Heilbron, from an original story by Adelaide Heilbron and Howard Hawks

Production Company: Famous Players-Lasky/Paramount
Producer: Adolph Zukor, Jesse L. Lasky
Cast: Leatrice Joy, Ernest Torrence, Allan Forrest, Mildred Harris, Lawrence Gray, Charles Crockett
Running time: 8 reels
Black & white

The Road to Glory (1926)
Director: Howard Hawks
Screenplay: L. G. Rigby, from an original story by Howard Hawks
Production Company: Fox Film Corp.
Producer: William Fox
Cinematography: Joseph August
Cast: May McAvoy, Leslie Fenton, Ford Sterling, Rockliffe Fellowes, Milla Davenport, John MacSweeney
Running time: 6 reels
Black & white

Honesty – the Best Policy (1926)
Director: Chester Bennett
Screenplay: L. G. Rigby, from an original story by Howard Hawks
Production Company: Fox Film Corp.
Producer: William Fox
Cinematography: Ernest G. Palmer
Cast: Rockliffe Fellowes, Pauline Starke, Johnnie Walker, Grace Darmond, Mickey Bennett, Mack Swain
Running time: 5 reels
Black & white

Fig Leaves (1926)
Director: Howard Hawks
Screenplay: Hope Loring, Louis D. Lighton, from an original story by Howard Hawks
Production Company: Fox Film Corp.
Producer: William Fox
Production design: William S. Darling, William Cameron Menzies
Costumes: Adrian
Cinematography: Joseph H. August
Editing: Rose Smith
Cast: George O'Brien, Olive Borden, Phyllis Haver, André de Beranger, William Austin, Heinie Conklin
Running time: 7 reels
Black & white with colour sequences

The Cradle Snatchers (1927)
Director: Howard Hawks
Screenplay: Sarah Y. Mason
Production Company: Fox Film Corp.
Producer: William Fox
Production design: William S. Darling
Cinematography: L. William O'Connell
Editing: Ralph Dixon
Cast: Louise Fazenda, J. Farrell MacDonald, Ethel Wales, Franklin Pangborn,
Dorothy Phillips, William Davidson
Running time: 59 minutes
Black & white

Paid to Love (1927)
Director: Howard Hawks
Screenplay: William M. Conselman, Seton I. Miller
Production Company: Fox Film Corp.
Producer: William Fox
Production design: William S. Darling
Cinematography: L. William O'Connell
Editing: Ralph Dixon
Cast: George O'Brien, Virginia Valli, J. Farrell MacDonald, Thomas Jefferson, William
Powell, Merta Sterling
Running time: 80 minutes
Black & white

A Girl in Every Port (1928)
Director: Howard Hawks
Screenplay: Seton I. Miller, from an original story by Howard Hawks
Production Company: Fox Film Corp.
Producer: William Fox
Production design: William S. Darling
Costumes: Kathleen Dax
Cinematography: L. William O'Connell, Rudolph Berquist
Editing: Ralph Dixon
Cast: Victor McLaglen, Robert Armstrong, Louise Brooks, Myrna Loy, Maria
Casajuana, Gladys Brockwell
Running time: 64 minutes
Black & white

Fazil (1928)
Director: Howard Hawks
Screenplay: Seton I. Miller

Production Company: Fox Film Corp.
Producer: William Fox
Cinematography: L. William O'Connell
Editing: Ralph Dixon
Cast: Charles Farrell, Greta Nissen, Mae Busch, Vadim Uraneff, Tyler Brooke, Eddie Sturgis
Running time: 75 minutes
Black & white

The Air Circus (1928)
Director: Howard Hawks
Screenplay: Seton I. Miller, Norman Z. McLeod
Production Company: Fox Film Corp.
Producer: William Fox
Cinematography: Dan Clark
Editing: Ralph Dixon
Cast: Louise Dresser, Sue Carol, David Rollins, Arthur Lake, Charles Delaney, Heinie Conklin
Running time: 88 minutes
Black & white

Trent's Last Case (1929)
Director: Howard Hawks
Screenplay: Scott Darling
Production Company: Fox Film Corp.
Producer: William Fox
Cinematography: Harold Rosson
Cast: Donald Crisp, Raymond Griffith, Raymond Hatton, Marceline Day, Lawrence Gray, Nicholas Soussanin
Running time: 66 minutes
Black & white

Sound Period

The Dawn Patrol (1930)
Director: Howard Hawks
Screenplay: Howard Hawks, Dan Totheroh, Seton I. Miller
Production Company: First National Pictures for Warner Bros.
Producer: Robert North
Production design: Jack Okey
Cinematography: Ernest Haller
Music: Leo F. Forbstein

Editing: Ray Curtiss
Cast: Richard Barthelmess, Douglas Fairbanks Jr, Neil Hamilton, William Janney, James Finlayson, Clyde Cook
Running time: 95 minutes
Black & white

The Criminal Code (1931)
Director: Howard Hawks
Screenplay: Seton I. Miller, Fred Niblo Jr
Production Company: Columbia Pictures Corp.
Producer: Harry Cohn
Production design: Edward Jewell
Cinematography: James Wong Howe, Ted Tetzlaff
Editing: Edward Curtiss
Cast: Walter Huston, Phillips Holmes, Constance Cummings, Boris Karloff, DeWitt Jennings, Mary Doran
Running time: 97 minutes
Black & white

Scarface (1932)
Director: Howard Hawks
Screenplay: Ben Hecht
Production Company: Caddo Company for United Artists Corp.
Producer: Howard Hughes
Production design: Harry Oliver
Cinematography: Lee Garmes, L. W. O'Connell
Music: Adolph Tandler, Gus Arnheim
Editing: Edward Curtiss
Cast: Paul Muni, Ann Dvorak, Karen Morley, Osgood Perkins, C. Henry Gordon, George Raft
Running time: 90 minutes
Black & white

The Crowd Roars (1932)
Director: Howard Hawks
Screenplay: Kubec Glasmon, John Bright, Seton I. Miller, Niven Busch, from an original story by Howard Hawks
Production Company: First National Pictures-Vitaphone for Warner Bros.
Producer: Bryan Foy
Production design: Jack Okey
Cinematography: Sid Hickox
Music: Leo F. Forbstein
Editing: John Stumar, Thomas Pratt

Cast: James Cagney, Joan Blondell, Ann Dvorak, Eric Linden, Guy Kibbee, Frank McHugh
Running time: 85 minutes
Black & white

Tiger Shark (1932)
Director: Howard Hawks
Screenplay: Wells Root
Production Company: First National Pictures-Vitaphone for Warner Bros.
Producer: Bryan Foy
Production design: Jack Okey
Costumes: Orry-Kelly
Cinematography: Tony Gaudio
Music: Leo F. Forbstein
Editing: Thomas Pratt
Cast: Edward G. Robinson, Richard Arlen, Zita Johann, Leila Bennett, Vince Barnett, J. Carroll Naish
Running time: 80 minutes
Black & white

The Prizefighter and the Lady (1933)
Director: W. S. Van Dyke (and Howard Hawks, uncredited)
Screenplay: John Lee Mahin, John Meehan, Frances Marion
Production Company: Metro-Goldwyn-Mayer
Producer: W. S. Van Dyke
Production design: Fredric Hope, David Townsend
Costumes: Dolly Tree
Cinematography: Lester White
Editing: Robert J. Kern
Cast: Myrna Loy, Max Baer, Primo Carnera, Jack Dempsey, Walter Huston, Otto Kruger
Running time: 102 minutes
Black & white

Today We Live (1933)
Director: Howard Hawks
Screenplay: Edith Fitzgerald, Dwight Taylor, William Faulkner
Production Company: Metro-Goldwyn-Mayer
Producer: Howard Hawks
Production design: Cedric Gibbons
Costumes: Adrian
Cinematography: Oliver T. Marsh
Editing: Edward Curtiss

Cast: Joan Crawford, Gary Cooper, Robert Young, Franchot Tone, Roscoe Karns, Louise Closser Hale
Running time: 110 minutes
Black & white

Viva Villa! (1934)
Director: Jack Conway (and Howard Hawks, uncredited)
Screenplay: Ben Hecht
Production Company: Metro-Goldwyn-Mayer
Producer: David O. Selznick
Production design: Harry Oliver
Costumes: Dolly Tree
Cinematography: James Wong Howe, Charles G. Clarke
Music: Herbert Stothart
Editing: Robert J. Kern
Cast: Wallace Beery, Leo Carrillo, Fay Wray, Donald Cook, Stuart Erwin, Henry B. Walthall
Running time: 115 minutes
Black & white

Twentieth Century (1934)
Director: Howard Hawks
Screenplay: Ben Hecht, Charles MacArthur
Production Company: Columbia Pictures
Producer: Howard Hawks
Cinematography: Joseph August
Editing: Gene Havlick
Cast: John Barrymore, Carole Lombard, Walter Connolly, Roscoe Karns, Ralph Forbes, Charles Levison
Running time: 91 minutes
Black & white

Barbary Coast (1935)
Director: Howard Hawks
Screenplay: Ben Hecht, Charles MacArthur
Production Company: Samuel Goldwyn Productions for United Artists
Producer: Samuel Goldwyn
Production design: Richard Day
Costumes: Omar Kiam
Cinematography: Ray June
Music: Alfred Newman
Editing: Edward Curtiss

Cast: Miriam Hopkins, Edward G. Robinson, Joel McCrea, Walter Brennan, Frank Craven, Brian Donlevy
Running time: 90 minutes
Black & white

Ceiling Zero (1936)
Director: Howard Hawks
Screenplay: Frank Wead
Production Company: Cosmopolitan Productions for Warner Bros.
Producer: Harry Joe Brown
Production design: John Hughes
Costumes: B. W. King, Mary Dearry
Cinematography: Arthur Edeson
Music: Leo F. Forbstein
Editing: William Holmes
Cast: James Cagney, Pat O'Brien, June Travis, Stuart Erwin, Barton MacLane, Henry Wadsworth
Running time: 95 minutes
Black & white

The Road to Glory (1936)
Director: Howard Hawks
Screenplay: Joel Sayre, William Faulkner
Production Company: Twentieth Century-Fox
Producer: Darryl F. Zanuck
Production design: Hans Peters
Costumes: Gwen Wakeling
Cinematography: Gregg Toland
Music: Louis Silvers
Editing: Edward Curtiss
Cast: Fredric March, Warner Baxter, Lionel Barrymore, June Lang, Gregory Ratoff, Victor Kilian
Running time: 103 minutes
Black & white

Come and Get It (1936)
Director: Howard Hawks, William Wyler
Screenplay: Jane Murfin, Jules Furthman
Production Company: Samuel Goldwyn Productions and Howard Productions for United Artists
Producer: Samuel Goldwyn
Production design: Richard Day
Costumes: Omar Kiam

Cinematography: Gregg Toland, Rudolph Maté
Music: Alfred Newman
Editing: Edward Curtiss
Cast: Edward Arnold, Joel McCrea, Frances Farmer, Walter Brennan, Andrea Leeds,
Frank Shields
Running time: 99 minutes
Black & white

Bringing Up Baby (1938)
Director: Howard Hawks
Screenplay: Dudley Nichols, Hagar Wilde
Production Company: RKO Radio Pictures
Producer: Howard Hawks
Production design: Van Nest Polglase
Costumes: Howard Greer
Cinematography: Russell Metty
Music: Roy Webb
Editing: George Hively
Cast: Cary Grant, Katharine Hepburn, Charles Ruggles, Walter Catlett, Barry
Fitzgerald, May Robson
Running time: 102 minutes
Black & white

Only Angels Have Wings (1939)
Director: Howard Hawks
Screenplay: Jules Furthman (from an original story by Howard Hawks, uncredited)
Production Company: Columbia Pictures
Producer: Howard Hawks
Production design: Lionel Banks
Costumes: Robert M. Kalloch
Cinematography: Joseph Walker
Music: Dimitri Tiomkin
Editing: Viola Lawrence
Cast: Cary Grant, Jean Arthur, Richard Barthelmess, Rita Hayworth, Thomas
Mitchell, Allyn Joslyn
Running time: 121 minutes
Black & white

His Girl Friday (1940)
Director: Howard Hawks
Screenplay: Charles Lederer
Production Company: Columbia Pictures
Producer: Howard Hawks

Production design: Lionel Banks
Costumes: Robert M. Kalloch
Cinematography: Joseph Walker
Music: M. W. Stoloff
Editing: Gene Havlick
Cast: Cary Grant, Rosalind Russell, Ralph Bellamy, Gene Lockhart, Porter Hall, Ernest Truex
Running time: 92 minutes
Black & white

Sergeant York (1941)
Director: Howard Hawks
Screenplay: Abem Finkel, Harry Chandlee, Howard Koch, John Huston
Production Company: Warner Bros.
Producer: Jesse L. Lasky, Hal B. Wallis
Production design: John Hughes
Costumes: Smoke Kring
Cinematography: Sol Polito, Arthur Edeson
Music: Max Steiner
Editing: William Holmes
Cast: Gary Cooper, Walter Brennan, Joan Leslie, George Tobias, Stanley Ridges, Margaret Wycherly
Running time: 134 minutes
Black & white

Ball of Fire (1942)
Director: Howard Hawks
Screenplay: Charles Brackett, Billy Wilder
Production Company: Samuel Goldwyn Productions for RKO Radio Pictures
Producer: Samuel Goldwyn
Production design: Perry Ferguson
Costumes: Edith Head
Cinematography: Gregg Toland
Music: Alfred Newman
Editing: Daniel Mandell
Cast: Gary Cooper, Barbara Stanwyck, Oscar Homolka, Dana Andrews, Dan Duryea, Henry Travers
Running time: 111 minutes
Black & white

The Outlaw (1943)
Director: Howard Hughes (and Howard Hawks, uncredited)
Screenplay: Jules Furthman

Production Company: Howard Hughes Productions for United Artists
Producer: Howard Hughes
Cinematography: Gregg Toland
Music: Victor Young
Editing: Wallace Grissell
Cast: Jack Buetel, Jane Russell, Thomas Mitchell, Walter Huston, Mimi Aguglia, Joe Sawyer
Running time: 121 minutes
Black & white

Air Force (1943)
Director: Howard Hawks
Screenplay: Dudley Nichols, William Faulkner
Production Company: Warner Bros.
Producer: Hal B. Wallis
Production design: John Hughes
Costumes: Milo Anderson
Cinematography: James Wong Howe
Music: Franz Waxman
Editing: George Amy
Cast: John Ridgely, Gig Young, Arthur Kennedy, Charles Drake, Harry Carey, George Tobias
Running time: 124 minutes
Black & white

Corvette K-225 (1943)
Director: Richard Rosson (and Howard Hawks, uncredited)
Screenplay: Lt John Rhodes Sturdy
Production Company: Universal Pictures
Producer: Howard Hawks
Production design: John B. Goodman, Robert Boyle
Cinematography: Tony Gaudio, Harry F. Perry, Bert A. Eason
Music: David Buttolph
Editing: Edward Curtiss
Cast: Randolph Scott, James Brown, Ella Raines, Barry Fitzgerald, Andy Devine, Fuzzy Knight
Running time: 99 minutes
Black & white

To Have and Have Not (1944)
Director: Howard Hawks
Screenplay: Jules Furthman, William Faulkner
Production Company: Warner Bros.

Producer: Howard Hawks
Production design: Charles Novi
Costumes: Milo Anderson
Cinematography: Sid Hickox
Music: Leo F. Forbstein
Editing: Christian Nyby
Cast: Humphrey Bogart, Walter Brennan, Lauren Bacall, Dolores Moran, Hoagy Carmichael, Walter Molnar
Running time: 101 minutes
Black & white

The Big Sleep (1946)
Director: Howard Hawks
Screenplay:William Faulkner, Leigh Brackett, Jules Furthman
Production Company: Warner Bros.
Producer: Howard Hawks
Production design: Carl Jules Weyl
Costumes: Leah Rhodes
Cinematography: Sid Hickox
Music: Max Steiner
Editing: Christian Nyby
Cast: Humphrey Bogart, Lauren Bacall, John Ridgely, Martha Vickers, Dorothy Malone, Peggy Knudsen
Running time: 113 minutes
Black & white

Red River (1948)
Director: Howard Hawks
Screenplay: Borden Chase, Charles Schnee
Production Company: Monterey Productions for United Artists
Producer: Howard Hawks
Production design: John Datu Arensma
Cinematography: Russell Harlan
Music: Dimitri Tiomkin
Editing: Christian Nyby
Cast: John Wayne, Montgomery Clift, Joanne Dru, Walter Brennan, Coleen Gray, Harry Carey, Sr
Running time: 126 minutes
Black & white

A Song Is Born (1948)
Director: Howard Hawks
Screenplay: No screen credit (Charles Brackett and Billy Wilder, uncredited)
Production Company: Samuel Goldwyn Productions for RKO Radio Pictures
Producer: Samuel Goldwyn
Production design: George Jenkins, Perry Ferguson
Costumes: Irene Sharaff
Cinematography: Gregg Toland
Music: Emil Newman, Hugo Friedhofer
Editing: Daniel Mandell
Cast: Danny Kaye, Virginia Mayo, Benny Goodman, Tommy Dorsey, Louis Armstrong, Lionel Hampton
Running time: 113 minutes
Colour

I Was a Male War Bride (1949)
Director: Howard Hawks
Screenplay: Charles Lederer, Leonard Spigelgass, Hagar Wilde
Production Company: Twentieth Century-Fox
Producer: Sol C. Siegel
Production design: Lyle Wheeler, Albert Hogsett
Cinematography: Norbert Brodine, O. H. Borradaile
Music: Cyril Mockridge
Editing: James B. Clark
Cast: Cary Grant, Ann Sheridan, Marion Marshall, Randy Stuart, William Neff, Eugene Gericke
Running time: 105 minutes
Black & white

The Thing from Another World (1951)
Director: Christian Nyby (and Howard Hawks, uncredited)
Screenplay: Charles Lederer
Production Company: Winchester Pictures Corp. for RKO Radio Pictures
Producer: Howard Hawks
Production design: Albert S. D'Agostino, John J. Hughes
Costumes: Michael Woulfe
Cinematography: Russell Harlan
Music: Dimitri Tiomkin
Editing: Roland Cross
Cast: Margaret Sheridan, Kenneth Tobey, Robert Cornthwaite, Douglas Spencer, James Young, Dewey Martin
Running time: 89 minutes
Black & white

The Big Sky (1952)
Director: Howard Hawks
Screenplay: Dudley Nichols
Production Company: Winchester Pictures for RKO Radio Pictures
Producer: Howard Hawks
Production design: Albert S. D'Agostino, Perry Ferguson
Costumes: Dorothy Jeakins
Cinematography: Russell Harlan
Music: Dimitri Tiomkin
Editing: Christian Nyby
Cast: Kirk Douglas, Dewey Martin, Elizabeth Threatt, Arthur Hunnicutt, Buddy Baer, Steven Geray
Running time: 122 minutes
Black & white

Monkey Business (1952)
Director: Howard Hawks
Screenplay: Ben Hecht, I. A. L. Diamond, Charles Lederer
Production Company: Twentieth Century-Fox
Producer: Sol C. Siegel
Production design: Lyle Wheeler, George Patrick
Costumes: Charles LeMaire, Travilla
Cinematography: Milton Krasner
Music: Leigh Harline, Lionel Newman
Editing: William B. Murphy
Cast: Cary Grant, Ginger Rogers, Charles Coburn, Marilyn Monroe, Hugh Marlowe, Henri Letondal
Running time: 97 minutes
Black & white

The Ransom of Red Chief (1952)
(The fourth episode in the five-part portmanteau film *O'Henry's Full House*, with the other episodes directed by Henry Koster, Henry Hathaway, Jean Negulesco and Henry King.)
Director: Howard Hawks
Screenplay: Nunnally Johnson
Production Company: Twentieth Century-Fox
Producer: André Hakim
Production design: Chester Gore
Cinematography: Milton Krasner
Music: Alfred Newman
Editing: William B. Murphy

Cast: Fred Allen, Oscar Levant, Lee Aaker, Kathleen Freeman, Irving Bacon, Alfred Mizner
Running time: 27 minutes

Gentlemen Prefer Blondes (1953)
Director: Howard Hawks
Screenplay: Charles Lederer
Production Company: Twentieth Century-Fox
Producer: Sol C. Siegel
Production design: Lyle Wheeler, Hugh S. Fowler
Costumes: Charles LeMaire, Travilla
Cinematography: Harry J. Wild
Music: Lionel Newman
Editing: Hugh S. Fowler
Cast: Jane Russell, Marilyn Monroe, Charles Coburn, Elliott Reid, Tommy Noonan, George Winslow
Running time: 91 minutes
Colour

Land of the Pharaohs (1955)
Director: Howard Hawks
Screenplay: William Faulkner, Harry Kurnitz, Harold Jack Bloom
Production Company: Continental Company for Warner Bros.
Producer: Howard Hawks
Production design: Alexandre Trauner
Costumes: Mayo
Cinematography: Lee Garmes, Russell Harlan
Music: Dimitri Tiomkin
Editing: Rudi Fehr, Vladimir Sagovsky
Cast: Jack Hawkins, Joan Collins, Dewey Martin, Alexis Minotis, James Robertson Justice, Luisa Boni
Running time: 106 minutes
Colour

Rio Bravo (1959)
Director: Howard Hawks
Screenplay: Jules Furthman, Leigh Brackett
Production Company: Armada Productions for Warner Bros.
Producer: Howard Hawks
Production design: Leo K. Kuter
Costumes: Marjorie Best
Cinematography: Russell Harlan
Music: Dimitri Tiomkin

Editing: Folmar Blangsted
Cast: John Wayne, Dean Martin, Ricky Nelson, Angie Dickinson, Walter Brennan, Ward Bond
Running time: 141 minutes
Colour

Hatari! (1962)
Director: Howard Hawks
Screenplay: Leigh Brackett
Production Company: Malabar Productions for Paramount
Producer: Howard Hawks
Production design: Hal Pereira, Carl Anderson
Costumes: Edith Head, Frank Beeston Jr
Cinematography: Russell Harlan
Music: Henry Mancini
Editing: Stuart Gilmore
Cast: John Wayne, Hardy Kruger, Elsa Martinelli, Red Buttons, Gérard Blain, Michèle Girardon
Running time: 159 minutes
Colour

Man's Favorite Sport? (1964)
Director: Howard Hawks
Screenplay: John Fenton Murray, Steven McNeil
Production Company: Gibraltar-Laurel Productions for Universal
Producer: Howard Hawks
Production design: Alexander Golitzen, Tambi Larsen
Costumes: Edith Head, Pete Saldutti
Cinematography: Russell Harlan
Music: Henry Mancini
Editing: Stuart Gilmore
Cast: Rock Hudson, Paula Prentiss, Maria Perschy, John McGiver, Charlene Holt, Roscoe Karns
Running time: 120 minutes
Colour

Red Line 7000 (1965)
Director: Howard Hawks
Screenplay: George Kirgo
Production Company: Laurel Productions for Paramount
Producer: Howard Hawks
Production design: Hal Pereira, Arthur Lonergan
Costumes: Edith Head

Cinematography: Milton Krasner
Music: Nelson Riddle
Editing: Stuart Gilmore, Bill Brame
Cast: James Caan, Laura Devon, Gail Hire, Charlene Holt, John Robert Crawford, Marianna Hill
Running time: 110 minutes
Colour

El Dorado (1967)
Director: Howard Hawks
Screenplay: Leigh Brackett
Production Company: Laurel Productions for Paramount
Producer: Howard Hawks
Production design: Hal Pereira, Carl Anderson
Costumes: Edith Head
Cinematography: Harold Rosson
Music: Nelson Riddle
Editing: John Woodcock
Cast: John Wayne, Robert Mitchum, James Caan, Charlene Holt, Arthur Hunnicutt, Michele Carey
Running time: 126 minutes
Colour

Rio Lobo (1970)
Director: Howard Hawks
Screenplay: Burton Wohl, Leigh Brackett
Production Company: Malabar Productions for National General Pictures
Producer: Howard Hawks
Production design: Robert Smith
Costumes: Leah Rhodes, Ted Parvin
Cinematography: William Clothier
Music: Jerry Goldsmith
Editing: John Woodcock
Cast: John Wayne, Jorge Rivero, Jennifer O'Neill, Jack Elam, Chris Mitchum, Victor French
Running time: 114 minutes
Colour

Documentaries about Howard Hawks

The Great Professional: Howard Hawks (1967)
BBC-TV
Director: Nicholas Garnham, Peter Bogdanovich
Producer: Barrie Gavin
Editor: Robert K. Lambert
Running time: 60 minutes
First broadcast: 10 July 1967

Plimpton! Shoot-Out at Rio Lobo (1970)
David L. Wolper Productions for ABC-TV
Director: William Kronick
Producer: William Kronick
Editor: Howard Billingham
Running time: 52 minutes
First broadcast: 9 December 1970

The Men Who Made the Movies: Howard Hawks (1973)
WNET/13 for PBS
Director: Richard Schickel
Producer: Richard Schickel
Editor: Geof Bartz
Running time: 58 minutes
First broadcast: 18 November 1973

Howard Hawks: American Artist (1997)
BFI/BBC
Director: Kevin Macdonald
Producer: Paula Jalfon
Editor: Cliff West
Running time: 55 minutes
First broadcast: 1 March 1997

Bibliography

Agee, James, 'Films', *The Nation* (8 June 1946).

——, 'Films', *The Nation* (31 August 1946).

Alloway, Lawrence, *Violent America: The Movies, 1946–1964* (New York: Museum of Modern Art, 1971).

Ameripoor, Alex and Donald C. Willis, 'Howard Hawks: An Interview', in Willis, *The Films of Howard Hawks*, pp. 196–209.

Anderson, Michael J., '*Hatari!* and the Hollywood Safari Picture', *Senses of Cinema* no. 52 (2009): http://sensesofcinema.com/2009/feature-articles/hatari-and-the-hollywood-safari-picture/.

Arbuthnot, Lucie and Gail Seneca, 'Pre-Text and Text in *Gentlemen Prefer Blondes*', in Steven Cohan (ed.), *Hollywood Musicals: The Film Reader* (London: Routledge, 2002), pp. 77–85.

Arnold, David, 'My Rifle, My Pony, and Feathers: Music and the Making of Men in Howard Hawks' [sic] *Rio Bravo*', *Quarterly Review of Film and Video* vol. 23 no. 3 (2006), pp. 267–9.

Auriol, Jean-George, '*A Girl in Every Port*', *La Revue du cinéma* (December 1928), trans. John Moore, repr. in Hillier and Wollen, *American Artist*, pp. 13–14

Bacall, Lauren, *By Myself* (London: Jonathan Cape, 1979).

Baltzell, E. Digby, *The Protestant Establishment: Aristocracy & Caste in America* (New York: Random House, 1964).

Barr, Charles, 'CinemaScope: Before and After', *Film Quarterly* vol. 16 no. 4 (Summer 1963), pp. 4–24.

Basinger, Jeanine, *The World War II Combat Film: Anatomy of a Genre* (New York: Columbia University Press, 1986).

Bazin, André, 'The Western: Or the American Film Par Excellence', in *What Is Cinema? Vol. II*, trans. Hugh Gray (Berkeley: University of California Press, 1971), pp. 140–8.

——, 'The Evolution of the Western' in *What Is Cinema? Vol. II*, pp. 149–57.

——, 'How Could You Possibly Be a Hitchcocko-Hawksian?', trans. John Moore, *Cahiers du cinéma* no. 44 (February 1955), repr. in Hillier and Wollen, *American Artist*, pp. 32–4.

Becker, Jacques, Jacques Rivette and François Truffaut, 'Howard Hawks Interview', trans. Andrew Sarris, *Cahiers du cinéma* (February 1956), repr. in Breivold, *Howard Hawks: Interviews*, pp. 3–15.

'Behind the Photograph: Hairston and Tiomkin' (May 2014), in Dimitri Tiomkin: The Official

Website: http://www.dimitritiomkin.com/5984/may-2014-behind-the-photograph-hairston
-and-tiomkin/.

Belton, John, 'Howard Hawks', in *The Hollywood Professionals Vol. 3: Howard Hawks, Frank Borzage, Edgar G. Ulmer* (London: Tantivy Press, 1974), pp. 9–73.

——, 'Hawks and Co.', *Cinema* no. 9 (1971), repr. (rev. version) in McBride, *Focus on Howard Hawks*, pp. 94–108.

——, *Widescreen Cinema* (Cambridge, MA: Harvard University Press, 1992).

——, Sheldon Hall and Steve Neale (eds), *Widescreen Worldwide* (Bloomington: Indiana University Press, 2010).

Berg, A. Scott, *Goldwyn: A Biography* (New York: Alfred A. Knopf, 1989).

Biesen, Sheri Chinen, *Blackout: World War II and the Origins of Film Noir* (Baltimore, MD: Johns Hopkins University Press, 2005).

Bingham, Dennis, *Whose Lives Are They Anyway? The Biopic as Contemporary Film Genre* (New Brunswick, NJ: Rutgers University Press, 2010).

Birdwell, Michael E., *Celluloid Soldiers: The Warner Brothers' Campaign against Nazism* (New York: New York University Press, 1999).

Biskind, Peter, 'The Man Who Minted Style', *Vanity Fair* (April 2003), pp. 100–11.

Block, Bruce, *The Visual Story: Seeing the Structure of Film, TV and New Media* (Boston, MA: Focal Press, 2001).

Bogdanovich, Peter, *The Cinema of Howard Hawks* (New York: Museum of Modern Art, 1962).

——, 'Interview with Howard Hawks', in Hillier and Wollen, *American Artist*, pp. 50–67.

——, 'Howard Hawks: Ride, Boldly Ride', in *Who the Devil Made It?*, pp. 244–56.

——, 'Howard Hawks: The Rules of the Game', in *Who the Devil Made It?*, pp. 256–378.

——, 'Leo McCarey: The Ineluctability of Incidents', in *Who the Devil Made It?*, pp. 383–436.

——, *Who the Devil Made It? Conversations with Legendary Film Directors* (New York: Ballantine, 1997).

Bordwell, David, *Narration in the Fiction Film* (Madison: University of Wisconsin Press, 1985).

——, *Poetics of Cinema* (New York: Routledge, 2008).

——, *The Way Hollywood Tells It: Story and Style in Modern Movies* (Berkeley: University of California Press, 2006).

——, 'Widescreen Aesthetics and *Mise en Scène* Criticism', *Velvet Light Trap* no. 21 (Summer 1985), pp. 18–25.

——, Janet Staiger and Kristin Thompson, *The Classical Hollywood Cinema: Film Style and Mode of Production to 1960* (New York: Columbia University Press, 1985).

Boxwell, David, 'Howard Hawks', *Senses of Cinema* no. 20 (2002): http://sensesofcinema.com/2002/great-directors/hawks/.

Brackett, Leigh, 'A Comment on "The Hawksian Woman"', *Take One* vol. 3 no. 8 (July/ August 1971), repr. in Hillier and Wollen, *American Artist*, pp. 120–2.

——, 'Working with Hawks', *Take One* vol. 3 no. 6 (October 1972), repr. in Karen Kay and Gerald Peary (eds), *Women and the Cinema: A Critical Anthology* (New York: Dutton, 1977), pp. 193–8.

Brantley, Robin, 'What Makes a Star? – Howard Hawks Knew Best of All', *New York Times* (22 January 1978), D11, p. 19.

Breivold, Scott (ed.), *Howard Hawks: Interviews* (Jackson: University of Mississippi Press, 2006).

Bron, '*The Blue Dahlia*', *Variety* (30 January 1946), p. 10.

Brookes, Ian, '"A Rebus of Democratic Slants and Angles": *To Have and Have Not*, Racial Representation, and Musical Performance in a Democracy at War', in Graham Lock and David Murray (eds), *Thriving on a Riff: Jazz and Blues Influences in African American Literature and Film* (New York: Oxford University Press, 2009), pp. 203–20.

Burwell, '*True Grit*: Carter Burwell's Notes', http://www.carterburwell.com/projects/ True_Grit.html.

Buszek, Maria Elena, *Pin-Up Grrrls: Feminism, Sexuality, Popular Culture* (Durham, NC: Duke University Press, 2006).

——, 'Representing "Awarishness": Burlesque, Feminist Transgression, and the 19th-Century Pin-Up', *Drama Review* vol. 43 no. 4 (Winter 1999), pp. 141–62.

Cahiers du cinéma no. 139 (January 1963), 'Howard Hawks' issue.

'Cal York's The Monthly Broadcast from Hollywood', *Photoplay* (August 1932), p. 111.

Caps, John, *Henry Mancini: Reinventing Film Music* (Urbana: University of Illinois Press, 2012).

Carpenter Wilde, Meta and Orin Borsten, *A Loving Gentleman: The Love Story of William Faulkner and Meta Carpenter* (New York: Simon and Schuster, 1976), p. 49.

Cavell, Stanley, *Pursuits of Happiness: The Hollywood Comedy of Remarriage* (Cambridge, MA: Harvard University Press, 1981).

Chopra-Gant, Mike, *Hollywood Genres and Postwar America: Masculinity, Family and Nation in Popular Movies and Film Noir* (New York: I. B Tauris, 2006).

Cochrane, Kira, 'Jane Russell: Mean! Moody! Misunderstood!', *Guardian* (1 March 2011): http://www.theguardian.com/film/2011/mar/01/jane-russell-outlaw-gentlemen.

Coe, Richard L., 'Hot Licks Lads Pine for a Plot', *Washington Post* (26 November 1948), p. 15.

Cohen, Harvey, G. *Duke Ellington's America* (Chicago, IL: University of Chicago Press, 2010).

Cohen, Mitchell, 'Hawks in the 30s', *Take One* vol. 4 no. 12 (1975), pp. 9–13.

Combs, Richard, 'The Choirmaster and the Slavedriver: Howard Hawks and *Land of the Pharaohs*', *Film Comment* vol. 33 no. 4 (July/August 1997), pp. 42–9.

Corkin, Stanley, 'Cowboys and Free Markets: Post-World War II Westerns and U.S. Hegemony', *Cinema Journal* vol. 39 no. 3 (2000), pp. 66–91.

——, *Cowboys as Cold Warriors: The Western and U.S. History* (Philadelphia, PA: Temple University Press, 2004).

Corn, Joseph J., *The Winged Gospel: America's Romance with Aviation, 1900–1950* (New York: Oxford University Press, 1983).

Cossar, Harper, *Letterboxed: The Evolution of Widescreen Cinema* (Lexington: University of Kentucky Press, 2010).

——, 'Ray, Widescreen and Genre: The True Story of Jesse James', in Steve Rybin and Will Scheibel (eds), *Lonely Places, Dangerous Ground: Nicholas Ray in American Cinema* (Albany: State University of New York Press, 2014), pp. 189–209.

Coyne, Michael, *The Crowded Prairie: American National Identity in the Hollywood Western* (London: I. B. Tauris, 1997).

Craven, Wayne, *Colonial American Portraiture: The Economic, Religious, Social, Cultural, Philosophical, Scientific, and Aesthetic Foundations* (Cambridge, MA: Harvard University Press, 1986).

Creekmur, Corey, 'The Cowboy Chorus: Narrative and Cultural Functions of the Western Title Song', in Kalinak, *Music in the Western*, pp. 21–36.

Crichton, Kyle, 'The Flying Hawks', *Collier's* (16 January 1943), pp. 36–7, 53.

Crowther, Bosley, 'Movie Review: "Ball of Fire" a Delightful Comedy, With Gary Cooper and Barbara Stanwyck in Lead Roles, Opens at Music Hall', *New York Times* (16 January 1942), p. 25.

——, 'The Screen in Review: "Blue Dahlia", of Paramount, With Alan Ladd and Veronica Lake in the Leading Roles, Proves an Exciting Picture', *New York Times* (9 May 1946), p. 27.

——, 'The Screen in Review: *Gentlemen Prefer Blondes* at Roxy, With Marilyn Monroe and Jane Russell', *New York Times* (16 July 1953), p. 20.

——, 'The Screen in Review: "Song Is Born", Study of Modern Jaaz [sic] Starring Danny Kaye, Virginia Mayo, at Astor', *New York Times* (20 October 1948), p. 37.

——, 'The Screen; "The Big Sleep", Warner Film in Which Bogart and Bacall Are Paired Again, Opens at Strand', *New York Times* (24 August 1946), p. 6.

Custen, George, *Bio/Pics: How Hollywood Constructed Public History* (New Brunswick, NJ: Rutgers University Press, 1992).

——, 'The Mechanical Life in the Age of Human Reproduction: American Biopics, 1961–1980', *Biography* vol. 23 no. 1 (Winter 2000), pp. 127–59.

Darby, William and Jack DuBois, *American Film Music* (Jefferson, NC: McFarland, 1990).

D'Arc, James V., 'Howard Hawks and the Great Paper Chase', in John Boorman and Walter Donohue (eds), *Projections 6: Film-makers on Film-making* (London: Faber & Faber, 1996), pp. 315–24.

De Lannoy, Yuna, 'Innovation and Imitation: An Analysis of the Soundscape of Akira Kurosawa's *Chambara* Westerns', in Kalinak, *Music in the Western*, pp. 117–30.

Deutelbaum, Marshall, 'Basic Principles of Anamorphic Composition', *Film History* vol. 15 no. 1 (2003), pp. 72–80.

Doty, Alexander, 'Everyone's Here for Love: Bisexuality and *Gentlemen Prefer Blondes*', in *Flaming Classics: Queering the Film Canon* (London: Routledge, 2000), pp. 131–53.

Douchet, Jean, '*Hatari!*, *Cahiers du cinéma* no. 139 (January 1963), trans. John Moore, repr. in Hillier and Wollen, *American Artist*, pp. 77–82.

Douglas, Kirk, *The Ragman's Son: An Autobiography* (New York: Simon and Schuster, 1988).

Drummond, Phillip, *High Noon* (London: BFI, 1997).

Duffy, James P., *Lindbergh vs. Roosevelt: The Rivalry That Divided America* (Washington, DC: Regnery, 2010).

Dunning, Jennifer, 'Howard Hawks, Director of Films and Developer of Stars, Dies at 81', *New York Times* (28 December 1977), p. 34.

Dyer, Peter John, 'Sling the Lamps Low', *Sight and Sound* vol. 29 no. 4 (Summer 1962), repr. in McBride, *Focus on Howard Hawks*, pp. 78–93.

Dyer, Richard, *Heavenly Bodies: Film Stars and Society* (London: BFI/Macmillan, 1986).

——, *In the Space of a Song: The Uses of Song in Film* (London: Routledge, 2012).

Ehresmann, Patrick, 'Western, Italian Style', trans. Didier Thanus: http://www.chimai.com/resources/specials/ehresmann-western.cfm?screen=special&id=3&language=en&page=all&nb_pages=10.

Eldridge, Roy with James Goodrich, 'Jim Crow Is Killing Jazz', *Negro Digest* (October 1950), pp. 44–9.

Ellington, Duke, 'The Most Essential Instrument', *Jazz Journal* vol. 18 no. 12 (December 1965) repr. in Mark Tucker (ed.), *The Duke Ellington Reader* (New York: Oxford University Press, 1993), pp. 368–71.

——, 'The Duke Steps Out', *Rhythm* (March 1931), pp. 46–50.

Emge, Charles, 'Movie Music: "Song" Muddles Through – With Recording Troubles', *Down Beat* (December 1948), p. 8.

Enticknap, Leo, *Moving Image Technology: From Zoetrope to Digital* (London: Wallflower Press, 2005).

Erenberg, Lewis A., *Swingin' the Dream: Big Band Jazz and the Rebirth of American Culture* (Chicago, IL: University of Chicago Press, 1998).

Farber, Manny, 'Crime without Passion', *New Republic* (3 June 1946), p. 806.

——, 'Howard Hawks', *Artforum* (April 1969), repr. in Robert Polito (ed.), *Farber on Film: The Complete Film Writings of Manny Farber* (New York: Library of America, 2009), pp. 653–8.

——, 'Journey into the Night', *New Republic* (23 September 1946), p. 351.

Faulkner, William, *Selected Letters of William Faulkner*, Joseph Blotner, ed. (New York: Random House, 1977).

Ferber, Edna, *Come and Get It* (Garden City, NY: Doubleday, Doran & Co, 1935).

Finkelstein, Sidney, *Jazz: A People's Music* (New York: Citadel Press, 1948).

Frank, Pat, 'The Girl Who Almost Got Away', *Cosmopolitan* (1 July 1950), pp. 49, 72–9.

Gabbard, Krin, *Jammin' at the Margins: Jazz and the American Cinema* (Chicago, IL: University of Chicago Press, 1996).

Gabor, Mark, *Pin-Up: A Modest History* (London: André Deutsch, 1972).

Gallagher, John Andrew, 'Truffaut Interview', in *Film Directors on Directing* (Westport, CT: Greenwood Press, 1989), pp. 262–8.

Gendron, Bernard, '"Moldy Figs" and Modernists: Jazz at War (1942–1946)', in Krin Gabbard (ed.), *Jazz among the Discourses* (Durham, NC: Duke University Press, 1995), pp. 31–56.

Gerblinger, Christiane, 'James Whale's Frankensteins: Re-Animating the Great War', *CineAction* nos 82/3 (2010), pp. 2–9.

Giddins, Gary, 'Benny Goodman (The Mirror of Swing)', in *Visions of Jazz: The First Century* (New York: Oxford University Press, 1998), pp. 156–62.

Gilbey, Ryan, 'Days of Gloury', *Sight and Sound* vol. 19 no. 9 (September 2009), pp. 16–21.

Gillespie, Dizzy with Al Fraser, *To Be, or Not to Bop* (1979, Minneapolis: University of Minnesota Press, 2009).

Godard, Jean-Luc (as Hans Lucas), 'Defence and Illustration of Classical Construction', trans. Tom Milne, *Cahiers du cinéma* no. 15 (September 1952), repr. in Jean Narboni and Tom

Milne (eds), *Godard on Godard: Critical Writings by Jean-Luc Godard* (London: Secker & Warburg, 1972), pp. 26–30.

Goldstein, Laurence, *The Flying Machine and Modern Literature* (Bloomington: Indiana University Press, 1986).

'Goodman Sextet Revived for Danny Kaye Film: Goodman and Hampton Revive That Torrid Sextet of Past in Picture', *Chicago Defender* (16 August 1947), p. 10.

Grant, Cary, 'Archie Leach', *Ladies' Home Journal* (Part 2: March 1963), pp. 23–42.

Grant, Jack D., '"Big Sleep" Hits BO Hard', *Hollywood Reporter* (13 August 1946), p. 3.

——, '"Blue Dahlia" Crack Drama', *Hollywood Reporter* (28 January 1946), p. 3.

Gross, Larry, 'Hawks and the Angels', *Sight and Sound* vol. 7 no. 2 (February 1997), p. 12–15.

Hammond, John with Irving Townsend, *John Hammond on Record: An Autobiography* (New York: Ridge Press, 1977).

Hampton, Lionel with James Haskins, *Hamp: An Autobiography* (New York: Amistad, 1993).

'Hampton Triumphs in Pix "A Song Is Born"', *Chicago Defender* (24 July 1948), p. 9.

Handyside, Fiona, 'Beyond Hollywood, into Europe: The Tourist Gaze in *Gentlemen Prefer Blondes* (Hawks, 1953) and *Funny Face* (Donen, 1957)', *Studies in European Cinema* vol. 1 no. 2 (2004), pp. 77–90.

Hanson, Curtis Lee, 'An Interview with Dimitri Tiomkin', in *Dimitri Tiomkin: The Man and His Music* (London: National Film Theatre, 1986).

Haralovich, Mary Beth, 'Film Advertising, the Film Industry, and the Pin-Up: The Industry's Accommodations to Social Forces in the 1940s', in Bruce A. Austin (ed.), *Current Research in Film: Audiences, Economics, and Law, Vol. I* (Norwood, NJ: Ablex, 1985), pp. 127–64.

Hartmann, Susan M., *The Home Front and Beyond: American Women in the 1940s* (Boston, MA: Twayne, 1982).

Haskell, Molly, *From Reverence to Rape: The Treatment of Women in the Movies* (Chicago, IL: University of Chicago Press, 1987).

——, 'Howard Hawks', in Richard Roud (ed.), *Cinema: A Critical Dictionary*: The Major Film-Makers, Vol. 1, From Aldrich to King (London: Secker & Warburg, 1980), pp. 473–86.

——, 'Howard Hawks: Masculine Feminine', *Film Comment* vol. 10 no. 2 (March 1974), pp. 34–9.

——, '*Man's Favorite Sport?* (Revisited)', *Village Voice* (21 January 1971), repr. (revised version) in McBride, *Focus on Howard Hawks*, pp. 135–8.

Hatch, Robert, 'Movies: The New Realism', *New Republic* (8 March 1948), p. 27.

——, 'Movies: Troubled Times', *New Republic* (26 July 1948), p. 29.

Henderson, Brian, 'The Searchers: An American Dilemma', *Film Quarterly* vol. 34 no. 2 (Winter 1980/1), pp. 9–23.

Hepburn, Katharine, *Me: Stories of My Life* (New York: Alfred A. Knopf, 1991).

Higham, Charles and Joel Greenberg, *The Celluloid Muse: Hollywood Directors Speak* (London: Angus and Robertson, 1969).

Hillier, Jim (ed.), *Cahiers du Cinéma: The 1950s: Neo-Realism, Hollywood, New Wave* (Cambridge, MA: Harvard University Press, 1985).

—— (ed.), *Cahiers du Cinéma: The 1960s: New Wave, New Cinema, Reevaluating Hollywood* (Cambridge, MA: Harvard University Press, 1986).

—— and Peter Wollen (eds), *Howard Hawks: American Artist* (London: BFI, 1996).

Hincha, Richard, 'Selling CinemaScope: 1953–1956', *Velvet Light Trap* no. 21 (Summer 1985), pp. 44–53.

Honey, Maureen, *Creating Rosie the Riveter: Class, Gender, and Propaganda during World War II* (Amherst: University of Massachusetts Press, 1984).

Hopper, Hedda, 'Please Try to Understand Me', *Photoplay* (March 1953), pp. 14–15.

Houseman, John, 'Today's Hero: A Review', *Hollywood Quarterly* (January 1947), pp. 161–3.

Hughes, Langston, 'Art and the Heart', *Chicago Defender* (6 April 1946), p. 12.

Jancovich, Mark, '"A Former Director of German Horror Films": Horror, European Cinema and the Critical Reception of Robert Siodmak's Hollywood Career', in Patricia Allmer, Emily Brick and David Huxley (eds), *European Nightmares: Horror Cinema in Europe since 1945* (London: Wallflower Press, 2012), pp. 185–93.

——, '"Frighteningly Real": Realism, Social Criticism and the Psychological Killer in the Critical Reception of the Late 1940s Horror-Thriller', *European Journal of American Culture* vol. 31 no. 1 (April 2012), pp. 25–39.

——, '"Master of Concentrated Suspense": Horror, Gender and Fantasy in Lang's 1940s Films', *Studies in European Cinema* vol. 5 no. 3 (2008), pp. 171–83.

——, '"Realistic Horror": Film Noir and the 1940s Horror Cycle', in Karen McNally (ed.), *Billy Wilder, Movie-Maker: Critical Essays on the Films* (Jefferson, NC: McFarland, 2011), pp. 56–69.

——, '"Thrills and Chills": Horror, the Woman's Film and the Origins of Film Noir', *New Review of Film and Television* vol. 7 no. 2 (June 2009), pp. 157–71.

Jones, Robert, 'How Hollywood Feels about Negroes', *Negro Digest* (August 1947), pp. 4–8.

Kael, Pauline, 'The Man from Dream City', *New Yorker* (14 July 1975), pp. 40–68.

Kalinak, Kathryn (ed.), *Music in the Western: Notes from the Frontier* (New York: Routledge, 2011).

Keith, Slim with Annette Tapert, *Slim: Memories of a Rich and Imperfect Life* (New York: Simon and Schuster, 1990).

Kemper, Tom, *Hidden Talent: The Emergence of Hollywood Agents* (Berkeley: University of California Press, 2010).

Kitses, Jim, *Horizons West* (London: Thames & Hudson/BFI, 1969).

Kobal, John, 'Howard Hawks', in *People Will Talk* (New York: Alfred A. Knopf, 1985), pp. 483–501.

Kracauer, Siegfried, 'Hollywood's Terror Films: Do They Reflect an American State of Mind?', *Commentary* no. 2 (1946), pp. 132–6.

Langlois, Henri, 'The Modernity of Howard Hawks', trans. Russell Campbell, *Cahiers du cinéma* no. 139 (January 1963), repr. in McBride, *Focus on Howard Hawks*, pp. 65–9.

Lee, David D., *Sergeant York: An American Hero* (Lexington: University of Kentucky Press, 1985).

Leinberger, Charles, 'The Dollars Trilogy: "There Are Two Kinds of Western Heroes, My Friend!"' in Kalinak, *Music in the Western*, pp. 131–47.

Lesser, Budd, 'Forum', *Daily Variety* (10 December 1953), p. 10.

Limbacher, James L., *Four Aspects of the Film* (New York: Arno Press, 1978).

Lingeman, Richard R., *Don't You Know There's a War On? The American Home Front, 1941–1945* (New York: G. P. Puttnam's Sons, 1970).

Loos, Anita, *Gentlemen Prefer Blondes: The Intimate Diary of a Professional Lady* (New York: Boni & Liveright, 1925).

Lucas, Blake, '*The Dawn Patrol*', *Magill's Survey of Cinema. English Language Films. Second Series. Vol. II COB-HAL* (Englewood Cliffs, NJ: Prentice-Hall, 1981),pp. 578–82.

Macee, Jeffrey, *The Uncrowned King of Swing: Fletcher Henderson and Big Band Jazz* (New York: Oxford University Press, 2005).

Maltby, Richard, '*Film Noir*: The Politics of the Maladjusted Text', *Journal of American Studies* vol. 18 no. 1 (April 1984), pp. 49–71.

Manning, Robert, *Re-examining the Maladjusted Text: Post-war America, the Hollywood Left and the Problem of Film Noir*, PhD Thesis, University of East Anglia, forthcoming.

Mast, Gerald (ed.), *Bringing Up Baby* (1988, New Brunswick, NJ: Rutgers University Press, 1994).

——, '"Everything's Gonna Be All Right": The Making of *Bringing Up Baby*', in Mast, *Bringing Up Baby*, pp. 3–16.

——, *Howard Hawks, Storyteller* (New York: Oxford University Press, 1982).

May, Elaine Tyler, 'Rosie the Riveter Gets Married', in Lewis A. Erenberg and Susan E. Hirsch (eds), *The War in American Culture: Society and Consciousness during World War II* (Chicago, IL: University of Chicago Press, 1996), pp. 128–43.

McBride, Joseph (ed.), *Focus on Howard Hawks* (Englewood Cliffs, NJ: Prentice-Hall, 1972).

——, 'Hawks', *Film Comment* vol. 14 no. 2 (March/April 1978), pp. 36–41, 70–1.

——, *Hawks on Hawks* (Berkeley: University of California Press, 1982).

—— and Gerald Peary, 'Hawks Talks: New Anecdotes from the Old Master', *Film Comment* vol. 10 no. 3 (May/June 1974), repr. in Breivold, *Howard Hawks Interviews*, pp. 71–99.

—— and Michael Wilmington, '"Do I Get to Play the Drunk This Time?" An Encounter with Howard Hawks', *Sight and Sound* vol. 40 no. 2 (Spring 1971), repr. in Breivold, *Howard Hawks: Interviews*, pp. 59–70.

McCarthy, Todd, *Howard Hawks: The Grey Fox of Hollywood* (New York: Grove Press, 1997).

McElhaney, Joe, *The Death of Classical Cinema: Hitchcock, Lang, Minnelli* (Albany: State University of New York Press, 2006).

——, 'Howard Hawks: American Gesture', *Journal of Film and Video* vol. 58 nos 1/2 (Spring/Summer 2006), pp. 31–45.

McGee, Mark Thomas, *Beyond Ballyhoo: Motion Picture Promotion and Gimmick* (Jefferson, NC: McFarland, 2001).

Medcraft, Russell G. and Norma Mitchell, *Cradle Snatchers* (1931, New York: Samuel French, 1925).

'Memphis Mad on 2 Counts at Movie "Song Is Born"', *Chicago Defender* (11 December 1948), p. 1.

Meyerowitz, Joanne, 'Women, Cheesecake, and Borderline Material: Responses to Girlie Pictures in the Mid-Twentieth-Century U.S.', *Journal of Women's History* vol. 8 no. 3 (Fall 1996), pp. 9–35.

Miller, Frank, *Censored Hollywood: Sex, Sin and Violence on the Screen* (Atlanta, GA: Turner, 1994).

Mitchell, Reid, 'The GI in Europe and the American Military Tradition', in Paul Addison and Angus Calder (eds), *Time to Kill: The Soldier's Experience of War in the West, 1939–1945* (London: Pimlico Press, 1997), pp. 304–16.

Moss, Carlton, 'Your Future in Hollywood', *Our World* (May 1946), pp. 9–10.

Movie no. 5 (December 1962), 'Howard Hawks' issue.

Mulvey, Laura, '*Gentlemen Prefer Blondes*: Anita Loos/Howard Hawks/Marilyn Monroe', in Hillier and Wollen, *American Artist*, pp. 214–28.

Narboni, Jean, 'Against the Clock: *Red Line 7000*', trans. Diana Matias, *Cahiers du cinéma* no. 180 (July 1966), repr. in Jim Hillier (ed.), *Cahiers du Cinéma: The 1960s: New Wave, New Cinema, Reevaluating Hollywood* (Cambridge, MA: Harvard University Press, 1986), pp. 216–19.

Naremore, James, *More Than Night: Film Noir in Its Contexts* (Berkeley: University of California Press, 1998).

Neale, Steve, *Genre and Hollywood* (London: Routledge, 2000).

Nichols, Dudley, '*Air Force*: Screenplay', in Suid, *Air Force*, pp. 47–219.

Peary, Gerald, 'Fast Cars and Women', in McBride, *Focus on Howard Hawks*, pp. 109–17.

Penley, Constance, Saunie Salyer and Michael Shedlin, 'Hawks on Film, Politics, and Childrearing', *Jump Cut* (January/February 1975), repr. in Breivold, *Howard Hawks*, pp. 101–2.

Pippin, Robert B., *Hollywood Westerns and American Myth: The Importance of Howard Hawks and John Ford for Political Philosophy* (New Haven, CT: Yale University Press, 2010).

Pitzulo, Carrie, *Bachelors and Bunnies: The Sexual Politics of Playboy* (Chicago, IL: University of Chicago Press, 2011).

Playboy (December 1953), p. 1. 'What Makes Marilyn?', *Playboy* (December 1953), pp. 17–18.

Prince, David, Peter Lehman and Tom Clark, 'Lee Garmes, A.S.C: An Interview', *Wide Angle* vol. 1 no. 3 (1976), pp. 62–79.

Pye, Douglas, 'Introduction: Criticism and the Western', in Ian Cameron and Douglas Pye (eds), *The Movie Book of the Western* (London: StudioVista, 1996), pp. 9–21.

Reddick, L. D., 'Educational Programs for the Improvement of Race Relations: Motion Pictures, Radio, the Press, and Libraries', *Journal of Negro Education* vol. 13 no. 3 (Summer 1944), pp. 367–89.

Richards, Jeffrey, *Visions of Yesterday* (London: Routledge & Kegan Paul, 1973).

Rivette, Jacques, 'The Genius of Howard Hawks', trans. Russell Campbell and Marvin Pister, *Cahiers du cinéma* no. 23 (May 1953), repr. in Hillier, *Cahiers du Cinéma: The 1950s*, pp. 126–31.

Robinson, Edward G. with Leonard Spigelglass, *All My Yesterdays: An Autobiography* (New York: Signet, 1973).

Rochard, Henri, 'Male War Bride Trial to Army', *Baltimore Sun* (28 September 1947), repr. (in condensed version) as 'I Was a Male War Bride', *Reader's Digest* (November 1947), pp. 1–4.

Rockwell, Norman, 'Rosie the Riveter', *Saturday Evening Post* (29 May 1943), p. 1.

Rohmer, Eric (as Maurice Schérer), 'The Cardinal Virtues of CinemaScope', trans. Liz Hern, *Cahiers du cinéma* no. 31 (January 1954), repr. in Hillier, *Cahiers du Cinéma: The 1950s*, pp. 280–3.

—, 'Masters of Adventure', trans. Julia Cooper, *Cahiers du cinéma* no. 29 (December 1953), pp. 43–5.

Roud, Richard, *A Passion for Films: Henri Langlois and the Cinémathèque Française* (1983, Baltimore, MD: Johns Hopkins University Press, 1999).

Rowe, Kathleen, *Unruly Women: Gender and the Genres of Laughter* (Austin: University of Texas Press, 1995).

Russell, Jane, *My Path and My Detours: An Autobiography* (New York: Franklin Watts, 1985).

Russell, Lee, 'Howard Hawks', *New Left Review* (March/April 1964), repr. in Hillier and Wollen, *American Artist*, pp. 83–6.

Salt, Barry, *Film Style and Technology: History and Analysis*, 2nd edn (London: Starword Press, 1992).

Sargeant, Winthrop, *Jazz: Hot and Hybrid* (1938, New York: Dutton, 1946).

Sarris, Andrew, 'Films', *Village Voice* (9 December 1965), p. 21.

—, *The American Cinema: Directors and Directions, 1929–1968* (New York: Dutton, 1968).

—, 'Who the Hell Is Howard Hawks?', *Framework* vol. 43 no. 1 (Spring 2002), pp. 9–17.

—, *'You Ain't Heard Nothin' Yet': The American Talking Film, History and Memory, 1927–1949* (New York: Oxford University Press, 1998).

Scheuer, Philip K., 'His Melodies Linger On', *Cue* (23 March 1957), np.

—, 'Jam Session Attended by Prof. Danny Kaye', *Los Angeles Times* (5 November 1948), p. A6.

Scheurer, Timothy K., *Music and Mythmaking in Film* (Jefferson, NC: McFarland, 2008).

Schlesinger, Arthur M. Jr, *The Age of Roosevelt: The Coming of the New Deal, 1933–1935* (Boston, MA: Houghton Mifflin, 2003).

Schwarz, David, 'Bringing Up Hawks: Andrew Sarris and Molly Haskell on the Discovery of an Auteur', *Moving Image Source* (25 September 2008): http://www.movingimagesource.us/articles/bringing-up-hawks-20080925.

Shlaes, Amity, *The Forgotten Man: A New History of the Great Depression* (New York: Harper-Collins, 2007).

Skal, David J., *The Monster Show: A Cultural History of Horror* (London: Plexus, 1994).

Sklar, Robert, 'Empire to the West: *Red River*', *Cineaste* (Fall 1978), repr. in Hillier and Wollen, *American Artist*, pp. 152–62.

Slobin, Mark, 'The Steiner Superculture', in Slobin (ed.), *Global Soundtracks: Worlds of Film Music* (Middletown, CT: Wesleyan University Press, 2008), pp. 3–35.

Slotkin, Richard, *Gunfighter Nation: The Myth of the Frontier in Twentieth-Century America* (Norman: University of Oklahoma Press, 1998).

'A Song Is Born: New Danny Kaye Picture Brings Together Top Jazzmen in Single Band', *Ebony* (May 1948), pp. 41–3.

'A Song Is Born', *Time* (1 November 1948), pp. 41–2.

Spellerberg, James, 'CinemaScope and Ideology', *Velvet Light Trap* no. 21 (Summer 1985), pp. 26–34.

Spoto, Donald, *Marilyn Monroe: The Biography* (London: Chatto & Windus, 1993).

Springer, John Parris, 'Beyond the River: Women and the Role of the Feminine in Howard Hawks's *Red River*', in Peter C. Rollins and John E. O'Connor (eds), *Hollywood's West: The American Frontier in Film, Television, and History* (Lexington: University of Kentucky Press, 2005), pp. 115–25.

Staiger, Janet, 'Authorship Approaches', in David A. Gerstner and Janet Staiger (eds), *Authorship and Film* (New York: Routledge, 2002), pp. 27–61.

—, *Interpreting Films: Studies in the Historical Reception of American Cinema* (Princeton, NJ: Princeton University Press, 1992).

Stowe, David W., *Swing Changes: Big Band Jazz in New Deal America* (Cambridge, MA: Harvard University Press, 1994).

Straw, Will, 'Documentary Realism and the Postwar Left', in Frank Krutnik, Steve Neale, Brian Neve and Peter Stanfield (eds), *'Un-American' Hollywood: Politics and Film in the Blacklist Era* (New Brunswick, NJ: Rutgers University Press, 2008), pp. 130–41.

Strayhorn, Billy, 'The Ellington Effect', *Down Beat* (5 November 1952), p. 2.

Strub, Whitney, 'Black and White and Banned All Over: Race, Censorship and Obscenity in Postwar Memphis', *Journal of Social History* vol. 40 no. 3 (Spring 2007), pp. 685–715.

Studlar, Gaylyn, *This Mad Masquerade: Stardom and Masculinity in the Jazz Age* (New York: Columbia University Press, 1996).

Suid, Lawrence Howard, 'Introduction: Mythmaking for the War Effort', in Suid (ed.), *Air Force* (Madison: University of Wisconsin Press, 1983), pp. 9–46.

Swires, Steve, 'Leigh Brackett: Journeyman Plumber', in Patrick McGilligan (ed.), *Backstory 2: Interviews with Screenwriters of the 1940s and 1950s* (Berkeley: University of California Press, 1991), pp. 15–26.

Tagg, Philip and Bob Clarida, '*The Virginian* – Life, Liberty and the US Pursuit of Happiness', in *Ten Little Title Tunes: Towards a Musicology of the Mass Media* (New York: Mass Media Music Scholars' Press, 2003), pp. 277–396.

Thomson, David, 'At the Acme Bookshop', *Sight and Sound* vol. 50 no. 2 (Spring 1981), pp. 122–5.

—, *The Big Sleep* (London: BFI, 1997).

'Tiomkin's Plea: Give Film Music More "Liberty"', *Variety* (31 January 1957), pp. 4, 63.

Trauner, Alexandre, *Décors de Cinéma: Entretiens avec Jean-Pierre Berthomé* (Paris: Jade-Flammarion, 1988).

Truffaut, François, *The Films in My Life*, trans. Leonard Mayhew (London: Allen Lane, 1980).

Tucker, Mark, *Ellington: The Early Years* (Oxford: Bayou Press, 1991).

'US Senate Subcommittee Hearings on Motion Picture and Radio Propaganda, 1941', in Steven Mintz and Randy W. Roberts (eds), *Hollywood's America: Twentieth-century America through Film*, 4th edn (Oxford: Blackwell, 2010), pp. 170–4.

Van der Linden, F. Robert, *Airlines and Air Mail: The Post Office and the Birth of the Commercial Aviation Industry* (Lexington: University of Kentucky Press, 2002).

'Walker Wins May Camera Award', *American Cinematographer* (July 1939), p. 299.

Warshow, Robert, 'Movie Chronicle: The Westerner', in *The Immediate Experience: Movies, Comics, Theatre, and Other Aspects of Popular Culture* (New York: Doubleday, 1962), pp. 135–54.

Weaver, William R., 'Review of *The Blue Dahlia*', *Motion Picture Herald* (2 February 1946), p. 2829.

——, '*The Big Sleep*: Bogart, Bacall and Murder', *Motion Picture Herald* (17 August 1946), p. 3149.

Weber, Max, 'The Protestant Ethic and the "Spirit" of Capitalism', in Peter Baehr and Gordon C. Wells (eds), *The Protestant Ethic and the 'Spirit' of Capitalism and Other Writings* (New York: Penguin, 2002), pp. 1–202.

West, Elliot, 'Thinking West' in William Deverell (ed.), *A Companion to the American West* (Oxford: Blackwell, 2007), pp. 25–50.

Westbrook, Robert B., '" I Want a Girl, Just Like the Girl That Married Harry James": American Women and the Problem of Political Obligation in World War II', *American Quarterly* vol. 42 no. 4 (December 1990), pp. 587–614.

'What Makes Marilyn?', *Playboy* (December 1953), pp. 17–18.

Wilde, Hagar, 'Bringing Up Baby', *Collier's* (10 April 1937), pp. 20–2, 70.

Willis, Donald C., *The Films of Howard Hawks* (Metuchen, NJ: Scarecrow Press, 1975).

Wilson, Brian, '*The Dawn Patrol*', *Senses of Cinema* no. 49 (2009): http://sensesofcinema. com/2009/cteq/dawn-patrol/.

Wise, Naomi, 'The Hawksian Woman', *Take One* (January/February 1971), repr. in Hillier and Wollen, *American Artist*, pp. 111–19.

Wollen, Peter, *Signs and Meaning in the Cinema* (London: Secker & Warburg, 1969).

——, 'Introduction', in Hillier and Wollen, *American Artist*, pp. 1–11.

——, 'Who the Hell Is Howard Hawks?', *Framework: The Journal of Cinema and Media* vol. 43 no. 1 (Spring 2002), pp. 9–17.

Wood, Robin, *Howard Hawks* (London: Secker & Warburg/BFI, 1968).

——, *Howard Hawks* (1968, rev. edn, Detroit, MI: Wayne State University Press, 2006).

——, 'Howard Hawks: The Grey Fox of Hollywood', *CineAction* no. 45 (February 1998), p. 29.

——, 'Who the Hell Is Howard Hawks?', *Focus!* no. 1 (February 1967), pp. 3–6; *Focus!* no. 2 (March 1967), pp. 8–18.

Wright, Will, *Sixguns and Society: A Structural Study of the Western* (Berkeley: University of California Press, 1975).

Wynne, Neil A., *The African American Experience during World War II* (Lanham, MD: Rowman & Littlefield, 2010).

York, Cal, 'Cal York's The Monthly Broadcast from Hollywood', *Photoplay* (August 1932), p. 111.

Zanuck, Darryl F., 'CinemaScope in Production', in Martin Quigley, Jr (ed.), *New Screen Techniques* (New York: Quigley, 1953), pp. 155–8.

Index

Page numbers in **bold** indicate detailed analysis; those in *italics* denote illustrations; *n* = endnote.

List of Illustrations

While considerable effort has been made to correctly identify the copyright holders this has not been possible in all cases. We apologise for any apparent negligence and any omissions or corrections brought to our attention will be remedied in future editions.

Gentlemen Prefer Blondes, © Twentieth Century-Fox Film Corporation; *I Was a Male War Bride*, © Twentieth Century-Fox Film Corporation; *A Girl in Every Port*, © Fox Film Corporation; *Only Angels Have Wings*, © Columbia Pictures Corporation; *The Dawn Patrol*, © First National Pictures; *Hatari!*, © Paramount Pictures Corporation/Malabar Productions; *His Girl Friday*, © Columbia Pictures Corporation; *Red River*, Monterey Productions; *Land of the Pharaohs*, © Continental Company Ltd; *The Big Sleep*, © Warner Bros.; *El Dorado*, © Paramount Pictures Corporation/Laurel Productions; *Rio Bravo*, © Armada Productions; *The Outlaw*, © Hughes Productions; *Bringing Up Baby*, RKO Radio Pictures Inc.; *Man's Favorite Sport*, © Universal Pictures Company Inc./Laurel Productions Inc./Gibraltar Productions; *Duel in the Sun*, © Vanguard Films; *Air Force*, © Warner Bros./First International; *A Song Is Born*, © Samuel Goldwyn Inc.; *Red Line 7000*, © Paramount Pictures Corporation/Laurel Productions; *The Criminal Code*, Columbia Pictures Corporation; *The Dawn Patrol*, © First National Pictures.